SIXTEENTH-CENTURY
TUSCAN DRAWINGS
FROM THE UFFIZI

SIXTEENTH-CENTURY TUSCAN DRAWINGS FROM THE UFFIZI

Annamaria Petrioli Tofani
Graham Smith

OXFORD UNIVERSITY PRESS
in association with the Detroit Institute of Arts
New York Oxford 1988

Oxford University Press

Oxford New York Toronto
Delhi Bombay Calcutta Madras Karachi
Petaling Jaya Singapore Hong Kong Tokyo
Nairobi Dar es Salaam Cape Town
Melbourne Auckland
and associated companies in
Berlin Ibadan

Published by Oxford University Press, Inc.,
200 Madison Avenue, New York, New York 10016

Oxford is a registered trademark of Oxford University Press

This catalogue is published in conjunction with the exhibition
"Sixteenth-Century Tuscan Drawings from the Uffizi" presented at the
Detroit Institute of Arts from October 16, 1988 to January 8, 1989.

The exhibition has been made possible with the assistance of the
National Endowment for the Arts, a Federal Agency of the United States
of America, and an indemnity from the Federal Council on the Arts and
Humanities. Additional support was provided by Società Italiana Vetro S.p.A.,
the State of Michigan, the City of Detroit, and the Founders Society.

Library of Congress Cataloging-in-Publication Data

Petrioli Tofani, Annamaria.
Sixteenth-century Tuscan drawings from the Uffizi/Annamaria
Petrioli Tofani, Graham Smith.
p. cm.
Catalog of an exhibition held at the Detroit Institute of Arts,
Oct. 16, 1988–Jan. 8, 1989.
Bibliography: p.
Includes index.
ISBN 0-19-505597-7
ISBN 0-19-505598-5 (pbk.)
1. Drawing, Italian—Italy—Tuscany—Exhibitions.
2. Drawing—16th century—Italy—Tuscany—Exhibitions. 3. Galleria
degli Uffizi—Exhibitions. I. Smith, Graham, 1942–
II. Galleria degli Uffizi. III. Detroit Institute of Arts.
IV. Title.
NC256.T8P47 1988 88-1678
741.945'51–dc19 CIP

9 8 7 6 5 4 3 2 1

Printed in Japan
on acid-free paper

Foreword

The Detroit Institute of Arts is privileged to present this unique exhibition of one hundred Tuscan drawings of the sixteenth century from the Gabinetto Disegni e Stampe, Galleria degli Uffizi. The Uffizi lists in its current inventory about ten thousand drawings by Tuscan artists, the largest of such holdings in Italy, indeed anywhere in the world. In recent years the Uffizi has presented monographic exhibitions of various cinquecento artists but has never mounted a survey such as this. While individual drawings have been lent to important exhibitions, this exhibition marks the first time the Uffizi has sent such a large group of drawings outside of Italy. About forty percent of the drawings in this exhibition have never been exhibited before; fifty percent have been shown only in Florence.

The only exhibition of drawings in recent memory to cover this period embracing the High Renaissance, Mannerism, and the Early Baroque was the exhibition "Florentine Drawings of the Sixteenth Century," organized by Nicholas Turner from the holdings of the British Museum and shown in London in 1986. However, the present exhibition has a different emphasis as it presents a larger number of works from the latter part of the century. Over half of the drawings are works by Late Mannerist or Early Baroque artists, including those associated with the Tuscan cities of Arezzo, Pisa, and Siena.

The loan of drawings from the Uffizi was first proposed by Ellen Sharp, Curator of Graphic Arts at the Detroit Institute of Arts, in 1982 when plans were being made for exhibitions to celebrate the Institute's centennial in 1985. Detroit has an established tradition of exchange programs with Florence. In 1973–74 the Detroit Institute of Arts organized the exhibition "The Twilight of the Medici, 1670–1743," shown in Detroit and Florence; in 1976–77 the city of Florence lent Verrocchio's sculpture *Putto with Dolphin* to the museum for the opening of Detroit's Renaissance Center; "Treasures of Ancient Nigeria," organized by Detroit, was shown in Florence in 1984. Most recently, in 1985 and 1986, "Italian Renaissance Sculpture in the Time of Donatello," a centennial project, was shown in Detroit, Fort Worth, and Florence.

Ms. Sharp discussed the proposal for an exhibition of sixteenth-century drawings from the Uffizi with Graham Smith, Professor of the History of Art and Director of the Center for Western European Studies at the University of Michigan, Ann Arbor. Dr. Smith had long showed a special interest in the collections and programs of the Institute's Graphic Arts department and has recently written the entries for a forthcoming catalogue of Italian sixteenth-century drawings in our collection. Dr. Smith reported that an exhibition of the Uffizi drawings was already underway in Malibu under the aegis of George Goldner, Curator of Drawings at the J. Paul Getty Museum. Dr. Goldner and the trustees of the Getty Museum readily agreed to a cooperative effort to present this exhibition in Detroit and Malibu. However, when it was discovered that the Uffizi's lending policy limited exhibition time to a ten-week period, it became evident that only one showing in this country was feasible. When the Getty Museum decided to curtail its loan exhibition program, the Detroit Institute of Arts proceeded on its own with successful negotiations with Annamaria Petrioli Tofani, Director of the Uffizi, and with the Ministero per i Beni Culturali ed Ambientali in Rome, leading to the present significant exhibition.

Samuel Sachs II
Director, Detroit Institute of Arts

Acknowledgments

We are most grateful to Annamaria Petrioli Tofani, Curator of Drawings and Prints and Director of the Galleria degli Uffizi, for her constant support of this project. Despite a demanding schedule in her new position, she has contributed thirty-six entries to the catalogue as well as an introduction outlining the development of the Uffizi collection. And to Graham Smith, whose enthusiasm for this project has never flagged, we extend our heartfelt thanks. Dr. Smith has devoted a sabbatical leave to writing a majority of the catalogue entries.

We were fortunate to be able to utilize the skills of both Patrick Young, photographer at the University of Michigan, who photographed all the drawings for the catalogue, and Kelly Pask who compiled the bibliography. Our appreciation goes to Joyce Berry, Senior Editor, Oxford University Press, New York, for her interest in the catalogue. We are also indebted to George Goldner, Curator of Drawings at the J. Paul Getty Museum, for his support of the exhibition and for his assistance with our application for federal indemnity.

The presentation of this exhibition would not have been possible without the indemnification granted by the Federal Council on the Arts and Humanities, Arts and Artifacts Indemnity Act, or without the substantial grant received from the National Endowment for the Arts.

Ellen Sharp, Curator of Graphic Arts, has directed all the aspects of the presentation of this exhibition in Detroit. My congratulations to her and to the following staff members who have made important contributions to this project: Douglas F. Bulka, Senior Preparator; Diana M. Bulka, Preparator; Thomas G. Salas, Assistant to the Preparators; Susanna T. Patrick, National Endowment for the Arts Intern, Department of Graphic Arts; Donald E. Jones, Assistant Director of Development, and Mary Piper, Grants Coordinator; Linda Downs, Curator of Education, and Linda Margolin, Assistant Curator of Education; Louis Gauci, Director of Exhibitions and Design; Lisa J. Steele, Director of Marketing and Public Relations, and Margaret M. DeGrace, Associate Director of Public Relations; Julia P. Henshaw, Director of Publications; Judith R. Dressel, Head Registrar and Exhibitions Coordinator; and Karen Serota, Museum Registration Consultant.

Detroit, Mich.
February 1988 Samuel Sachs II

The original idea for this exhibition, in which the Gabinetto Disegni e Stampe degli Uffizi is pleased to offer its contribution to the celebration surrounding the hundredth anniversary of the founding of the Detroit Institute of Arts, was that of Ellen Sharp, who then followed every phase of its realization with enthusiasm and determination.

A project of this size could never have been developed and completed without the approval and constant support of Samuel Sachs II, who continued the policy of collaboration and exchange between Florence and Detroit that has in the past achieved such outstanding results as the "Twilight of the Medici, 1670–1743" in 1974 and "Italian Renaissance Sculpture in the Time of Donatello" in 1985 and 1986.

Essential contributions were made by Julia Henshaw, who solved many of the problems connected with the publication of this catalogue; by Susan Scott Cesaritti, who translated the Italian texts into English; and by Susanna Weber, who helped with research and manuscript coordination. To them, to all my colleagues at the Gabinetto Disegni e Stampe degli Uffizi who, under the guidance of Gianvittorio Dillon, helped with the organization in Florence, I express my sincere appreciation and heartfelt thanks.

Finally, I wish to express special gratitude to Graham Smith, who shared with me the scholarly burden of the exhibition, discussing all problems as they arose and kindly agreeing to write the largest part of the catalogue.

Florence, Italy Annamaria Petrioli Tofani
February 1988 Director, Galleria degli Uffizi

It is a great pleasure to acknowledge the individuals and institutions that helped to make the work of the past months both enjoyable and possible. The project was begun in the summer of 1985 during a period of residence as a guest scholar at the J. Paul Getty Museum in Malibu. I am most grateful to John Walsh, Director of the Museum, and to George Goldner, Curator of Drawings, for inviting me to the Museum as a guest of the Department of Drawings and for the opportunity to study Italian drawings in a beautiful and congenial environment. Much of the preliminary work for this catalogue was accomplished during three visits to Florence between 1986 and 1987. The study room of the Gabinetto Disegni e Stampe degli Uffizi provided another haven for the multitudinous demands of everyday academic life. I am deeply grateful to the staff of the Gabinetto Disegni for their unflagging patience, their good nature, and for their readiness to help in a wide variety of ways.

My entries were written at the University of Michigan between January and October 1987. The work was immeasurably assisted by a sabbatical during the winter

semester of 1987. David Huntington, Chairman of the Department of the History of Art, was characteristically sympathetic during the period of research and writing and granted me much-needed time away from teaching during the fall semester of 1986. I am also grateful to Marvin Eisenberg for his lively interest in the project.

As the references and bibliography indicate, I have benefited immensely from the research of a great many scholars. In particular, I want to acknowledge the special assistance and informal instruction of George Goldner and Annamaria Petrioli Tofani, Director of the Gabinetto Disegni e Stampe degli Uffizi, both of whom read many of my entries and offered valuable suggestions. More important than that, however, was the opportunity to observe and work with two scholars whose knowledge of Italian drawings is both awesome and inspirational. I am also deeply grateful to Annamaria Petrioli Tofani for agreeing to the exhibition and for selecting the drawings. Most of all, I appreciate her willingness to accept me as a collaborator on the catalogue and her exceptional generosity when it came to distributing entries on the drawings between us.

In the preparation of the final manuscript I was assisted by several friends and colleagues on both sides of the Atlantic. In Florence, Susanna Weber provided valuable research assistance, especially with regard to the entries of Alessandro Casolani. In addition, she was of great assistance in facilitating communications between Italy and the United States and particularly in making arrangements for color transparencies of the drawings to be photographed by Patrick Young. Susan Scott Cesaritti also helped expedite matters in numerous ways. In Ann Arbor, Kelly Pask provided invaluable assistance in reviewing my entries and in compiling and checking the bibliography. I am also much indebted to Julia Henshaw for her interest in this project and for her gentle editorial guidance.

Finally, I am grateful to Samuel Sachs II, Director of the Detroit Institute of Arts, and to Ellen Sharp, Curator of Graphic Arts, for supporting this exhibition through its long period of gestation and for ensuring its realization.

Ann Arbor, Mich. Graham Smith
February 1988 Professor of the History of Art
University of Michigan, Ann Arbor

Contents

The Development of the Uffizi Graphics Collection

Annamaria Petrioli Tofani

The origins of the Uffizi's collection of drawings and prints are to be found in the passion for collecting and the family fortunes of the Medici, the dynasty that ruled Florence and Tuscany politically and economically for over two centuries. It is not surprising that the most important collection of drawings in Italy, as well as one of the most prestigious in the world, was developed in Florence, considering the close association of the city with the arts in terms of both figurative expression and theory.

A few comments on the importance of drawing may be appropriate. In the Renaissance the well-known formula to distinguish between the styles of the two major Italian schools had already been made: "Firenze uguale disegno" (Florence is synonymous with drawing) and "Venezia uguale colore" (Venice is synonymous with color). Added to this is the testimony offered by the many Florentine treatises in which the concept of drawing is clearly and carefully presented in its historical evolution and illuminated from every angle.

In 1437 Cennino Cennini considered drawing "the foundation of art," saying that only diligent practice leads to the mastery of the image's ideal form, while at the same time condemning those artists who in his opinion had more "practice" than "art."[1] Almost half a century later Cristoforo Landino in his 1481 commentary on Dante expressed a strong appreciation for Andrea del Castagno based mainly on the fact that he was a great draftsman.[2] Similar ideas are found throughout Leon Battista Alberti's *De Pictura* (1436), which was so infused with the Florentine cultural climate that its author dedicated it to Filippo Brunelleschi.[3] The same ideas can be found toward midcentury in Lorenzo Ghiberti's *Commentaries*.[4] Leonardo tried to claim historical primacy for drawing, writing that "the first painting was composed of only a line, drawn around a man's shadow cast by the sun on the wall," and then going on to make statements that are significantly more daring in their implications.

> Painting is divided into two principal parts; outline, which surrounds the forms of the objects depicted—and which are termed drawing—and the second which is called shadow. But this drawing is of such excellence that it not only investigates the works of nature, but infinitely more than those that nature produces. This demands of the sculptor that he finish his images with knowledge, and it assigns their perfect end to all the manual arts, although they be infinite. And for this reason we conclude that design is not only a science but a deity whose name should be duly commemorated, a deity which repeats all the visible works of God the highest.[5]

We have here a clear anticipation of the famous etymological interpretation "di Dio segno" proposed by Federico Zuccaro in 1607.[6] This also anticipates, at least on the theoretical level, Michelangelo's equation as recorded in the *Dialoghi* of Francisco de Hollanda: an equation with drawing on one side and on the other the peremptory statement that this is not only the "source and body" of artistic expression in all its range of possible forms, but also the "root of all knowledge."[7]

In the sixteenth century the idea of drawing reaches full maturity in both concept and style and achieves its highest value. Pontormo, questioned by Benedetto Varchi in his investigation into a comparison of all the arts in 1546, stated that "one thing only is there which is noble, which is its foundation, and this is drawing."[8] Benvenuto Cellini did not hesitate to state that a good draftsman can never produce an inferior work of art.[9]

Vasari—for whom drawing, "the parent of our three arts, Architecture, Sculpture and Painting, having its origin in the intellect, draws out from many single things a general judgment"—became the most authoritative interpreter of these sentiments. He wrote that drawing is "nothing other than a visible expression and declaration of our inner conception and of that which others have imagined and have given form to in their idea"; furthermore, "when the intellect puts forth refined and judicious conceptions, the hand which has practiced drawing for many years exhibits the perfection and excellence of the arts as well as the knowledge of the artist."[10] A refined and tireless draftsman, an attentive critic of the concept of drawing, a conscientious expert on antique and contemporary techniques (his detailed description of these is fundamental for modern-day specialists), Vasari reached the most logical consequence of these premises, seen in historical perspective. His activity as a collector secured for research and historical investigation, as well as for esthetic enjoyment, the highest achievements of human thought.

The importance of Vasari's role as a collector in establishing appreciation of the drawing as a work of art is described in many writings on the subject. He was undoubtedly one of the first to give this form an attention that went beyond earlier consideration of drawings as simple tools of the trade, justified in their preservation only insofar as they served as visual records for the artist, as "storehouses" of images that could be used again, or as learning exercises suited only to apprentices in the workshop. In the second half of the sixteenth century Vasari's example led to the foundation of other important collections, such as that of Niccolò Gaddi or those that Vincenzo Borghini in 1584 tells us were found in the homes of Bernardo Vecchietti and

Ridolfo Sirigatti.[11] These all, in one way or another, became part of the Uffizi's collection of prints and drawings.

Although the history of this collection reaches far into the past, the documents that would allow us to adequately reconstruct its earliest episodes seem to be irretrievably lost. Based on scattered hints found in the literature, the only information that is known with some certainty is that the Medici owned graphic works of art at the time of Lorenzo il Magnifico (1449–1492) and that throughout the sixteenth century various members of the family continued to devote increasing attention to graphics.[12] For instance, Grand Duke Cosimo I (1519–1574), according to Vasari, owned several "drawings and sketches and cartoons" by Michelangelo that he kept "as jewels,"[13] as well as "a book of animals" by Piero di Cosimo that were "beautiful and bizarre, drawn very diligently in pen, and executed with an inestimable patience."[14] Records show that his son Francesco (1541–1587) had in his collection many sheets by Antonio da Sangallo the Elder, Michelangelo, and Leonardo.[15]

Through various legacies a traditional core of graphic works was formed fairly early and stayed within the main branch of the Medici family. Especially at the beginning, external factors must have influenced additions or subtractions, whether by gifts, exchanges (a time-honored practice among collectors), the natural deterioration of a material as fragile as paper, massive destruction and plunder during wars or political uprisings (frequent occurrences in Florentine history), or by acquisition of single pieces or of partial or entire collections. Among the most significant and historically verifiable acquisitions made during the sixteenth century are the large number of drawings that Vasari's heirs gave to Francesco I,[16] as well as the important series of studies of fortresses by Antonio da Sangallo the Elder given to the Grand Duke in 1574.[17]

All this is part of what could be called the prehistory of the collection, given the impossibility not only of tracing single works within the current holdings (except in a few fortunate instances), but also of establishing if and to what extent the earliest nuclei can still be found there. The Medici and later the Lorraine family frequently and extensively reorganized their collections, often destroying the old mounts. These would of course have been invaluable today as a point of reference for reconstruction of the vicissitudes of the individual works and their provenance.

The history of the Uffizi collection of drawings and prints begins in the seventeenth century. There is scattered information about individual drawings in inventories of the Uffizi done in 1635[18] and 1638[19] (where for the first time specific reference is made to a "drawings cabinet" and about sheets in the possession of such peripheral members of the family as Cardinal Giovan Carlo [1611–1663], brother of Grand Duke Ferdinand II and the early owner of Michelangelo's Damned Soul).[20] In addition, a rich store of documents is still being analyzed by scholars. These illustrate the formation of

the core of the current collection, assembled by Leopoldo (1617–1675), Ferdinand's older brother, who became a cardinal in 1667.[21]

A man of rare intelligence and profound humanistic and scientific learning, Leopoldo de' Medici spent an enormous fortune throughout his life to gather into his apartments in Palazzo Pitti an extraordinary collection of art objects, including about twelve thousand drawings. The responsibility for their conservation and cataloguing was given to one of the most competent and prominent people in artistic and literary circles of the time: the historian Filippo Baldinucci (1625–1696), who was himself a passionate collector of graphic works. It is to Baldinucci that we owe the compilation of an early summary catalogue of the precious pages given over to his care.

As Baldinucci proceeded with his cataloguing task, he drew the inspiration to write a monumental history. His Notizie dei Professori del Disegno shows very clearly the intellectual approach that distinguished the Florentine concept of the figurative arts in the seventeenth century. The idea that drawing constitutes a fundamental basis, an irreplaceable starting point for any form of figurative expression, was strongly fixed in Baldinucci's mind and certainly also in Leopoldo's. It is expressly repeated in the book's dedication to Grand Duke Cosimo III: "as I have compiled some information about the arts, which have as their foundation drawing, I frankly dare to offer them to Your Most Serene Highness."[22]

From this point on the graphics collection, which had clearly become a specialization separate from the other branches of the Medici collections (paintings, sculptures, scientific instruments, etc.), began its autonomous life, growing alongside the others but no longer in close symbiosis as had earlier been the case. To this group of drawings and prints gathered by Cardinal Leopoldo, but including also the earlier Medici holdings, were later added the private properties of other members of the family and their followers. Apollonio Bassetti, Cardinal Giovan Carlo's secretary, left 937 drawings in 1699[23]; an unspecified number of sheets were left by Prince Ferdinand (1663–1713)[24]; and Cosimo III (1642–1723) left 193 drawings at his death.[25]

In the meantime the collection was transferred from the Medici's private residence in Palazzo Pitti to the Uffizi in 1689.[26] This was a significant move, since it was to a location that, although not public, was still the place where the artistic patrimony of the rulers of Tuscany received a sort of official consecration and began to lose the characteristics of a private collection while taking on those of government property. As had already happened for other art forms, drawings now became not only a source of dynastic pride and prestige but also material for study and consultation. Baldinucci had catalogued them in volumes according to a strictly historical criterion, by century and school. In the course of the transfer, unfortunately, "more than 4700 pieces rejected as useless passed elsewhere,"[27] part of them

perhaps to decorate family homes scattered throughout the Tuscan countryside, and part sold or destroyed.

The later evolution of the collection can be followed through an extensive, well-organized documentation, which seems to grow almost daily. The archival research that has been promoted in recent years sometimes goes forward in small increments and sometimes in substantial ones. In eighteenth-century Florence, the concept of drawing inherited from earlier centuries continued to play a leading role not only in artistic practice but also in the formation of theory. Luigi Lanzi in 1782 recorded these ideas, which he attributed to Winckelmann:

When a painter produces a picture . . . the diligence he brings to it, and the color spread over it, in a certain sense hide his talent; whereas in the lines he draws on paper, he reveals in plain truth and naturalness his gift, thus there the freshness of the hand, there the possession of drawing, there does he best reveal his character and spirit, and that divine inspiration which forms painters no less than poets.[28]

In 1737, with the death of Gian Gastone (b. 1671), the Medici dynasty ended and the French family of Lorraine ascended the throne of Tuscany. The last descendant of the Medici family, the Palatine Electrix Anna Maria Luisa (1667–1743), made an important agreement with Gian Gastone that secured for the city of Florence all the art treasures collected by her family in more than two centuries. This farsighted agreement eliminated any risk of dispersion of the enormous Medici artistic patrimony, which the Lorraine family indeed helped significantly to enrich. For example, in the area of graphics, there are some of the acquisitions made during the time of Pietro Leopoldo (1747–1792), such as eight hundred unbound drawings, eight volumes of architectural drawings, and eight thousand prints that had been part of Niccolò Gaddi's sixteenth-century collection; more than three thousand drawings bought from Ignazio Hugford; and more than one thousand pieces from the Michelozzi collection.[29] Thanks to these and other acquisitions, the Uffizi collection numbered twenty thousand drawings at the end of the eighteenth century when Giuseppe Pelli Bencivenni compiled a sort of handwritten catalogue of it in four volumes, which gives a clear, even if incomplete, overview of the collection's size and structure.[30]

At the same time the print collection was also growing. It occupied fifty volumes in 1782, according to Lanzi: "A sufficient number for anyone who reflects that the collection is just beginning, and that notwithstanding this fact it is rich with a large quantity of rare prints, and in particular those of Antonio Durero and M. Antonio."[31] This number, however, is small compared to the 170 volumes into which the drawings had in the meantime been gathered.

In Florence—contrary to the case in other important European cities—prints were considered not so much for their intrinsic artistic value as for their convenient use in the reproduction of images, and thus merited less attention from Florentine collectors. The following passage from Lanzi, who was perhaps the most credible spokesman in Florentine culture and art at this time, leaves no doubt on the subject:

And truly those who have the noble gift of painting, find no easier means for satisfying it, than to browse the eye and the mind among those sheets, wherein the faithful burin depicts the inventions of gentlemen. Thus they learn, almost without realizing it, the history of every painter, the drawing of every school, the detail of what is most marvelous in every gallery, rather in every city in the World. The same can be said for the two sister arts, Architecture and Sculpture; whose beautiful products are spread by the same means, as the works of Painting.[32]

The formation of the Kingdom of Italy in 1860 had repercussions on the Medici-Lorraine art collections, which became public property to all effects and purposes. This change in their legal status produced strong positive effects. Although members of the Savoy family throughout their reign ignored the Florentine graphic collections and were probably even unaware of their existence, in the decades immediately following the unification of Italy a growing number of donations were made to the collection. These donations came not only from collectors—exceptional from every point of view was Emilio Santarelli's donation of about thirteen thousand drawings in 1866[33]—but also from artists themselves. Some, like the architects Giuseppe Martelli and Pasquale Poccianti or the painters Antonio Ciseri and Stefano Ussi,[34] considered public institutions the most worthy recipients of their graphic production, realizing that, when kept in an institution well equipped for conservation and study, their work would acquire additional importance as a document of their artistic development. It is to donations rather than acquisitions that the collection's possibilities for future growth are entrusted. The collection of the Gabinetto Disegni e Stampe currently contains more than one hundred thousand prints and drawings. A recent, very welcome acquisition was the gift of a complete group of etchings by Giorgio Morandi, donated by the artist's sisters.[35]

The holdings in the Uffizi of drawings and prints by artists from outside Italy are numerically very rich and distinguished by famous masterpieces by Dürer, Rembrandt, Van Dyck, Poussin, and Watteau, but they are less important than the collection of the Italian works, since there are imbalances and sometimes striking lacunae among the foreign works. The case of Rembrandt is characteristic: although there is a large group of his engravings in the Uffizi, there is perhaps one drawing, and that one is problematic. Another example is the Spanish school, of which the Uffizi owns the most important nucleus of drawings outside of Spain without having even one work—drawing or engraving—by Goya.

Among the best represented in the collection are of course Florentine and Tuscan artists; to them, for the sixteenth century alone, current inventories attribute

about ten thousand drawings. Next, in lesser number, are the Venetians, who received special attention from the expert eye and passion for collecting of Leopoldo de' Medici; the Uffizi holds the largest number of Titian drawings in a public collection. Other Italian schools—Genoese, Roman, Bolognese, Neapolitan, etc.—are all quite well represented and make the Gabinetto Disegni e Stampe the most significant graphics collection in Italy.

This overview of the major historical events and prevailing philosophy underlying the growth of the Uffizi's drawings collection over five centuries should give a fairly clear picture of the size of the collection today and the shape of its various components. It should also explain the reasons for the selection of drawings we made when shaping this exhibition for the Detroit Institute of Arts.

Our intention was to prepare for a public by now quite used to artistic and cultural exchanges with Florence not only a documentation of the highest quality of one of the supreme moments of Italian art—in the sixteenth century drawing in Italy reached its full bloom—but also a picture of the significance and orientation of a specific collection with a long history. The choice fell on the theme of Tuscan drawings in the sixteenth century, an area in which the Uffizi's collection is very rich. We were thus able to make a selection that, while considering the conservation criteria which discourages moving sheets that are particularly delicate and fragile, at the same time illustrates in all its aspects—even the most unusual and little known—this great moment in an artistic civilization that found in drawing an especially distinguished means of expression.

The exhibition opens with a group of artists who at the beginning of the century guarantee a continuity with Renaissance tradition, but who infuse it with the new sensibility of an audience that was starting to consider the rigid rules of fifteenth-century perspective too great a limit on the artist's freedom of expression. This audience favored compositional schemes that still held requisite good balance and grandiose monumentality but at the same time moved progressively away from the depiction of everyday reality that was a mainspring of fifteenth-century art. In this section we can see, along with the beautiful drawings of Fra Bartolommeo and Andrea del Sarto, some important works by lesser known artists like Granacci and Albertinelli, as well as interesting examples by Sogliani, who represents the final developments of this movement.

The central, and in a certain sense the most exciting part, of the exhibition presents works by the great Mannerist innovators. These artists, continuing firmly along the path indicated by Michelangelo and expressing the political and social uncertainty and cultural and psychological torment which afflicted their world, brought about a real revolution in figurative style by adopting a syntax that distorted reality and achieved a visionary high drama. The exquisite drawings of Pontormo, Rosso Fiorentino, and Beccafumi, offering a moving testimony

of intense artistic struggles which are rich in ethnic implications, come to mind here, as do the sheets by the sculptor Baccio Bandinelli, which are more distant and academic but still showing great stylistic prowess.

We were also able to provide a rich documentation, both in quantity and quality, of the second generation of Mannerists—those artists who drew from the lessons of the masters to develop a vein of cerebral and sophisticated abstraction, adapting it to the purpose of dynastic glorification and the tendentious decorative requirements of the Medici entourage. Attention is concentrated on the outstanding figures of Agnolo Bronzino, Giorgio Vasari, Francesco Salviati, and Stradanus, and for each we have tried to bring into focus their most famous and important projects, such as Vasari's decorations for the Palazzo Vecchio.

As the conclusion to this broad survey of Mannerism, the exhibition hosts works by a group of artists—like the architect and scenographer Buontalenti or the painters Alessandro Allori, Giovan Battista Naldini, and Andrea Boscoli—who continued in this style practically up to the end of the sixteenth century. At very high levels of professional skill and sometimes reaching moments of real poetry, they achieved in drawing results that were perhaps superior to their official works in other media.

In the last decades of the century, the remnants of a declining Mannerism merge more and more frequently with figurative expressions of a completely different nature, favored by the intellectual climate of the Counter Reformation which advocated a return to "normality." The interpreters of this new tendency, which drew the artists' attention back to the simple beauty of daily life viewed with a poetic affection, include Santi di Tito, Poccetti, Jacopo da Empoli, and Cigoli, all artists of great stature whose drawings reveal important affinities with the burgeoning age of the Baroque.

Throughout this panorama we felt it was useful to give an example, albeit limited, of the ways that these varying stylistic tendencies were received in other parts of Tuscany, particularly in Siena where first-rate artists were working, such as Sodoma, Beccafumi, the elegant Alessandro Casolani, Francesco Vanni, and Ventura Salimbeni.

Notes

Unless otherwise indicated, all translations in the text are by Susan Scott Cesaritti.

1. C. Cennini, *Il libro dell'Arte* [1437], ed. by F. Brunello, Vicenza, 1971.

2. C. Landino, *Commento a Dante* [1481], cf. K. Frey, *Il Codice Magliabechiano cl. XVII, 17*, Berlin, 1892.

3. L. B. Alberti, *De Pictura libri II* [1436], in *Della Pittura e delle Statue di Leonbatista Alberti*, Milan 1804, Libro II, pp. 45–53 passim.

4. L. Ghiberti, *Commentarii* [mid-fifteenth century], ed. J. von Schlosser, Berlin, 1912.

5. Leonardo da Vinci, *Treatise on Painting*, vol. 1, ed. A. P. MacMahon, Princeton University Press, 1956, p. 61.

6. Zuccaro proposes in a pun that the word *disegno* (drawing) derives from *segno di Dio* (di-segn-o). Federico Zuccaro, *Scritti d'Arte [1607]*, ed. D. H. Keikamp, Florence, Leo Olschki, 1961, p. 302.

7. Francisco de Hollanda, *Dialoghi*, Lisbon, 1548.

8. B. Varchi, *Due lezioni . . . nella prima delle quali si dichiara un sonetto di M. Michelangelo Buonaroti, nella seconda si disputa quale sia più nobile arte la Scultura, o la Pittura, con una lettera d'esso Michelangnolo, et più altri eccellentiss. Pittori, et scultori, sopra la quistione sopradetta*, Florence, 1549.

9. B. Cellini, *Sopra l'arte de Disegno*, in B. Cellini, *Trattati dell'Oreficeria e della Scultura*, ed. G. Milanesi, Florence, 1857.

10. Giorgio Vasari, *Vasari on Technique*, trans. Louisa S. Maclehose, ed. G. Baldwin Brown, London, J. M. Dent and Co., 1907; N.Y., Dover Publications, 1960, p. 205.

11. V. Borghini, *Il Riposo di Raffello Borghini. In cui della Pittura, e della Scultura si favella, de' più illustri Pittori, e Scultori, e delle più famose opere loro si fa mentione; e le cose principali appartenenti a dette arti s'insegnano [1584]*, Florence, 1984, pp. 13–14, 20–21.

12. A. Petrioli Tofani, in *Restauro e conservazione delle opere d'arte su carta*, exhibition catalogue by various authors, Florence, Gabinetto Disegni e Stampe degli Uffizi, 1981, pp. 161 ff.

13. Giorgio Vasari, *Le vite de' più eccellenti pittori scuptori ed architettori scritte da Giorgio Vasari pittore aretino con nuove annotazione e commenti Gaetano Milanesi*, vol. 7, Florence, G. C. Sansoni Editore, 1906, p. 272.

14. Ibid., vol. 4, p. 138.

15. See the letter from 1574 (in J. W. Gaye, *Carteggio inedito d'artisti . . .*, vol. 3, Florence, 1839–40, pp. 391–392) with which Antonio di Orazio da Sangallo sent to Francesco a gift of about one hundred architectural drawings by his uncle Antonio the Elder. See also G. Pelli Bencivenni, *Saggio istorico della Real Galleria di Firenze*, Florence, 1779, pp. 137–138.

16. See the testimony of Pietro, the brother of Giorgio Vasari, of June 29, 1574, published in K. Frey, *Der literarische Nachlass Giorgio Vasaris*, vol. 2, Munich, 1930, p. 842.

17. See note 15.

18. *Inventario del 1635*, manuscript in Uffizi library, inv. no. 75.

19. *Invent:o della Galleria, Tribuna e altre Stanze, Consegnato a Bastian Bianchi come custode di essa, fatto questo di sù detto, 9 di Dic:re 1638 . . .*, 1638, manuscript in the Uffizi library, inv. no. 76.

20. Vasari/Milanesi, vol. 7, p. 272, n. 2.

21. See A. Forlani Tempesti, A. Petrioli Tofani, P. Barocchi, G. Chiarini de Anna, *Omaggio a Leopoldo de' Medici*, exhibition catalogue, Florence, Gabinetto Disegni e Stampe degli Uffizi, 1976.

22. F. Baldinucci, *Notizie del professori del disegno [1681–1728]*, vol. 1, F. Ranalli, Florence, 1845, p. 5.

23. A. Petrioli Tofani, *Gabinetto disegni e stampe degli Uffizi: Inventario, 1. Disegni esposti*, Florence, 1986, pp. ix, xx.

24. *Inventario dei Mobili e masserizie della Proprietà del Ser.mo Signor Principe Ferdinando di gloriosa ricordanza, ritrovate dopo la di lui morte nel suo appartamento nel Palazzo de' Pitti*, Florence, Archivio di Stato, Guardaroba 1222.

25. This information is found in an inventory from 1687 in a manuscript in the Florence State Archives (Guardaroba 779, ins. 9, cc. 995–1027); see A. Petrioli Tofani (note 23), p. xx.

26. The *Ristretto delle cose più notabili della città di Firenze . . .*, published in Florence in 1689 by the "Eredi di Francesco Onofri," says that the one hundred twenty volumes of drawings making up the collection of Cardinal Leopoldo were at the Uffizi until a place could be found for them (p. 82).

27. G. Pelli Bencivenni, *Saggio istorico della Real Galleria di Firenze*, vol. 2, Florence, 1779, pp. 183–186.

28. L. Lanzi, *La Real Galleria di Firenze accresciuita e riordinata per commando di S.A.R. l'Arciduca Granduca di Toscana*, Florence, 1782.

29. A. Petrioli Tofani (note 12), pp. 170–172.

30. A. Petrioli Tofani, "Pasquale Nerino Ferri, primo direttore del Gabinetto Disegni e Stampe Uffizi," in *Gli Uffizi, quattro secoli di una Galleria*, proceedings of the Convegno internazionale di studi, September 10–24, 1982, Florence, 1983, 2, pp. 424–425, n. 10.

31. L. Lanzi (note 28), pp. 148–155.

32. Ibid.

33. A. Forlani Tempesti, M. Fossi Todorow, G. Gaeta, A. Petrioli Tofani, *Disegni italiani della collezione Santarelli, sec. XV–XVIII*, exhibition catalogue, Florence, Gabinetto Disegni e Stampe degli Uffizi, 1967.

34. The Martelli collection (4984F–5075F, 5522A–6708A) was acquired in 1872, the Poccianti collection (7204A–7623A) in 1888, the Ciseri drawings (19018F–19037F) in 1893, and the Ussi collection (19291F–19825F) in 1901.

35. The growth of the collection since the end of World War II is documented in A. Forlani Tempesti and A. Petrioli Tofani, *Acquisizioni 1944–1984*, Florence, 1974; *Giorgio Morandi, Mostra delle acqueforti donate dalle sorelle dell'artista*, Florence, 1978; A. Petrioli Tofani, G. Dillon, G. Godoli, A. Natali, E. Neri Lusanna, C. Sisi, *Dieci anni di acquisizioni 1974–1984*, Florence, 1985; and G. Dillon, *Il Bisonte 1959–1982, Una stamperia d'arte a Firenze*, Florence, 1987.

Introduction to the Exhibition

Ellen Sharp

The emphasis on drawing *(disegno)* in Florence was often contrasted by writers in sixteenth-century Italy with the dominance of coloristic effects *(colore)* in Venice.

Disegno embraced not only technical execution but also imaginative invention; it was considered both an intellectual and an intuitive activity. In many drawings in this exhibition evidence is seen of *pentimenti*, or the repetitive delineation of details. Hands or feet, for example, have been drawn over an earlier sketch without erasures (cat. nos. 12 and 51). This action by the artist was not viewed as a correction as much as it was seen as creative experimentation. Often, as a kind of exercise of the imagination, several studies of the same figure were made (cat. nos. 67 and 81).

In 1563 Vasari established the Accademia del Disegno in Florence under the patronage of Cosimo I de' Medici. Almost all the important Florentine artists were members of the Accademia. Although the Accademia represented all three arts—painting, sculpture, and architecture—one of its basic principles was that the arts had a common origin in *disegno*. One of the reasons for the formation of the Accademia was to focus attention on the training of artists as draftsmen, which in the last decades of the century emphasized drawings from life (cat. nos. 79 and 81).

The medieval guild system in Florence gradually dissolved in the fifteenth century. Among the reasons for the demise of the guilds was the Renaissance artist's desire to elevate himself above the status of a craftsman. However, the practice whereby a promising young artist was apprenticed to a master continued into the sixteenth century. The apprentice began his training with an intensive program in drawing. Line drawings by a respected master would be traced, then engravings would be copied, followed by copies of plaster casts of antique sculpture, studies of cadavers, and finally drawings from live models. As engravings of the period show, artists in cinquecento workshops drew in artificial light. Light could thus be made to fall on the figure from different directions. The distortion of the human figure, elongations, and twisted poses favored by the Mannerists were more readily achieved when working under a controlled light that could be adjusted to vary highlights and cast shadows.

In the fifteenth century certain types of drawings were identified that evolved in the development of a composition. "First thoughts" *(pensieri)*—free, loosely executed compositional sketches in which the artist experimented with various ideas—were followed by studies of individual figures *(studi)*, which could be incorporated into finished compositional sketches or into the final drawing *(modello)* that was then squared for transfer to the full-scale cartoon. During the course of the sixteenth century both the rapid sketch and the independent finished drawing (or presentation drawing) took on a separate identity from these sequential working drawings.

In this exhibition there are examples of all these types of drawing, with the exception of the full-size cartoon. There are a preponderance of figure drawings, which have always been one of the dominant and particular glories of Florentine art, as the thorough study of the anatomy of the human figure was emphasized in Florentine workshops. In the sixteenth century medical science and art were closely allied. The illustrated anatomical treatise of Vesalius, *De humani corporis fabrica libri septem,* first published in 1543 in Basel, provided models for cinquecento drawing books, for if the artist was to draw the nude it was deemed necessary to have a knowledge of the human form, beginning with the skeleton (cat. no. 51).

In the fifteenth century the favored medium for artists was pen and ink, or metal point on a prepared ground. While pen and ink continued to be used in the sixteenth century, one of the salient characteristics of cinquecento drawings was the expressive use of black and red chalk. In this exhibition over half of the drawings are executed in these media. Chalk, especially red chalk, made possible more luminous effects, a more supple molding of face and body, than could be achieved with the pen. It was admirably suited to convey the febrile atmosphere, intensity, and nervous tension found in many Mannerist drawings. Toward the end of the century we find a definite trend toward combinations of media, such as pen with color washes and white heightening on blue paper, a color associated with Venetian drawings and the drawings of the Umbrian master Federico Barocci, who had a strong influence on many Tuscan artists and especially the Sienese.

Michelangelo, who was an artistic force unto himself in the sixteenth century and exerted a powerful influence that few artists could escape, is represented in this exhibition by the striking *Bust of a Woman in Profile* (cat. no. 15). This highly finished drawing is a superb example of the presentation drawing.

The drawings in this exhibition are not only representative of the different types of drawings utilized in the sixteenth century, but they also illustrate the varied activities in which cinquecento artists engaged. Artists were expected to be versatile enough to devise architectural schemes (cat. nos. 38, 76), to design villas, garden

xvii

fountains (cat. no. 45), fireworks, jewelry, armaments, tapestries, and ornaments, as well as to create designs for all sorts of festive occasions including triumphal entries, weddings (cat. no. 89), theatrical entertainments, and funerals (cat. nos. 33, 51). These spectacles were commissioned by the rulers of the ducal courts of Italy. The Medici festivals were among the most lavish.

Festivals in the sixteenth century often featured *intermezzi*, or interludes between acts of a play. Devised around mythological themes, the *intermezzi* incorporated dancing and singing and were produced in the belief that ancient Greek and Roman entr'actes were being recreated. *Intermezzi* evolved into an art form that reached a peak of elaboration and technical ingenuity in the last two decades of the century in the designs of Bernardo Buontalenti, whose capacity for theatrical fantasy can be seen in the two drawings that are design studies for a niche for the Cappella dei Principi, the funerary chapel of the Medicis in San Lorenzo (cat. nos. 47, 48). The *intermezzi* led to the development of the earliest operas. We have a record of one of these operas—*Euridice* by Ottavio Rinuccini with music by Jacopo Peri, first presented in the Palazzo Pitti in 1600—in a drawing in the exhibition by Cigoli (cat. no. 86).

In addition to the sheer esthetic pleasure that study of the expressive and varied draftsmanship in this exhibition affords, careful study of these drawings offers many rewarding reminders of dramatic events during the reign of the Medicis in Florence, their military exploits, the colorful life of their court, and their patronage of the arts. After a decline in the beginning of the century, the return to power of the Medici in Florence was firmly established by the coronation of Cosimo I as Grand Duke of Tuscany in 1569. The architectural projects of Cosimo I (r. 1537–74), continued by his successors, changed the medieval aspects of the "city of flowers" and contributed in a major way to the magnificent prospects that still exist in Florence today. Several drawings related to the Palazzo Vecchio, seat of the Florentine government and official residence of Cosimo I, were restructured and decorated by Giorgio Vasari and his assistants beginning in 1555 (cat.

nos. 37, 38), and several were preparatory for the Salone dei Cinquecento (cat. no. 40), the Studiolo of Francisco I (cat. nos. 44, 59), and the Apartment for Eleanora of Toledo (cat. no. 29). Other sheets can be connected with the Medici villa at Poggio a Caiano (cat. nos. 20, 42, 49).

Cosimo I extended Medici rule throughout Tuscany. The drawing by Stradanus, *The Return to Florence of the Marquis of Marignano* (cat. no. 40), depicts the victorious return of Cosimo's *condottieri* to the city after the capture of Siena in April 1555. Another drawing by the same artist, *The Medici Golden Age* (cat. no. 41), pays tribute to the regeneration of the Medici dynasty under Cosimo. The symbol of this rebirth, a new leafy bough springing from a severed tree, appears here as well as in a drawing by Salviati related to a Medici commission (cat. no. 32). Many of the decorations commissioned by the Medici for their villa at Poggio a Caiano and for the *salone* of the Palazzo Vecchio deal not only with dynasty, military triumphs, and the new Medici Golden Age but also with themes of time and the cycles of nature.

A similar cyclical pattern of artistic activity can be seen in this exhibition, surveying as it does a century of draftsmanship in Tuscany. Beginning with the work of Fra Bartolommeo and Andrea del Sarto, who carried on the tradition of the High Renaissance after the departure from Florence in 1508 of Leonardo for Milan and Michelangelo and Raphael for Rome, the exhibition traces the various phases of Mannerism until the emergence of the Early Baroque style in the 1560s and 1570s. The drawings of innovators such as Santi di Tito and Cigoli heralded a return to naturalism and looked back to the work of Andrea del Sarto for inspiration. However, in contrast to the quiet order and clarity of the High Renaissance artists, the drawings of their successors, fueled by the religious ideals of the Counter Reformation, introduced fervent emotions and agitated movement. Furthermore, Florentine art lost the independent identity and leadership it exhibited in the High Renaissance and Early Mannerist periods, displaying an eclecticism that drew upon the art of Venice, Bologna, Parma, and Rome.

Editor's Notes

Descriptive information is given only for the recto of each sheet unless otherwise noted.

Dimensions

The maximum dimensions are given for each drawing with height preceding width.

Exhibition and References

Exhibition and bibliographical references are indicated by a short form consisting of the city and date of exhibition for the former and the author's name and date of publication for the latter. Complete citations are listed under the short forms in the bibliography.

Authors

Each entry is signed with the author's initials:
A.M.P.T. Annamaria Petrioli Tofani
G.S. Graham Smith

Catalogue of the Exhibition

Post-Renaissance Classicism

Baccio della Porta, called Fra Bartolommeo

Florence 1472—Pian di Mugnone 1517

1. *Studies for a Saint Bartholomew*

Red chalk with traces of black chalk, the head of the principal figure gone over with a stylus, squared in black chalk, the vertical line at the center of the sheet in red chalk; 276 × 187 mm

ANNOTATIONS: on recto at lower left corner in blue pencil, *1141;* at lower right in brown ink, in a sixteenth-century hand, *78;* on verso in brown ink by Filippo Baldinucci, *di Fra Bart°;* in blue pencil, *227S*

227S (1141E)

EXHIBITIONS: Florence 1954, no. 9, fig. 4; Amsterdam 1954, no. 19, fig. 6; Florence 1986, no. 68, fig. 85.

REFERENCES: Santarelli 1870, 23, no. 3; Frantz 1879, 226; Gruyer 1886, 57; Ferri 1890, 63; Morelli and Habich 1893, 86; Schonbrunner and Meder 1896–1908, 5; Jacobsen 1898, 273; Berenson 1903, 1:139, 2: no. 227; Knapp 1903, 115, 291; Gamba 1914, no. 19, pl. 19; Gabelentz 1922, 2: no. 163; Venturi 1925, part 1: 294, fig. 206; Berenson 1938, 1:160 and 2: no. 227; Berenson 1961, 2: no. 277; Shearman and Coffey 1976, no. 9, pl. 9.

The drawings gathered on this splendid sheet are preparatory studies for the figure of Saint Bartholomew in Fra Bartolommeo's monumental *Marriage of Saint Catherine,* now in the Accademia in Florence (reproduced in Freedberg 1979, fig. 32; the connection was made first by Gruyer 1886, 57; see Florence 1986, no. 68, with full bibliography). Painted for San Marco in Florence in 1512, the altarpiece was greatly admired by Giorgio Vasari in the mid-sixteenth century (Vasari/Milanesi 4:184–186).

The full-length figure on the left side of the sheet is a study from life of a studio assistant, as Fischer recognized (Florence 1986, 121), although the head is treated in a rather generalized and abstract fashion, reminiscent of Fra Bartolommeo's studies from mannequins. In this case, however, the muscles and tendons of the model's left leg are treated with an anatomical accuracy and attention to detail that exclude the possibility that Fra Bartolommeo was working from a mannequin.

In the lower right section of the sheet are studies of the model's feet and two sketches of his right hand with the fleshing knife, the implement of Bartholomew's martyrdom. It is evident that these drawings were intended to give authority to significant details of figure and pose that remained visible after Saint Bartholomew was clothed in the long, flowing garment that he wears in the finished painting. In addition, the studies for the saint's feet are shaded according to the lighting in the finished altarpiece. Similar studies for the left arm of

the saint are preserved in the Boymans-van Beuningen Museum in Rotterdam (M 57; Florence 1986, 121).

Also on the right side of the sheet, in the upper segment, is a superb drawing of a man's head. Fra Bartolommeo's virtuoso control of the red chalk is particularly evident in this study. The man's close-cropped hair is rendered with crisp detail, and his jaw and neck are realized with strong, forceful strokes, while the face itself is modeled with a soft, granular veil of chalk, achieving an effect very similar to Leonardo's chiaroscuro. Clearly, this is a character study, intended to record the features and expression of the model. Equally clearly, however, another purpose of the drawing is to study the effect of particular lighting conditions on the figure.

Fischer connected the study of a head with Saint Barnabas in Fra Bartolommeo's unfinished altarpiece for the Hall of the Great Council in the Palazzo Vecchio and with the *Saint Mark* in the Palazzo Pitti rather than with the Saint Bartholomew (Florence 1986, 121; the paintings reproduced in Knapp 1903, figs. 52 and 84). In the *Marriage of Saint Catherine* Bartholomew is bearded, not clean-shaven, but apart from that the relationships between this drawing and the saint are compelling. The treatment of the hair, the furrowed brow, and the angle and inclination of the head in this study are all repeated in the painting. Perhaps the most telling evidence that this drawing is preparatory to the Saint Bartholomew is provided by the handling of light. The direction and quality of light in the drawing prepare

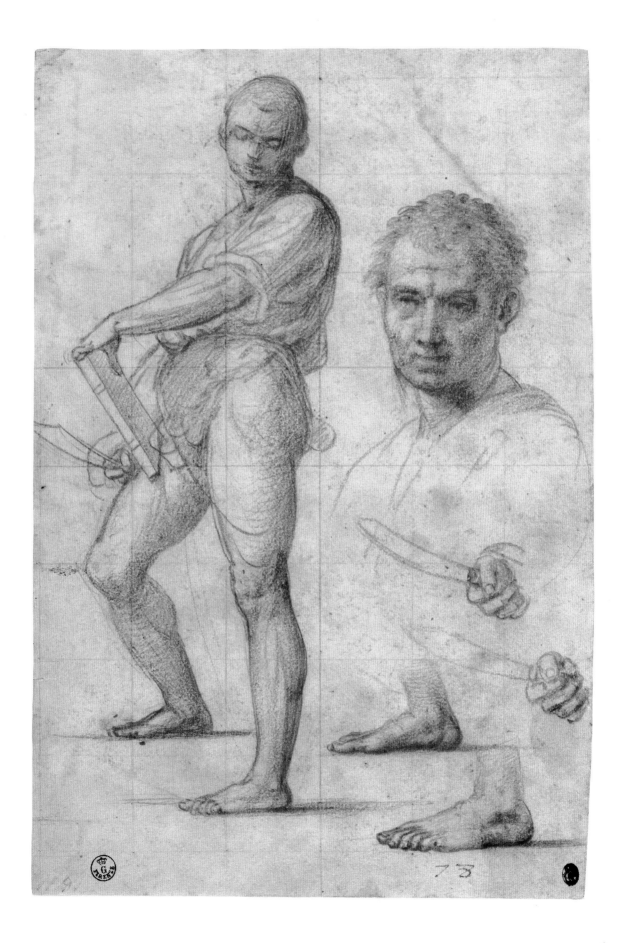

3

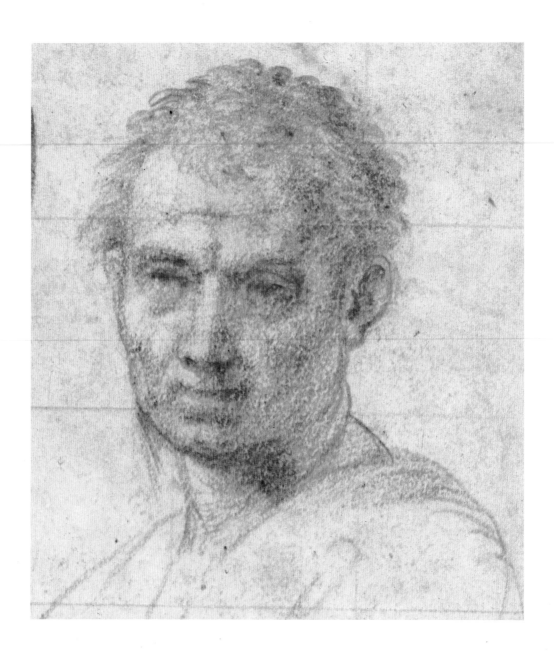

4

directly for the dramatic Leonardesque illumination of Bartholomew in the altarpiece. The cartoon for the head of Saint Bartholomew is preserved in the Boymans-van Beuningen Museum (N 143; Florence 1986, 121).

This drawing should also be considered in relation to other preparatory studies for the Saint Bartholomew, preserved in the Boymans-van Beuningen Museum, the Albertina, and the Uffizi. In the Albertina is a sheet with two drawings in red chalk, similar to the full-length figure here (4875; Stix and Fröhlich-Bum 1932, no. 153, fig. 153; also reproduced in Knapp 1903, fig. 52). These studies are less finished and freer in handling than this drawing, and, as Fischer observed (Florence 1986, 121), differ from it in the particular detail of the fuller presentation of the book held by the model. The sheet in the Albertina appears to have provided the starting point for a second drawing in the Uffizi, in

which the figure is depicted with the flowing draperies worn in the completed painting (Florence 1986, no. 69, fig. 84). Another drapery study, in the Boymans-van Beuningen Museum, takes the figure shown here as its point of departure and prepares directly for the finished painting (M 64; Florence 1986, 121).

Studying the present drawing in relation to Fra Bartolommeo's other drawings for Saint Bartholomew provides a vivid insight into the involved and rigorous character of the artist's preparatory process. This drawing also establishes clearly the close relationship between Fra Bartolommeo's drawings and the effects of light and shade in the finished paintings. Finally, this sheet effectively demonstrates Fra Bartolommeo's masterly control of red chalk, illustrating his ability to coax from it an extraordinary variety of effects.

G.S.

2. *The Virgin and Child*

Black and white chalk on gray-brown prepared paper, squared for enlargement in black chalk; 358 × 248 mm

ANNOTATIONS: on recto at lower left corner in brown ink, *522;* on verso in pencil, *2/522 esp. Frate/corn. 11/Tavola di Besançon* (the last line canceled and *Louvre/1511–1512* substituted)

522E

EXHIBITIONS: Florence 1939, 15; 1940, 118; Paris 1950, no. Florence; 410 Florence 1986, no. 63, fig. 79.

REFERENCES: Gruyer 1886, 104; Ferri 1890, 63; Morelli and Habich 1893, 86; Jacobsen 1898, 273; Knapp 1903, 288; Berenson 1903, 2: no. 274; Gamba 1914, no. 17, pl. 17; Gabelentz 1922, 2: no. 160, pl. 50; Venturi 1925, part 1: 305, fig. 216; Berenson 1938, 2: no. 274; Berenson 1961, 2: no. 274; Petrioli Tofani 1986, 234, 522E.

As Knapp recognized, this drawing is a finished preparatory study for the Virgin and Child in Glory in the Carondelet Altar, now in the cathedral of Besançon (1903, 288; the altarpiece reproduced as fig. 55). Commissioned from Fra Bartolommeo and Mariotto Albertinelli by Ferry Carondelet, archdeacon of the metropolitan church of Besançon and imperial envoy to the papal court, the painting was executed between the summer of 1511 and late 1512 (Borgo 1971, 362–371).

The drawing is very close to the Virgin and Child in the finished altarpiece and, as the squaring indicates, evidently was enlarged to become the cartoon. There are certain differences between the drawing and the painting, however, particularly with regard to the figure of the Christ Child. Pentimenti in the area of Christ's right arm and hand suggest that Fra Bartolommeo was less satisfied with the infant than with the figure of the Virgin. In fact, in the painting he changed the pose of the Christ Child, bringing his left arm and hand up to rest on his chest, rather than on his leg, as is the case in the drawing.

Although he realized the monumental forms of the Virgin and Child with great authority, Fra Bartolommeo rendered the faces of the figures in a rather simple and schematic fashion. Indeed, Fischer (Florence 1986, 115, no. 63) suggests that the Virgin was drawn from a mannequin rather than a live model. Clearly, in this drawing Fra Bartolommeo's primary concerns are with the composition and with lighting. In fact, the combination of rich, velvety passages of black chalk with brightly illuminated areas in white chalk closely approximates the Leonardesque quality of the light in the painting, in addition to establishing precisely its direction.

G.S.

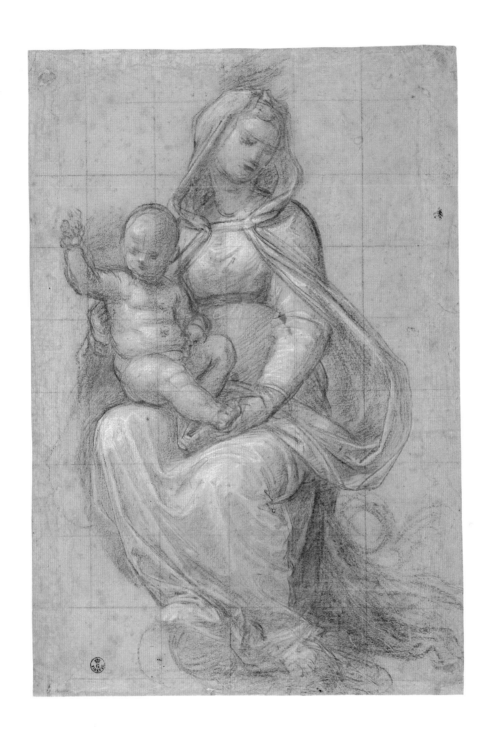

Andrea del Sarto

1486 Florence 1530

3. *Adoration of the Magi*

Red chalk; 366 × 309 mm

667E

EXHIBITIONS: Florence 1910, 8; Florence 1980, no. 31; Florence 1986, no. 6.

REFERENCES: Lagrange 1862, no. 321; Ferri 1881, 40; Ferri 1890, 133; Bayersdorfer 1893, pl. xviii; Jacobsen 1898, 278; Guinness 1899, 87; Berenson 1903, 2:107; Comandé 1952, 5, 122 n. 10; Berenson 1961, 2:107; Freedberg 1963, 2:29–30; Monti 1965, 139 n. 59; Florence, Palazzo Strozzi 1980, no. 31, 60; Petrioli Tofani 1985, no. V; Petrioli Tofani 1986, 292–293; Florence 1986, no. 6, 199–200.

Andrea del Sarto holds a specific position of great importance in the panorama of early sixteenth-century Florentine painting. For many artists, whether his contemporaries or of later generations, his work represents an example of how it was possible to move beyond the contents and methods of early Renaissance art toward a style more suitable to the expression of new problems facing the modern world.

Sarto left Florence, where he was educated in the school of Piero di Cosimo, only on rare occasions: in 1518–19 for a trip to France, where he had been invited to the prestigious court of Francis I; in 1523–24 for a stay at Luco di Mugello, where he fled to escape the plague; and perhaps also around 1520 for a trip to Rome. In Florence his work became a point of both cultural and stylistic reference due to the cohesive strength with which he managed to combine the restlessness of Leonardo's luminism and the tensions of the Mannerists with the serene monumentality of Fra Bartolommeo and the classical balance of Raphael.

His drawings bear particularly effective witness to this great complexity of richness of stylistic content, as can be seen in the *Adoration of the Magi*. Following the judgment of Di Pietro, who had challenged its traditional attribution to Sarto, this important drawing was transferred several decades ago to a group of works by anonymous Umbrian artists of the sixteenth century (archival note). However, its obvious Florentine manner, recognized more recently by Freedberg (1963, 2:29–30), who has strongly defended the attribution to Sarto, led Forlani Tempesti (Florence, Palazzo Strozzi 1980, 60 no. 31) to return it to its position in the portfolio of this artist, under whose name it was shown in the "Il primato del Disegno" of 1980 in Palazzo Strozzi.

In this drawing, one of the most significant among Sarto's graphic works, can be seen his typical stylistic traits of using quick broad strokes of red chalk that seem at first glance rough and hurried but that serve as functional renderings of both the figures and their surroundings.

The general structure of the composition, with its figures distributed horizontally across the front and architectural elements and topographical features acting as scenic backdrops, shows certain analogies with Sarto's fresco the *Journey of the Magi* in the atrium of the Santissima Annunziata, documented to 1511. These analogies, along with the unusual importance which the background landscape assumes in both these scenes, have led many scholars (beginning with Ferri in 1881) to consider the drawing an early idea that was subsequently modified in the painting. It must be kept in mind, however, that the subject of the drawing, clearly an Adoration of the Magi, could hardly have been an alternative to the different episode of the Journey, although it is reasonable to suppose that the scene of the Adoration was conceived for another fresco in the same cycle that was never realized. Berenson had already noted in this drawing the graphic devices borrowed from Piero di Cosimo (1903, 2:107); to these can be added important influences from Filippino Lippi and, more important, from Pietro Perugino. A particularly useful term for comparison—not only for its similar subject—can be found in a Perugino drawing in the British Museum (1853.10.81; Popham and Pouncey 1950, 1:115 no. 187), which scholars agree undoubtedly represents a sketch for a lost fresco described in detail by Vasari (Vasari/Milanesi 3:574), painted by Perugino in the cloister of the Florentine convent of the Gesuati at Porta a Pinti.

A.M.P.T.

8

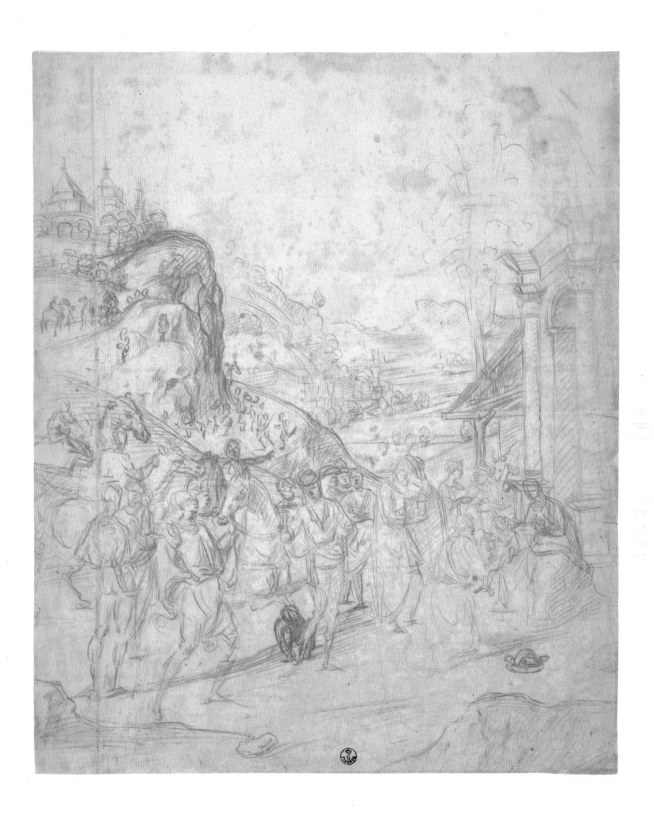

4. *Various Studies for a Standing Male Figure*

Red chalk partially gone over with wash; 274 × 343 mm

ANNOTATIONS: at upper right in charcoal (sideways) and on verso at lower right, in an antique hand, *19*

307F

EXHIBITIONS: Florence 1910, 9; Florence 1986, no. 16.

REFERENCES: Ferri 1890, 136; Jacobsen 1898, 277; Berenson 1903; 2: no. 70; Knapp 1907, 133; Di Pietro 1910, 21; Ferri 1912–21a, ser. 4 fasc. 3, no. 3: Knapp 1928, 116; Fraenckel 1935, 172; Berenson 1938, 2: no. 113a; Freedberg 1963, 2:53; Monti 1965, 153 n. 92; Shearman 1965, 2:335; Shearman and Coffey 1976, 10, 24–25; Petrioli Tofani 1985, 2 and no. X; Florence 1986, no. 16, 213–215.

This drawing and Uffizi 639E, preparatory for a head of an angel, are the only two surviving pieces of evidence of a lost painting that must have represented one of the heights of Sarto's achievement, at least judging from the tone of Vasari's narration (Vasari/Milanesi 5:23). This work also, once it had arrived in France, prepared the ground for the favorable reception that the artist received at the court of Francis I. The painting was a *Pietà* commissioned by the Florentine merchant Giovanbattista Puccini, who had frequent commercial contacts with France. All traces of it were lost almost as soon as it arrived on the other side of the Alps; we cannot be certain that it became part of the royal collection as is sometimes maintained.

The composition of the *Pietà* is documented in an engraving by Agostino Veneziano (Bartsch 1803–21, 45 n. 40), which, besides furnishing irrefutable evidence for the identification of the two preparatory drawings held by the Uffizi, also provides an invaluable chronological point of reference. The print is dated 1516 and it must have been made just after the completion of the painting, before it was sent to France. In this regard Vasari recounts that Sarto "was persuaded to have it engraved at Rome [this is evidently an allusion to the residence of the engraver, who must have worked from a drawing; this does not imply that the panel was sent to Rome for the sole purpose of having a print made of it] by Agostino Viniziano; but as it did not succeed very well he never suffered anything to be printed again" (Vasari/Gaunt 2:310).

Correcting an earlier suggestion by Jacobsen (1898, 277), who had interpreted the drawing as preliminary for the figure of the young man who is climbing the stairs on the right in the fresco of the *Visitation* of 1524 in the Chiostro dello Scalzo, in 1903 Berenson indicated its unequivocal relationship with the Puccini *Pietà*. At the same time he implicitly reestablished a chronology more in keeping with the characteristics of its drawing style, which, although in keeping with those of other sheets from these same years, could not as easily fit in with the works of the following decade.

The drawing is undoubtedly a preparatory study for the figure of the angel holding the nail on the extreme right of the composition engraved by Agostino Veneziano. It is a study that documents the initial phase of this process, the moment in which Sarto, assisted by a co-worker who was willing to pose for him, was searching for the internal structure of the figure that will later be hidden by voluminous drapery. He then proceeds in separate sketches to bring into focus the movement of the left arm through space and the cadence of the upper edge of the cloak along the model's side. This last detail, to which the artist evidently attached great importance, was studied further in two more variations on the verso of the same sheet.

A.M.P.T.

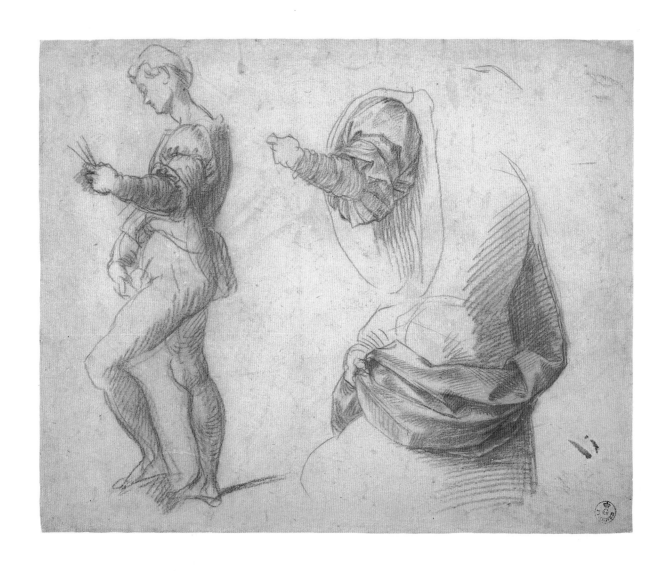

5. *Two Studies for a Man's Head*

Red chalk; 228 × 141 mm

648E

EXHIBITIONS: Florence 1910, 15; Florence 1939, 9; Florence 1940, 139; Florence 1986, 27.

REFERENCES: Ferri 1881, 39; Ferri 1890, 132; Guinness 1899, 52; Berenson 1903, 2:96; Knapp 1907, 134; Di Pietro 1910a, 69; Ferri 1912–21a, ser. 4, fasc. 3, no. 23; Knapp 1928, 117; Fraenckel 1935, 176; Berenson 1938, 2:96; Berenson 1954, pl. xliv; Becherucci 1955, pl. 31; Shearman 1959, 130 n. 35; Berenson 1961, 2: no. 96; Freedberg 1963, 2:102, 165; Monti 1965, 161 n. 130, 180 n. 183; Shearman 1965, 2:349, 367; Shearman and Coffey 1976, 28; Petrioli Tofani 1985, subnote xxi; Petrioli Tofani 1986, 287; Paris 1986, 50; Florence 1986, no. 27, 231–232.

"When Cardinal Giulio de' Medici was commissioned by Pope Leo to have the vaulting of the Medici Palace at Poggio a Cajano . . . decorated with stucco and painting, the charge of the works and payments was entrusted to Ottaviano de' Medici the Magnificent. . . . He entrusted a third to Francia Bigio, a third to Andrea, and the rest to Jacopo da Pontormo. But in spite of Ottaviano's entreaties and offers of money he could not prevail upon them to finish the work. Andrea alone completed with great diligence a scene on a wall of Caesar receiving tribute of all the animals" (Vasari/Gaunt 2:315).

It is thought that this fresco alludes allegorically to an episode from the life of Lorenzo the Magnificent, who in 1487 received a gift of exotic animals from the Sultan of Egypt (for an iconographical interpretation see Cox-Rearick 1984, 87–116 and bibliography). It is not certain that the painting was ever finished. In 1582 Alessandro Allori, who was charged with completing the decoration, altered it along a vertical strip more than two meters high, eliminating a false column that would have divided the composition into two unequal parts, and completely repainted the surface of the smaller section.

The fresco with the *Tribute of the Animals to Caesar* was completed in the period between Sarto's return from France in 1519 and the death of Pope Leo X in December 1521. It marks a crucial point in the evolution of Sarto's style and is a convincing demonstration of how the artist was able to utilize his newly found sense of compositional balance and formal content in the large scale required of wall decoration. He had already successfully experimented with these principles in more modest proportions in some of the frescoes in the Chiostro dello Scalzo, in the *Madonna of the Harpies* in the Uffizi, and the *Disputation on the Trinity* in the Palazzo Pitti, as well as in easel paintings such as the *Charity* in the Louvre.

It is easy to understand that here more than elsewhere Sarto needed the support of drawing as an instrument both of compositional development and formal analysis for single figures; it is perhaps no coincidence that this fresco remains among those best documented by drawings in Sarto's oeuvre. There remain, along with a beautiful compositional sketch in the Louvre (1673), numerous drawings that document a wide range of moments in the creative process, from studies of life models and ancient sculptures, to those of dynamic movements and relationships of volumes; from psychological investigations and studies of animals to exercises on a single passage of drapery, three of which are held by the Uffizi (this one, 10897F, and 295F; Shearman 1965, 2:246).

This sheet—whose quality is among the highest found in Italian drawings of the early sixteenth century—shows a study from life of the head of a young man, repeated partially in the upper section of the sheet where it appears without the beard, for the figure holding a pitcher on his shoulders in the group at the left of the fresco. Before Shearman (1959, 130 n. 35) formulated this identification, which is supported by the presence on the verso of studies for the raised right arm of the same figure and the left leg of the young man who holds back the lion, a number of proposals were advanced for these two studies as preparatory to other paintings, none of which were completely convincing. Becherucci (1955, 31) was the only one who came close to the truth in noticing a resemblance to the apostle on the extreme left of the *Panciatichi Assumption* in the Palazzo Pitti, where this drawing could, in fact, have found a later reutilization.

A.M.P.T.

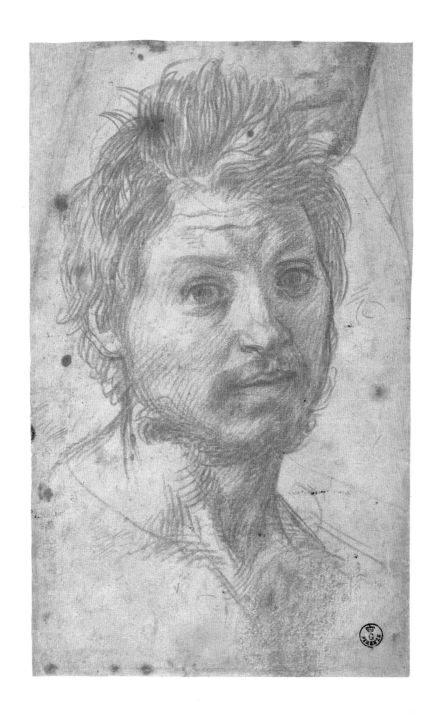

13

6. *Seated Male Nude*

Black chalk; 265 × 190 mm. Mounted

303F

EXHIBITIONS: Florence 1910, 16; Florence 1939, 9; Florence 1940, 140; Florence 1986, no. 54.

REFERENCES: Ferri 1890, 136; Berenson 1903, 2: no. 111; Di Pietro 1910a, 86; Ferri 1912–21a, ser. 4, fasc. 3, no. 24; Leporini 1925, no. 7; Fraenckel 1935, 171; Berenson 1938, 2: no. 111; Becherucci 1955, pl. 30; Shearman 1959, 130 n. 35; Berenson 1961, 2: no. 111; Freedberg 1963, 2:115; Monti 1965, 169 n. 147; Shearman 1965, 2:333; Petrioli Tofani 1985, 7 and no. XXVII; Florence 1986, no. 54, 265.

The large panel of the *Assumption* in the Palazzo Pitti was commissioned by the merchant Bartolommeo Panciatichi, perhaps for the chapel under his patronage in the Dominican church of Notre-Dame du Confort in Lyons. It is without a doubt, with its height of almost four meters, the most ambitious work of its kind done by Sarto up to this point. With this painting he had to face significant technical problems, beyond the obvious difficulties of organizing a composition of homogeneous and balanced forms on such a large surface. The wood of the panel split several times, causing delays while he repainted the surface or undertook restoration procedures. For these reasons, even though the artist must have been fairly far along with the work by the end of 1523, when he moved to Luco di Mugello to escape the plague that spread through Florence in that year, it was never entirely finished. However, the fact that the major part of its execution and consequently also all the graphic work that preceded it can be ascribed to the period between 1522 and 1523 is clear from Vasari, who lists it among the works realized between Sarto's trip to France and his stay in the Mugello area (Vasari/Milanesi 5:33), as well as from a study of the preparatory drawings.

A composition of this size and complexity must have required long and careful preparation, and in fact a large number of drawings can be linked with many of the figures that appear in it. Unfortunately, the studies for the overall composition are missing, except for some early ideas for general groupings that are on the verso of sheets in the Fondation Custodia in Paris (J 2537) and the British Museum (1910.2.12.37).

Among the drawings of single figures, this one from the Uffizi holds a place of major importance, both for the strength of its realization, in which Sarto takes advantage of the qualities offered by a black chalk that is especially soft and pasty, and because it is an important witness to the artist's working methods as he developed the central image of the Virgin of the *Assumption*. Using a nude model, he tries to bring into focus the position of the limbs of the figure. Although in the painting these will be completely covered by the voluminous draperies, they are essential to the internal construction of the figure and constitute the support for its airy gesturing and the resulting effect of solemn monumentality, which is further accentuated by the foreshortening. This study can be placed at the beginning of a process of gradual approach to the painting, whose various phases are well documented by other drawings in the Uffizi collection.

The scattered spots of oil paint, for the most part of a reddish color, that appear on this and other sheets in the series are "original" and demonstrate that the artist worked directly from the drawings in his shop.

A.M.P.T.

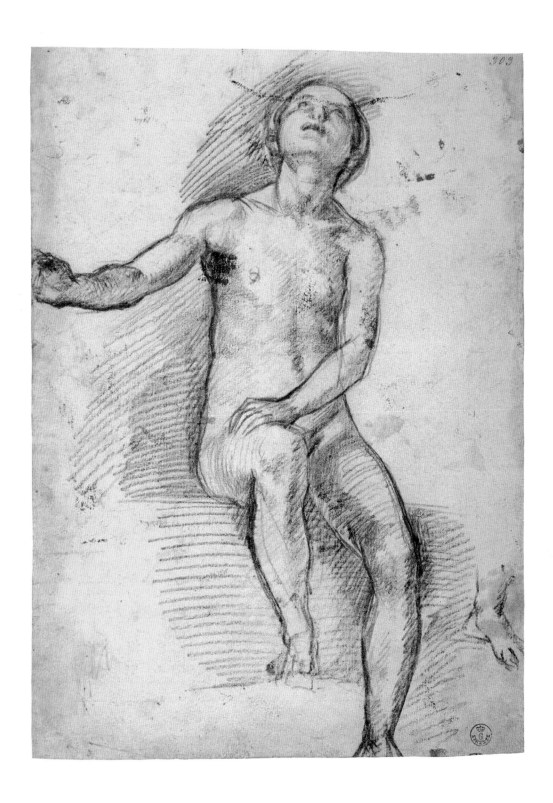

Francesco Granacci

Villamagna (Florence) 1469/70—Florence 1541

7. *Study of Drapery for a Standing Male Figure*

Black chalk partially gone over with wash and heightened with white; 389 × 149 mm

6352F

EXHIBITIONS: None.

REFERENCES: Berenson 1903, 2: no. 978; Berenson 1938, 2: no. 978; Berenson 1961, 2: no. 978; von Holst 1974, 164 n. 61.

Granacci's artistic career began in the workshop of Domenico Ghirlandaio, where the young painter found the direction necessary to develop his innate taste for compositions that were simple and structured with carefully balanced elements. His pronounced gifts as a narrator in plain, direct language were also given free rein by his master. These traits established the projectory that Granacci's work was to follow throughout his painting career. They were never substantially eroded by any of his later experiences, even when he encountered the forceful personality of Michelangelo, whom Granacci came to know in the course of their mutual visits to Lorenzo il Magnifico's collections of classical art in the gardens of San Marco. Granacci stayed for a while in Rome with Michelangelo in 1508 when the latter was beginning work on the ceiling of the Sistine Chapel.

Also not without consequence was Granacci's direct contact with Pontormo, whose prescient message of peremptory modernity was not easy to ignore. The two artists collaborated around 1515 on the pictorial decoration of a celebrated room in Pier Francesco Borgherini's palace in Florence (the panel with *Stories of Joseph* by Granacci done in that context is now in the Uffizi [2152]). He must have felt a closer affinity of style with the other two participants in the project, Bachiacca and Andrea del Sarto, from whose example Granacci probably drew the increased breadth of his compositions and the serene monumentality of his figures.

Contrary to Berenson's attributions, which enlarged inordinately the traditional corpus of Granacci's graphic work by inserting a great many sheets that had been attributed to other contemporary Florentines, the surviving drawings by Granacci's hand are few, amounting to no more than twenty sheets, for the most part those traditionally attributed to Granacci, as von Holst has convincingly reestablished (1974, 164 n. 61). To von Holst's list we might perhaps add Uffizi 10909F, catalogued among the anonymous sixteenth-century artists and representing a meeting between two groups of horsemen against the background of a city which seems to be Florence.

Of traditional attribution also is the drawing shown here, in which Granacci, following a habit common to Florentine artists of the time and exemplified to its highest degree in a famous series of studies of drapery done by Leonardo and his school, studies the effect of light on the folds of a cloak. He plays skillfully with the relationship between the soft, velvety grays of his chalk and the starkness of the white lead, while the figure supporting the cloak is barely suggested on the sheet by a few summary, evanescent lines. Even though this study does not have an exact counterpart in any of the paintings known to be by the artist, the opinion of both Berenson and von Holst that it must be placed in a fairly advanced phase of Granacci's career must be correct.

A.M.P.T.

16

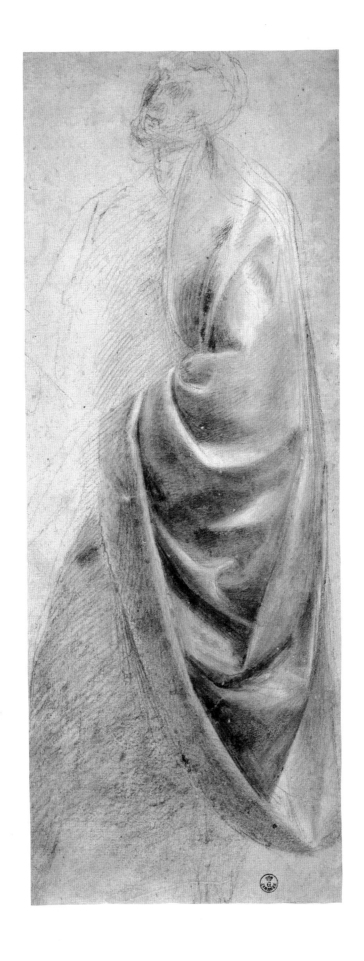

17

Mariotto Albertinelli

1474 Florence 1515

8. *Study for the Head of an Angel*

Black chalk, with stumping, heightened with white; 199 × 169 mm

ANNOTATIONS: on the verso in chalk, *17* and *461 esp. / Frate / anzi Sogliani*

461E

EXHIBITIONS: None.

REFERENCES: Ferri 1881, 28; Ferri 1890, 60; Knapp 1903, 284; Gabelentz 1922, 2: no. 124; Berenson 1903, 2: no. 2523; Borgo 1976, 325, no. 4, fig. 70; Petrioli Tofani 1986, 206–207, 461E

Traditionally attributed to Fra Bartolommeo (Ferri 1881, 28; Ferri 1890, 60), this drawing was subsequently classified as by Giovanni Antonio Sogliani on Berenson's recommendation (1903, 2: no. 2523). The present attribution was first proposed by Knapp in 1903 (284). As he recognized, the drawing is a study for the head of an angel in Albertinelli's *Annunciation with God the Father*, executed for the main altar of the Chapel of the Confraternity of San Zanobi in Florence between 1506 and 1511 (despite the date of 1510 inscribed on the painting), and now in the Accademia (Borgo 1976, 318–322, fig. 29). The angel is placed on the extreme right of the painting at the upper level and looks down on the Virgin Annunciate.

The soft, rather sweet features and expression of the drawing are repeated precisely in the painting, as is the treatment of light and dark. In the altarpiece the angel is lit from above and from the left by a light that seems to emanate from God the Father. We can take it then that the Uffizi angel is the final study for the figure in the painting. A similar but freer study for the head of Gabriel is preserved in the Kupferstichkabinett in Berlin (Borgo 1976, 324, fig. 71; Florence, Palazzo Strozzi 1980, no. 7). That drawing shows a very similar refinement in modeling and has much the same sfumato effect.

G.S.

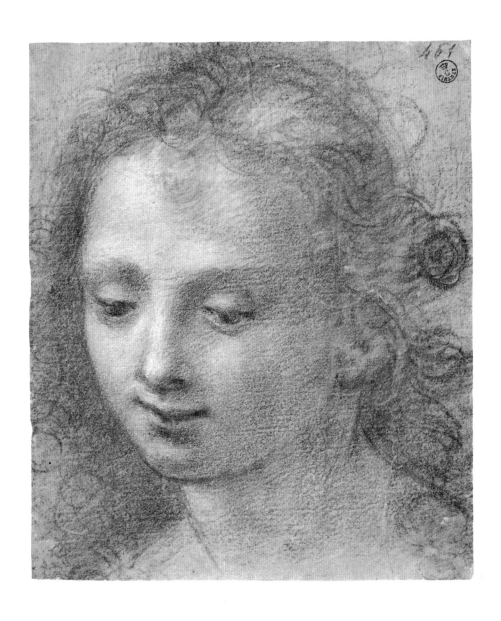

Giovanni Antonio Sogliani

1492 Florence 1544

9. *Standing Male Wearing a Cloak*

Charcoal and white chalk, on gray paper; 308 × 168 mm

14540F

EXHIBITIONS: None.

REFERENCES: Berenson 1903, 2: no. 2614; Berenson, 1938, 2: no. 2614; Berenson 1961, 2: no. 2614; Bacou 1963, 42–43.

Sogliani's place in Florentine painting in the first half of the sixteenth century, even if not that of protagonist, was in any case rather important, since his work represents a highly significant and easily distinguished milestone in the transition from the methods of the Renaissance to those of the Counter Reformation in painting. The role which he played in this process was that of furnishing to artists of succeeding generations a modern and wide-ranging interpretation of the simple balance and lucid rationality of quattrocento composition. He also prepared for these same generations a "normal" (and for this reason more readily understandable) key to interpretation of the ingenious asperities of form and peremptory spirituality of the great masters who were his contemporaries or only slightly older, such as Fra Bartolommeo, Andrea del Sarto, and Pontormo.

Following these intellectual inclinations and this type of approach to the context of his times—both certainly favored by his long acquaintance with Lorenzo di Credi, with whom according to Vasari he remained for twenty-four years—Sogliani achieved a highly professional figurative language characterized by a cultured eclecticism that was greatly appreciated by both patrons and the public (Vasari/Milanesi 5:123). These traits can be found also in the many drawings of his that have come down to us and which, often easily associated with paintings, allow scholars to form a fairly precise idea of the

characteristics and stylistic evolution in his graphic oeuvre.

This is the case of the sheet shown here, which, as Bacou (1963, 42–43) was the first to point out, is preparatory for the figure of a saint holding a long cross on the right in the *Martyrdom of Saint Acasius* in San Lorenzo. Vasari tells us that this work, signed and dated 1521, was commissioned by Alfonsina Orsini, widow of Piero de' Medici, for the church of San Salvatore di Camaldoli in Florence, from which it was removed after the siege of 1529 (Vasari/Milanesi 5:124–125; see Paatz, 1953, 5:45; for the intervening passages see also Paatz, 1931, 2:313). The drawing, on the verso of which is a study for another figure in the same composition (with which 1281E and 6771F in the Uffizi and 237 and 2722 in the Louvre can also be connected), shows a strong influence from Fra Bartolommeo in the handling of lines and the chiaroscuro contrasts obtained by mixing charcoal with white chalk creating a solemn monumentality. This sheet was originally attributed to Fra Bartolommeo until P. N. Ferri, in a handwritten note on the inventory card which seems to date from the end of the nineteenth century, determined that it was done by Sogliani. Another version of the sheet, which was in the Michel Gaud collection, was auctioned at Sotheby's in Munich on June 20, 1987 (*Dessins italiens du XIV au XVIIe siècle*, p. 27, no. 17).

A.M.P.T.

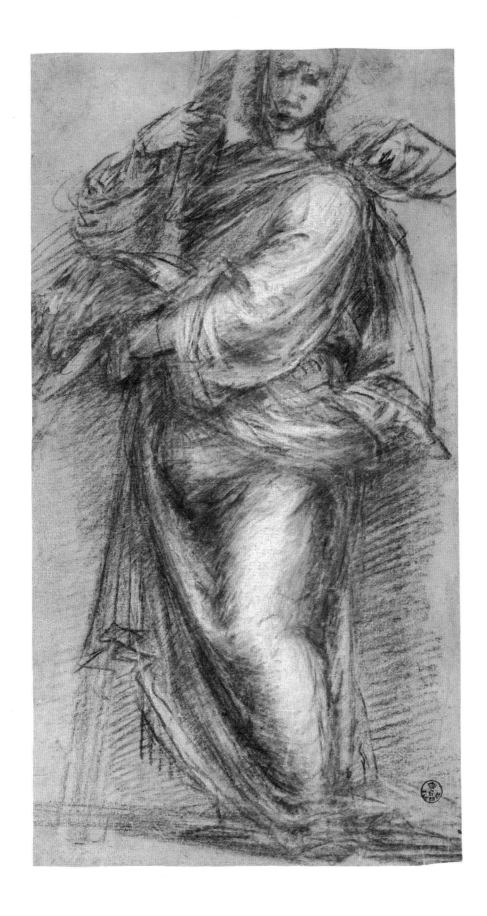

21

Giovanni Antonio Sogliani

10. *Holy Family with the Young Saint John the Baptist and Saint Anne*

Charcoal and white chalk, on paper tinted light brown on recto; 270 × 388 mm

7418F

EXHIBITIONS: None.

REFERENCES: None.

The attribution of this sheet to Sogliani is based exclusively on considerations of style, since it has no counterpart in any of the paintings known to be by him. Formerly catalogued among the anonymous sixteenth-century artists, the extremely skillful drawing style (even if it is a bit superficial in the excessive ease with which he sketches the images) and the choice of media, which are those used almost always by Sogliani, point decidedly in his direction.

Elements typical of Sogliani's figurative expression can also be traced in the types and postures of the figures who, in their somewhat theatrical and mannered sentimentalism, show a misunderstanding of the example of Leonardo. Furthermore, the composition of the group is clearly a variation of a formula already used by Sogliani in a simplified form in a panel in the Uffizi showing the Madonna and Child with the young Saint John the Baptist, where the spatial and dynamic relationship between the figures is resolved in a manner very similar to that found in the nucleus formed here by the child, the Madonna, and Saint Anne.

The painting in the Uffizi is not dated, but it seems that this drawing can be placed into Sogliani's work somewhere between the preparatory studies for the *Martyrdom of Saint Acasius* (cat. no. 9) and a sheet such as the following one, which seems to be done by a more mature hand.

A.M.P.T.

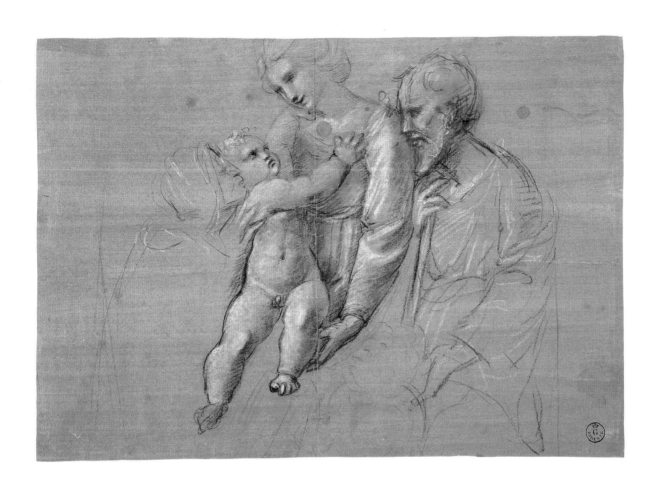

23

Giovanni Antonio Sogliani

11. *Studies for a* Sacra Conversazione

Charcoal and white chalk, on white paper darkened and squared in red; 289 × 211 mm

17054F

EXHIBITIONS: None.

REFERENCES: Berenson 1903, 2: no. 2685; Berenson 1938, 2: no. 2685; Berenson 1961, 2: no. 2685.

Among the rich collection of Sogliani's drawings in the Uffizi is a group of studies that entered into the collection at an unknown date, all glued to the pages of a notebook, with an attribution to an anonymous artist of the sixteenth century in the circle of Fra Bartolommeo (16989F–17077F). Probably before their publication in 1903 by Berenson (who usually mentioned that he had found a drawing under a different attribution than the one he proposed, but in this case did not) these drawings were moved to Sogliani by Ferri. This attribution is supported by abundant stylistic evidence and by the fact that a number of the drawings are connected with documented works by the artist. Further, it could be that the name of Sogliani appeared in handwritten notes on the supporting pages of the notebook, which was itself destroyed in a restoration project of 1953.

The possibility is not to be excluded that the drawings, which go back to various stages of Sogliani's activity (many of them can be connected to paintings whose dates are separated even by as much as two decades), could be part of the group which at the artist's death—according to his will it seems—passed into hands of his friend Bartolommeo Gondi (Vasari/Milanesi 5:130).

The drawing shown here, of a type that would certainly please Naldini or Maso da San Friano for the way in which the figures seem to emerge from a tangle of lines and a chiaroscuro play rich in pictorial allusions, should be included among Sogliani's mature works. This judgment is confirmed by the fact that, among all the studies in the group, the best possibilities for comparison can be found with those that are preparatory for the fresco showing *Saint Dominic Fed by Angels* in the Refectory of the Convent of San Marco, done in 1536 (see especially Uffizi 17060F).

The presence of squaring on the sheet indicates that this composition, in which Sogliani develops the figures (in particular the central one, which would seem to represent the Virgin) using nude models according to a custom learned from Fra Bartolommeo and Andrea del Sarto, was destined to be translated into larger dimensions, probably those of an unidentified painting. On the verso of the sheet (which is marked with a separate inventory number [17053F] due to a mistake by an early cataloguer), appears a study for a clothed figure who seems to be, with a change only in the position of the hands, the same model who posed nude for the Virgin on the recto.

A.M.P.T.

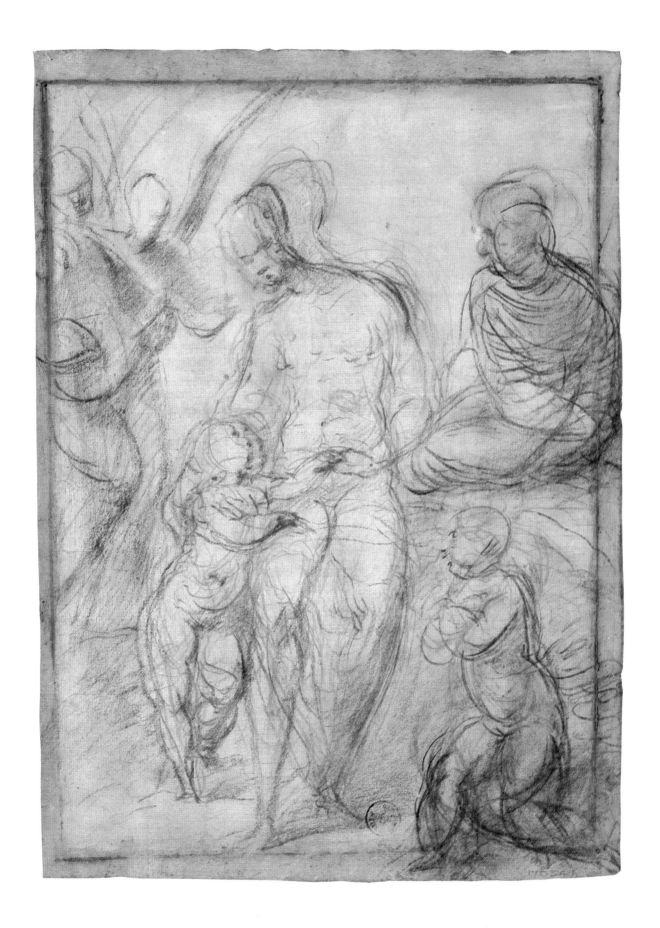

25

Giovanni Antonio Bazzi, called Sodoma

Vercelli 1477—Siena 1549

12. *Study for a* Pietà

Black chalk with some white chalk; 225 × 199 mm

ANNOTATION: at the lower edge of the sheet, an old indecipherable annotation in ink, cut by the lower margin of the sheet

563E

EXHIBITIONS: Vercelli and Siena 1950, Disegni no. 2.

REFERENCES: Ferri 1890, 279; Cust 1906, 200; Hayum 1976, 58, 266; Petrioli Tofani 1986, 251–252, 563E.

Ferri (1890, 279) identified this beautiful drawing as a study for a fresco *Pietà*, executed by Sodoma about 1535 in a tabernacle on the facade of the Palazzo Bambagini in Siena. The fresco was in a fragmentary state by the beginning of this century, but in the sixteenth century Vasari, who was notoriously critical of Sodoma's works, described it as possessing "una grazia e divinità maravigliosa" (Vasari/Milanesi 6:396). The drawing too is of great beauty, representing Mary seated, supporting the dead Christ on her knees. Mary herself is lightly indicated, Sodoma having focused his attention upon the body of Christ and, to a lesser extent, on the draperies of the Virgin, the latter forming a support for Christ's body. Christ himself is treated in a fashion that is not too dissimilar to the *Study for a Risen Christ* (cat. no. 13), with emphatic treatment of the contours of the figure (with evidence of pentimenti in the position of Christ's right arm), combined with delicate and soft interior modeling of his shoulders and torso.

Citing Freedberg as her source for the observation, Hayum suggested a relationship between Sodoma's composition and Pontormo's *Deposition* in Santa Felicita in Florence (1976, 58). The relation, if one exists, is not striking. Rather, Sodoma's composition recalls Michelangelo's marble *Pietà* in Saint Peter's, a work that Sodoma had surely seen during his Roman sojourn. There may also be some recollection of Leonardo's compositions of the Virgin and Child and Saint Anne in the massing of the figures, as well as in the soft sfumato of the drawing.

G.S.

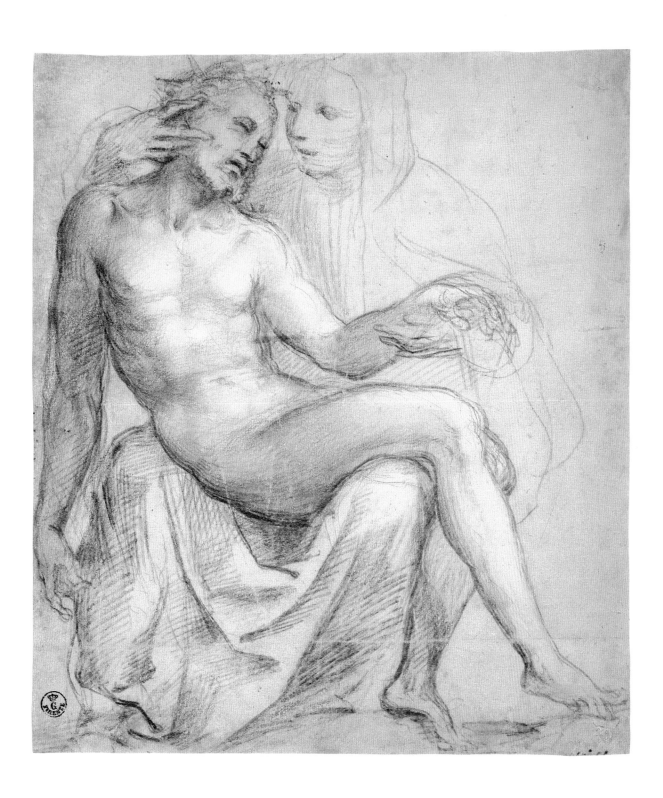

27

13. *Study for a Risen Christ and a Flying Angel*

Red chalk; 266 × 177 mm

ANNOTATIONS: on recto at lower right in ink, *11;* on verso in ink, *Gio. Ant° Licorno* and in pencil *già attributo a Pordenone*

1743F

EXHIBITIONS: Vercelli and Siena 1950, Disegni no. 10; Florence 1961, no. 78.

REFERENCES: Ferri 1890, 280; Cust 1906, 214 n. 3; Hayum 1976, 233–234; Goldner 1985, 775–776.

Sodoma painted two *Resurrections* during the 1530s, one in fresco in the Palazzo Pubblico in Siena, and the other on panel, for the church of San Tomaso d'Aquino in Naples. The latter work, which is now in the Museo di Capodimonte, is inscribed and dated 1535. There is general agreement that the fresco in Siena dates from the same period (for a discussion of the paintings and related drawings, see Hayum 1976, 231–238).

Ferri connected this drawing with the fresco in the Palazzo Pubblico (1890, 280); Carli related it to both paintings (Vercelli and Siena 1950, Disegni no. 10); Hayum preferred to associate it with the Naples picture (1976, 237). In fact, the drawing is not sufficiently close to either picture to require that it be considered a preparatory study for one or the other. Indeed, it can also be associated with other works by Sodoma, such as the Christ in the upper section of *Saint Catherine Swooning* in the chapel of Saint Catherine in San Domenico in Siena (Goldner 1985, 775 n. 4; Hayum 1976, fig. 65). The figure appears again in Sodoma's *Sacrifice of Isaac* in the cathedral of Pisa, executed between 1541 and 1542 (Hayum 1976, 251–255, fig. 84). With his upward gaze, expansive gesture, and dramatic windswept draperies, Abraham perhaps reflects most closely the present drawing for the *Risen Christ*. This observation serves to underscore that this drawing should not be connected too dogmatically with any particular paintings by Sodoma. Nor does the quick sketch of an angel flying to the right, at the lower right of the drawing, clarify the situation, since similar but not identical putti or angels appear in all four works just mentioned.

The drawing is executed in a manner that complements the dynamic character of the figure and draperies. There are many pentimenti and instances where the contours of the figure are repeated several times. The result is a turbulent drawing of great vigor and beauty. At the same time, the interior modeling of the torso and legs of Christ is handled with great delicacy and sensitivity, creating a Leonardesque softness and sfumato.

This drawing is quite different in style and medium from another, formerly in the Seibl collection and now in the J. Paul Getty Museum in Malibu (86.GA.2.), which is connected with the Siena *Resurrection* (Goldner 1985, 775–776, fig. 2). Executed in pen rather than chalk, the Seibl *Risen Christ* is at once clearer and less spontaneous in appearance than the Uffizi study. On the other hand, the differences in style from the Seibl sheet need not exclude an approximately contemporary dating of about 1535–40.

G.S.

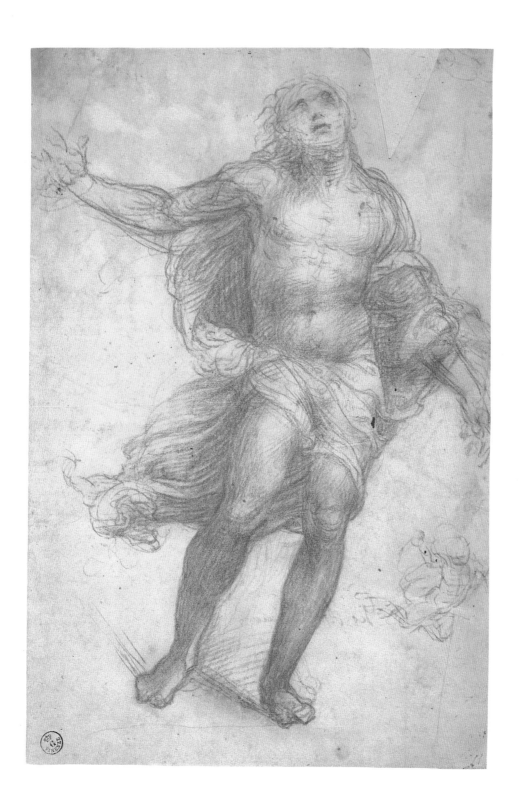

29

14. *A Group of Figures, Two of Whom Are Restraining a Nude Woman*

Pen and brown ink; 181 × 135 mm

ANNOTATION: at lower right a partial blind stamp with the arms of the Medici (Lugt 2712, incorrectly identified as the collector's stamp of Cardinal Leopoldo de' Medici)

565E

EXHIBITIONS: Vercelli and Siena 1950, Disegni no. 7.

REFERENCES: Ferri 1881, 34; Ferri 1890, 279; Cust 1904, 256–257; Cust 1906, 181; Petrioli Tofani 1986, 252–253, 565E

This tempestuous and violent study was connected by Cust with an unrealized fresco by Sodoma depicting Saint Catherine of Siena exorcizing a possessed woman, intended for the chapel of Saint Catherine in San Domenico in Siena (1904, 256–257). Sodoma painted two scenes on the altar wall, *Saint Catherine Swooning* and the *Vision of Saint Catherine*, and one on one of the lateral walls, the *Beheading of Niccolò Tullio*. The decoration of the chapel was completed in 1593 by Francesco Vanni, who executed a *Saint Catherine Exorcizing a Possessed Woman* in oil on canvas for the remaining lateral wall (reproduced in Cust 1904, 63; Vanni's *modello* for the composition is in the Louvre [2022] [Florence 1976, no. 6; reproduced in color in Bacou 1982, no. 43]).

This drawing can be associated with four other pen studies in the Uffizi (562E, recto and verso, 1507E, and 1508E; 562E, recto and verso reproduced in Petrioli Tofani 1986; 1507E and 1508E reproduced in Cust 1904, 62), all of which show Sodoma exploring ideas for a Saint Catherine exorcizing a possessed woman. Vanni's eventual treatment of the subject is very different from Sodoma's (recalling compositions by Federico Barocci), particularly in showing the possessed woman writhing on the ground before Saint Catherine rather than struggling Laocoön-like in an upward position. Nevertheless, there are sufficient links between the drawings by Sodoma and Vanni's painting to support Cust's view that the commission given to Vanni revived one abandoned by Sodoma and that Vanni probably had seen Sodoma's drawings.

Vasari criticized Sodoma for not making composition drawings for his multifigured compositions and stated that instead he would draw directly onto the plaster (Vasari/Milanesi 6:395). In view of the scarcity of drawings by Sodoma, this account of his procedure may well have some degree of truth. That being the case, the fact that eight or nine drawings can be connected with the Saint Catherine cycle is an indication of its importance in Sodoma's oeuvre.

Sodoma's relationship to Leonardo da Vinci is a much-debated issue, but it is worth pointing out that the pose and full figure of the possessed woman recall Leonardo's standing *Leda*, as we know it from the Ex-Spiridon and Borghese versions. Significantly, the former painting was at one time attributed to Sodoma, a view that is still supported by some scholars (Ettlinger and Ottino della Chiesa 1967, nos. 34, 107). Moreover, another apparently contemporary sheet of drawings by Sodoma in the Uffizi (1506E) combines several Leonardesque motifs—a Leda type, a horse, and an infant. In addition, the open pen work, with hatching that follows the contours of the figures, employed in this and other drawings in the series, is similar to Leonardo's draftsmanship in his *Leda* studies and in other drawings from his second Florentine period.

The violence of the subject, the dense interlocking of three principal figures, and the manner in which the possessed woman flings her head back and up to the left all suggest that Sodoma may also have had in mind the famous Laocoön group. Sodoma's interest in antique sculpture is well documented (an inventory of the contents of his studio taken in 1529 lists several antique fragments [Wolk 1984, 32 n. 2]), and so it is not improbable that he would draw on that most expressive of sculptures for the inherently violent subject of Saint Catherine exorcizing a possessed woman. In this context, it is interesting that Hayum describes the body of the decapitated Niccolò Tullio as a copy of the Belvedere Torso (1976, 50).

G.S.

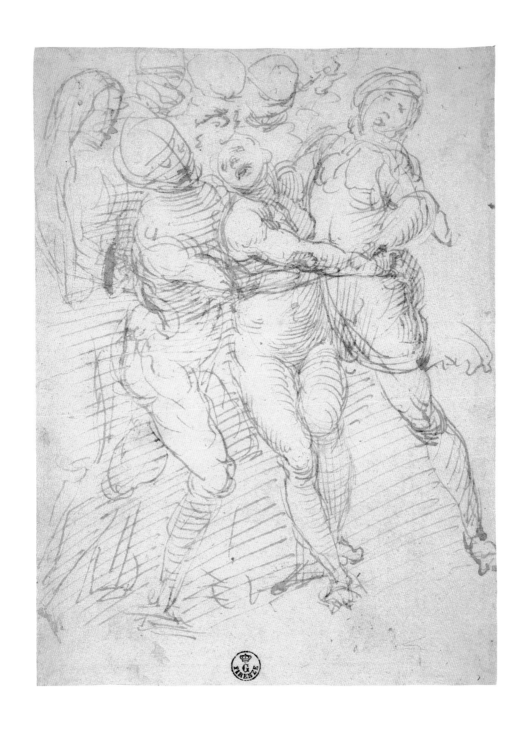

31

Michelangelo

Michelangelo Buonarroti

Caprese 1475—Rome 1564

15. *Bust of a Woman in Profile and Sketches for a Bust of a Child and for a Man with a Beard* (recto); *Various Studies* (verso)

Black chalk; 357 × 252 mm

598E

EXHIBITIONS: Amsterdam 1954, no. 116; Florence 1954, no. 94; Florence 1975, no. 91; Florence, Palazzo Vecchio 1980, no. 494.

REFERENCES: Lagrange 1862, 552, no. 299; Album Michelangiolesco 1875, no. 17; Gotti 1875, 2: 169; Saint-Cyrde Rayssac 1875, 7–8; Mantz 1876b, 182; Ferri 1881, 36; Ferri 1890, 38; Wölfflin 1890, 269; Morelli and Habich 1892–93, 88, no. 189; Wölfflin 1899, 225; Ricci 1902, 177; Berenson 1903, 2: no. 1626; Justi 1909, 349; Thode 1913, 83, no. 206; Voss 1920, 1:161; Brinckmann 1925, no. 87; Popp 1925, 72; Panofsky 1927–28, 242 n. 23; Berenson 1935, 243, 251, 261; Berenson 1935, 2: no. 1626; Berge 1938, 89; Delacre 1938, 151; Popham and Wilde 1949, 265; Goldscheider 1951, 50; Florence 1954, 56–57, no. 94; Marcucci 1958, 36; Dussler 1959, 230–231, no. 491; Wilde 1959, 370; Tolnay 1960, 168, no. 149; Berenson 1961, 2: no. 1626; Barocchi 1962, 233–235, no. 185; Berti 1965, 478 n. 163; Shearman 1967, 57–58; Hartt 1971, 383; Florence 1975, no. 91; Tolnay 1976, 2: 90, no. 307; Florence, Palazzo Vecchio 1980, 265, no. 494; Petrioli Tofani 1986, 265–266.

It was Michelangelo's habit to give drawings to his friends as gifts; the drawings intended for this purpose are characterized by great technical precision and a highly polished style. Vasari tells us that Michelangelo gave to "his very good friend Gherardo Perini, a Florentine gentleman . . . three pages of heads done in black chalk which were divine." After Perini's death in 1564 (a few months after that of Michelangelo), the three sheets passed "into the hands of the most illustrious don Francesco prince of Florence, who kept them (like jewels), as in fact they are" (Vasari/Gaunt 4:174).

These three sheets from the private collection of Prince Francesco, who became Grand Duke of Tuscany Francesco I at the death of his father Cosimo I in 1574, came directly into the official Medici family collections that then became the nucleus of the collections of the Florentine museums, including the Gabinetto Disegni e Stampe. The "divine heads" (598E, 599E, and 601E) can be identified with a group of six drawings by Michelangelo described in a list of objects constituting the Medici family patrimony, compiled between 1560 and 1567, where the sheet shown here is cited as "un disegno di una testa di donna e parte di busto, acconciatura Antica, con du[e] altri schizzi di teste" (a drawing of a woman's head and part of her bust, Antique hairstyle, with two other sketches of heads) (Archivio di Stato di Firenze, Guardaroba Medicea 65, c. 164; published in Frey 1930, 2: 57n).

The provenance of this drawing is absolutely indis-putable, even if in the course of the centuries records of some transfers may have been lost. The quality of its execution is extraordinary and it is rich in characteristics most typical of Michelangelo's style. These qualities have been enthusiastically praised by Lagrange, Rayssac, Mantz, Wölfflin, Justi, and Thode, and more recently decisively reiterated by Delacre, Wilde, and Goldscheider. Yet many scholars have doubted in sum or in part its authenticity as a work by Michelangelo, some (Voss, Marcucci, Barocchi) reviving an earlier proposal by Morelli, who thought it was by Bachiacca, others referring to a hypothetical "Andrea di Michelangelo" (Berenson) or Antonio Mini (Dussler, Popp, Berge), others still (Brinckmann) calling it an anonymous copy of a lost Michelangelo original. Such a fluctuation of opinion has led to changes in attribution within the Uffizi, where the sheet was listed under Michelangelo's name in all the early inventories up to the nineteenth century (see Petrioli Tofani 1986), when Ferri transferred it to Bachiacca, where it stayed until the 1950s, when Sinibaldi reattributed it to Michelangelo.

The drawing's subject continues to perplex and cause discussion among scholars. In all the early descriptions, in both the inventories and elsewhere, it is described as a study of figures, attributing to the drawing the significance of a purely formal elaboration independent of its content. It thus becomes a sort of stylistic exercise on the theme of the human figure that could be read as an attempt to represent artistically a topic widely debated

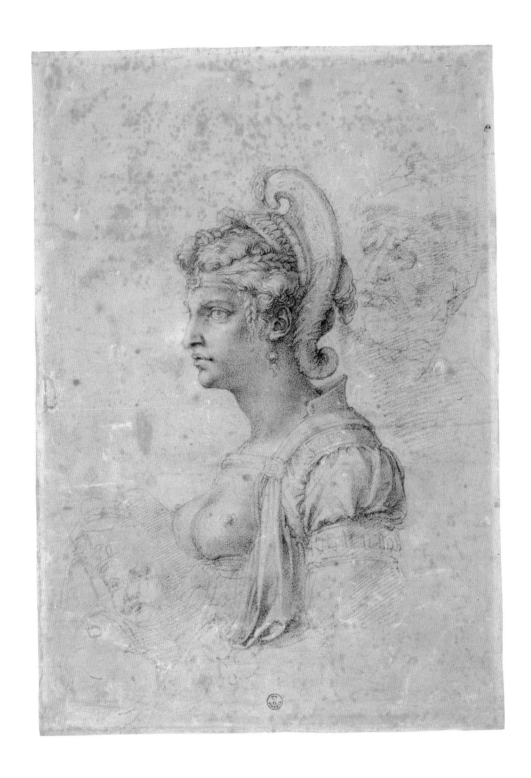

at the time: the dialectic between nature (suggested by the heads of the child and especially of the man, evoked through a naturalistic play of light and shade, affectionately rendered and rich in dynamic tension) and art (represented by the intellectual abstraction of the bust of the woman, lifted onto a universal and ideal plane that is completely detached from any reality of form or feeling).

Among the many identifications of the figures proposed from time to time throughout the literature—from Zenobia, as indicated by the title of a painted sixteenth-century version in Sir Joshua Reynolds's collection and known from a 1788 print by William Sharp, to Justi's Herod and Marianna, to Tolnay's Athena—the most plausible seems to be the proposal of Wilde, who sees in it a representation of Venus with Vulcan and Cupid. This interpretation coincides with the results of another interesting investigation undertaken by Wilde involving a drawing in the Royal Collections at Windsor (0419), which he convincingly attributes to Giulio Clovio, a famous copyist of Michelangelo's works whose presence in Florence is documented between 1551 and 1553. Wilde maintains that the Windsor sheet, a copy of this original, could be the one described in the inventory done at Clovio's death as "the combat between Mars and Venus done by Do[n] Giulio and invention of Michelangelo" (Bertolotti 1882, 212).

The importance of this drawing as a stylistic point of reference and its fame throughout sixteenth-century artistic circles are evidenced by the many versions in drawing or painting that derive from it. Besides those already mentioned, there is a painted *Portrait of a Courtesan* in the Remak collection in Berlin attributed to Bachiacca (Berge 1935), and a painting sold at auction in Florence in 1969 under the name of Michele di Ridolfo del Ghirlandaio (*Catalogo dell'arredamento esistente nella Villa Medicea La Ferdinanda di Artimino*, October 4–8, 1969, 291, ill. no. 901).

This drawing is one of the artist's great masterpieces in the medium, as well as one of the most significant examples of Florentine Mannerism. Its influence is felt in the intensely dramatic figurative language of Rosso Fiorentino and Pontormo as well as in the sophisticated formal elegance found in the work of Vasari, Salviati, and Alessandro Allori. While there is no documentary evidence to determine the date of its execution, according to a theory put forward by Wilde and repeated throughout the bibliography on Michelangelo, it is probably from the period around 1525, when he was working in Florence in San Lorenzo. It should be emphasized that this type of highly polished drawing, which Wilde calls a "presentation drawing," leaves a wide margin for conjecture about its date.

The verso (below) of the sheet contains a series of anatomical sketches; although their rapid, disordered notations make their attribution difficult, the tendency today is to consider them at least in part as Michelangelo's.

A.M.P.T.

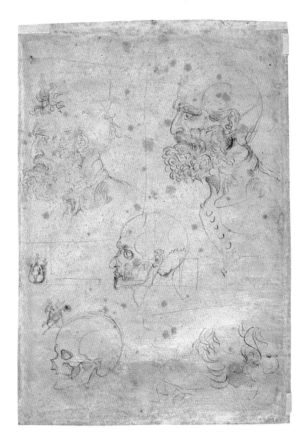

Early Mannerism

Baccio Bandinelli

1493 Florence 1560

16. *The Drunkenness of Noah*

Red chalk; 313 × 435 mm. Mounted

ANNOTATIONS: at lower right in pen, in a nineteenth-century (?) hand, *88* (sideways)

6912F

EXHIBITIONS: None.

REFERENCES: Ferri 1890, 31; Ferri 1912–21b, ser. 4, fasc. 4 no. 25; Beck 1973, 7–11; Ward 1981, 6, 12 n. 11.

Baccio Bandinelli was a sculptor but also a painter and an excellent draftsman—"certainly, Baccio's drawings were very beautiful," wrote Vasari (Vasari/Milanese 6:152). He was a student first of his father Michelangelo di Viviano, who was a successful goldsmith in Florence, and later of the sculptor Giovanfrancesco Rustici, in whose shop he had occasion also to meet Leonardo. It was by following Rustici's teachings, diligently copying Michelangelo's cartoon for the *Battle of Cascina,* and carefully studying the extraordinary lessons of Rosso Fiorentino that Bandinelli was able to refine his distinguished talent as a draftsman, obtaining the technical prowess and sureness of style that form the base on which rests the sophisticated academism of his sculptural style.

An artist who was highly appreciated in the Medici circle, he received numerous important commissions from various members of the family in both Florence and Rome. In Rome, where he was invited to work on several occasions by Popes Leo X and Clement VII, Bandinelli was able to cultivate his strong interest in classical art, which is evident in all of his principal sculptural works to a greater or lesser degree. The eminently sculptural quality of Bandinelli's artistic expression can clearly be seen in his abundant production of drawings, even in those that served as studies for paintings. In these the essential linearism of Mannerist derivation is altered and distorted by the strength of the chiaroscuro used by the artist for three-dimensional effect.

Evidence of this handling may be seen in the present drawing, which Beck (1973, 7–11) connected with a composition showing *Noah the Inventor of Wine* des-tined to become a painting. Bandinelli turned his attention in the last years of his life to this work, which is part of a group described in greater detail in cat. no. 18. Aside from the fact that the subject of this drawing is unequivocally the *Drunkenness of Noah,* the presence in it of strong reminders of the expressive peculiarities of Rosso Fiorentino, such as a tendency to splinter the surface through a simplified play of light and shade, seems to suggest an earlier date.

Ward, who accepted a very late date for the drawing, cautiously theorizes a possible connection with the bas relief with similar content in the Bargello, stating that it could have been an early plan that was subsequently discarded (Ward 1981, 6, 12 n. 11). This opinion was first advanced by Ferri (1890, 41). However, even though the subject is the same, the composition of the relief is quite different. A drawing which can be linked to it with greater probability—the study of heads (Uffizi 6868F), of which at least one variation seems preparatory to the head of the protagonist—is fairly distant stylistically from this one.

Another theory that could be advanced for the identification of the present drawing, although it too is impossible to substantiate given the state of knowledge about the artist, is that it could be a preparatory study for an early painting by Bandinelli described by Vasari as "Noah, who drunk with wine reveals his shame in the presence of his sons" (Vasari/Milanesi 6: 139). All traces of this have unfortunately been lost.

A rather beautiful sketch for the figure of one of the sons of Noah, shown here on the left, has been discovered by Ward in the British Museum (1946.7.13.268).

A.M.P.T.

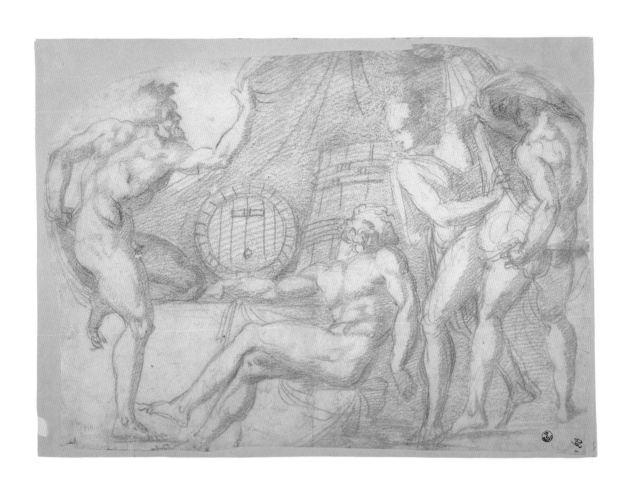

17. *Christ Shown to the People*

Pen and brown ink and traces of black chalk; 424 × 566 mm. Mounted

705E

EXHIBITION: Florence 1976a, no. 21.

REFERENCES: Florence 1976a, no. 21, 53–54; Petrioli Tofani 1986, 308.

Ample documentation in the Archivio di Stato in Florence establishes that this very beautiful drawing became part of Cardinal Leopoldo de' Medici's collection in 1674 when he bought it in Bologna through his agent Annibale Ranuzzi (Florence 1976a); it came to the Uffizi along with his entire collection at the cardinal's death in 1675.

Even though the provenance of this drawing can be reconstructed faithfully from a very early date, little is known of its position in Bandinelli's oeuvre. Its style would seem to indicate a mature phase, although one not too late in the evolution of the artist.

One possible direction for investigation is suggested by the drawing's Bolognese provenance. According to Vasari, Bandinelli went to Bologna at least twice during his lifetime, both times to meet Pope Clement VII: in 1530 on the occasion of the coronation of Charles V and two years later for another meeting between the Pope and the emperor (Vasari/Milanesi 6: 152, 155–156). It seems, however, that in both cases these were brief stays, during which Bandinelli would not have been involved in any artistic activity.

If, as is more probable, the drawing reached Bologna in some other way, Vasari provides another possibility, although it too is destined to remain at the level of conjecture (Vasari/Gaunt 3:207–208). He describes the work done by Bandinelli for the arrangement of the choir in the cathedral of Florence, affirming that in the predella of the altarpiece "there were many stories of the passion of Christ, to be done all in bronze." It is not impossible that this study had as its origin the plan for one of these reliefs, which, it seems, the artist never finished. There is hardly any documentation on these reliefs (see Middeldorf 1929, 184–188; Heikamp 1964, 33), so such a connection is undoubtedly tenuous.

A modicum of support for this link is furnished by Vasari, who adds: "The duke saw the model [of the arrangement for the Choir] and Baccio's duplicate designs, and they pleased him for their variety, number and beauty, as Baccio worked in wax with spirit and designed well" (Vasari/Gaunt 3:208).

If by using the expression "duplicate designs" (doppi desegni) Vasari meant to refer to the size of the actual sheets opened up, this is exactly the case with the present drawing, which still clearly shows traces of the central fold given to the paper during its manufacture and along which the sheet would usually have been cut. If such a theory should prove to be correct, it would also bring into the realm of possibility a connection between the reliefs for the predella of the altar of the cathedral and other drawings of similar dimensions showing scenes of the Passion of Christ, now dispersed among a number of collections. No proposals for identification of these have been advanced. Among them is the beautiful *Crucifixion* in the Albertina (14181; Florence, Palazzo Strozzi 1980, no. 72).

A.M.P.T.

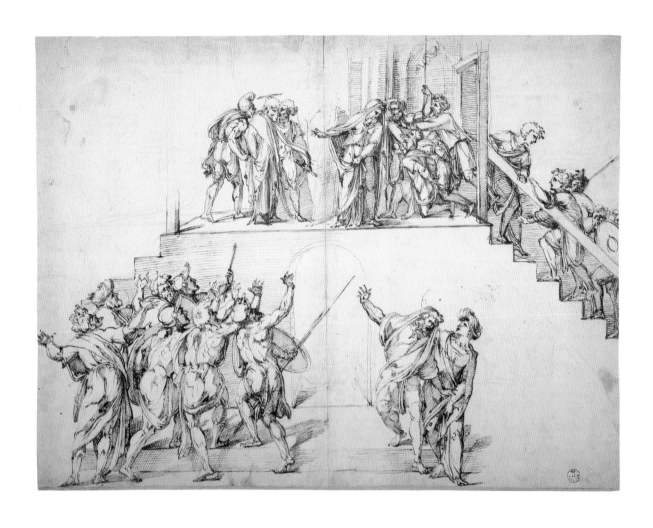

18. *Male Nude Leaning Back and Anatomical Sketches*

Black chalk, with stumping and traces of the stylus; 268 × 293 mm

6971F

EXHIBITIONS: None.

REFERENCES: Utz 1971, 354; Ward 1981, 9, 13 n. 30; Petrioli Tofani 1982, 71.

Describing Bandinelli's participation in the work on the Neptune Fountain in Piazza della Signoria at the end of his life, Vasari wrote "and there he began some cartoons for paintings to adorn the rooms of the Pitti Palace. They were painted by a youth called Andrea del Minga, who manipulated his colors very creditably. The scenes represented the creation of Adam and Eve, their expulsion from Paradise, Noah and Moses with the tables" (Vasari/Gaunt 3:212).

The drawing is connected with the last of these paintings, *Moses in the Act of Engraving the Tables of the Law,* now in the storerooms of the Florentine museums (5055); see Beck 1973, 7–11; Florence, Palazzo Vecchio 1980, nos. 521.1 and 521.2).

Its traditional attribution to Bandinelli has been contested only by Utz, who preferred to assign it, but without a convincing argument, to the hand of Bandinelli's pupil Vincenzo de' Rossi. In fact, it is a study of very high quality in which Bandinelli interprets Michelangelo's example, translating the older artist's formal synthesis, rich in dramatic tension, into less disturbing rhythms of abstract elegance.

It is always difficult—even in a case such as this one which offers a precise connection with a work from the artist's last years—to propose exact dates for Bandinelli's drawings, given the artist's habit of using the same drawings for different works, often separated by many years. This habit perhaps helps explain the differences in style and graphic idiom between the sheet considered here—which must be more or less contemporaneous with the execution of the cartoon—and the only other sheet than can be linked to the same composition: Uffizi 6916F, a study for the figure of Moses. In its steady line and cool light this study, which is reminiscent of Bronzino, could be of an earlier date. Furthermore, while in the present drawing the figure on paper is exactly the same as the one that appears in the painting, in the second case the drawing is an academic study from life that will have to be substantially changed to be used for the figure of Moses. This is a study that Bandinelli could very well have found in earlier materials on hand in the workshop.

A.M.P.T.

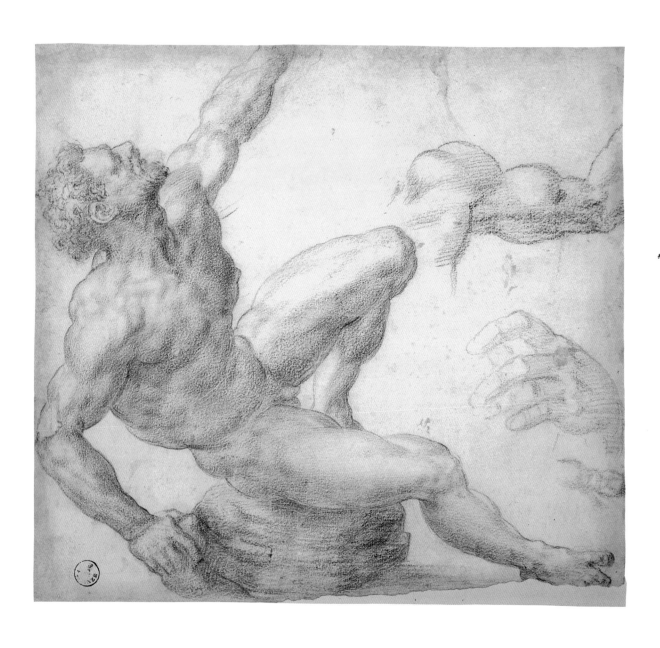

Jacopo Carucci, called Pontormo

Pontormo (Empoli) 1494—Florence 1557

19. *Head of a Laughing Child*

Black chalk with some stumping, heightened with touches of white, with some brownish gray wash; 217 × 168 mm

654E

EXHIBITIONS: Florence 1910, 34; Paris 1950, no. 423; Milan 1970, no. 5.

REFERENCES: Ferri 1890, 117; Berti 1965a, no. VIII; Cox-Rearick 1964 and 1981, 1:127–128, no. 36; Petrioli Tofani 1986, 288, 654E.

This lively drawing, originally catalogued as by Andrea del Sarto, was subsequently reattributed to Pontormo by Ferri and identified as the final study for the Christ Child in Pontormo's altarpiece for Francesco Pucci, dated 1518, in San Michele Visdomini in Florence (1890, 117).

In the painting, the Christ Child is supported by Joseph and turns to his right as if drawn to the high altar of the church, at once foreseeing and welcoming his Passion (Freedberg 1971, fig. 71). The movement, direction of gaze, and expression of the Christ Child are all established in this drawing, which can be considered the definitive study for the Christ Child. An earlier study appears on the recto of another sheet in the Uffizi (92201F; Cox-Rearick 1964 and 1981, 2: fig. 53; reproduced in color in Berti 1965a, no. Xr). These drawings also appear to have served for the head of the putto who holds back the curtain at the top right of the altarpiece.

In addition to establishing the features and pose of the Christ Child, this drawing is also important in establishing the lighting of the figure (Cox-Rearick 1964 and 1981, 1:128). In this and other final studies for the Visdomini altar, Pontormo succeeds in creating a remarkably effective and evocative graphic equivalent to the Leonardesque chiaroscuro of the finished painting. This last observation points up the central importance to Pontormo's graphic and painterly development of Leonardo da Vinci, his first teacher in Florence. Indeed, the very animation and expressive intensity of the Visdomini Christ Child ultimately recall Leonardesque types, much as the dynamism of composition and darkness of color of the Visdomini altar derive from compositions by Leonardo such as the great unfinished *Adoration of the Magi* in the Uffizi (for Leonardo's influence on Pontormo's drawing style, see Cox-Rearick 1964 and 1981, 1:20–21 and 62, and Posner 1974, 37–38).

G.S.

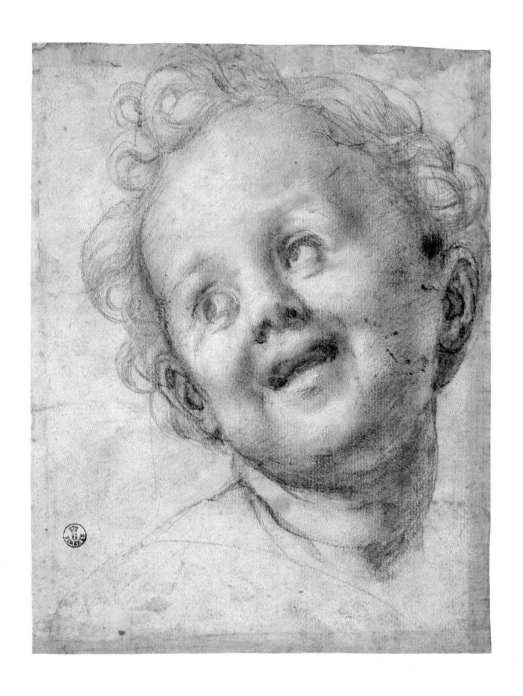

45

20. *Seated Nude Boy Gesturing toward the Spectator with His Right Arm and Leaning Back on His Left Arm*

Red chalk over faint traces of black chalk; 405 × 262 mm

ANNOTATION: at the the top left edge in ink in a seventeenth-century hand, *iacopo da puntormo*

6727F

EXHIBITIONS: Florence 1910, 30; Florence 1939, 31; Florence 1940, 51; Naples 1952, no. 62.

REFERENCES: Ferri 1890, 120; Berenson 1903, 2: no. 2210; Clapp 1914, 261, pl. 3; Clapp 1916, 35, fig. 75; Cox-Rearick 1964 and 1981, 1:183, no. 143; Cox-Rearick 1970, 368, no. 142a.

This superb study of a nude boy seems almost to quiver with life as a result of the aureole of hatching that surrounds the figure like an electric field. Pontormo's study is a strange combination of accurate observation and heightened stylization. The modeling of the torso and legs is a tour de force of anatomical drawing. The boy's stylized features and wild, gaping eyes are typical of Pontormo's nervous, highly charged figures, while his fingers, which rather bring to mind a crumpled glove, remind one of the jagged, pointing, sticklike fingers of Rosso Fiorentino's figures of about 1518–21.

Although such a trip is not documented, it is generally believed that Pontormo visited Rome in 1519 (see Cox-Rearick 1964 and 1981; 1:166–167, no. 104). The immediate visible result was an increased monumentality in Pontormo's figure types, as a result of his firsthand experience of the Sistine ceiling and the Vatican *Stanze*. Individual figure studies, this drawing among them, recall Michelangelo's *ignudi* and prophets, as well as emulating Michelangelo's anatomical knowledge and difficult foreshortenings. Pontormo appears to have been especially impressed by the *Prophet Jonah*. The way in which this figure leans back while gesturing dramatically in the direction of the spectator recalls the *Jonah* fairly directly, as Cox-Rearick observed (1964 and 1981, 1:183, no. 143).

Berenson connected this drawing with Pontormo's monumental fresco lunette in the *salone* of the Villa Medici at Poggio a Caiano, near Florence, although there is no figure in precisely this pose in the fresco or in composition drawings made in preparation for it (1903, 2: no. 2210). Clapp did not follow Berenson on this, arguing that the emotional intensity of this drawing was inconsistent with the idyllic, pastoral character of the *Vertumnus and Pomona* lunette (1914, 261). Cox-Rearick (1964 and 1981, 1:83, no. 143) pointed out that many of the studies for the fresco show a similar agitation. In addition, she introduced a compositional drawing for the fresco and connected this figure with a boy in that work. This drawing is certainly consistent in style with other figure studies securely related to the *Vertumnus and Pomona* and from the period 1519–21.

The present drawing has also been related to the Visdomini altar (see cat. no. 19) in a manuscript note in the Uffizi inventory. The connection may have been suggested by the similarity between Mary's boldly foreshortened right arm and hand, pointing in the direction of the high altar, and the gesture of the young boy. In style, however, this drawing compares more closely with Pontormo's luminous red chalk studies from the period 1519–21 than with his earlier and rougher studies from around 1518.

G.S.

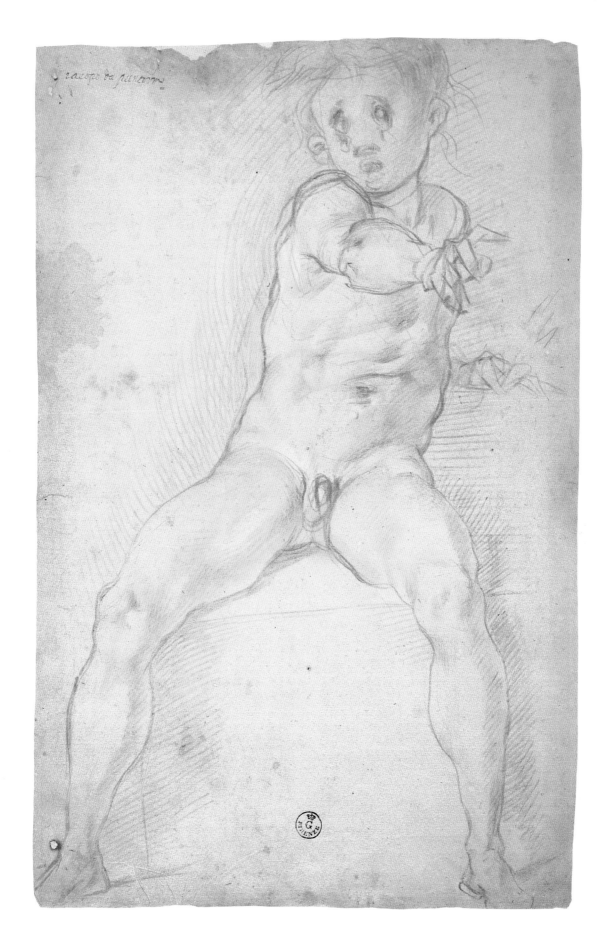

Jacopo da Pontormo

47

21. *The Archangel Gabriel*

Black chalk and yellowish brown wash over traces of red chalk, with traces of white heightening, squared in red chalk, and with some traces of indentation from a stylus; 391 × 215 mm

6653F

EXHIBITIONS: Florence 1910, 23; Florence 1939, 25; Florence 1940, 44; Florence 1954, no. 52; Amsterdam 1954, no. 72; Milan 1970, no. 22; Florence, Palazzo Strozzi 1980, no. 412.

REFERENCES: Ferri 1890, 118; Berenson 1903, 2: no. 2145; Clapp 1914, 208; Clapp 1916, 47, fig. 87; Voss 1920, 1:170, fig. 50; Voss 1928, 45, pl. 5; Berenson 1938, 2: no. 2145; Cox-Rearick 1964 and 1981, 1:263, no. 278 and 2: fig. 266; Berti 1965a, no. XLV; Forster 1966, fig. 52; Forlani Tempesti 1967, 70–86; Florence 1972, 120, figs. 189–190; Pillsbury 1977, 177–180.

This stunning drawing has long been recognized to be the final *modello* for the Archangel Gabriel in Pontormo's fresco of the Annunciation in the Capponi Chapel in Santa Felicità, Florence, datable circa 1527–28 (Berenson 1903, 2: no. 2145). Executed in a variety of media, the drawing corresponds in almost every particular of pose, draperies, and lighting to the finished painting. Certain pentimenti are visible in the drawing, however, particularly in relation to the feet and left arm of Gabriel. The companion to this drawing, a highly finished study for the *Virgin Annunciate*, executed in red chalk, is also in the Uffizi (448F; Cox-Rearick 1964 and 1981, 1:263, no. 278 and 2: fig. 268). Both drawings must have been preceded by more exploratory studies, of the kind that exist for the dome decoration, but these have not survived.

The *Gabriel* is unusual among Pontormo's drawings in its painterly character and in the extent to which wash is employed. The result is highly dramatic, possessing a visual animation that nicely complements the physical energy and dynamism of the figure. Cox-Rearick has argued that the wash was applied by a late sixteenth-century Florentine draftsman, rather than by Pontormo himself (1964 and 1981, 1:264, no. 279). Her reasons are the color of the wash, which she maintains was one not employed by Pontormo, and the manner of its application. According to Cox-Rearick, the wash is unintelligently applied in certain areas, in particular on the draperies of Gabriel's sleeve, immediately behind his right shoulder and arm and in front of his left arm. Gabriel's wings were also added later, in Cox-Rearick's view. Berti (1965a, no. XLV) also believed that the wash was added later. These opinions were adopted by Forlani Tempesti (Milan 1970, no.

22). More recently, however, opinion has moved toward accepting the autograph character of the drawing in entirety. Although he did not address the problem directly, Pillsbury (1977, 179) cited the brush and wash technique of the *Gabriel* in support of the autograph nature of two other drawings, executed in a similar technique, also in the Uffizi. In 1980 (Florence, Palazzo Strozzi 1980, no. 412), as a result of Pillsbury's implicit acceptance of the wholly autograph character of the *Gabriel*, Forlani Tempesti reversed her previously expressed view.

The discrepancies between the treatment of Gabriel's draperies in the drawing and in the fresco, observed by Cox-Rearick, seem to support Pontormo's authorship rather than the reverse. In almost every other aspect of the study, the wash accurately reflects the treatment of light and dark in the fresco. If the wash was applied by a later artist, then it must have been done in front of the fresco itself. In that case, it is hard to understand why the copyist, having been so meticulous in every other respect, would have slipped up so obviously in these two areas. Rather, it must simply be that Pontormo departed from his *modello* in the final stages of the execution of the fresco. Perhaps more compellingly, it is difficult to imagine the appearance of the *Gabriel* without the wash, since its effect depends almost entirely on the combination of wash with what is often a quite cursory indication of forms in chalk. Indeed, without the wash in some areas there would be no drawing. (In that respect, the *modello* for the *Gabriel* is quite different from that for the *Virgin Annunciate*, rather than being a true pendant to it.)

G.S.

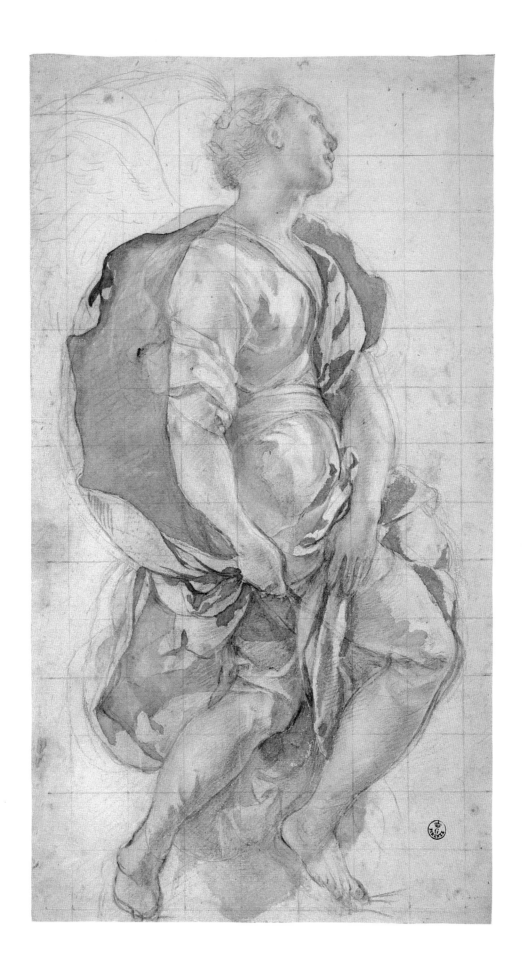

49

22. *Study for Moses Receiving the Tables of the Law*

Black chalk, lightly squared in black chalk, with some traces of indentation with a stylus; 385 × 148 mm

INSCRIPTION: at lower edge of sheet, near center, in brown ink, *10 / [br]accia e due dita*

6749F

EXHIBITIONS: Florence 1910, 38; Florence 1956, no. 139, fig. 167b.

REFERENCES: Berenson 1903, 2: no. 2230; Clapp 1914, 276; Clapp 1916, 76, fig. 139; Tolnay 1950, 40, fig. 48; Cox-Rearick 1964 and 1981, 1:329–330 and 2: fig. 339; Berti 1965a, 26; Berti 1973, 108–109, no. 133F1.

The last decade of Pontormo's life was taken up by a commission to decorate the choir of San Lorenzo with frescoes, now lost, representing primarily Old Testament subjects (Cox-Rearick 1964 and 1981, 1:318–327; Ciletti 1979, 765–770, with bibliography). Pontormo's diary, which runs from March 1554 to October 1557, is a unique and moving record of his activity at San Lorenzo during the last two years of his life, when he was working on the frescoes of the lower range of the choir (Cecchi 1956; extracts in Cox-Rearick 1964 and 1981, 1:347–356; Mayer 1982). In addition, some thirty drawings, in the Uffizi and elsewhere, make evident the labor that Pontormo devoted to this project and provide us with a sense of the appearance of individual scenes (Cox-Rearick 1964 and 1981, 1:327–344, nos. 350–382 and 2: figs. 338–364).

Clapp (1914, 276) correctly identified this drawing, once thought to represent God the Father speaking with Noah (Berenson 1903, 2: no. 2230), as a composition study for a Moses receiving the Tables of the Law. Although this subject is not mentioned in the early descriptions of the choir, the proportions of the composition and Pontormo's inscription on it establish that this is the *modello* for one of the tall, narrow frescoes on the side walls of the upper range of the choir. Cox-Rearick has argued persuasively that the scene of Moses receiving the Tables of the Law occupied the space at the corner on the left side wall, opposite a scene depicting The Four Evangelists (1964 and 1981, 1:329–330).

The drawing depicts God the Father supported by two angels in the upper portion of the composition, with Moses, seen from the back, kneeling below with arms upstretched holding the Tables of the Law. God reaches down with his left hand to point to a passage in the text. Several other studies survive, both for the composition as a whole and for individual figures and details in it, including four studies for the arm and shoulder of God the Father (Cox-Rearick 1964 and 1981, 1:328, 330, nos. 351, 355, 356), but this drawing appears to represent the definitive scheme. There is, however, a pentimento in this drawing indicating that Pontormo lowered the head of Moses. In view of the probable intended location of the fresco, it is reasonable to date the drawing about 1545–49 (Cox-Rearick 1964 and 1981, 1:329–330, no. 354).

It has been suggested that this and other compositions for the choir of San Lorenzo reflect a knowledge of Michelangelo's recently completed *Last Judgment* in the Sistine Chapel in Rome, a knowledge that Pontormo supposedly acquired on a purported visit to Rome in 1539 or in the early 1540s, before he began work on the choir of San Lorenzo (on the supposed Roman trip or trips, see Cox-Rearick 1964 and 1981, 1:333 n. 37). In fact, the *Moses Receiving the Tables of the Law* still reflects Pontormo's admiration for Michelangelo's earlier Roman works. Moses is a "distant echo" of the *Libyan Sibyl*, as Cox-Rearick correctly observed (1964 and 1981, 1:330, no. 356), and the overall composition of *Moses Receiving the Tables of the Law* may be seen as a translation into vertical format of Michelangelo's *Creation of Adam*. At the same time, the elongated proportions of the figures and the curious contrast between the puttylike anatomy of God the Father and

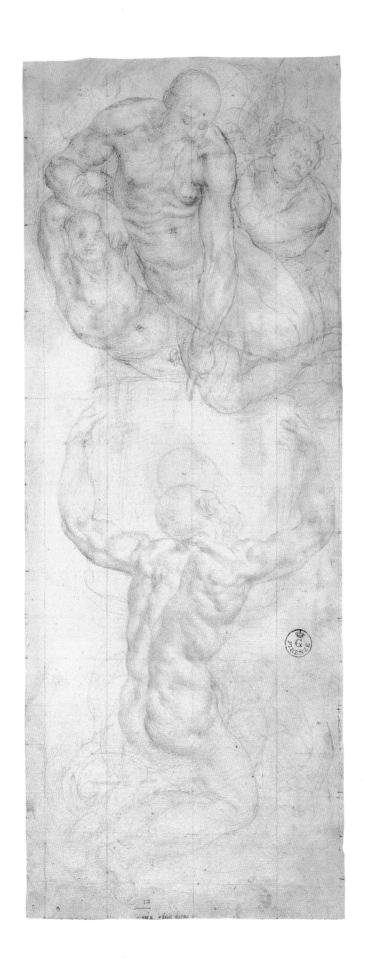

his angels and the sculptural tautness of the back of Moses (reminiscent of the *Belvedere Torso*) are characteristic of Pontormo's late style, as is his preference now for black chalk (Cox-Rearick 1964 and 1981, 1:21; Berti 1965a, 4–5; Vitzthum 1966, 311). In format, approach to space, figure type, and figure proportions *Moses Receiving the Tables of the Law* is also very similar to the *Lamentation of Jacob* and *Joseph*

Takes Benjamin as His Servant and Judah Begs for the Release of Benjamin, two tapestries designed by Pontormo about 1545–49 for the Sala dei Duecento in the Palazzo Vecchio (Forster 1966, figs. 77, 78; for the various titles assigned to the latter tapestry, see Smith 1982, 185 n. 3).

G.S.

Giovanni Battista di Jacopo, called Rosso Fiorentino

Florence 1494—Paris 1540

23. *Enthroned Madonna and Child with Four Saints*

Black chalk on beige paper; 330 × 250 mm

ANNOTATIONS: top right corner in ink, *479;* near lower left corner in ink, *52*

479F

EXHIBITIONS: Florence 1940, 105; Paris 1950, no. 426; Naples 1952, no. 160; Amsterdam 1954, 41, no. 45; Florence 1954, 22, no. 30; Florence 1960a, no. 87; Florence, Palazzo Strozzi 1980, no. 457.

REFERENCES: Ferri 1890, 125; Berenson 1903, 2: no. 2397; Kusenberg 1931, 139, no. 6; Barocchi 1950, 210, fig. 188; Petrioli Tofani 1972, no. 72; Carroll 1976, 1:205–212, D.8, fig. 18; Darragon 1983, 37–38, fig. 13; Washington 1987, 19, fig. 1.

Although this beautiful and elaborate drawing cannot be connected directly with any of Rosso Fiorentino's several paintings depicting the enthroned Madonna and Child with Saints, it has so many features of composition, figure type, and style in common with them that the traditional attribution has never been doubted.

The drawing represents the Virgin seated with the Christ Child standing at her right side, so that their heads are almost level with each other. Mary supports Christ with her right hand, while he places his left hand on her breast, linking the child to his mother in an intimate and moving fashion. The two do not look at each other, however, but rather are drawn apart; Christ's attention is pulled in the direction indicated by John the Baptist, and Mary appears to look into the book held by the bearded saint on the right. A female saint, presumably Saint Margaret, although she kneels on a horned demon rather than her usual dragon, is depicted in the left foreground, and an almost nude male figure, presumably Saint Sebastian, stands at the right looking toward the Christ Child.

The composition has a good deal in common with a group of altarpieces executed by Rosso between about 1518 and 1522. The earliest, commissioned in January 1518, is the *Enthroned Madonna and Child with Saints*, intended for the church of Ognissanti, in Florence and now in the Uffizi (Carroll 1976, 1:113–115, P. 10 and 2: fig. 16; Franklin 1987, 652–662). Next is the Villamagna *Enthroned Madonna and Child with Saints John the Baptist and Bartholomew*, dated 1521, now in the Archiepiscopal Museum in Volterra (Carroll 1976, 1:124, P. 14 and 2: fig. 23). Latest in the sequence is the Dei altarpiece, dated 1522, now in the Palazzo Pitti (Carroll 1976, 1:125, P.15 and 2: fig. 26). This last is also the most ambitious and complex of the series,

representing the Madonna and Child accompanied by ten saints.

The figures in this drawing are less exaggeratedly gaunt in proportion and do not radiate quite the same degree of tension as their counterparts in the Ognissanti altarpiece or in contemporanous drawings, such as the *Skeletons,* in the Uffizi (6499F; Carroll 1976, 1:195–201, D.6 and 2: fig. 15; Florence, Palazzo Strozzi 1980, no. 609), or the *John the Baptist Preaching,* at Christ Church, Oxford (Byam Shaw 1976, 1: no. 124 and 2: pl. 90; Carroll 1976 1:191–194, D.5 and 2: fig. 13), but seem closer in style and mood to the more restrained types in the Dei altarpiece. Indeed, as early as 1890, Ferri (125) believed this drawing to be a study for that painting—an opinion that has been shared by several later scholars, including Berenson (1938, 2: no. 2402A), Marcucci (Florence 1954, no. 30), and Sinibaldi (Florence 1960a, no. 87).

While the nature of the relationship between the Virgin and Child has a closer parallel in the Villamagna altarpiece, this drawing certainly shares many features with the Dei altarpiece (in particular, Saints Margaret and Sebastian occupy much the same positions in the study that Saints Catherine and Sebastian do in the painting). In addition, the presence of Saint Sebastian in both compositions in itself establishes a link between them and may provide a hint at the date of the drawing. Saint Sebastian occupies a prominent position in the right foreground of the Dei altarpiece, immediately in front of and to the right of Saint Bernard, but this was not part of the original program, as is evident if one compares Rosso's composition with Raphael's *Madonna del Baldacchino,* also in the Palazzo Pitti. Very possibly the outbreak of plague in Florence in 1522 was the reason for the addition of Saint Sebastian, whose

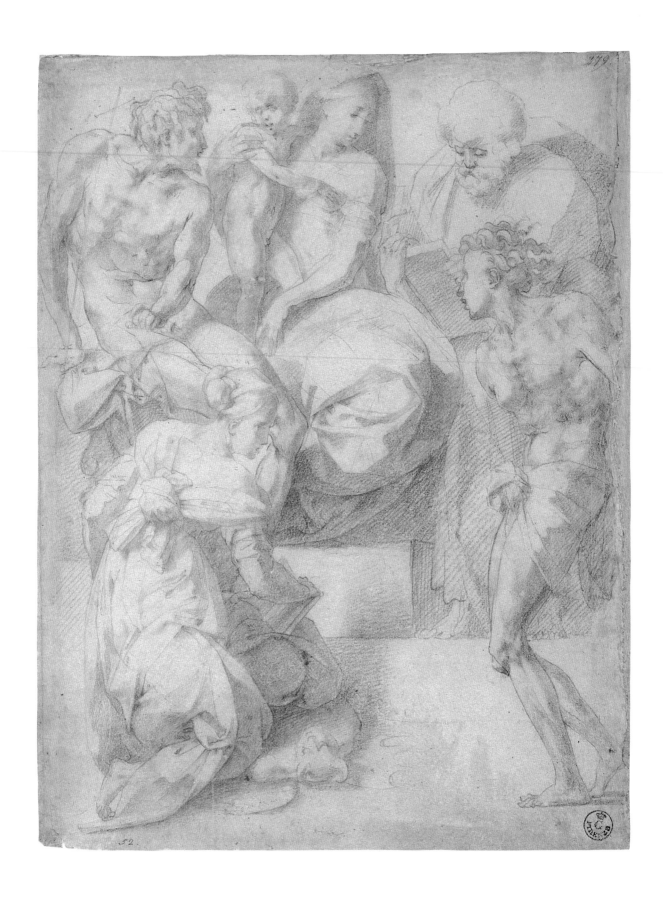

protection against the plague had been invoked since the seventh century (Réau 1959, part 3:1190–1191; I am indebted to Linda Wolk for this suggestion). Since Saint Sebastian was not commonly represented in *sacra conversazione* altarpieces in Florence during the fifteenth and early sixteenth centuries (for representations of Saint Sebastian in Florentine painting during the fifteenth century, see Hadeln 1906, 17–24), his appearance in this drawing perhaps implies that it too should be dated during the plague of 1522–23. The principal centers for the cult of Saint Sebastian in Florence were the Pucci Chapel in the Santissima Annunziata, in which was preserved a relic of the saint's arm, and, behind the church, the confraternity of Saint Sebastian (see Cox-Rearick 1987, 159–160). In view of Rosso's close association with the Santissima Annunziata (Shearman 1960, 152–156), it is possible that this drawing is related to a commission for that context.

Relationships to the Dei altarpiece notwithstanding, several elements in the Uffizi drawing look forward to the heightened stylishness and elegance of Rosso's *Marriage of the Virgin* in San Lorenzo, inscribed and dated 1523 (Carroll 1976, 1:128, P. 17 and 2: fig. 28; reproduced in color in Smith 1976, 25), and to still later works. For example, the Saint Margaret compares closely with a woman in the lower left corner of Rosso's *Pietà* at Borgo San Sepolcro, datable 1527–28 (Carroll 1976, 1:137–139, P. 21 and 2: fig. 78); and the motif of the draperies knotted at the back recurs in a drawing representing the bust of a woman with an elaborate coiffure in the Metropolitan Museum in New York (Bean 1982, no. 226), datable between 1523 and 1528. Similarly, the windblown locks of Saint Sebastian and his figure proportions link him with *Apollo* in the engraved series of "Roman Deities in Niches," dated 1526 (Carroll 1976, 2: fig. 53). If these last similarities were made intentionally by Rosso, this association would be particularly appropriate, since the mythology of Apollo, the divine archer, and the legend of Saint Sebastian, the plague saint, did in fact overlap (Réau 1959, 1199).

The drawing style of the *Enthroned Madonna and Child with Four Saints* is exceptionally delicate and refined but also rather idiosyncratic in character. For most of the figures in the drawing, Rosso relies on a fine, slightly nervous line to establish the contours of figures and to describe the configurations of their draperies. In certain areas, however, he succeeds in defining and describing his forms almost without line, employing instead an exceedingly soft, even, velvetlike shading. This is the case, for example, with the heads of the Virgin and Child. Very similar to this drawing in treatment of line and shading is a study of a woman seated in a niche (Uffizi 6492F), as Carroll observed (1976, 1:224–229, D.13 and 2: fig. 31). Although that drawing cannot be dated precisely, internal evidence suggests that it is contemporary with Rosso's *Moses and the Daughters of Jethro* of 1523–24, in the Uffizi. In drawing style and figure type, a study of a seated nude youth in the British Museum (Turner 1986, no. 106) is very similar to the Saint John the Baptist in this drawing, as is the closely related seated figure of a bearded man in the Uffizi (6498F; Carroll 1976, 1:222–223, D.12 and 2: fig. 29). The latter drawing is dated around 1522–23 by Carroll, while he believes the British Museum study to date around 1537, during the period of Rosso's activity in France (Carroll 1966, 176; Carroll 1976, 2:419–422, D.50). Another characteristic of this drawing is the peculiar manner in which Rosso treats the draperies of his figures, spinning a web of fine lines in the interiors of the forms (as distinct from the shading indicating areas of light and dark). This mannerism, which is especially evident in Mary's voluminous garment, appears too in the underdrawing visible in both the *Descent from the Cross* in the Pinacoteca Comunale in Volterra, dated 1521, and the Dei altarpiece.

These and other characteristics would seem to suggest a date about 1521–24 for this drawing, and the presence of Saint Sebastian might incline one to narrow the period to 1522–23. On the other hand, the striking relationships to works produced by Rosso in the Roman and immediately post-Roman periods make a slightly later date also possible and indicate that it would be unwise to be dogmatic regarding the date of the *Enthroned Madonna and Child with Four Saints*.

G.S.

24. *Standing Male Nude*

Red chalk; 407 × 126 mm

ANNOTATION: at lower edge of the sheet in brown ink, *Clemente Bandinelli*

6992F

EXHIBITIONS: None.

REFERENCES: Carroll 1961, 449–450, fig. 7; Carroll 1976, 1:230–233, D.14, fig. 36; Washington 1987, 86 n. 9, no. 10a.

Despite its former attribution to Clemente Bandinelli, son of the sculptor Baccio Bandinelli, this highly finished study of a bearded male nude with muscles tensed and right fist clenched is certainly by Rosso Fiorentino, as Carroll recognized (1961, 449–450; 1976, 1:230–233, D.14). The emphasis on the taut outline of the figure combined with the detailed and delicate interior modeling of the musculature compares well with other nude studies by Rosso in the British Museum and in the Uffizi (Carroll 1976, 2: figs. 25, 29, 129; Turner 1986, no. 106). Moreover, as Carroll pointed out, this figure compares closely with certain of Rosso's male types as they appear in the "Roman Deities in Niches" and "Hercules" suites of engravings, done by Gian Jacopo Caraglio from designs by Rosso. This drawing recalls in particular the *Saturn*, the *Neptune*, and the *Mars*—perhaps most strikingly the *Mars*, because of the attention given to the swollen quadriceps and tensed buttocks of that figure (Carroll 1976, 2: figs. 47, 58, and 51, respectively; Washington 1987, nos. 21, 25, 29). In addition, without necessarily being a preparatory study for the figure, this drawing is virtually a mirror reversal of the Hercules in the engraving *Hercules Shooting the Centaur Nessus*, as Carroll again recognized (1961, 449; 1976, 1:230 and 2: figs. 35, 36; Washington 1987, no. 10).

The "Roman Deities in Niches" can be dated to 1526 from an inscription on a tablet in the *Saturn*, the first image in the series, and the "Hercules" suite can reasonably be placed in the preceding year (for the chronology of the Roman prints, see Carroll 1976, 1:74–80; Washington 1987, nos. 21–40). While this drawing can be related to drawings produced in Florence about 1522–23, it seems reasonable to date it circa 1525–26 because of its closeness to the Roman prints. Perhaps also in support of a Roman provenance is the remarkable similarity in motif and style of this drawing to Raphael's famous study for the *Battle of Ostia*, now in the Albertina (Washington 1984–85, no. 19). Although Rosso could not have seen the drawing itself, since Raphael sent it to Albrecht Dürer as a gift, presumably he knew the fresco and had made studies from it.

Another striking resemblance (in this case prospective rather than retrospective) is to Baccio Bandinelli's figure of Hercules in the *Hercules and Antaeus* sculpture group in front of the Palazzo Vecchio. This relationship may have prompted the old attribution to Clemente Bandinelli.

G.S.

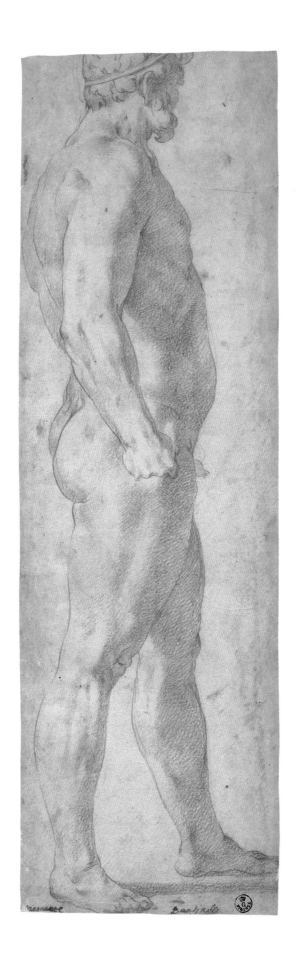

Domenico Beccafumi

Valdibiena, near Siena ca. 1486—Siena 1551

25. *A Group of Five Apostles*

Black chalk; 302 × 230 mm

10770F

EXHIBITIONS: Paris 1950, no. 419; Amsterdam 1954, no. 98; Florence 1954, no. 77.

REFERENCES: Dami 1919, 26, no. 22; Judey 1932, 140, no. 118; Gibellino-Krasceninnicowa 1933, 123.

The last major commission described by Vasari in his life of Beccafumi is the decoration of the apse of the cathedral of Siena (Vasari/Milanesi 5:651–652). Between 1539 and 1544 (with the bulk of the work taking place in 1544), Beccafumi painted there an Ascension of Christ, a glory of angels, and the Virgin with the twelve apostles. The Ascension and attendant angels occupied the upper level of the apse, with the Virgin and apostles being painted in the lower level. According to Vasari, the Virgin, Saint Peter, and Saint John were depicted in the central section, while the lateral frescoes each contained groups of five apostles represented in an open loggia. Much of this decoration was destroyed by an earthquake in 1798, but the lateral sections with the groups of apostles survive. As Sinibaldi recognized, this drawing is closely related to the group of apostles on the left side of the apse (Florence 1954, 47–48, no. 77). Sinibaldi also identified several rapid pen sketches in the Uffizi as preliminary studies for the groups of apostles (Florence 1954, nos. 74, 75).

The relationship between this composition drawing and the fresco is extremely close, with the poses of the figures and the configuration of the draperies being almost identical. The open loggia, which is an important feature of the finished composition, is not indicated in the drawing, however, although a study for one of the capitals appears on the verso of one of the preliminary drawings in the Uffizi (Florence 1954, no. 75). There is also one area in the drawing which is difficult to inter-

pret without the help of the painting. The right hand of the apostle at the left of the composition (perhaps Saint Philip) overlaps the architectural frame of the doorway in the fresco and seems to project into the space of the choir, as does the cross propped by his side. In the drawing, his right hand is so faintly indicated that the gesture is difficult to read. The apostles' expressions and the direction of their gazes also are less defined in the drawing than in the finished fresco.

Sanminiatelli (1967) did not include this composition study in his catalogue of Beccafumi's drawings. It may be that the exceptionally close relationship between the drawing and the fresco led him to consider it a copy from the painting rather than a study for it. The existence of several differences in detail and small changes in the distribution of light and dark would seem to exclude this possibility, however. Moreover, the quality of the drawing, the vitality and range of its technique, and the fact that in some respects the heads of the apostles are more recognizably Beccafumi's than those in the painting confirm the autograph nature of the sheet.

Vasari criticized the frightened, graceless expressions of Beccafumi's apostles. It should be emphasized, however, that their agitation is entirely consistent with their roles as witnesses to the Ascension of Christ, which Beccafumi represented taking place above them.

G.S.

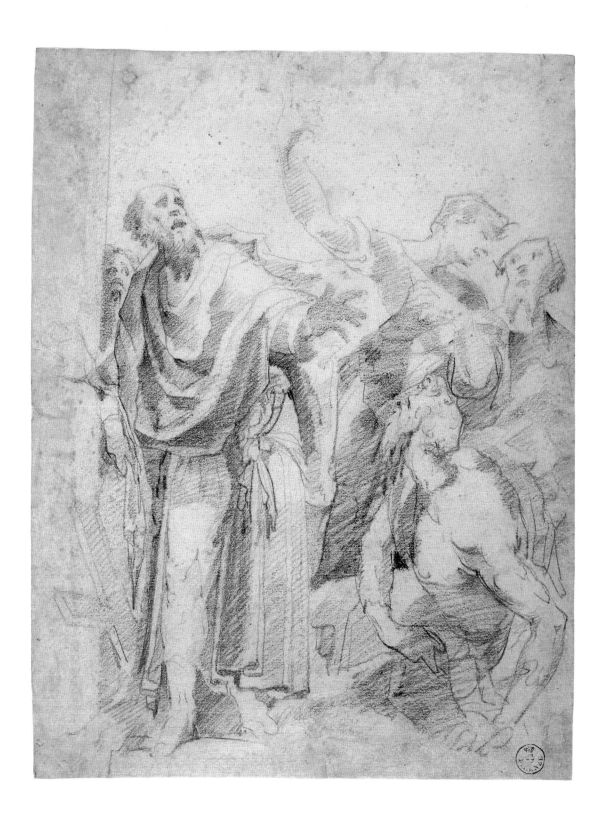

59

26. *Saint Paul*

Pen and brown ink and pale gray-brown wash; 163 × 80 mm

ANNOTATION: at upper left in pencil, 7

1262F

EXHIBITIONS: Amsterdam 1954, no. 97; Florence 1954, no. 76.

REFERENCES: Ferri 1890, 172; Dami 1919, 26; Judey 1932, 138, no. 83; Sanminiatelli 1967, 144–145, no. 33.

This rapid exploratory drawing conveys with remarkable effectiveness the fervor and tempestuous nature of the apostle. At the same time, the pose and anatomy of the figure are strongly suggested by the flurry of pen strokes and pale washes. The saint's torso and muscular left leg emerge from the web of animated pen strokes much as Michelangelo's unfinished captives struggle free from their surrounding blocks of marble.

Sinibaldi (Florence 1954, no. 76) considered this figure to be a study for the principal figure in the group of five apostles painted by Beccafumi on the right side of the apse of Siena cathedral in 1544 (reproduced in Sanminiatelli 1967, pl. 65a; see previous entry). A chalk preparatory study for this figure is in the Pinacoteca in Siena (reproduced in Brandi 1933–34, 361, fig. 11). Sinibaldi also related the present drawing to a figure, whom she identified as Saint Peter, on a sheet of pen studies in the Uffizi (1261F; Florence 1954, no. 74) and proposed that both might be sketches for the lost Saint Peter in the lower central section of the apse decorations.

Sanminiatelli (1967, no. 33, 144–145) accepted the connection with the apostles in the apse of Siena cathedral but identified the figure as Saint Paul rather than Saint Peter, arguing that he holds a sword rather than a cross, as Sinibaldi had suggested. Sanminiatelli also suggested that at some point in the planning of the decoration the Virgin might have been intended to be flanked by Saint Peter and Saint Paul (rather than Peter and John as described by Vasari) and proposed that this drawing might be linked to that project. In fact, it is possible that Vasari's description is inaccurate since a young apostle at the right of the group on the right side of the apse would seem to be identifiable as John.

On the other hand, this figure does not seem naturally designed for a group composition. Instead he recalls the single figures of evangelists in niches, painted by Beccafumi in the apse of Pisa cathedral in 1538 (Sanminiatelli 1967, pls. 57–57c). He also brings to mind an engraving and a series of chiaroscuro woodcuts of apostles done from Beccafumi's designs about the same time as the apostles for Siena cathedral (Sanminiatelli 1967, 133–135, nos. 5–7, 9–12, partially illustrated; Bartsch 1983a, IV:13–15, 22, 23). The figure is similar in pose and type to the chiaroscuro woodcuts depicting *Saint Philip* and *Saint Peter* (Bartsch 1983a, IV:13, 14) and might well be an early study for an unrealized *Saint Paul* for this series. It is also worth mentioning that the figure appears to stand on a plinth, as do the woodcut apostles.

According to Vasari, Beccafumi began a series of twelve marble apostles for Siena cathedral a short time before his death (Vasari/Milanesi 5:652–653). Given that Beccafumi's several undertakings involving apostles and evangelists were nearly contemporaneous, it is not surprising that there should be some overlap in the preparatory studies and that a free sketch such as this one might seem to be related to more than one project.

G.S.

61

High Mannerism

Agnolo Bronzino

1503 Florence 1574

27. *Three Studies for the Drapery of Christ in a* Noli me tangere *and Two Separate Sketches of Heads*

Red chalk, the heads in black chalk; 385 × 281 mm

6633F

EXHIBITIONS: None.

REFERENCES: Clapp 1914, 196; Forlani 1963, no. 93; Cox-Rearick 1964, 1:379, no. A109; Cox-Rearick 1981, 1:415–2, no. A109; Cox-Rearick 1981a, 289–293.

This beautiful sheet was once attributed to Pontormo and more recently given to Clemente Bandinelli, son of the sculptor Baccio Bandinelli, but the current attribution to Bronzino is certainly correct. Cox-Rearick (1981a, 289–293) demonstrated that the drapery studies are connected with those of Christ in a lost tabernacle fresco representing the *Noli me tangere* episode, executed by Bronzino in the garden of San Girolamo delle Poverine in Florence. The general appearance of this fresco is known from a large squared *modello* that appeared on the London art market in 1975 (Clifford 1975, 319, fig. 54; Cox-Rearick 1981a, pl. 36, figs. 1, 2, 4). Interestingly enough, Bronzino did not transfer the principal drawing in its entirety to the *modello*. While the pose of Christ and the general arrangement of his draperies are maintained, Bronzino used the lower of the two detail studies as the model for the gathering of folds at Christ's waist.

In this sheet of studies, Bronzino clearly is not simply concerned with establishing the configuration and flow of Christ's draperies but is also intent on recording accurately the pictorial qualities and the impression of volume created by the action of light upon them. While this sheet is the only certain example of a study of this type that we have by Bronzino, the type itself was well established in Florentine drawing from the late fifteenth century. Although different in medium, the elaborately finished brush drawings of draperies by Leonardo and his contemporaries served much the same purpose. Also similar in intention is the sheet of studies by Andrea del Sarto for the sleeve and draperies of Saint John in the Pucci *Pietà* (cat. no. 4).

The date of Bronzino's *Noli me tangere* has not been established precisely. In style the drawing compares with studies by Pontormo connected with the Capponi Chapel decorations, but other known works by Bronzino make it difficult to accept that the sheet could be contemporaneous with Bronzino's work at Santa Felicità. A date in the early 1530s, just after Bronzino's activity at Pesaro, seems most likely (Clifford 1975, 319; Cox-Rearick 1981, 291–292).

It is difficult to make anything of the slight sketches of heads done sideways at the left side of the sheet.

G.S.

64

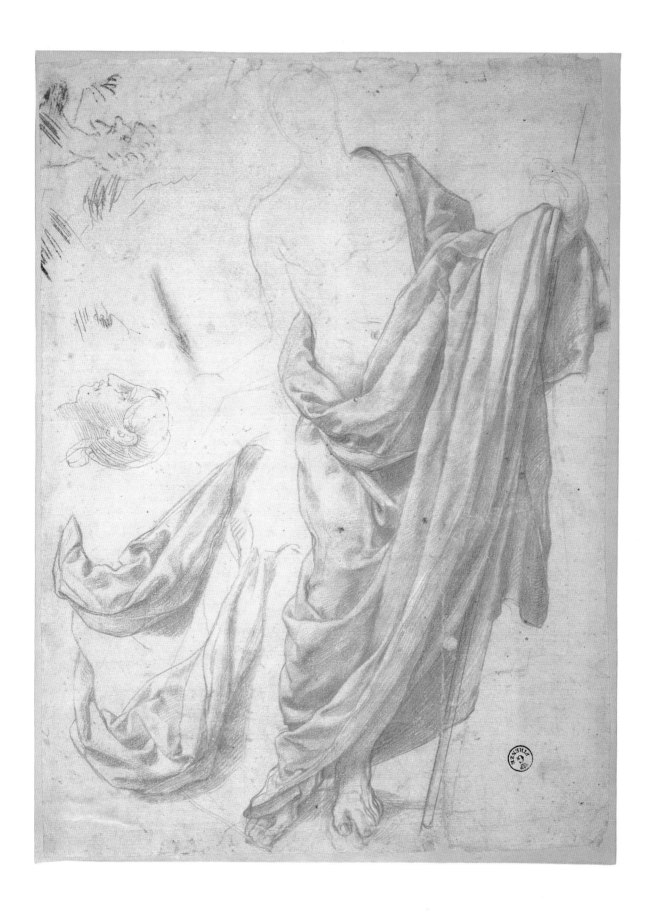

28. *Three-Quarter-Length Study of a Seated Man*

Black chalk on cream paper, squared on the verso in black chalk; 388 × 256 mm

6698F

EXHIBITIONS: Florence 1910, 22; London 1930, no. 534; Florence 1939, 26; Florence 1940, 51; Paris 1950, no. 425; Amsterdam 1954, no. 77, fig. 14; Florence 1954, no. 56, fig. 12; Florence 1963, no. 12.

REFERENCES: Ferri 1890, 119; Berenson 1903, 2: no. 2002; Clapp 1914, 243–244; Clapp 1916, 85; McComb 1928, 8; Popham 1931, no. 233, pl. 197; Berenson 1938, 2: no. 2181A; Becherucci 1943, 10, pl. 25; Tietze 1953, 365–366; Berti 1956a, 8–9, fig. 5; Berenson 1961, 2: no. 2181A, 3: fig. 971; Andrews 1964, 158; Cox-Rearick 1964, 1:297, no. 331 and 2: fig. 325; Forster 1964, 381, 385; Berti 1965a, no. LVII; Shearman 1965, 1:130, n. 1; Andrews 1966, 581; Berti 1966, 53; Forster 1966, 108, fig. 107; Forlani Tempesti 1977, 79; Smyth 1971, 49–50 n. 18; Berti 1973, 84, no. 16; Cox-Rearick 1981, 1:357–7, no. 331, 415–3, no. A130a; McCorquodale 1918, 43–46, pl. 29.

This splendid portrait study has been much discussed in the literature on both Pontormo and Bronzino. Presumably on the basis of an annotation, *Portrait de lui-même,* which appeared on the old mount, Ferri, who attributed the drawing to Pontormo, described it as "the portrait of a craftsman, probably of the artist himself" (1890, 119; the annotation is recorded by Clapp 1914, 243–244). In large part because of the research of Berti and Cox-Rearick (Berti 1956a and 1973, 84; Cox-Rearick 1964 and 1981, 1:112 n. 16 and 297–298, no. 331), there seems now to be general agreement that the sitter is Pontormo. The continuing discussion centers on whether the drawing is by Bronzino or by Pontormo himself, and consequently whether it is a self-portrait or a study of the older artist by his former pupil.

The drawing represents a mature bearded man, presumably in his forties. The sitter wears an artisan's smock and hat, the former being gathered at the waist by a piece of cord, and holds a piece of paper in his left hand (this motif is studied again in a detail near the left bottom corner of the sheet).

The composition is reminiscent of Andrea del Sarto's *Portrait of a Young Man,* in the collection of the Duke of Northumberland at Alnwick, as Shearman observed (1965, 1:130 n. 1, pl. 27a), but it is also closely related to several portraits painted by Bronzino during the 1530s and early 1540s, among them the *Man with a Lute,* the *Portrait of Ugolino Martelli,* and the *Portrait of Bartolommeo Panciatichi* (Baccheschi 1973, nos. 18,

24, 34, pls. IX, XIII, and XVII). Relationships to the *Man with a Lute* are especially striking in the lighting, the angle of the head, turned slightly to the right, and the motif of the hand resting on the leg of the sitter. At the same time, the features of the sitter and the attention given to the left arm and hand recall Bronzino's depiction of Bartolommeo Panciatichi. Indeed, as early as 1916, Clapp (85) described this drawing as the inspiration for Bronzino's *Portrait of Bartolommeo Panciatichi.*

The style of the drawing is also consistent with that of Bronzino, comparing particularly well with the study for the *Man with a Lute,* in the collection of the Duke of Devonshire at Chatsworth (Smyth 1971, 3–4, fig. 4). The drawings are similar in the attention given to the silhouettes of the figures and in the description of patterns of light and shade created by the folds of the tunics. Of the two drawings, the Uffizi example is the more finished and meticulous in description, suggesting that it would be appropriate to date it about 1535–40, close to the *Portrait of Bartolommeo Panciatichi.*

Although he accepted the attribution to Pontormo, Clapp (1916, 85) uncharitably described this drawing as "elaborate but tame." This in itself might be interpreted to imply that Clapp was not entirely comfortable with placing the drawing in Pontormo's oeuvre. Ferri's attribution was accepted by several other scholars, including Berenson (1903, 2: no. 2002, and 1938, 1:294, 2: no. 2181A), McComb (1928, 8), and Becherucci (1943, 10), and, more recently, has been supported by

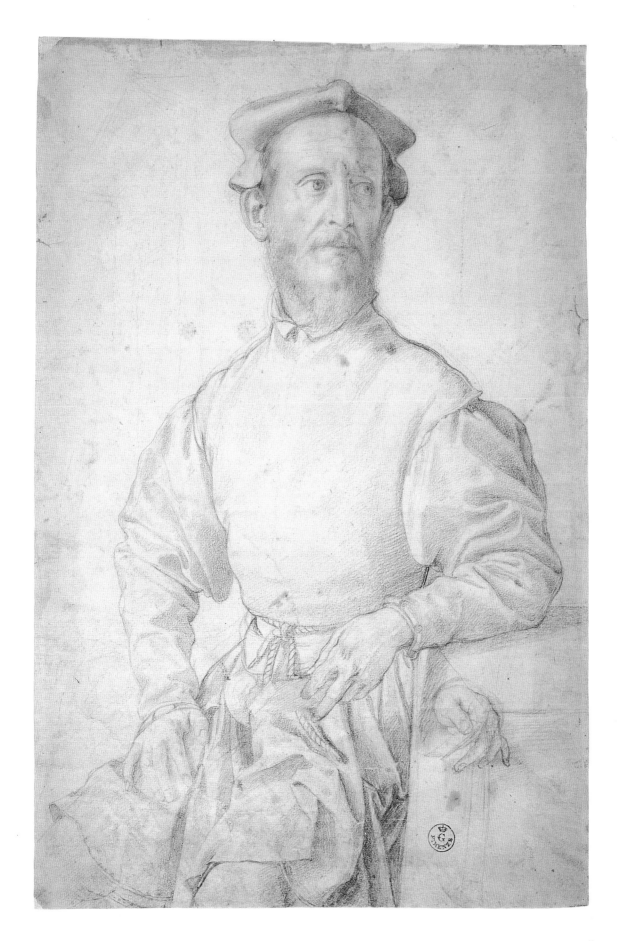

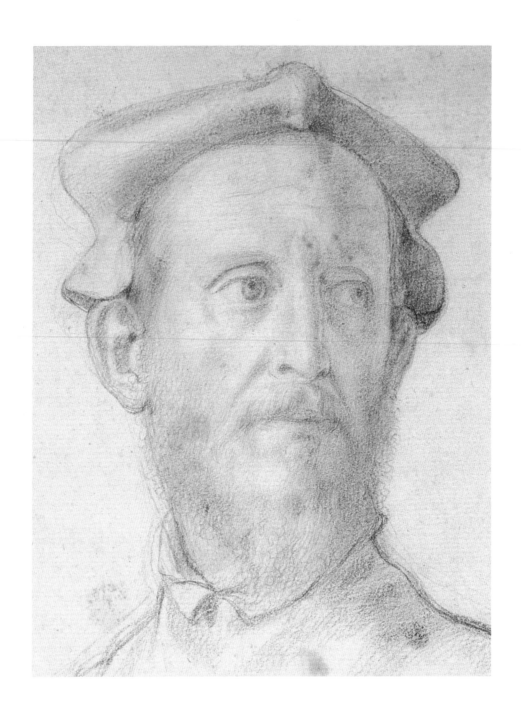

Berti (1965a, no. XXX; 1966, 53; and 1973, 84). However, the weight of opinion now seems to favor Bronzino as the author of the drawing. Scholars who have attributed the drawing to Bronzino include Andrews (1964, 158; and 1966, 581), Forster (1964, 381; and 1966, 108), Shearman (1965, 1:130 n. 1), Smyth (1971, 49–50 n. 18, with a useful review of earlier opinions), and Cox-Rearick, who originally catalogued the drawing as a study by Pontormo for a self-portrait (1964, 1:297–298, no. 331; cf. 1981, 1:357–7, no. 331, and 415–3, no. 130a, with bibliography since 1964).

Bronzino's early activity as a portraitist was profoundly affected by Pontormo (Berti 1965a, no. LVII; and 1966, 53). Consequently, the uncertainty regarding this drawing should not be entirely surprising. The fastidious quality of the draftsmanship, the precisely descriptive character of the interior modeling in com-bination with the more abstract and ornamental character of the silhouette, and the sitter's poise all point to Bronzino as the author of this imposing study, however. It should also be said that this drawing does not have the usual character of a self-portrait. As Andrews observed (1966, 581), the averted gaze would have been difficult, if not impossible, to depict in a self-portrait.

Internal and external evidence suggests then that this drawing is a portrait of Pontormo drawn by Bronzino, perhaps with the intention of using it as a study for a commissioned portrait of another sitter. As was suggested earlier, an appropriate date for the drawing is circa 1535–40, during the period that Bronzino and Pontormo were working together at Careggi and Castello.

G.S.

29. *The Virgin Annunciate*

Black chalk, squared in black chalk; 335 × 142 mm

13846F

EXHIBITIONS: Florence 1963, no. 21, fig. 14; Florence, Palazzo Strozzi 1980, no. 133.

REFERENCES: Cox-Rearick 1971, 21–22; Smyth 1971, 79 n. 212; Cheney 1973, 166.

Forlani Tempesti, who published this highly finished drawing for the first time, identified it as the definitive study for the Virgin Annunciate in the *Annunciation* panels painted by Bronzino in 1564 to flank his earlier *Deposition* in the Chapel of Eleonora in the Palazzo Vecchio (Florence 1963, no. 21). As Forlani Tempesti pointed out, the fact that the drawing is virtually identical to the painting and is squared for enlargement normally would indicate that only the full-scale cartoon lies between this and the finished painting.

Some scholars, including Smyth (1971, 79) and Cheney (1973, 166), have been troubled by a certain dryness in execution, however, and have rejected the attribution to Bronzino himself, preferring to see the sheet as deriving from the painting rather than being preparatory to it. There are certain differences in detail and style between the drawing and the panel, however (the clearest reproduction of the painting is that in Cox-Rearick 1971, fig. 24). Mary appears younger and more graceful in the painting, with longer, more elegant hands and fingers. Also, in the painting her eyes are modestly lowered so that they are less visible than in the drawing. The lectern and book also seem slightly altered in the painting, the lectern being less angled into the space and the pages of the book being flattened. In addition, the lectern is closer to the Virgin in the painting, seeming almost to touch her right arm. Differences of this kind argue against the drawing's having been done from the painting.

Another possibility, considered but rejected by Cox-Rearick (1971, 21–22), is that the drawing is by a pupil of Bronzino, perhaps Alessandro Allori, done from another drawing by Bronzino. As mentioned by Petrioli Tofani (Florence, Palazzo Strozzi 1980, no. 133), the high quality of the Uffizi drawing (despite its precise and slightly labored appearance) would seem to support the attribution to Bronzino himself.

G.S.

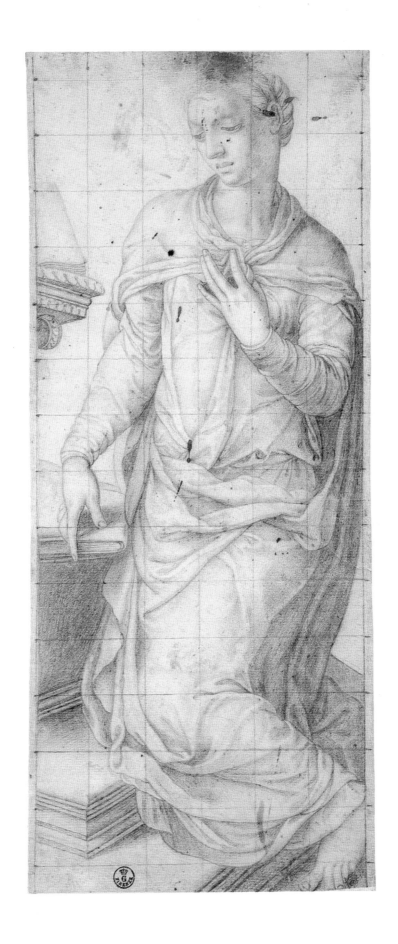

Agnolo Bronzino

30. *Study of a Kneeling Nude Man Looking Up*

Black chalk, squared in black chalk, on cream paper; 355 × 277 mm

10220F

EXHIBITIONS: Leningrad 1982, no. 28, fig. 28; Tokyo 1982, no. 20, pl. 20; Jerusalem 1984, no. 21, pl. 21.

REFERENCES: Cox-Rearick 1971, 21 n. 82; Smyth 1971, 45 n. 211.

Following Pontormo's death on January 1, 1557, Cosimo I de' Medici commissioned Bronzino to complete the decoration of the choir of San Lorenzo in Florence and to execute two scenes from the life of Saint Lawrence in the aisles of the church, just before the crossing. Cosimo referred to drawings for the latter scenes in a letter written to Bronzino from Pisa on February 11, 1565, and in the same letter he ordered the artist to prepare cartoons (Gaye 1840, 3:166, no. CLIII). Only one of the scenes was executed, the *Martyrdom of Saint Lawrence,* being unveiled on August 10, 1569 (McCorquodale 1981, pl. 106).

This drawing can be connected with the figure working the bellows under Saint Lawrence's gridiron, in the left near foreground of the composition. A related study, also squared, for the nude man with a staff in the immediate foreground at the left corner is in the Louvre (Smyth 1971, fig. 40; and Monbeig-Goguel 1972, no. 13). A third drawing, for the river god in the right bottom corner, is in the collection of Alice and John Steiner (sold at Christie's on December 9, 1975 [*Apollo* December 1975, advertising section, 20]; Olszewski 1981, 34–35, no. 10).

Formerly given to Alessandro Allori, the Uffizi drawing was attributed to Bronzino by Cox-Rearick (1971, 21 n. 82). Smyth rejected the attribution to Bronzino, comparing the Uffizi drawing unfavorably to that in the Louvre (1971, 45). In fact, the drawing seems consistent in style and quality with the sheet in the Louvre. The figure also compares well with those in two almost precisely contemporary drawings that are certainly by Bronzino, one in the Cabinet des Dessins of the Louvre (Monbeig-Goguel 1972, no. 12) and the other at Christ Church, Oxford (Byam-Shaw 1976, 1: no. 132 and 2: pl. 88). These drawings are connected with Bronzino's decorations on the facade of the Palazzo Ricasoli on the occasion of the triumphal entry into Florence of Francesco de' Medici and his bride, Giovanna of Austria, in December 1565 (on these decorations, see Pillsbury 1970, 74–83). The strong contours and rather schematic interior modeling of the figure have close counterparts in the drawing at Oxford, the *Virtues and Blessings of Matrimony Expelling Vices and Ills.*

G.S

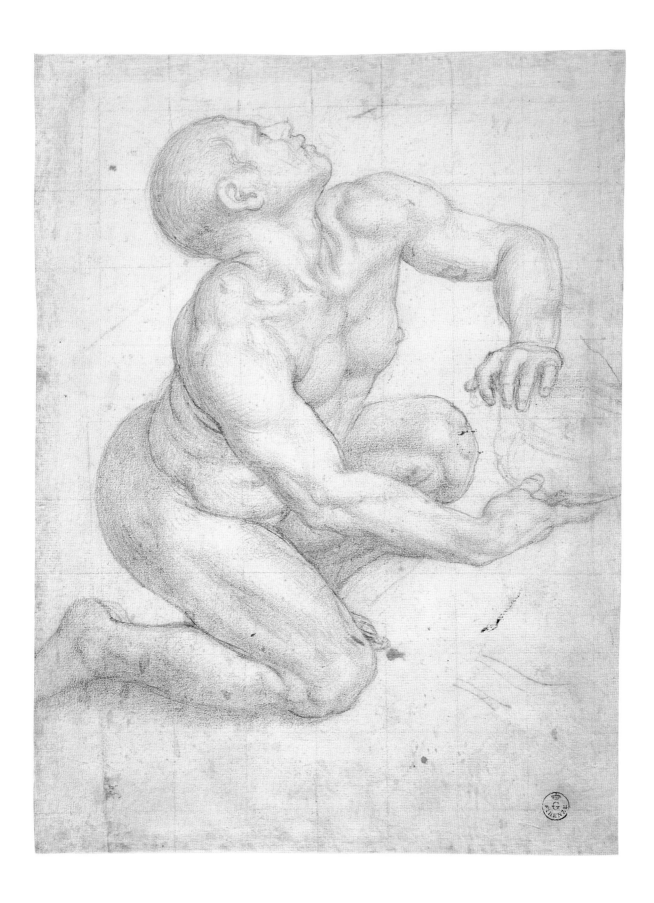

73

Francesco de' Rossi, called Salviati

Florence 1510—Rome 1563

31. *Holy Family*

Red chalk; 135 × 120 mm

ANNOTATIONS: at center of lower edge in ink, *52:510;* on mount in pencil, *Rosso Fiorentino*

473F

EXHIBITIONS: Naples 1952, no. 67.

REFERENCES: Ferri 1890, 124; Berenson 1903, 2: no. 2395; Kusenberg 1931, 152, no. 2; Berenson 1938, 2:311, no. 2399A; Barocchi 1950, 221–222, fig. 210; Cheney 1963, 339; Shearman 1965, 1:169 n. 2; Carroll 1971, 15, nn. 1, 4, fig. 1.

This study for a *Holy Family,* which was given to Rosso Fiorentino by Ferri (1890, 124) and by Berenson (1903, 2: no. 2395; 1938, 2: no. 2399A), was attributed to Francesco Salviati by Kusenberg (1931, 152, no. 2). Kusenberg's attribution has been supported by Cheney (1963, 339) and Carroll (1971, 15, and nn. 1 and 4, with references), among others, and there is now general agreement among scholars that this elaborately finished composition study is by Salviati.

The Christ Child is depicted as a plump, animated infant, intensely examining the small creature (presumably a goldfinch) that he grasps with both hands; he appears to be standing on a bed or large cushion and is supported by the Virgin. The Virgin is a stylish and sensual figure, with delicate features, a long, graceful neck, elegant hands and fingers, and an elaborate coiffure. Joseph is represented fast asleep in the right background.

Shearman suggested that Salviati's composition was inspired by a *Holy Family,* which is now in the Metropolitan Museum, painted by Andrea del Sarto about 1529 (1965, 1:169 n. 2, fig. 164a). This observation is certainly convincing with regard to the composition of Salviati's drawing. At the same time, Salviati's young, stylish Virgin is very different from Andrea del Sarto's matronly figure. A similar transformation is apparent in a closely related drawing by Salviati in the Louvre (Monbeig-Goguel 1972, no. 127, fig. 127; Carroll 1971, fig. 11). One of the results of Salviati's north Italian journey, in the spring and summer of 1539, was a marked increase in the Parmigianinesque element in his

work (Cheney 1963, 337). In fact, the type of Virgin represented in this drawing is strikingly reminiscent of Parmigianino's female figures. Moreover, the "flattened profile, tiny features, arched neck, and figure proportions" of Psyche in a preparatory sketch in the Szépmuvészeti Museum in Budapest for the *Adoration of Psyche as a Goddess* (Cheney 1963, 337 and fig. 5), Salviati's first Venetian commission, bring to mind the Virgin in the Uffizi *Holy Family* and support Shearman's suggestion that this drawing should be dated between 1535 and 1539. In turn, Psyche and the Virgin both have close counterparts among the figures in a drawing by Salviati in the Uffizi representing *Rebecca and Eliezer at the Well* (14610F; Carroll 1971, fig. 2). Derived from a lost composition by Rosso, Salviati's *Rebecca and Eliezer* has also been dated in the late 1530s. In light of these relationships, it seems reasonable to place this drawing in the context of Salviati's north Italian journey.

The purpose of the drawing has not been established. While it could well be a composition study for a private devotional picture, the degree of finish and the close attention given to modeling (through the employment of a variety of types of hatching, ranging from dense cross-hatching to a delicate stipple effect) suggest that the sheet may have been intended as a model for an engraver. In fact, we know from Vasari that Salviati left drawings in Bologna in late June 1539, with the expectation that they would be engraved by Girolamo Fagiuoli (Cheney 1963, 337).

G.S.

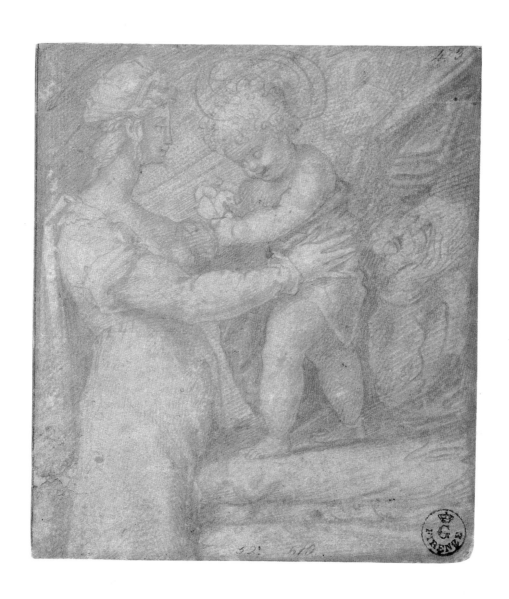

32. *A Procession of Male Figures (Joseph Sold into Egypt[?])*

Pen and brown ink and brownish gray wash, over black chalk, partially and faintly squared in black chalk; 260 × 199 mm

656F

EXHIBITIONS: None.

REFERENCES: None.

Formerly given to Vasari, the attribution to Salviati was proposed, in the form of annotations on the old mat, by Janet Cox-Rearick, and, tentatively, by Alessandro Cecchi. The attribution to Salviati is quite convincing, both on the basis of graphic style and because of the appearance in the drawing of certain figure and facial types that are characteristic of Salviati. The fierce horseman, at the top center of the group, with his shaggy hair and twin-pointed beard, is a recognizable Salviati type, as are the sketchy figures in the background. In addition, the virtuoso use of wash, both to establish areas of light and dark and for purposes of modeling (on the two figures at the left foreground), is typical of Salviati.

The subject of the drawing is difficult to establish, but it may represent Joseph sold into Egypt with the Ishmaelites (Genesis 37:27–28). Soon after taking up residence in the Palazzo Vecchio in May 1540, Cosimo I de' Medici commissioned a great series of twenty tapestries illustrating the life of Joseph to decorate the Sala dei Duecento (Florence, Palazzo Vecchio 1980, 50–63, nos. 80–99; Smith 1982, 183–196). Bronzino had principal responsibility for the cycle, providing designs for sixteen of the tapestries, but Pontormo prepared three designs and Salviati provided one, representing Joseph interpreting Pharaoh's dream of the fat and lean kine (Florence, Palazzo Vecchio 1980, no. 87). The composition of this drawing compares fairly well with the right section of Bronzino's tapestry representing four episodes leading up to and including the sale of Joseph (Florence, Palazzo Vecchio 1980, no. 82). Moreover, the young man with short, curly hair and kiltlike tunic, at center foreground of the composition, can be compared with Salviati's Joseph in *Joseph Interprets Pharaoh's Dream of the Fat and Lean Kine*. It may be that this drawing was for an unexecuted composition, made at an early stage in the planning of the series, at a time when Salviati was expected to have a more extensive role in the cycle than turned out to be the case.

Two other factors lend weight to this suggestion. The first is the relationship in style and composition between this drawing and another, also in the Uffizi (10311F), which is certainly for the Joseph series, being the *modello* for *Joseph Receiving Benjamin* (Smyth 1971, 32–33, figs. 30–32). Although Smyth attributed the drawing to Bronzino himself, it was catalogued in the Uffizi as a copy by Allori from the tapestry. More recently, Cheney described it as "rather Vasari-like" (1973, 169). It is possible that the present drawing and the related drawing in the Uffizi are both by Salviati, the latter being reworked by Bronzino and used as the *modello* for the tapestry, and the former being discarded but absorbed into the composition of the large *Sale of Joseph*.

One other element in the drawing connects it with the period of Salviati's activity in Florence for Cosimo I de' Medici. This is the tree on the rock at the top left of the composition. An almost identical motif appears prominently against the skyline in Salviati's *Triumph of Camillus* of 1544, in the Sala dell' Udienza in the Palazzo Vecchio. There the device is intended to celebrate Cosimo's character as a new, vigorous ruler, while also underlining his legitimacy by alluding to his links with the earlier branch of the Medici family (Cox-Rearick 1984, 239, 253). The Joseph series was intended to promote similar ideas of novelty and rebirth in the context of dynastic continuity (Smith 1982, 187–193), and so it would be entirely appropriate to find the device in a design for one of the tapestries.

Various types of evidence combine then to place this drawing in the context of Salviati's Florentine activity for Cosimo I de' Medici, about 1544–45, possibly in the early stages of preparation for the Joseph tapestry cycle.

G.S.

33. *Design for a Casket*

Pen and brown ink and brown wash; 162 × 302 mm. The drawing has been trimmed around the silhouette of the casket and mounted

ANNOTATIONS: at bottom right in ink, *15;* on mount at bottom right corner in ink, *759;* on verso of mount in pencil, *CXCIII - 756. Fº Salviati*

1577E

EXHIBITIONS: None.

REFERENCES: Ferri 1890, 126; Di Pietro 1921; Kris 1929, 1:65–66; Cheney 1963, 349 n. 71; Hayward 1976, 143–145, 149–150; Monbeig-Goguel 1978, n. 49; Florence, Palazzo Strozzi 1980, 198, no. 475.

Francesco Salviati's reputation today rests primarily on his work in painting, but his introduction to the art of design was through the craft of the goldsmith (Vasari/ Milanesi 7:6; Hayward 1976, 143). In fact, Salviati continued to associate with goldsmiths throughout his life, and, according to Vasari, his greatest friend was the Florentine goldsmith Manno di Sebastiano Sbarri, known as Manno Fiorentino (Vasari/Milanesi 7:42).

This inventive and fanciful design for an ornate casket is characteristic of Salviati's fertile imagination, as well as being representative of Mannerist designs for objects of this kind; masks, terms, seated nudes, animal heads, foliage, and swags combine with oval cartouches to form a dense and richly varied surface. This drawing is similar in style, technique, and character to other ornamental designs by Salviati in the Uffizi and elsewhere. Especially close is a study in the Uffizi for a casket surmounted by a reclining figure of Mercury (1612E; Florence, Palazzo Strozzi 1980, no. 475). Also similar is a drawing, attributed to Perino del Vaga, depicting a stepped casket surmounted by three winged victories (Uffizi 1603E; Ferri 1890, 151; Hayward 1976, pl. 59).

Several scholars have connected the two drawings by Salviati with the Farnese Casket in the Museo di Capodimonte, Naples (Kris 1929, 1:65–66; Florence, Palazzo Strozzi 1980, no. 475). Commissioned by Cardinal Alessandro Farnese in 1547 from Manno Fiorentino, Salviati's friend, the Farnese Casket is decorated with six carved rock-crystal plaques based on designs by Perino del Vaga (De Rinaldis 1923, 145–165; Hayward 1976, 135, 149–150, 368, pls. 321–327). Consequently, Perino has been proposed as the author also of the design of the casket. However, Hayward argues that "Salviati's claim to authorship seems to be the stronger" (1976, 149).

While our drawing resembles the Farnese Casket in certain elements of its design (in particular, the terms and the oval cartouches surmounted by paired, seated figures), the overall relationship is not compelling. Salviati's casket does not quite have the profusion of ornament and figural decoration of the Farnese Casket. Also, the simpler treatment of the lid of Salviati's casket might suggest a date slightly earlier in the 1540s than that of the Farnese Casket. Although the body of the chest is far removed from the architectural clarity and classicism of the gilt casket designed for Clement VII by Valerio Belli in 1532, now in the Museo degli Argenti in Florence (Hayward 1976, pl. 244; Florence, Palazzo Vecchio 1980, no. 408, col. pl. facing 51), the treatment of the lid is not dissimilar. Indeed, several of the most striking elements in the Farnese Casket (in particular, the strong recollections of Michelangelo's tomb of Lorenzo de' Medici in the New Sacristy of San Lorenzo) are absent from this drawing. Nor are there any indications that the design was intended for a member of the Farnese family, whereas the casket as executed bears a wealth of devices linking it to the heraldry of the Farnese family. Rather to the contrary, the two goats' heads at the corners of Salviati's casket might indicate that it was a project intended for Cosimo de' Medici (for Cosimo I's adoption of Capricorn as his *impresa* see Cox-Rearick 1984, 269–283).

In certain details and in handling this drawing is similar to a study by Salviati in the British Museum for the *soprapporta* depicting *Peace with Two Bound Captives* in the Sala dell' Udienza in the Palazzo Vecchio (Turner 1986, no. 126). The British Museum sheet can be dated about 1544, and so a date in the mid-1540s would also seem reasonable for the Uffizi *Design for a Casket.* Very possibly it records a project for a casket for Cosimo I, executed at the height of Salviati's activity at the ducal court.

G.S.

78

34. *God Creating the Animals*

Pen and brown ink and brownish gray and brown washes, over occasional faint traces of black chalk; 256 × 180 mm

ANNOTATIONS: on verso at bottom left corner in ink, legible through the mount, *Fran^co Salviati;* on mount in red chalk, canceled in black pencil, *d'Enrico Golzio;* in pencil, *FR. SALVIATI (Kloek)*

14351F

EXHIBITIONS: None.

REFERENCES: None.

An old annotation on the backing attributed this delightful drawing to the Netherlandish Mannerist Hendrik Goltzius. The present attribution, to Francesco Salviati, was proposed by Wouter Kloek in 1970 in the form of a note on the backing and would seem to be confirmed by the annotation *Fran^co Salviati,* in a sixteenth-century hand, on the verso of the sheet.

Executed in a variety of washes, the drawing represents God the Father, surrounded by faintly drawn angels, in the act of creating the animals (Genesis 1:24–26), represented by two dragons, two goats, and a lion and lioness. Three fishes squirm in a stream at the bottom right corner of the drawing, alluding to the preceding day of creation, when God created the fish and the fowl (Genesis 1:20–23). The subject is treated in a lively and witty fashion, with God's gesture suggesting that of an animal trainer, as much as Creator, and the dragons and lions restive and aggressive, even at the moment of their creation.

The attribution to Salviati is entirely convincing on the grounds of style and figure type. Convincing comparisons can be made with two drawings in the Louvre, both of which represent the *Incredulity of Thomas* (Monbeig-Goguel 1972, nos. 145 and 147, 1). The pictorial treatment of light and dark, the liveliness of the hair and beard of God, and the general sense of animation and imagination also suggest affinities with Salviati's works from the late 1540s and from the 1550s, such as the decorations of the Palazzo Sacchetti in Rome (Freedberg 1979, fig. 209).

Salviati's treatment of the subject is unusual in depicting God in flight. In earlier Florentine and Roman creation cycles, such as Paolo Uccello's in the Chiostro Verde at Santa Maria Novella or Raphael's in the Vatican *Logge,* God stands on earth, surrounded by the animals that he has just created (Borsook 1980, pl. 87a; Davidson 1985, figs. 10, 11). This is the case too with the mosaic creation cycle in Saint Mark's in Venice, which Salviati had also known (Demus 1935, fig. 27). Salviati transposed the more dramatic, airborne God from the earlier episodes by Raphael, such as the *Separation of the Earth from the Waters* and the *Creation of the Sun and Moon* (Davidson 1985, fig. 10).

Curiously, the closest parallel to Salviati's *Creation of the Animals* is that by Tintoretto, painted between September 1550 and November 1553 for the Scuola della Trinità in Venice and now in the Accademia (Bernari and De Vecchi 1970, no. 82A, pl. VII). Like Salviati, Tintoretto combined the creation of the fish and fowl with the creation of the animals and represented God the Father in full flight, with billowing draperies. In Tintoretto's depiction, however, the sky and sea are full of birds and fish in frantic migration accompanying God in his flight.

There is no mention of a creation cycle in the literature on Salviati, or of a *God Creating the Animals.* Two motifs in the drawing may hint at the intended recipient of the finished work, however. Salviati's emphasis on the goats and lion might suggest a connection with Florence under Cosimo I de' Medici, with the lion being the Florentine *Marzocco* and the goats alluding to Cosimo's personal device, the Capricorn (see Cox-Rearick 1984, 269–283). It is conceivable that this drawing is connected with Salviati's rejected designs for the choir of San Lorenzo (Vasari/Milanesi 7:30). While *God Creating the Animals* was not among the scenes executed by Pontormo and Bronzino, the San Lorenzo cycle was composed primarily of Old Testament subjects. On the other hand, the liveliness and miniaturelike quality of the drawing bring to mind the small Old Testament scenes in the border of a tapestry *Resurrection* in the Uffizi, woven by Nicholas Karcher from a design by Salviati between October 1545 and September 1549 (Florence, Palazzo Vecchio 1980, no. 103; reproduced in color in Viale Ferrero 1961, pl. 37).

G.S.

Giorgio Vasari

Arezzo 1511—Florence 1574

35. *Head of a Woman in Profile*

Black chalk and traces of white chalk; 241 × 205 mm

1214E

EXHIBITIONS: None.

REFERENCES: Petrioli Tofani 1985a, 417–420; Petrioli Tofani 1987, 503–504.

A fundamental eclecticism distinguishes Vasari's figurative vocabulary. The reasons for it can be found not only in the events of his life, which was marked by frequent trips to the major centers of Italian art, but also in his cultural approach. His extensive activity as a historian and theoretician of the figurative arts—as well as painter, draftsman, architect, and designer of stage sets—familiarized him with other artists, whether predecessors or contemporaries.

His sure artistic instinct permitted him to absorb useful lessons from the most disparate sources without ever compromising his own personal expressive syntax. Vasari was born in Arezzo and began his artistic training there under Guglielmo di Marcillat, and, as he himself reports, he drew from "all the good pictures to be found in the churches of Arezzo" (Vasari/Gaunt 4: 257). Rosso Fiorentino was working in the city in 1528, and the young artist fell under his spell. He also received important suggestions from Andrea del Sarto, Baccio Bandinelli, and Agnolo Bronzino. He met Francesco Salviati upon his arrival in Florence and again in 1532 in Rome, in 1539 in Bologna, and two years later in Venice; the two artists were tied by a personal friendship. Other influences came from Parmigianino and the principal exponents of the strain of Mannerism that derived from Raphael, whom he met in Rome and also later in Parma, Modena, Verona, Mantua, and Naples.

The artist who left the strongest impression on Vasari, both in drawing and in painting, was Michelangelo, whom Vasari admired unconditionally. It could be said that the probable major reason for Vasari's enormous success in political circles—to the point of his becoming official court painter for the Medici and the principal spokesman for Duke Cosimo's efforts toward hegemony—lay in his extraordinary ability to adapt the difficult but unavoidable lesson of the great master. Vasari transformed the enormous psychological tension and difficult formalism of Michelangelo's art into a language that was much more accessible, refined, and sophisticated and could be adapted both to the large spaces of wall decoration and to laudatory celebrations of individual figures and entire dynasties.

While among the great quantity of paintings that Vasari boasted about executing in a very short time are some that show the signs of this haste and of the extensive intervention of his helpers, this is very rarely true of his drawings. Taken as a whole, they form one of the most interesting and varied chapters in the history of Italian graphic production of the sixteenth century.

The sharp precision of the outline of the image in this drawing, deriving evidently from Michelangelo's example, and the orderly series of parallel lines and cross-hatchings shape the surface in a refined play of light and shade that is intensified by the skillful use of white chalk. This fine drawing is a study for the head of Mary Magdalene kneeling at the foot of the cross in the Deposition altarpiece in the Santissima Annunziata in Arezzo, unfortunately a rather labored and schematic work that Vasari executed in 1536–37. A pen and ink compositional sketch for this same painting, identified by Davidson (1954, 228–231), is in the Wadsworth Atheneum in Hartford; that sheet and this study of the head are considered the earliest specimens of Vasari's graphic production whose date can be pinpointed with certainty.

Michelangelo's strong influence on this drawing, which both in the type of subject and in the pronounced twist of the head recalls certain heads on the Sistine ceiling and in particular that of the *Libyan Sybil*, led some early cataloguers to include it among Michelangelo's works. It is listed in Giuseppe Pelli Bencivenni's eighteenth-century *Inventario* as a Michelangelo drawing, where it is described as the "study of a beautiful head of a young girl, in black chalk" (no. 41 of volume VII of the *Volumi Piccoli*); it is attributed to Michelangelo also in the *Catalogo dei Disegni scelti . . . ,* compiled in 1849 by Antonio Ramirez di Montalvo. In the margin of this catalogue, however, a handwritten note by P. N. Ferri indicates it as "school of Michelangelo"; he excludes it from the group of Michelangelo's drawings in his catalogue published in 1890. This author established it as by Vasari in 1981.

The verso of the sheet contains a small sketch in black chalk of the back of a male nude, which does not seem to have any connection with the Arezzo *Deposition*.

A.M.P.T.

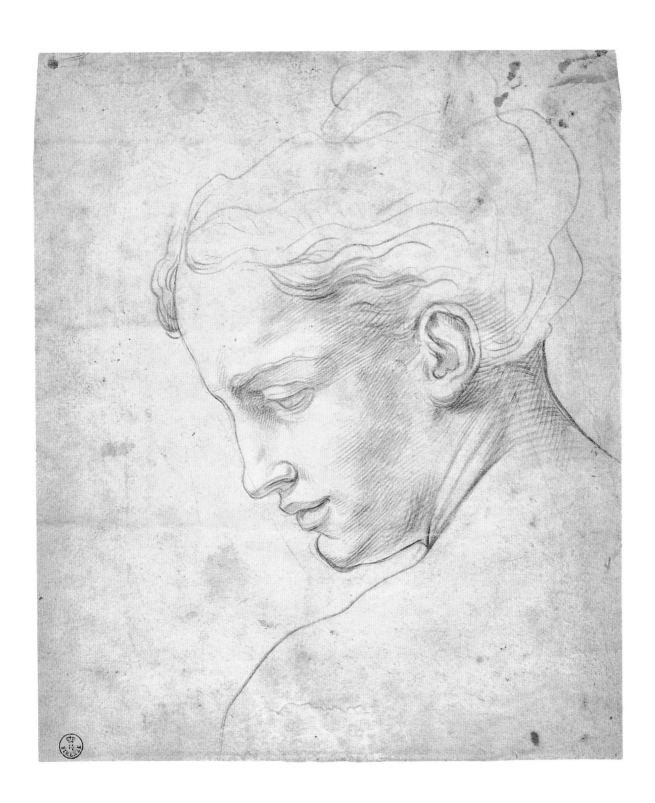

Giorgio Vasari

36. *Christ Standing against the Cross and Pouring His Blood into a Chalice*

Red chalk; 290 × 193 mm. Mounted

ANNOTATIONS: at lower left in black chalk in an eighteenth-century hand, *1*, and at lower right, *1433*

1433S

EXHIBITIONS: None.

REFERENCE: Santarelli 1870, 112, no. 1.

This fine drawing was attributed to Alessandro Allori in Emilio Santarelli's collection before it came into the Uffizi in 1867 and was correctly recognized as Vasari's by Philip Pouncey in a handwritten note on the mount.

The sophisticated, refined nature of the handling of the line is typical of this intellectual artist, whose hand is evident in the confident precision and abstract perfection of the outline as well as in the highly polished chiaroscuro, which derives clearly from Bronzino.

A precise counterpart for this figure does not appear in Vasari's paintings. For this reason, any attempt to give it a date must be made with circumspection. The only criterion for a hypothetical date is style; on this basis it seems that it can be placed broadly within the decade of the 1540s. The drawing method presents a number of analogies with other drawings from this same period in different techniques, beginning with the well-known drawings for the sets for Pietro Aretino's *La Talanta,* staged in Venice during the carnival season of 1542. The position, gesture, and elegant pose of Christ shows strong connections with the Christ in the *Calling of Saint Peter* in the Badia di Santa Flora e Lucilla in Arezzo of 1551.

Another aspect that makes this drawing an extremely interesting point of reference for the study of Vasari as a draftsman is its technique: among his drawings, those done only in chalk are a small minority, and those in red chalk extremely rare. Vasari's use of this medium differs strongly from the more "naturalistic" handling of Pontormo or Andrea del Sarto as well as the dramatic eccentricity found in Rosso Fiorentino.

A.M.P.T.

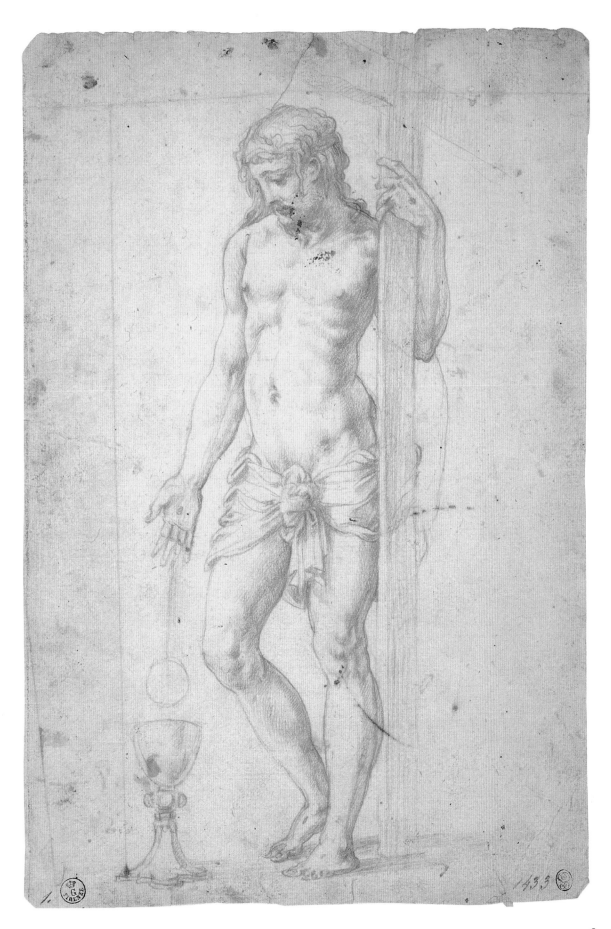

37. *The Liberation of San Secondo*

Pen, dark brown ink, brown wash, white lead, with traces of black chalk, on green tinted paper squared in black chalk; 249 × 257 mm

650F

EXHIBITION: Arezzo 1981, no. 42b.

REFERENCES: Ferri 1890, 155; Barocchi 1964a, 261 n. 4; Barocchi 1964b, 27; Monbeig-Goguel 1972, 158; Allegri and Cecchi 1980, 159; Arezzo 1981, 143, no. 42b.

Vasari's greatest undertaking as an artist was certainly the restructuring and decoration of the Palazzo Vecchio, the seat of Florentine government as well as the official residence of Cosimo I, who moved there in 1540 from his home in the Palazzo Medici Riccardi. While on the one hand this project can be interpreted as the most visible evidence of the Grand Duke's cultural policy, whose purpose was hegemony over the arts and the use of artists as instruments for the celebration of himself and his dynasty, on the other hand it produced the basic text for the study of the taste and style of late Mannerism in Florence.

The work, begun in 1555, kept Vasari—who was aided by a large group of collaborators among whom the most distinguished were Cristoforo Gherardi, Marco da Faenza, Stradanus, and later Naldini—busy practically to the end of his life, with some interruptions to execute important commissions like the altarpieces for churches in Florence, Perugia, Boscomarengo, Arezzo, and Rome, and fresco cycles for the Vatican and the dome of the Florence cathedral.

Vasari's work in the Palazzo Vecchio was extensive and profoundly changed the aspect of the medieval building. It involved architectural restructuring as well as the interior decoration of the apartments of Leo X, Duke Cosimo, his wife Eleonora of Toledo, the Apartment of the Elements, the Salone dei Cinquecento, and the Studiolo of Francesco I.

This drawing is of very high quality, with the relaxed elegance of its line and the skillful chromatic and luministic relationship between the various drawing media and the color of the paper. As noted by P. N. Ferri and O. H. Giglioli in handwritten notes on the inventory cards, it is preparatory for one of the ceiling panels of the room dedicated to the celebration of the military prowess of Cosimo's father, Giovanni delle Bande Nere, in the apartment of Leo X. The scene is an episode from 1519, when Giovanni defended in battle the dominion of San Secondo on behalf of his sister Bianca Riario.

The plan for the decoration of the entire ceiling, similar to that shown in cat. no. 38, is in the Louvre (2127; Monbeig-Goguel 1972, no. 208); studies for two analogous scenes are in the Courtauld Institute in London (1786, preparatory for the panel with *Giovanni della Bande Nere Swimming across the Po and Adda Rivers with His Army;* Monbeig-Goguel 1972, 158–160), in the Pinacoteca Ambrosiana in Milan (F269, *idem,* and in the Muzeum Narodowe in Warsaw (175–183), preparatory for the panel with *Giovanni delle Bande Nere Defending the Rozzo Bridge over the Ticino River;* Arezzo 1981, 159).

A.M.P.T.

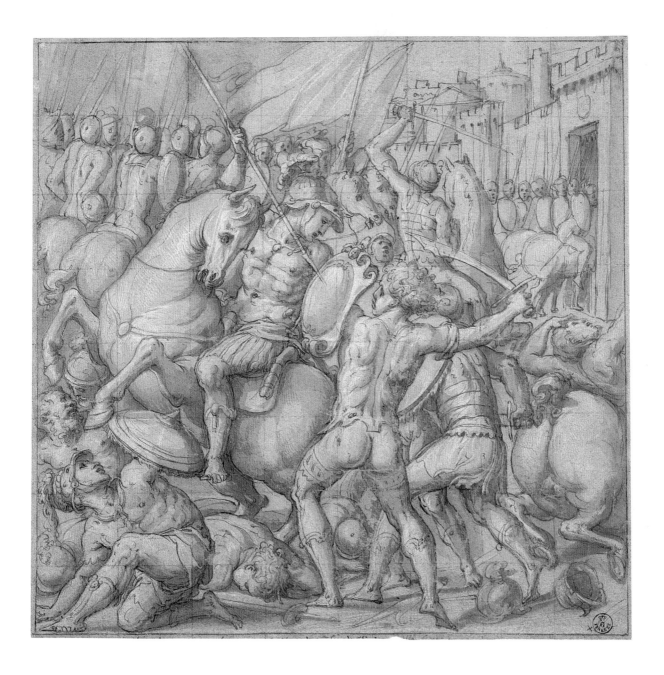

Giorgio Vasari

38. *Study for the Ceiling of the Saturn Terrace in Palazzo Vecchio*

Black chalk, pen, brown ink, and light brown wash; 377 × 402 mm. Mounted

ANNOTATIONS: at upper left in pen in an antique hand, *Stradano;* at lower left in black chalk in an eighteenth-century hand, *17, 75*

7 Orn

EXHIBITIONS: Florence 1950, no. 99; Florence 1963, no. 40; Florence 1964, no. 91.

REFERENCES: Florence 1950, 56, no. 99; Baldini 1950–52, no. 98; Florence 1963, no. 40; Vitzthum 1963, 58; Florence 1964, 70, no. 91; Allegri and Cecchi 1980, 108.

Ferri catalogued this drawing under the name of Giovanni Stradanus, probably following an earlier attribution that is indicated by the note in antique handwriting in the upper left of the sheet. It was returned to Vasari by Vitzthum on the basis of its drawing style, which denotes a light, agile hand, rich in decorative inflections, typical of Vasari and quite different from the capable but less refined work of his Flemish collaborator.

This drawing is of particular interest among those connected with the decoration of the Palazzo Vecchio since it most probably represents the earliest plan, which was then modified in the course of the work, for the ceiling of the Saturn terrace next to the Apartment of the Elements, a work that proceeded, with a number of interruptions, from 1560 to 1566. The drawing's similarities to the painted version as it appears today are so great that there is little room for doubt, despite the numerous changes introduced into the compositional scheme, including the addition of two more panels on either side of the central one to adapt the scheme to the rectangular form of the loggia, and the many modifications the finished work has undergone in the course of the centuries. In both the drawing and the painting, God, who presides over the passage of time, appears in the central tondo, albeit in different versions; here he is shown as a winged old man holding a scythe, seated on a chariot pulled by two deer. Another significant point of coincidence between the two is the representation in the side panels of the Hours, shown as nearly nude young women with dragonfly wings holding hourglasses and seated on small pedestals marked with Roman numerals from I to XII.

This drawing provides an invaluable document of the taste of a time and a society, a taste in which sophisticated cerebral Late Mannerist figurative expression encounters the inclination toward allegorical and literary themes of a typical court culture.

A.M.P.T.

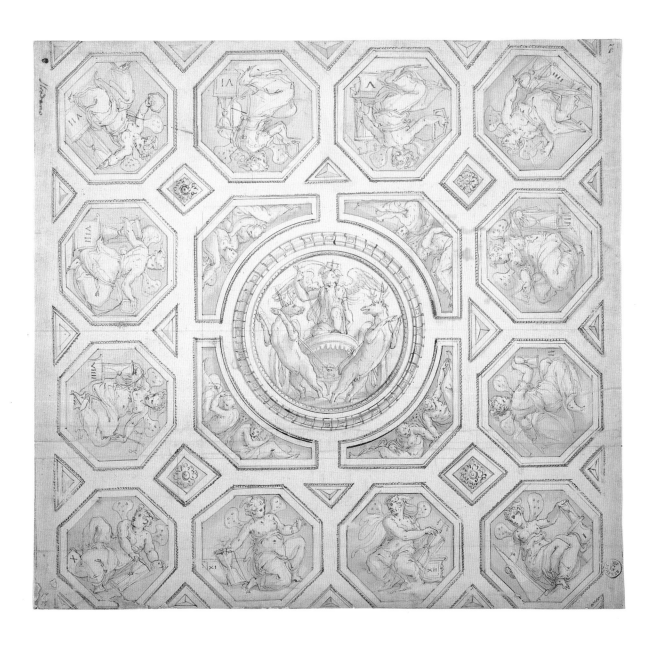

39. *The Crucifixion*

Pen and dark brown ink, with traces of black chalk; 391 × 270 mm. Mounted

623F

EXHIBITIONS: Florence 1964, no. 39; Arezzo 1981, no. 59a.

REFERENCES: Baldini 1950–52, no. 75; Forlani 1962, 226–227, no. 80; Florence 1964, 42, no. 39; Barocchi 1964b, 64; Hall 1979, 109–110 and n. 17; Arezzo 1981, 163–164, no. 59a.

The energetic use of the pen in this fine drawing shows a strong influence from Parmigianino and Perino del Vaga and is typical of Vasari's late drawings. It is found again in other drawings done in a similar technique such as the study of a Bacchanal from the 1560s (Uffizi 620F), or sketches for the frescoes in the dome of the Florence cathedral done between 1571 and 1573 and now for the most part in the Louvre.

This is an early sketch for an important commission that Vasari received from the bishop of Volterra, Alessandro Strozzi, for an altarpiece for the Strozzi family chapel in Santa Maria Novella, done in 1567 as part of the major remodernization of the medieval building ordered by Grand Duke Cosimo I.

At least a partial explanation of this composition's complex iconography and theory, as well as an idea of how Vasari's artistic and literary production could be used by a ruler for purposes of propaganda, can be gathered from Vasari's autobiography:

The duke, so admirable in every way . . . delights . . . as befits a Catholic prince, in restoring churches, like King Solomon. Thus recently he got me to remove the screen of Santa Maria Novella, which spoilt all its beauty, and . . . he has directed a rich decorative framework to be made round the columns of the side aisles . . . to be furnished with pictures . . . at the pleasure of their owners. In one of these frameworks of my own design I did for Alessandro Strozzi . . . a Christ on the Cross, as seen by Saint Anselm, with the seven Virtues, without which we cannot mount the seven steps to Jesus Christ, and other circumstances of the same vision. (Vasari/Gaunt 4:288–289)

Interpretation of the iconography and allegorical significance of a number of the figures in this composition—arranged according to a very crowded scheme in which the forms seem to emerge one out of another in a lucid and abstractly intellectual rhythm—is aided by the existence of a second drawing (Uffizi 624F) quite similar to this but much more highly finished and detailed, in which the various figures are accompanied by captions explaining their allegorical function.

A comparison of the two drawings provides very helpful indications of Vasari's working methods. After sketching a first idea of the composition that usually, as here, contained all its basic components, he would then develop these formally using more complex techniques, making highly finished drawings in which the black chalk, wash, and sometimes white lead or white chalk fill in the light and round out forms that had first been outlined in pen and ink. Translation of these designs, which could be defined as cartoons, to the painted version was then almost automatic and could be entrusted also to pupils or assistants. It is interesting to note how this working method excludes the studies from life models that were a major component of the method of other Florentine artists both before and after Vasari, constituting an intermediate step toward realization of the individual figures. This fact explains why drawings of figures isolated from their narrative context are rare in Vasari's corpus, and also gives a further demonstration of the highly intellectual and abstract quality of Vasari's artistic vocabulary.

A.M.P.T.

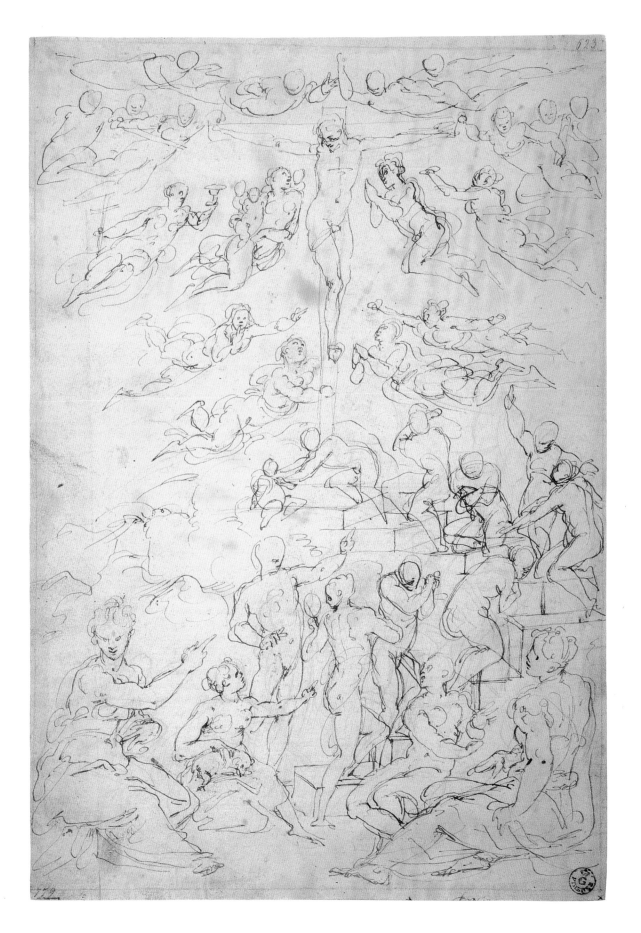

Jan van der Straet or Straeten, called Stradanus

Bruges 1523—Florence 1605

40. *The Return to Florence of the Marquis of Marignano*

Pen and brown ink and brown wash over traces of black chalk, the composition framed in brown ink; 345 × 345 mm

657F

EXHIBITIONS: Florence 1950, no. 80; Florence 1957, no. 72; Florence 1964, no. 33.

REFERENCES: Ferri 1890, 156; Baldini 1950–52, no. 80; Thiem 1960, 106, fig. 9; Barocchi 1964b, 59, 322; Vitzthum 1965, 55, pl. 46; Pillsbury 1976, 130–131; Allegri and Cecchi 1980, 252.

This large composition study is the *modello* for one of the principal scenes on the ceiling of the Salone dei Cinquecento in the Palazzo Vecchio, painted by Giorgio Vasari and his assistants between August 1563 and the end of 1565 (Allegri and Cecchi 1980, 235–255, 241, no. 16). The drawing and related painting commemorate the triumphant return to Florence of the Marquis of Marignano and his forces after taking Siena in April 1555. The scene takes place to the south of Florence, outside the Porta Romana, where the Marquis of Marignano and other *condottieri* were welcomed by the young Francesco de' Medici. The dome of Santa Maria del Fiore and Giotto's Campanile are clearly visible in the drawing at the top center of the sheet, and the Palazzo Vecchio can be seen near the top right corner, above the Porta Romana.

The painting differs from the drawing in several details, despite the finished character of the *modello*. In the panel the Marquis of Marignano turns to engage in conversation with the horseman on his right, thereby reducing the number of contacts between the figures in the painting and the viewer. Also the figures in the lower right corner are increased in number and are given the features of Vasari, Vincenzo Borghini and Giovambattista Adriani, his advisors, and his assistants, Stradanus, Giovan Battista Naldini, and Jacopo Zucchi.

Ferri (1890, 156) listed this drawing among those attributed to Vasari and connected it with the decorations of the Palazzo Vecchio. The old attribution to Vasari was maintained by Thiem (1960, 106) in his fundamental study of the drawings for the Salone dei Cinquecento and by Barocchi (1964b, 59, 322) in her monograph on Vasari. However, on the basis of relationships in style to a study in the Louvre signed and dated 1564 by Stradanus, Vitzthum (1965, 55) argued that this drawing and several others connected with the ceiling decorations should be given to Vasari's Flemish-born assistant. This view was supported by Pillsbury (1976, 130–131), who introduced documentary materials that established conclusively that Stradanus was Vasari's principal assistant in the Salone. Pillsbury also clearly formulated the working process in the Salone, suggesting that Vasari relied on Stradanus and his other assistants to develop his preliminary sketches for the ceiling into finished compositional models.

As a result of the studies by Barocchi, Vitzthum, and Pillsbury, we now recognize the patchy, loosely applied wash in this drawing to be typical of Stradanus's handling of the medium in the studies for the Salone. In this instance, however, Stradanus's wash is not entirely "disorganized" (Vitzthum 1965, 55), despite its rather untidy appearance. The contrast between the strong wash in the left foreground and the much paler wash of the right corner and upper portion of the drawing serves simultaneously to concentrate attention within the composition and to establish a sense of distance and atmospheric perspective. The massive, inflated hindquarters of the horses and the fierce, rather grotesque features of the principal figures in the drawing are also typical of Stradanus's "swollen forms" and "uncouth" types (Pillsbury 1976, 132).

G.S.

93

41. *The Medici Golden Age*

Pen and blue and brown ink and blue wash, heightened with white, on blue-green paper, the composition framed in brown ink; 385 × 286 mm

ANNOTATION: at lower right corner in ink, *B. Pupini*

1476F

EXHIBITION: Florence 1947 (not in catalogue).

REFERENCE: Ferri 1890, 305.

Presumably on the basis of the annotation on the sheet, Ferri (1890, 305) attributed this elaborate and lively composition study to the Bolognese painter Biagio Pupini and gave it the title *L'Età dell'oro*. The attribution to Stradanus was proposed in 1968 by Anna Forlani Tempesti (note in curatorial files), who connected the drawing with a closely related *modello* traditionally given to Stradanus (Uffizi 2341F; Ferri 1890, 347). The latter sheet elaborates the upper part of this drawing and is similar to it in style, technique, and subject matter.

This drawing is related in motif and technique to Stradanus's *modello* for *The Arts of Painting and Sculpture*, signed and dated 1573 (Turner 1986, no. 144). Both drawings employ a technique of modeling with many short pen strokes and touches of white heightening. Also, the pose and slightly lumpy figure of the woman with her back to the viewer seem to be adapted from a statuette of *Venus* that appears in the above *modello*.

The idyllic character of the scene, with nude figures bathing by a fountain and young women dancing, brings to mind a drawing in the Louvre by Giorgio Vasari representing *The Golden Age* (Monbeig-Gougel 1972, no. 224) and two paintings of the same subject, one in the National Gallery of Scotland by Francesco Morandini, called Il Poppi (Brigstocke 1978, 103–105, inv. no. 2268; reproduced in Edinburgh 1980, 104), and the other in the Uffizi by Jacopo Zucchi (*Gli Uffizi* 1979, P1917; Pillsbury 1974, fig. 5). Stradanus's drawing does not only represent the Golden Age, however.

Although the scenes in the foreground of the drawing evoke the "everlasting spring" of the Golden Age in which the human race, "untroubled by any fears," enjoyed a "leisurely and peaceful existence" (Ovid, 31–32), there are hints in the background of later, imperfect periods in the history of mankind. In the far distance, at the upper right, several figures are engaged in ploughing and tilling the fields. This area depicts a period subsequent to that in which "men were content with foods that grew without cultivation" and the earth, "though untilled," produced corn. In fact, this section must represent the Age of Silver in which corn "first began to be sown in long furrows, and straining bullocks groaned beneath the yoke." Nearer the foreground, Stradanus represented a group of soldiers gathered around their leader. (The military character of the group is fully evident in the related *modello*, Uffizi 2341F.) This group must indicate the Age of Bronze, "when men were of fiercer character, more ready to turn to cruel warfare." Finally, in an arbor at the upper left, Stradanus depicted a group of figures seated around a table and servants bringing dishes. One of the revelers has fallen into a drunken slumber, while the festivities seem to have roused indecorous passions in two of his companions. Two men are engrossed in a board game. This tableau suggests the depraved Age of Iron.

The Ages of Iron, Bronze, and Silver succeed each other as if we were moving back through successive layers of time. If this conceit had been consistently applied, the Golden Age ought to have been set deepest in space. Conversely, if closeness in time is suggested by nearness in space, the proximity of the bathing, music-making, and dancing figures would appear to suggest that Stradanus intended them to be the most nearly contemporary. There is an explanation for this apparent contradiction, however.

The area established as the precinct of the Golden Age is separated from the Ages of Bronze and Silver by a low wall. At the far right, there is a tree that stands almost as a boundary marker. With its luxuriant, new bough springing from the severed trunk, it is recognizable as a symbol of the regeneration of Florence and the Medici under Cosimo I (Ladner 1961, 1:304–305; Cox-Rearick 1984, 239) and identifies the area as the setting for a new Medici Golden Age brought about by his benevolent government.

The compositions by Vasari, Poppi, and Zucchi reflect an *invenzione* for a drawing depicting the Golden Age, written for Vasari by Vincenzo Borghini between 1565 and 1567 (Brigstocke 1978, 103–104). It is reasonable to suppose that Stradanus's drawing originated in the same context and at about the same time.

G.S.

42. *Hunting Ibex*

Pen and brown ink over faint traces of black chalk, the composition framed in brown ink (the head of the hunter carrying a gun, near foreground to the right of center, on a separate piece of paper affixed to the large sheet); 235 × 370 mm

INSCRIPTION: at lower left corner in brown ink, *inuentor della s[t]rada/strada fiami[n]gho. 1567/ 1567*

2346F

EXHIBITIONS: Florence 1947, 92; Florence 1960, no. F35, pl. LXXII; Florence 1963, no. 41, fig. 26.

REFERENCES: Orbaan 1903, 52; Thiem 1958, 95, fig. 4; Berti 1967, 88, fig. 84; Heikamp 1969, 55 and 67 n. 77; Kultzen 1970, 12, 28, pl. 2; Kloek 1975, no. 254; Scorza 1984, 434, fig. 65.

In the brief notice of Stradanus that Vasari included in his chapter on the members of the Accademia del Disegno in the 1568 edition of *Le vite,* he mentioned the former's activity as a painter in the Palazzo Vecchio but indicated that Stradanus's principal responsibility at the time of writing was the provision of tapestry cartoons for Cosimo and Francesco de' Medici (Vasari/Milanesi 7:617–618). Vasari mentioned several tapestry cycles designed by Stradanus for the apartments of the Palazzo Vecchio. He also referred to a series of cartoons representing scenes of hunting, fowling, and fishing intended for the Medici villa at Poggio a Caiano, telling us that Cosimo himself devised the program. According to Heikamp (1969, 50), Cosimo drew inspiration from a *Libro d'animali* once owned by the Florentine painter-eccentric Piero di Cosimo. Vasari praised the cartoons enthusiastically, citing them as evidence of Stradanus's mastery of the Italian style.

This composition study representing huntsmen in pursuit of ibex is one of a group of elaborately finished pen drawings by Stradanus, connected with the cycle of tapestries commissioned for Poggio a Caiano. The majority of the studies are signed and dated 1567. Other drawings in the group are preserved in the Uffizi, the Louvre, the Fitzwilliam Museum in Cambridge, and the Musée des Beaux-Arts in Orléans (Florence, Palazzo Vecchio 1980, 78, no. 25). The tapestry depicting the hunting of ibex and a closely related tapestry representing the hunting of chamois are documented by a payment of February 17, 1568 (Heikamp 1969, 55 and 72, document 19; the drawing for *Hunting Chamois,* which is in the Musée des Beaux-Arts in Orléans, is reproduced as fig. 29). Raffaello Borghini (3:155) re-

cords the presence of these tapestries and twelve other hunting pieces at Poggio a Caiano in 1584.

Despite the emphasis placed by Vasari on the Italian character of Stradanus's style in the hunting scenes, this drawing and others in the series have a distinctly northern flavor. The dog seated with his back to us at center foreground brings to mind similar animals in Albrecht Dürer's *Saint Eustace* (Panofsky 1955, fig. 114). Similarly, the ibex perched on a dizzy outcrop of rock at the upper left corner of Stradanus's composition recalls the goat teetering in the background of Dürer's *Fall of Man* (Panofsky, 1955, fig. 117). The fantastic mountains and gorges in the background also have a strongly northern character, reminiscent of the landscapes of Joachim Patinir. Similarly, the shaggy foliage and creeping roots of the tree in the right foreground recall the primeval forests of Albrecht Altdorfer.

This drawing and three other early designs by Stradanus for Poggio a Caiano were published by Hieronymus Cock in 1570 (Hollstein n.d., 4:190, nos. 512–515). Inscribed *IOANNES. STRADANVS. INVENTOR. H. Cock. excud. 1570,* the print of *Hunting Ibex* includes the elaborate tapestry border and a brief explanatory text: *Formosus nigris villis, et tergore fulvo,/ Lata reclinantur cui cornua, Panos amicus/ Ibex, adversis canibus concurrere gaudet.* The central image in Cock's engraving measures 230 × 357 mm and is slightly smaller than the drawing.

Stradanus followed this suite with three still more ambitious series of hunting prints. In 1578 he commissioned two series, comprising a total of 144 images, from the Antwerp publisher Philip Galle (Hollstein n.d., 7:81, nos. 424–527 and nos. 528–567); the third and

final series, which contains sixteen engravings, was published by Hans Collaert (Hollstein n.d., 4:213, nos. 173–188). Drawings connected with these prints are preserved in numerous collections in Europe and North America (Kultzen 1970, passim; Florence, Palazzo Vecchio 1980, 78). A group of twenty-five preparatory drawings for the more extensive series published by Galle was sold at Sotheby's in Monaco on March 1, 1987 (Sotheby's 1987; *Print Quarterly* 1987, 57–58, figs. 60 and 61).

The subject matter of the tapestries at Poggio a Caiano reflects Cosimo de' Medici's love of hunting. The popularity of the prints engraved from Stradanus's designs makes it evident that hunting, fowling, and fishing were pursued with ferocious passion throughout sixteenth-century Europe, however (Florence, Palazzo Strozzi 1980, 213, no. 522). A morning spent studying Stradanus's hunting prints and the similar suites of etchings by Antonio Tempesta leaves one amazed that any creatures survived the systematic carnage.

G.S.

Jacopo Zucchi

Florence ca. 1540—Rome ca. 1596

43. *The Ascension of Christ with the Virgin, Saint Agnes, and Saint Helen*

Pen and brown ink and brown wash over traces of black chalk, framed in brown ink; 314 × 159 mm

ANNOTATIONS: at bottom center in ink, *Iacº del Zucchi;* at bottom margin, right of center, canceled annotation in ink, *Giorgio Vasari*

7292F

EXHIBITIONS: Florence 1950, no. 122; Florence 1963, no. 90, fig. 38; Florence, Palazzo Strozzi 1980, no. 552.

REFERENCES: Ferri 1890, 166; Baldini 1950–52, no. 122; Pillsbury 1974, 7.

Jacopo Zucchi was the pupil and assistant of Giorgio Vasari. In Florence he participated in the decoration of the Salone dei Cinquecento and the Studiolo of Francesco I in the Palazzo Vecchio, and, in 1567 and again in 1572, he accompanied Vasari to Rome to assist him in several projects in the Vatican. On his second visit to Rome, Zucchi became court painter to Cardinal Ferdinando de' Medici, for whom he decorated several rooms in the Villa Medici; he remained in Rome as artist-in-residence to the Medici until his death in about 1596 (on the question of Zucchi's birth and death dates, see Pillsbury 1974a, 434 n. 2).

The two-tiered composition and theatrical lighting of this *modello* for an *Ascension* clearly are derived from Raphael's *Transfiguration,* which Zucchi had surely seen on the high altar of San Pietro in Montorio in Rome (Dussler 1971, 53, pl. 111). Like Raphael, Zucchi achieves an extraordinary sense of drama in this drawing. In large part, this is the result of his liberal use of strong, dark washes, which contrast sharply with areas where the paper is left untouched. The upper half of the composition, in which Christ is depicted ascending toward heaven, "borne up by his own strength" (Schapiro 1943, 138), is illuminated by a light of dazzling brightness, whereas the earthly level, occupied by the Virgin, the apostles, Saint Agnes, and Saint Helen, is largely obscured by the darkness of night. The "unerasable last footprints of Christ" (Schapiro 1943, 141), impressed on the Mount of Olives, are picked out by the blaze of a secondary light source, however. The athletic figure of Christ, "raised by his own power" (Schapiro 1943, 138), and the agitated gestures of the apostles also contribute to the sense of heightened drama.

The drawing has not been connected with a painting by Zucchi himself. However, Pillsbury (1974, 7) associated it with an altarpiece with the same subject, executed by Giovan Battista Naldini for the church of Santa Maria del Carmine. Commissioned originally from Maso da San Friano, about 1564, and transferred to Naldini in 1576, five years after Maso's death in 1571, the altarpiece is presumed to have been destroyed in a disastrous fire in the church in 1771 (Cannon Brookes 1965, 195–196). Naldini's painting was described by Raffaello Borghini in *Il Riposo* (1:131), however. In addition, a good sense of the appearance of Maso's and Naldini's paintings is provided by an elaborate composition drawing and four figure studies, by Maso, in the Uffizi, and an oil *modello,* by Naldini, in the Ashmolean Museum (reproduced in Cannon Brookes 1965, figs. 31–36). As Pillsbury observed (1974, 7), some connection between this drawing and the paintings by Maso and Naldini is indicated by the inclusion in all three compositions of Saint Agnes and Saint Helen as anachronistic witnesses to the Ascension of Christ. Borghini (1:131) criticized Naldini's altarpiece on precisely this point, emphasizing that neither Saint Agnes nor Saint Helen was alive at the time of the Ascension; he also indicated, however, that the saints were included to satisfy the wishes of the patrons. The painting was commissioned by a certain Elena Ottonelli about 1571 for the Chapel of the Company of Saint Agnes at Santa Maria del Carmine (Cannon Brookes 1965, 195).

Naldini's *modello* and Zucchi's drawing are linked iconographically by their inclusion of the Virgin, a detail that also distinguishes them from Maso's composition. For this reason, it seems likely that Zucchi's *Ascension* is contemporaneous with the *modello* by Naldini, rather than with Maso's drawings, and may have been exe-

cuted in competition with it. Perhaps Elena Ottonelli preferred Naldini's composition because it gave equal emphasis to Saints Agnes and Helen. Zucchi, by contrast, gave prominence to Saint Agnes, the titular saint of the chapel.

In part because of the connection with the Santa Maria del Carmine altarpiece and in part for stylistic reasons, Pillsbury dated the *Ascension* about 1571, just before Zucchi's transfer to Rome in 1572. While the drawing belongs in Zucchi's Florentine period, it also looks forward to paintings executed in Rome during the next two decades. The two-tiered composition, dramatic treatment of light and dark, and particular mannerisms in the treatment of the faces and hands of figures reappear in the *Christ Appearing to Saints Helen, Jerome, Peter, and Paul* and the *Pentecost,* two paintings done by Zucchi for Santo Spirito in Sassia in Rome in the 1580s (Pillsbury 1974a, figs. 10, 12). In addition, the nocturnal lighting and the animated gestures of the shepherds in Zucchi's strikingly Correggiesque *Adoration of the Shepherds,* in the Biblioteca Ambrosiana in Milan (Pillsbury 1974, pl. 14), directly recall this *Ascension.*

G.S.

Carlo Portelli

Loro Ciuffenna, Val d'Arno, before 1510(?)—Florence 1574

44. *Alexander and the Family of Darius*

Pen and brown ink and pale brown washes, over traces of black chalk; 328 × 217 mm

ANNOTATION: illegible annotation or inscription at lower center in ink, partially obscured by Uffizi collection stamp

1482F

EXHIBITIONS: None.

REFERENCES: None.

Traditionally given to the Bolognese painter Orazio Sammacchini, this unpublished composition study was attributed to Carlo Portelli by Marcia Hall, who also connected it with the Studiolo of Francesco I (annotation on the mat). Philip Pouncey independently associated the drawing with Portelli, describing it as "Florentine, close to Carlo Portelli" (annotation on the mat). Michael Rinehart also connected the drawing with the Studiolo but attributed it to Jacopo Coppi (annotation on the mat). Coppi did contribute an oval panel representing *The Family of Darius before Alexander* to the decorative program of the Studiolo (Bucci 1965, fig. 35). Presumably this prompted Rinehart's suggestion.

In style and in certain motifs the drawing is clearly related to a number of studies traditionally attributed to Carlo Portelli, an eclectic artist whose works recall Rosso Fiorentino, Jacopo Pontormo, Francesco Salviati, Agnolo Bronzino, and Giorgio Vasari, among others (Freedberg 1979, 463–464). This drawing compares particularly well with a composition study in Berlin representing *Christ Expelling the Money Changers from the Temple* (Barocchi 1968, pl. CXXXVI, fig. 6 and Florence, Palazzo Strozzi 1980, no. 421). Figures with the same exaggerated gestures and pointed, birdlike noses, bulbous foreheads, and bulging cheeks appear in both drawings. Moreover, in the background of the Berlin drawing there is a figure kneeling in precisely the pose adopted by the supplicant in the left background of the present drawing. Elements in this drawing also appear in a composition study in the Uffizi, connected by Barocchi with an *Allegory of the Immaculate Conception* painted by Portelli after 1555 (Uffizi 7267F; Barocchi 1968, pl. CXXXV, fig. 4). The pinched features and prominent breasts of the women in that drawing are identical to those of the wife and daughters of Darius, as is the eccentric and stylized manner in which they are realized.

Apart from inevitable similarities arising from their common subject matter, there appears to be no essential connection between this drawing and Coppi's *Family of Darius before Alexander*. Indeed, the compositions differ in several significant details. For example, in Coppi's painting Alexander is shown mounted and unattended, whereas in the drawing he is portrayed dismounted but accompanied by a group of soldiers. Moreover, the secondary scenes in the backgrounds of the two compositions are quite different from each other, although it is difficult to determine precisely what their subjects are.

Although he did not paint the *Family of Darius before Alexander*, Portelli did participate in the decoration of the Studiolo of Francesco I. In a letter written to Vasari on April 6, 1571, Vincenzo Borghini severely criticized a panel done by Portelli for the Studiolo, describing it as "una tavoluccia per un boto" (Frey 1930, 2:578–579). Portelli's age was the reason for his incompetence, according to Borghini, who thought that work of the kind required for the Studiolo was best handled by young artists. Hendel Sarsini (1960, 99–102) attributed the *Triumph of Neptune and Amphitrite* in the Studiolo to Portelli, but Pace (1973, 32) maintained that it in fact is by Francesco Brina. Whatever the truth of that matter, Portelli's documented participation in the Studiolo makes it likely that this drawing was a preparatory study for a panel intended for that decorative program. Evidently the commission was diverted to Jacopo Coppi, perhaps as a result of misgivings expressed by Borghini in an earlier letter to Vasari dated November 25, 1570 (Frey 1930, 2:543).

G.S.

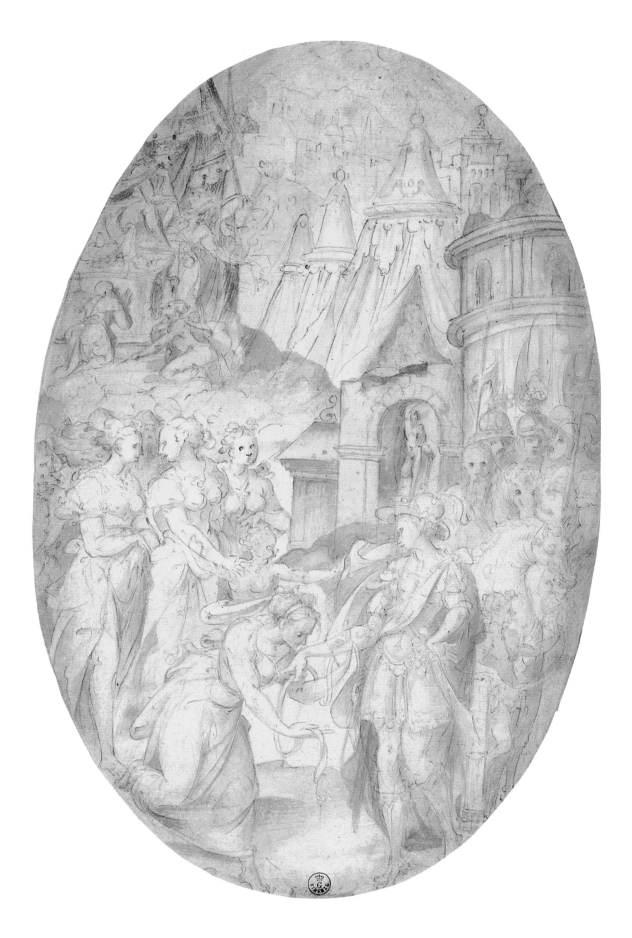

Bernardo Buontalenti

1531—Florence 1608

47. *Study of a Niche Containing a Statue, Surmounted by the Medici Coat of Arms*

Black chalk with brown washes; cut to the shape of the design; 373 × 194 mm

2484A

EXHIBITION: Florence 1968, no. 88.

REFERENCE: Ferri 1885, 101.

The original idea of constructing a funerary chapel at San Lorenzo for Cosimo I de' Medici and his family was due to Cosimo himself, who entrusted the project to Vasari around 1565 (for a concise history of the Cappella dei Principi, see Florence 1968, 91–94, no. 69). The project remained dormant during the reign of Francesco I but was taken up actively by Grand Duke Ferdinando in the early 1590s. In 1596 Don Giovanni de' Medici, Bernardo Buontalenti, Lodovico Cigoli, Giorgio Vasari the Younger, and others submitted models and presentation drawings for the Cappella dei Principi. Giovanni de' Medici and Buontalenti emerged as the principal contenders. Buontalenti executed a great many drawings for the details of the architecture, as Botto observed (Florence 1968, 107, no. 88), although Giovanni de' Medici's model for the Cappella dei Principi was definitively selected in August 1602.

One of a group of studies for the niches intended to contain a statue of the Madonna and Child and effigies of the grand dukes (see Florence 1968, nos. 81–83, figs. 61, 62), this dramatic drawing is particularly energetic and fanciful in its combination of figures, architectural elements, and decorative motifs. The niche is surmounted by a broken segmental pediment from which a Medici escutcheon rises. Michelangelesque figures flank the coat of arms, reclining on the tympanum. These elements in turn are framed and crowned by a gigantic fan shell. Buontalenti's novel use of traditional decorative motifs is especially evident in this last detail, as Botto pointed out (Florence 1968, 107, no. 88). Traditionally the fan shell had been contained within the pediment rather than expanding beyond it to form a grandiose theatrical backdrop.

The fact that Buontalenti combines the niche and the Medici escutcheon suggests that this drawing is earlier in the series of studies for the Cappella dei Principi than the following one (cat. no. 48). In the earlier projects Buontalenti appears to have combined the niches and coats of arms in the first story of the walls of the chapel (Florence 1968, no. 70, fig. 53). In contrast, later drawings enlarge the niches to fill the first story, and the coats of arms, also much enlarged, are moved into the second or attic story (Florence 1968, nos. 74, 75, 79, figs. 57–59).

Certain architectural elements in this drawing are reminiscent of Buontalenti's Porta delle Suppliche at the Uffizi, executed about 1580. Its impetuous, highly pictorial style also compares effectively with some early studies for that project (see Borsi 1974, figs. 203, 208).

G.S.

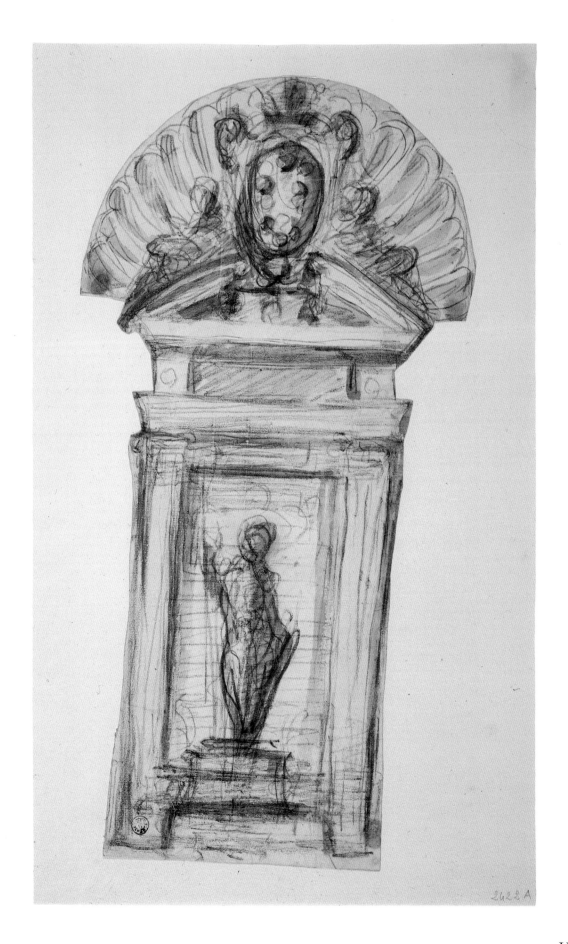

III

48. *Elevation of a Wall of the Cappella dei Principi with Two Lateral Arches*

Red chalk; 334 × 233 mm

ANNOTATION: at upper right in ink, *81*

2422A

EXHIBITION: Florence 1968, no. 74, fig. 58.

REFERENCES: Ferri 1885, 50; Giovannozzi 1933, 322 n. 1.

This spirited drawing is one of a series of studies executed by Buontalenti between 1596 and 1602 in connection with the Cappella dei Principi (see cat. no. 47). In it Buontalenti rapidly sketched the two-story elevation of one of the interior walls of the chapel, also indicating the lateral arches. At the first level columns flanked by pilasters frame a sarcophagus and a pedimented niche containing a hastily indicated figure. From the flurry of activity at the second level emerges a Medici escutcheon flanked by seated figures. On the lower left section of the sheet Buontalenti cursorily drew the profile of the wall.

Two closely related studies for the elevation of the walls of the Cappella dei Principi are also preserved in the Uffizi (Florence 1968, nos. 75, 79, figs. 57, 59).

G.S.

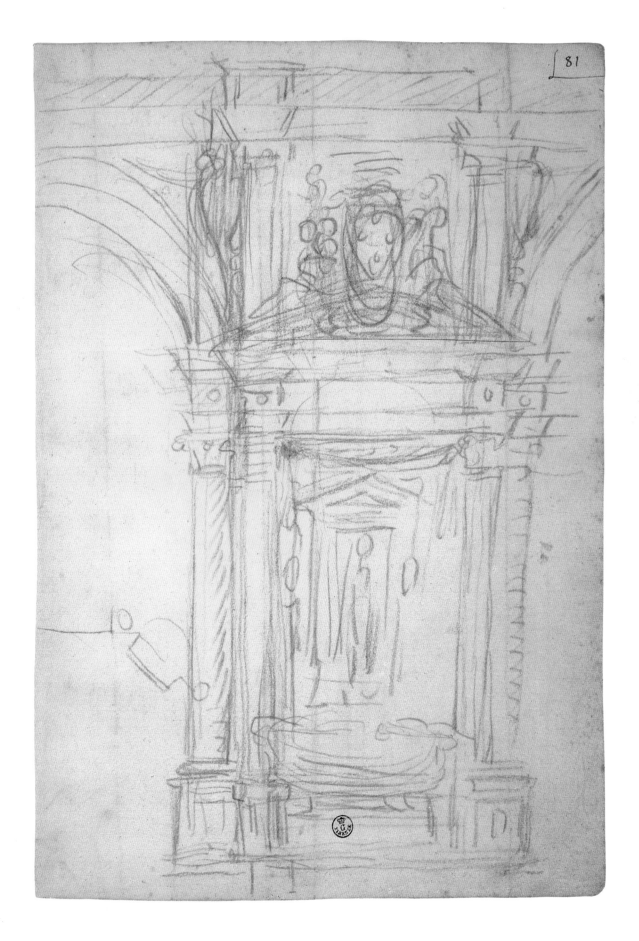

Alessandro Allori

1535 Florence 1607

49. *An Oval Cartouche Surrounded by Eight Nude Male Figures*

Black chalk, partially gone over in brown ink; 314 × 412 mm

ANNOTATIONS: on recto top right corner in pencil, *450;* bottom left corner in pencil, *561;* on verso in ink, in a seventeenth-century hand, *Ale padre Allorj*

450 Orn

EXHIBITIONS: None.

REFERENCE: Ferri 1890, 27.

This lively study for a decorative cartouche surrounded by male figures was listed by Ferri (1890, 27) among the drawings in the Uffizi traditionally attributed to Bronzino's pupil Alessandro Allori. The old attribution is correct, although a closely related study in the Ashmolean Museum is attributed to Francesco Salviati (Parker 1956, no. 684; the connection with the sheet in the Ashmolean Museum was made by Timothy Clifford in a handwritten note on the mat of the Uffizi drawing).

Between 1554 and 1559 Allori was in Rome, where he was very much influenced by Michelangelo's monumental nudes in the *Last Judgment* in the Sistine Chapel and by antique sculpture. Allori's admiration for Michelangelo is evident in this drawing. The standing lateral figures are derived from the *Last Judgment*, while the recumbent figures bring to mind the Times of Day or the River Gods for the New Sacristy at San Lorenzo.

Allori's Michelangelism was most exaggerated in the decorations of the Montauto Chapel in the Santissima Annunziata and in the *Descent from the Cross* in Santa Croce, paintings executed in Florence circa 1559–60, immediately after his return from Rome (for the Montauto Chapel see Venturi 1933, figs. 51, 52 and Pouncey 1977a, fig. 407; the Santa Croce altarpiece see Hall 1979, fig. 89). The exaggerated monumentality and Michelangelism of the figures in this drawing link it in a general way to the Montauto Chapel decorations and to the *Descent from the Cross.* Moreover, the lateral standing figures in this drawing are also very similar to the figures on ladders on either side of Christ in the *Descent from the Cross* and to the preparatory drawings for those figures (Hall 1979, fig. 89; Florence 1970, figs. 6, 7). In addition, an oval frame with masks is employed by Allori at the center of the vault of the Montauto Chapel (Pouncey 1977a, fig. 407).

On the other hand, the overall composition of this drawing is strikingly reminiscent of Pontormo's early Michelangelesque design for the *Vertumnus and Pomona* lunette at Poggio a Caiano (Uffizi 454F; Cox-Rearick 1964 and 1981, 1:177–178, no. 131 and 2: fig. 123). Since Allori himself completed the decoration of the great *salone* between June 1579 and September 1582, it is tempting to connect this drawing with that commission. In fact, the vertical oval cartouches containing *Virtus* and *Gloria,* on the end walls (Bardazzi and Castellani 1981, 2: pls. 553 and 569; also Cox-Rearick 1984, figs. 36 and 68), are decorated with masks and flanked by children in a manner that recalls this drawing. The child to the left of the frame containing *Virtus* is a mirror image of the figure seen here from behind on the right.

As a display of the male nude in a variety of complex poses, this drawing also brings to mind Allori's *Fishing for Pearls,* painted between 1570 and 1571 for the Studiolo of Francesco I (Venturi 1933, fig. 53). A variant on the right lateral figure in this drawing appears at the center of the painting.

The rather rough exploratory use of the chalk in this drawing can be compared with studies connected with the Montauto Chapel and the Santa Croce *Descent from the Cross* (Florence 1970, nos. 4, 7, figs. 4, 7). On the other hand, Allori also employs a similar drawing style in studies connected with his paintings for the Studiolo and the Poggio a Caiano decorations (see, for example, Florence 1970, no. 22, fig. 15). The handling of pen and chalk and the particular treatment of the anatomy of the nudes in this drawing compare well with the personification of the Nile and the sword-bearing soldier in Allori's *modello* for the *Banquet of Anthony and Cleopatra* for the Studiolo in the Courtauld Institute Galleries (Monbeig-Goguel 1971, pl. XXXVI). On balance, the relationships to the Studiolo and Poggio a Caiano seem stronger than those to the earlier works, and so I am inclined to date this drawing in the 1570s. It is possible that it has some relation to an early project for the treatment of the lunettes on the end walls of the Studiolo, as represented in a drawing by Vasari in the Musée des Beaux-Arts in Dijon (Rinehart 1964, 74–76, fig. 31; Monbeig-Goguel 1971, pl. XXIV). Alternatively, it may be connected with Allori's allegorical decorations on the end walls of the *salone* at Poggio a Caiano.

G.S.

115

50. *Christ before Caiaphas*

Black chalk, partially gone over in dark brown ink; 426 × 314 mm

18481F

EXHIBITIONS: None.

REFERENCE: Giglioli 1923.

The attribution of this vigorous composition study to Alessandro Allori is due to Giglioli (1923, 499), as is the identification of the subject as Christ before Caiaphas.

Christ's appearance before Caiaphas, following his arrest in the Garden of Gethsemane, is described in all four Gospels (Matthew 26:57–75; Mark 14:53–72; Luke 22:54–71; John 18:12–27). Allori depicts Christ at right center, standing before Caiaphas, who is seated at the left. Christ is bound but raises his right hand in a gesture indicating speech, thereby establishing that this is the moment when Christ acknowledged that he was the Son of God. Caiaphas flings out his arms in a gesture of astonishment and indignation at Christ's statement. The fact that Caiaphas is shown only partially clothed corresponds to the Gospel texts, which state that he tore his clothes to show his indignation at Christ's blasphemy. In the right background of the composition, at an upper level, Allori quickly sketched another scene, presumably a subsequent episode in the Passion cycle. From the general indications given, we might guess that it represents the Flagellation of Christ or the Ecce Homo. Another small figure is drawn at the top of the stairs, outside the room containing the scene just mentioned. An episode often associated with both the Flagellation of Christ and Christ before Caiaphas is the Denial of Peter. It may be that Allori also intended to include that episode as a subsidiary scene within the larger composition.

The entire composition is enclosed within a frame drawn with a rule but decorated freehand with scrolls and volutes. Outside the frame are several rapid thumbnail sketches executed in chalk. Two of those represent the figure of Christ; that to the right of the frame is quite detailed, despite its miniature scale, and explores the idea of showing Christ with both hands held slightly higher. On the verso there is a cursory sketch in black chalk for Christ and Caiaphas with a spectator kneeling between them. This group reverses the composition on the recto.

The drawing has not been connected with a painting by Allori. However, the composition and treatment of space, with the inclusion of subsidiary scenes in an elaborate architectural interior, have a great deal in common with Allori's *Christ and the Adulteress* of 1577, on the Cini Altar in Santo Spirito (reproduced in Venturi 1933, fig. 55). Moreover, the features, gesture, stance, and draperies of Christ in this drawing are strikingly similar to those of his counterpart in the Santo Spirito altarpiece. The *Christ before Caiaphas* also resembles, although less closely, Allori's *Christ and the Samaritan Woman* of 1575, on the Bracci Altar in Santa Maria Novella (Hall 1979, fig. 90). Finally, the agitated pose of Caiaphas brings to mind Perino del Vaga's cartoon for the *Martyrdom of the Ten Thousand*, for the Convent of the Compagnia dei Martiri at Camaldoli, a work that Allori certainly had in mind when he painted his own *Martyrdom of the Ten Thousand* for the Pitti Altar in Santo Spirito, between 1568 and 1575 (Hall 1979, 78 n. 55; Barsanti and Lecchini Giovannoni 1977, 448–450, 452; Allori's altarpiece and Perino's drawing in the Albertina are both reproduced in Barsanti and Lecchini Giovannoni, figs. 411, 412). The drawing style of the *Christ before Caiaphas* is also consistent with drawings associated with the altarpieces just mentioned, particularly a sheet in the Uffizi for the *Christ and the Samaritan Woman*, published by Giglioli (1923, 449, ill. on 503).

In view of these various relationships, it seems reasonable to believe that this drawing is a design for an altarpiece projected by Allori in the 1570s.

G.S.

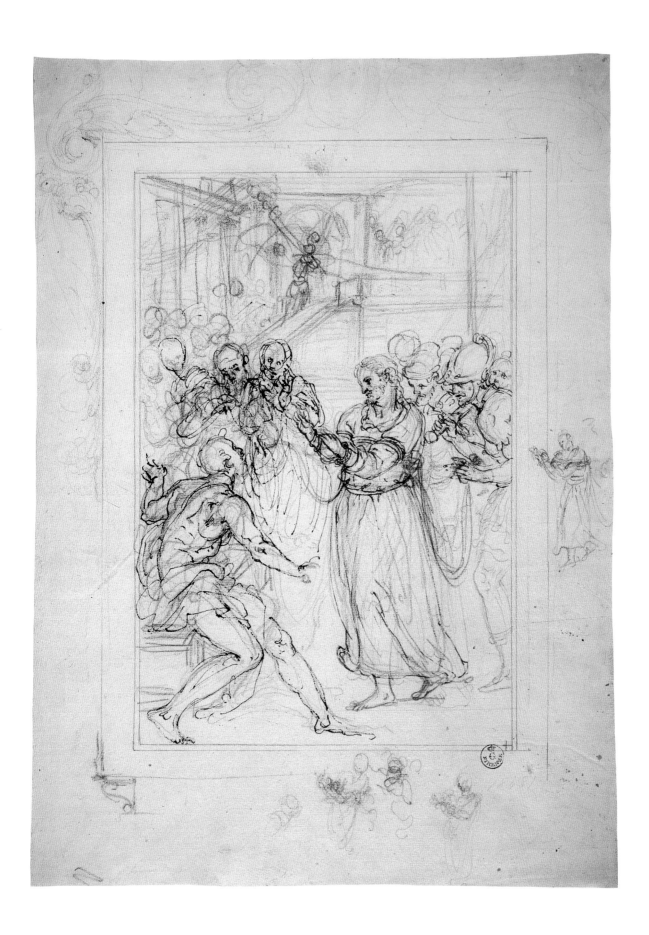

117

51. *A Genuflecting Skeleton*

Black chalk with traces of wash; 417 × 279 mm

ANNOTATION: on verso in black chalk, *47* (canceled) and below, *35*

6710F

EXHIBITIONS: Florence 1963, no. 52, fig. 40; Florence 1970, no. 15; Florence, Palazzo Medici Riccardi 1980, no. 8.3; Florence 1984, no. 24, fig. 31.

REFERENCES: Berenson 1903, 2: no. 2193; Clapp 1914, 250; Berenson 1938, 2: no. 2193; Nicco Fasola 1947, 40, fig. 20; Berenson 1961, 2: no. 2193; Cox-Rearick 1964, 1:385, no. A140; Wittkower 1964, 162, fig. 18; Amerson 1977, 26, fig. 23; Cox-Rearick 1970, 368–369, no. 176a, pl. 7a; Cox-Rearick 1981, 1:357–4, no. 176a.

The current attribution of this macabre study, traditionally given to Jacopo Pontormo, and three closely related drawings on identical paper, also in the Uffizi, is due to Forlani (Florence 1963, 46–47, no. 52; for the related drawings [6700F, 6709F, and 6711F] see Florence 1984, figs. 29, 30, 32; all four drawings are done on paper with a watermark representing a crossbow surmounted by a lily, inscribed in a circle [similar to Briquet 1907, 3: nos. 760–762]). Forlani's attribution has been accepted and supported by subsequent scholars, including Cox-Rearick (1964 and 1981, 1:A132, A139–141), Wittkower (1964, 162, fig. 16), Lecchini Giovannoni (Florence 1970, no. 15; Florence 1984, no. 24, fig. 31), and Petrioli Tofani (Florence, Palazzo Medici Riccardi 1980, no. 8.3). This drawing is identical to the others in the group in character and handling. It is, however, the only one in the group to show pentimenti; it is evident that Allori considered drawing the left leg of the skeleton slightly to the left of its present position.

The traditional attribution to Pontormo presumably was suggested by the presence of an annotation, *di jacopo,* on one of the sheets (6709F) and by the existence of several anatomical studies by or attributed to Pontormo (Cox-Rearick 1981, 1: nos. 176a, A61, A65, A147; Florence 1984, nos. 6–9, figs. 8–10). A sheet of four studies of the bones and shoulder of a left arm (Uffizi 6522F; Cox-Rearick 1970, no. 176a, pl. 7a; Florence 1984, no. 7, fig. 9), the only drawing in the group to be universally accepted as being by Pontormo, is in fact quite different in character and in handling from this drawing. Executed broadly in red chalk applied with great variety of pressure, Uffizi 6522F is highly pictorial in character. By contrast, this drawing, executed in black chalk with a rather uniform strength

of line, is at once more literal and descriptive but much less dashing than the studies by Pontormo (despite the gallant pose of the skeleton here). The even contour lines and fastidious, slightly dry treatment of light and shade in this drawing are characteristic of mid-sixteenth-century Florentine draftmanship, as Lecchini Giovannoni observed (Florence 1970, 26, no. 15), and Forlani's attribution to Allori is entirely convincing on the grounds of drawing style. This drawing and its companions are also quite different in character from Pontormo's sheet of studies in representing complete, animated skeletons in action.

The attribution to Allori is further supported by a relationship between the four drawings in the Uffizi and anatomical studies depicted in a book represented in a painting by Allori of *Christ between Saints Cosmas and Damian,* datable circa 1559–60 in the Royal Museum in Brussels (Florence 1963, 46, no. 50; the relevant detail is illustrated in Ragghianti 1972, fig. 64, and discussed on 81–82 n. 29).

Wittkower (1964, 118, 162, nn. to figs. 16 and 17) related the four skeletons in a general way to figures of Death executed by Allori in San Lorenzo for the funerary celebrations in honor of Michelangelo on July 14, 1564. Petrioli Tofani referred to Wittkower's suggestion, emphasizing its hypothetical nature, and introduced a drawing by Maso da San Friano depicting three animated skeletons, one of which is similar to those by Allori (Florence, Palazzo Medici Riccardi 1980, 388, no. 8.3 and no. 8.5, ill. on 387). As described in the *Esequie del divino Michelangelo* (Wittkower 1964, 118–121), the painted figures of Death were associated with attributes and devices and appear to have had no obvious connection with the rather courtly posturing of

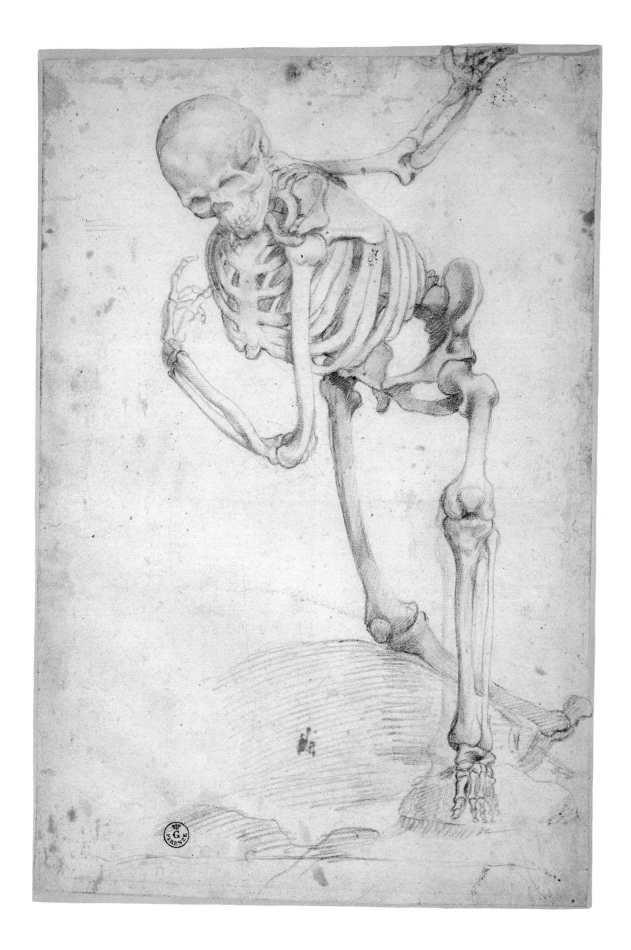

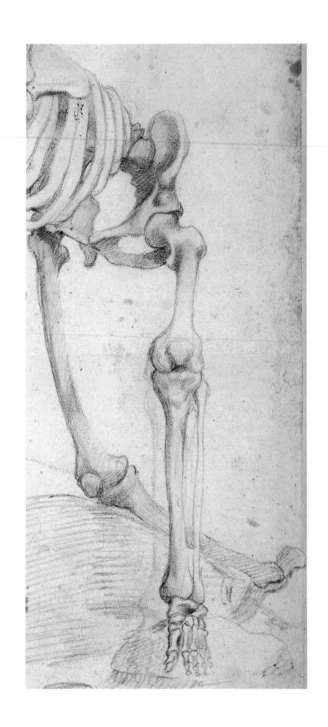

the skeletons in this series. Allori appears to have made something of a specialty of macabre figures of this kind, however, contributing a series of skeletons to the funeral decorations for Cosimo I in May 1574 (Borsook 1965, 40).

Regardless of any relationship to funerary decorations, Allori's skeletons have a place in the tradition of animated or narrative anatomies associated with the work of Rosso Fiorentino, in designs such as the famous *Skeletons* (Carroll 1976, 1:195–201, D.6 and 2: fig. 15; Florence, Palazzo Strozzi 1980, no. 609) and the so-called *Fury* (Carroll 1976, 1:74–80 and 2: fig. 33; Florence, Palazzo Strozzi 1980, no. 610). A drawing in the National Gallery of Scotland in Edinburgh, which was attributed to Rosso by Berenson (1903; 2:2428; also see Ragghianti Collobi 1974, 1:117–118 and 2: figs. 369–370) and which appears related both to Rosso's anatomical studies and to Allori's skeletons, has been associated with Allori by Andrews (1968, 1:110 and 2: figs. 751, 752).

In addition, Lecchini Giovannoni convincingly suggests that Allori's skeletons should be associated with illustrations for anatomical treatises, such as those of Vesalius (Florence 1984, 82–83). This proposal would seem to be supported by the presence of the book with anatomical studies in Allori's painting in Brussels.

G.S.

Alessandro Allori

52. *A Man Lying Face downwards and Other Related Studies*

Black chalk; 290 × 469 mm

ANNOTATION: on verso at center in brown ink in a seventeenth-century hand, *Aless'ndro Allori;* in black chalk in a sixteenth-century hand, *60*

10279F

EXHIBITION: Florence 1970, no. 54.

REFERENCES: None.

This beautiful and highly finished figure study has been identified by Lecchini Giovannoni (Florence 1970, 45, no. 54) as a preparatory drawing for a Saint Benedict as he is represented in two paintings of the *Temptation of Saint Benedict* by Allori, one in the Weingall Collection in Baltimore and the other in the Putt Collection in London. In the version in Baltimore the pose of Saint Benedict is a combination of the principal study on this sheet with the study of the head and left arm at top center of the sheet. According to Lecchini Giovannoni, the *Temptation of Saint Benedict* should be dated in the second half of the 1590s.

It is possible, however, that the sheet of studies was executed in connection with an earlier painting by Allori, his *Christ in Limbo* in the Salviati Chapel in San Marco, Florence, executed between 1584 and 1588 (Hall 1979, fig. 96). In that painting the pose of the devil, trampled under foot by Christ, appears to be a composite of the principal study on the present sheet and the two detail studies for the head and left arm. The devil's head is turned toward the spectator, as in the detail study at top center; the position of his left arm is as in the detail study at top right; and the position and lighting of the right arm and shoulder appear as in the principal study.

The way in which several studies and reprises are combined on the one sheet appears to be typical of Allori, as is the experimentation with alternative poses (see, for example, Uffizi 10299F, 10239F, 737F; Florence 1970, nos. 56, 73, 74, figs. 27, 40, 32). Allori adjusts the position of the model's left arm in two separate studies, and in one of those, turns the head of the model toward the spectator; he also studies in detail

the left leg and foot of the figure, removing the model's hose for this purpose. There are also several pentimenti evident in the area of the feet of the principal figure and in the position of the left arm in the detail study at top right. Also on the sheet, at the lower right, is a quick study of the head of a rather Pontormesque child.

Although this drawing is a study from life, the complication of pose and the polish of the drawing style associate it with Late Mannerism and with certain paintings and drawings by Allori's master, Agnolo Bronzino. Similarly complex figures appear, for example, in Bronzino's monumental *Resurrection,* in the Santissima Annunziata, and in the tiny *Allegory of Public Happiness,* in the Uffizi (Baccheschi 1973, nos. 95, 123; both reproduced in color in McCorquodale 1981, pls. XII, XVI). By contrast, many of Allori's drawings from the 1590s show a naturalism that associates him with the new realism of the Early Baroque in Florence. For these reasons, the style of this drawing would seem consistent with a dating in the early 1580s, in relation to the *Christ in Limbo.*

It is worth remembering that one of Bronzino's earliest independent paintings, a lunette in the cloister of the Badia in Florence (Baccheschi 1973, 3; McCorquodale 1981, fig. 8), represents the temptation of Saint Benedict, depicting the saint rolling in a thicket of briars and nettles to exorcize his erotic memories of a beautiful young Roman woman. There is perhaps a faint echo of Bronzino's Saint Benedict in Allori's figure. This would account for Allori's using the figure again in his paintings of the *Temptation of Saint Benedict.*

G.S.

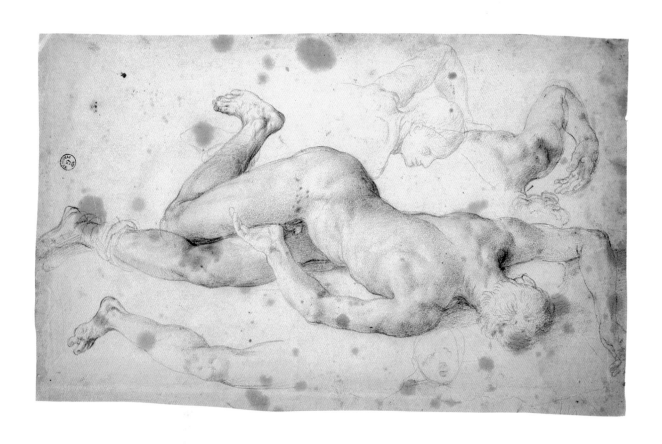

Girolamo Macchietti

ca. 1535 Florence 1592

53. *Study for a Dead Christ*

Red chalk on rose-tinted paper, with faint touches of white heightening; 255 × 193 mm

ANNOTATION: lower left corner in ink, *san machino*

12182F

EXHIBITIONS: None.

REFERENCES: Pace 1973a, 81 n. 45; Hall 1979, 74, 136, pl. 80.

Like Jacopo Zucchi and Francesco Morandini, Girolamo Macchietti was the pupil and assistant of Giorgio Vasari. After studying in Rome for two years, Macchietti returned to Florence in 1564; there he collaborated with Mirabello Cavalori on a painting for the funerary decorations in honor of Michelangelo. Macchietti was one of the artists gathered by Vasari to decorate the Studiolo of Francesco I between 1571 and 1572; he also participated in Vasari's renovation projects at Santa Maria Novella and Santa Croce, executing a *Martyrdom of Saint Lawrence* for the former in 1573 and a *Trinity* for the latter in 1575 (for a summary of Macchietti's career, see Florence, Palazzo Strozzi 1980, 136–137).

This moving drawing is a study for the Christ in the *Trinity*, painted by Macchietti for the Risaliti Chapel in Santa Croce (Hall 1979, 74, 136).

In the painting, the dead Christ was supported by God the Father, whose hands and right arm are indicated in the drawing. Macchietti's *Trinity* was removed from the Risaliti Chapel in 1592 and was replaced by an altarpiece with the same subject by Lodovico Cigoli (Hall 1979, pl. 81). Macchietti's painting is now lost, but its appearance is recorded by a drawing of the Risaliti Chapel preserved in the Uffizi (1647A; published by Sinibaldi 1963, 89–93, fig. 1; also reproduced in Hall 1979, pl. 79). If this drawing is accurate, it appears that Macchietti altered the position of the right hand of God the Father in the altarpiece. In the present

drawing God's hand passes under Christ's right arm, and his fingertips barely touch Christ's chest. The result is an image of great beauty and delicacy, in which the softly modeled body of Christ seems gently caressed by the disembodied hands of God, rather than physically supported by them. In the painting the relationship is more mundane, with God the Father seeming to prop up Christ's right arm.

Formerly attributed to the Bolognese painter Orazio Sammacchini, this drawing was first recognized as by Macchietti by Hall (Pace 1973a, 81 n. 45; Hall 1979, 74, 136). It is in fact characteristic of Macchietti's carefully modeled figure studies done in red chalk on tinted paper. A number of very similar figure drawings are known for the *Baths of Pozzuoli*, one of the two panels done by Macchietti for the Studiolo of Francesco I (see, for example, Marcucci 1955, figs. 5–8; Pouncey 1962, figs. 1, 2, 4; Monbeig-Goguel 1971, pl. XXXII; Monbeig-Goguel 1972, nos. 35–37, figs. 35–37; Florence, Palazzo Strozzi 1980, 137, no. 288, fig. 288).

Macchietti's move toward a new naturalism, very different from the extreme artificiality of High Mannerism, is apparent in this drawing. It appears that it was also evident in the finished painting, since, in 1584, Raffaello Borghini severely criticized Macchietti for making the dead Christ appear too lifelike (Borghini 1:127–128, 219–220).

G.S.

124

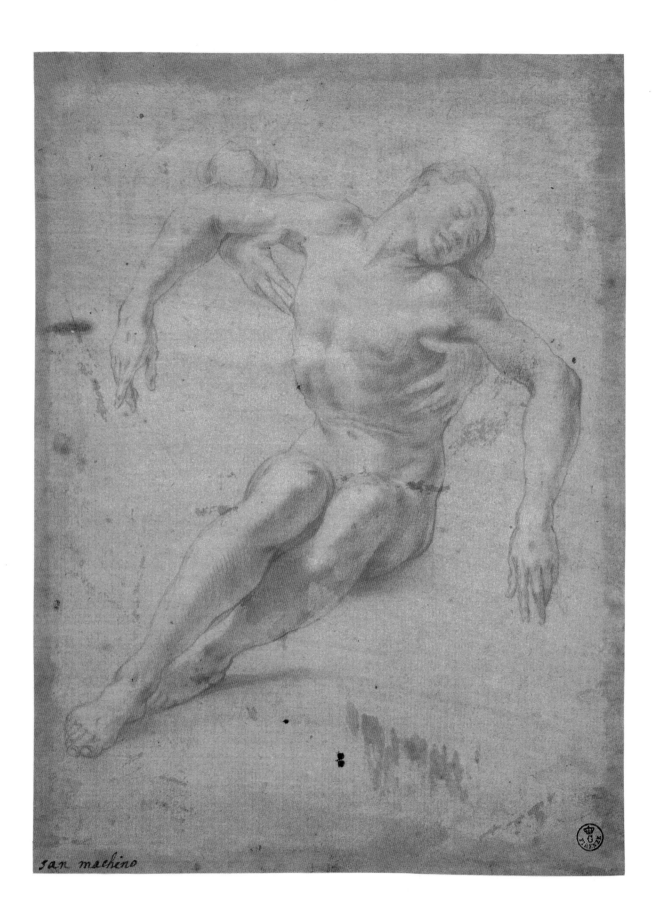

san machino

54. *Self-Portrait*

Black and red chalk; 255 × 122 mm

ANNOTATIONS: along lower edge in ink, *Ritt.*^{to} *di Girolamo Macchietti man [illegible] suoi;* at lower left corner in pencil, *1019;* at top right corner in pencil, *1088*

1088F

EXHIBITIONS: Florence 1911, 32.

REFERENCES: Marcucci 1955, 131, fig. 15 (incorrectly identified as 1088S); Thiem 1977, 10 (incorrectly identified as 1088S); Hall 1979, 97, pl. 77; Florence, Palazzo Strozzi 1980, 137, no. 290.

That this is a self-portrait by Girolamo Macchietti is indicated by the old annotation and by the character of the drawing, in which the subject steadily meets our gaze—as would inevitably be the case if he were scrutinizing himself in the mirror. The identification as Macchietti is confirmed by the resemblance of this drawing to another self-portrait, inserted by Macchietti into his *Martyrdom of Saint Lawrence,* painted for the Giuochi Chapel in Santa Maria Novella in 1573 (Hall 1979, 95–97, pl. 76). The presence of that self-portrait was commented upon by Raffaello Borghini, in *Il Riposo,* already in 1584 (Borghini 1:113–114). Macchietti appears to be older in the drawing than in the *Martyrdom of Saint Lawrence,* however.

A young man with similar features and identical eyes, but with long, wavy hair, is portrayed in a drawing, executed in black and red chalk on blue paper, preserved in the Wallraf-Richartz-Museum in Cologne. Formerly given to Bernardino Poccetti, this sheet was attributed to Macchietti by Thiem, who also suggested that the man portrayed was Macchietti himself (1977, 10, pl. III; also reproduced in Florence, Palazzo Strozzi 1980, fig. 290). This drawing is similar in style and medium to a preparatory study, in the Musée des Beaux-Arts at Lille, for the dwarf, child, and dog in Macchietti's *Martyrdom of Saint Lawrence* (Thiem 1977, pl. IV) and appears to be nearly contemporaraneous with it, if slightly earlier.

As Marcucci (1955, 131) and Hall (1979, 97) ob-served, Macchietti's *Self-Portrait* closely resembles the black and red chalk portrait studies of Federico Zuccaro. Zuccaro was resident in Florence between 1575 and 1579, when he completed the decoration of the interior of the dome of the cathedral of Florence, left unfinished by Vasari on his death in 1574, and, as a member of the Accademia del Disegno, he exerted considerable influence on Florentine art during this period (Heikamp 1967, 44–47). In fact, Macchietti's *Self-Portrait* is remarkably similar to a group of portrait studies done in Florence by Zuccaro in connection with the third zone of the west segment of the cupola (examples of these drawings are preserved in the British Museum, the Ecole des Beaux-Arts, and the National Gallery of Scotland [reproduced in Turner 1986, no. 170; Heikamp 1967, figs. 37a and 37b; and Andrews 1968, fig. 872, respectively]). The relationship is so striking that it appears likely that Macchietti had first-hand knowledge of Zuccaro's drawings and that his *Self-Portrait* was intended to emulate them. In any case, it is reasonable to date this drawing between 1575 and 1579, during the period of Zuccaro's residence in Florence. This means that the drawing might be separated from the self-portrait in the *Martyrdom of Saint Lawrence* and the Wallraf-Richartz-Museum drawing by as much as six years, sufficient time to account for the apparent differences in the age of the subjects.

G.S.

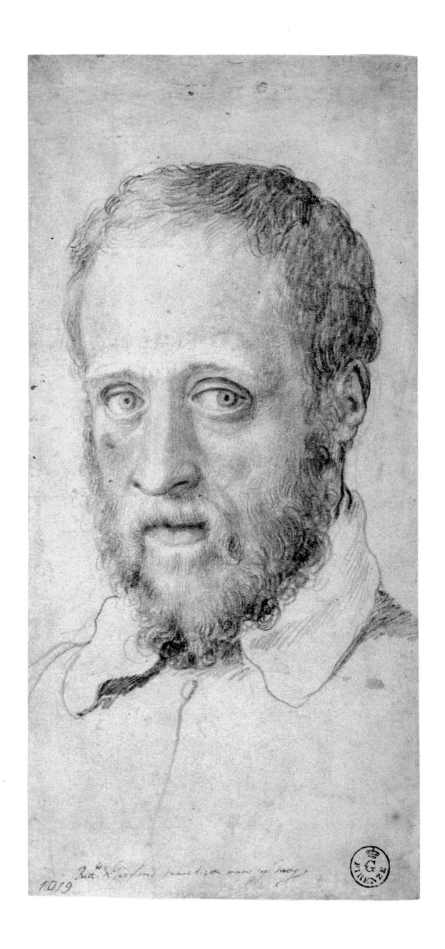

127

Giovan Battista Naldini

Fiesole ca. 1537—Florence 1591

55. *Allegory of the Immaculate Conception*

Black chalk and pen and dark brown ink; 325 × 233 mm

15519F

EXHIBITIONS: Florence 1963, no. 82; Florence 1964, no. 88.

REFERENCES: Forlani 1963, 64–65, no. 82; Florence 1964, no. 88; Barocchi 1964, 124; Barocchi 1964a, 285 n. 6; Barocchi 1964b, 59, 117; Barocchi 1965, 8, 31, n. 70.

Born in Fiesole around 1537—the date can be approximated by a statement made by Raffaello Borghini in about 1584 when he was writing *Il Riposo,* that Giovan Battista was forty-seven years old—Naldini spent a large part of his youth at Pontormo's side; he is mentioned often in Pontormo's *Diary,* especially between 1555 and 1556 (Cecchi, 1956, passim). From the recriminatory tone of some of the passages it seems that their relationship was not always completely smooth and serene. While professionally the pupil's admiration for his master was unbounded and the basic characteristics of his style throughout his career reflected Pontormo's teaching, in terms of their personal relationship the case was very different. Problems of communication between the difficult and irascible Pontormo and his simple, easygoing young apprentice were inevitable, as Vasari, who was an eyewitness, reports: "However, in his last years, [Pontormo] adopted Battista Naldini, a youth of good intelligence, who took as much care of Jacopo as the latter would permit. Under Jacopo he made considerable progress in design, and excited the highest expectations" (Vasari/Gaunt 3:254–255; see also Baldinucci 3:511).

It may be that these problems led the young Naldini to look for other sources of inspiration and to find the most important of them in the example of Andrea del Sarto, whose work was also of the highest quality but more "normal" and less upsetting than that of Pontormo. A number of surviving drawings (Petrioli Tofani 1987, passim) show that Naldini attentively copied Sarto's most famous works, especially the frescoes in the Chiostro dello Scalzo in Florence.

Naldini's artistic education was completed in Rome, where he went in 1560 on a study tour that is documented by a sketchbook containing copies of ancient works and of works by Raphael and his circle. This sketchbook has since been dismantled and its drawings are dispersed throughout a number of collections, with the greatest number of the surviving pages being held in Christ Church at Oxford (see Byam Shaw 1976).

The drawing exhibited here shows evidence of these influences from Naldini's past. In the Uffizi collection it was catalogued among the sixteenth-century anonymous works until P. N. Ferri attributed it to Naldini in a handwritten note on its inventory card. In the absence of any documentary reference, Forlani (Florence 1963, 65) proposed a very plausible date in the early 1560s, just after the artist's return from Rome. The strong lines and occasionally harsh handling of the pen, which define the relationships between light and shade by insistent parallel lines and strong contrasts, are quite similar to the style of the Roman sketchbook, while the tangle of bodies in the lower part of the picture and the dramatic tension created by the shocked, vacant expression on some of the faces are evident quotations from late works of Pontormo, particularly the lost frescoes for San Lorenzo. Conversely, the structure of the allegorical scene—evidently inspired by such Sarto compositions as the two large *Assumptions* or the Poppi altarpiece now in the Palazzo Pitti and closely related to Vasarian versions of the same subject in drawings in the Uffizi (1179E, 1181E, 1183E), Louvre (2082, 2083, 2197), Chatsworth (645), and Kupferstich Kabinett, Frankfort (4454)—denotes a balance in the distribution of its components and in the realization of their plastic and dynamic relationships that made it a good model for artists of the Counter Reformation.

On the verso of the sheet is a highly detailed study in black and white chalk of a foot wearing an elaborately styled sandal; it is very probably related to a painting that has not yet been identified.

A.M.P.T.

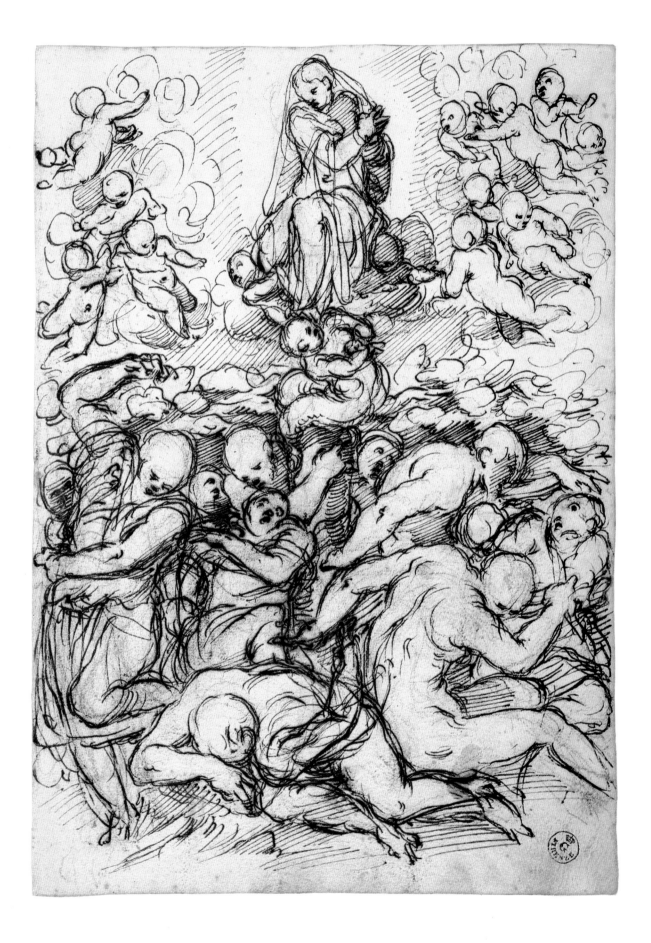

129

56. *A Seated Gentleman and Studies of Hands*

Black, red, and white chalk; 260 × 414 mm

ANNOTATION: on verso in an antique hand, *L. Cigoli*

857F

EXHIBITION: Florence 1940, 209, no. 4B.

REFERENCE: Florence 1940, 209, no. 4B.

As is indicated by the annotation on the verso, which probably dates from the eighteenth century, this fine drawing was attributed in the past to Lodovico Cigoli. Ferri catalogued it under Bernardino Poccetti in the last century, and in 1940 it was exhibited under this name in the Tuscan cinquecento show at Palazzo Strozzi. In 1968 Anna Forlani Tempesti returned it to Naldini (note in curatorial files).

Although it has not yet been possible to identify a painting among the artist's works that exactly utilizes this study, the characteristics of its style are typically and unmistakably Naldini's.

In an attempt to place this drawing chronologically within the artist's career, it seems that its special richness of chromatic shading—giving a smooth, even surface similar to that found in drawings by his contemporary Federico Barocci—can best be compared with sheets from the late 1560s, such as Uffizi 7450F. The latter drawing was most likely executed during Naldini's well-documented stay in Pisa in 1567 (Pillsbury 1976, 144 n. 67) and shows on the recto a copy of

Beccafumi's *Saint Matthew in the Cathedral* done in a style almost identical with that of this drawing.

The secular nature of the figure, who could be a prince or a court dignitary, indicates that it was meant for a historical painting or a dynastic celebration. It could be preparatory for one of the paintings decorating the temporary sets made for official ceremonies. It is documented that Naldini contributed to the sets for Prince Alberico's wedding to Isabella di Capua in Massa, for Michelangelo's funeral in 1564 in San Lorenzo, for Francesco de' Medici's wedding to Giovanna of Austria in 1565, and for Ferdinando I's wedding to Christine of Lorraine in 1589. The drawing could also relate to a painting in the Salone dei Cinquecento in Palazzo Vecchio, where Naldini was called to work with Vasari during the 1560s. Comparison of this drawing's style with Uffizi 1546S is particularly helpful, as the latter is preparatory for a group of figures for a scene on the walls of the *salone*, showing the Emperor Maximilian lifting the Siege of Livorno.

A.M.P.T.

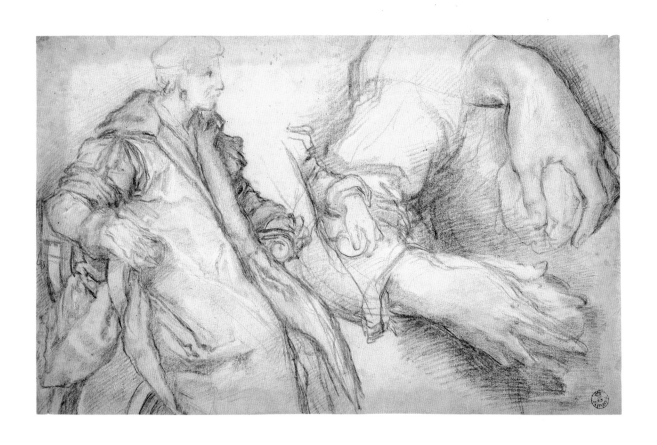

57. *Deposition from the Cross*

Black chalk, gray wash, and some traces of pen; 346 × 240 mm

ANNOTATIONS: at upper right in pen in an antique hand, 249, and at lower right, *Stradano;* at lower left in pen, 7.; on verso in pen, in an antique hand, *naldino o vasari*

5127S

EXHIBITIONS: None.

REFERENCES: Santarelli 1870, 363, no. 7; Forlani Tempesti 1968, 299.

Although the antique handwriting on the verso correctly notes that this drawing belongs to the circle of Vasari and Naldini, it was catalogued under Stradanus in Emilio Santarelli's collection, and it came to the Uffizi in 1867 under that name. Its attribution to Naldini, recognized by C. H. Smyth in a handwritten note on the mount, was accepted later by Forlani Tempesti without further comment.

Although the composition has no direct relationship with any of Naldini's known paintings, stylistically it shows similarities to other versions of the same subject that can be dated, more or less precisely, in the 1570s: the altarpiece from 1570–71 in Santa Maria Novella; a smaller painting in the Molinari Pradelli Collection (see Florence, Palazzo Strozzi 1980, 150, no. 323); drawing number 27213 in the Albertina (see Barocchi 1964, 126–127, fig. 9; as Poppi); and another in the Bertini collection in Prato (Petrioli Tofani 1982, 84, ill. 39).

A date in the 1570s is suggested also by an analysis of the drawing style, which with its rapid, often short lines interrupted by sharp angles and mobile play of light, emphasized here by a brilliant use of wash, is quite similar to studies for the *Presentation in the Temple* in Santa Maria Novella of 1577, to cite just one example. Further comparisons can be made with a composition sketch auctioned by Sotheby's in London on June 30, 1986 (lot 145); single figure studies in the Uffizi (715F, 7447F, 7451F, 7477F, 7501F, 7509F, 7535F, 9053F, 758S); in the British Museum (1893.7.31.16; see Turner 1986, 211, no. 160); and in the Musée Bonnat in Bayonne (147; see Bean 1960, no. 78). In all these drawings we find characteristics of style that are almost identical with this drawing.

A.M.P.T.

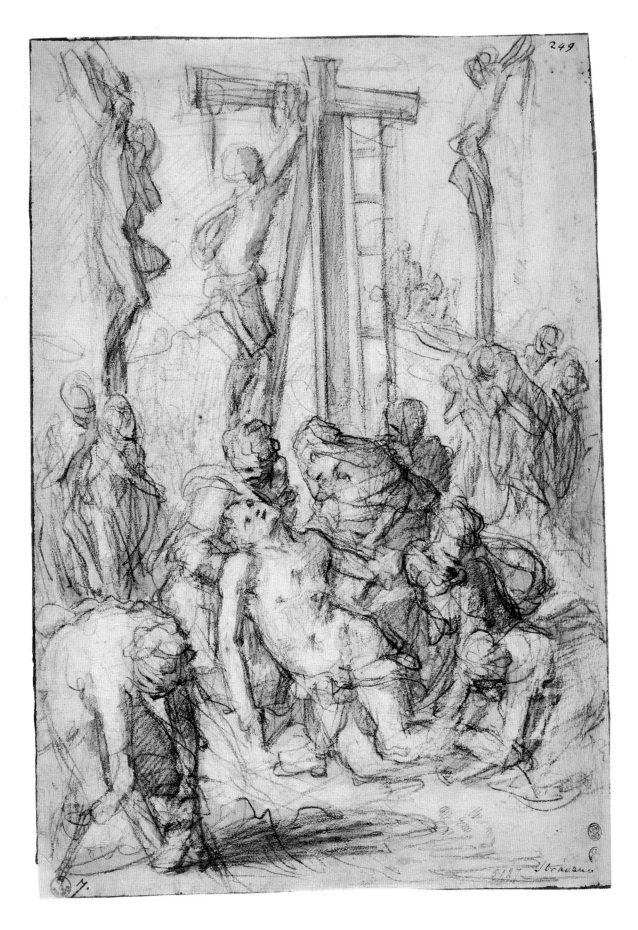

7.

Stradano

58. *Standing Male Nude*

Red chalk and traces of white chalk, the paper squared in black chalk; 418 × 218 mm. Mounted

17808F

EXHIBITIONS: None.

REFERENCES: Cox-Rearick 1964, 360; Barocchi 1965, 282 n. 199; Ward-Jackson 1979, 94.

The *Calling of Saint Matthew* painted for the Salviati Chapel in San Marco is the last of the many large altarpieces that Naldini executed for some of the most important churches in Florence. Dated 1588, it was begun a few years earlier, perhaps around 1584 (see Barocchi 1965, 264); this is then the period in which the drawings preparatory to it would have been done.

Despite the high praise given to this painting by Baldinucci (3:514–515) and the undeniable ability with which the artist solved the many problems posed by a spacious, very crowded composition that is also strongly infused with Catholic doctrine, it must be admitted that the final result was not among his most brilliant. It appears flawed by what can be considered the most common defect of Counter-Reformation paintings: a certain theatricality and a heavily stilted structure that serve as vehicles for their didactic purpose, in which most frequently any pictorial value is lost.

The effort that Naldini put into the execution of this work is shown by the large number of preparatory drawings that survive. These often achieve a degree of quality that is more readily appreciated—and perhaps is more convincing—than that of the painting. Note for example in this drawing the energetic confidence of his handling of the red chalk, which is of a particularly soft type similar to that used frequently by Sarto; the anatomy of the figure is marked by a sureness in the modeling and an elegant dignity of stature that already suggests the early Baroque.

Taken as a whole, the group of preparatory drawings for the *Calling of Saint Matthew* is so rich and elaborate that even in the absence of a study of the whole composition—which must have existed but is now lost—it can give us important information on the artist's working methods. Within a typically Florentine tradition coming straight down from the much-admired Pon-

tormo and Sarto, Naldini developed the individual figures starting from a nude model who posed in the desired position and then proceeded to give them the aspect and dress required by their narrative context. The nude shown here is preparatory for the figure of Saint Matthew.

Almost all these preparatory drawings are in the Uffizi. They represent the figure of Christ (nude in 15664F, and a study for the right foot in 7471F); the woman shown from the back in the left foreground (nude in 17811F and 7491F, and a study for the head in 7543F); the male figure in the far right foreground (nude in 7537F and 15663F, and a study for the arm in 7489F); the figures half-hidden by the latter (the full-figure nude in 7518F for the one on the right; and 742S and 7448F for the one on the right, with full figures both nude and dressed); and one of the figures in the background on the left (7466F and 7510F with both nude and dressed versions). To these can be added a sketch for the raised right arm of the young man running in from the left (7485F) and a beautiful study in two chalks for the head of the old bearded man who can just be seen in the middle ground on the far left of the composition (7445F, copied on sheet 2364S attributed to Giovanni di San Giovanni).

This drawing, of which there is another version with very few variations in the Victoria and Albert Museum (CAI. 596; see Ward-Jackson 1979, no. 201), was catalogued in the last century among anonymous artists of the seventeenth century and was transferred by Ferri first to Pontormo and then to Naldini (handwritten notes on the inventory card). A *bozzetto* in oils of the painting is found in Moscow in the Pushkin Museum (see Lasareff 1966, fig. 381).

A.M.P.T.

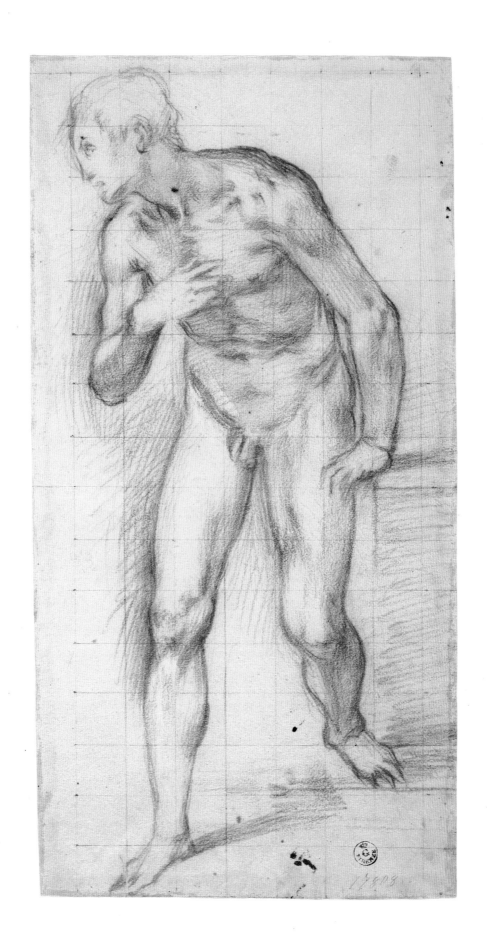

Francesco Morandini, called Il Poppi

Poppi ca. 1544—Florence 1597

59. *The Visitation*

Black chalk; 380 × 276 mm

ANNOTATIONS: at lower left corner in ink, *92;* on mount in pencil, *6393/F.° Morandini/d.° il Poppi*

6393F

EXHIBITION: Arezzo 1950, 71–72, no. 215.

REFERENCES: None.

Francesco Morandini, called Il Poppi, was a pupil of Giorgio Vasari, whom he assisted in the decoration of the Palazzo Vecchio. He also worked with Vasari in the Studiolo of Francesco I in the Palazzo Vecchio, contributing two panels to the program. However, Poppi's paintings exhibit a "subtly berserk whimsy" (Freedberg 1979, 615) that sets them apart from Vasari's and links them with works by Jacopo Pontormo and Rosso Fiorentino.

This elaborate *modello* was already attributed to Poppi in the manuscript inventory of the Uffizi collection in 1793. Although the drawing has not been connected with a Visitation by the artist, it is linked in style and motif to several paintings by Poppi.

In many respects the group of women at the left is simply a variation on that around Campaspe in Poppi's *Alexander Giving Campaspe to Apelles* in the Studiolo of Francesco I (Bucci 1965, fig. 6). In the drawing the woman on the right of the group has the same broad forehead, arched eyebrows over widely spaced eyes, and delicate mouth as Campaspe and her companion. She is also similar to the young woman portrayed in the following study by Poppi. In addition, the *modello* is linked to the panel in the Studiolo by some of the drapery configurations, by shared gestures, and by the elaborate architectural setting. At the same time, the women in *The Visitation* are more ample than those in *Alexander Giving Campaspe to Apelles*. This suggests that the drawing should be dated in the 1580s, close to Poppi's *Christ Healing the Leper* in the Salviati Chapel

in San Marco (Venturi 1933, fig. 234). In fact, the center angel in the drawing is almost identical to one holding a scroll in *Christ Healing the Leper*.

A feature that seems almost a signature of Poppi is the manner in which he applies a soft blush of modeling to the temples of his figures. This is a telling characteristic of the following study of the head of a young woman, and it is evident too in the treatment of Joseph and Zachariah in *The Visitation*. The high degree of finish of *The Visitation* also associates it with Poppi's *modello* for *The Discovery of the True Cross* in the Gabinetto Nazionale delle Stampe in Rome (Rome 1977, no. 3, fig. 3). Moreover, some of the classical structures in the background of that drawing reappear in *The Visitation*. Prosperi Valenti Rodinò (Rome 1977, no. 3) reasonably dated *The Discovery of the True Cross* circa 1585, which supports the dating of *The Visitation* in the 1580s.

Poppi's early association with Vasari is still evident in the background of *The Visitation* (Arezzo 1950, 71–72, no. 215). There are also affinities with paintings by Poppi's companions in the Studiolo. In particular, the figure types recall those of Jacopo Coppi in *The Family of Darius before Alexander* (Bucci 1965, fig. 35). The exaggerated homage paid to Mary by Elizabeth may also recall Pontormo's *Visitation* in the atrium of the Santissima Annunziata (Freedberg 1979, fig. 39), however, thereby confirming Poppi's interest in the works of the early Mannerists.

G.S.

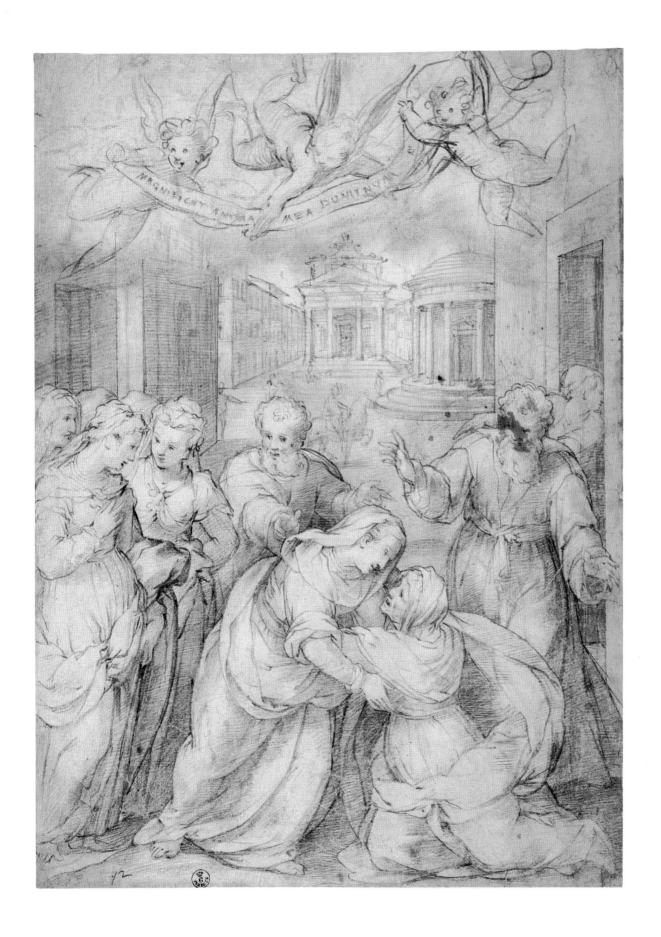

137

60. *Head of a Woman*

Black chalk; 93 × 60 mm

ANNOTATION: on mount in pencil, *6399/Franc.º da Poppi [?]* (the question mark in a different hand)

6399F

EXHIBITIONS: None.

REFERENCE: Barocchi 1964, 133 n. 70, fig. 20.

This delicate study of the head of a woman illustrates the elegant and aristocratic character of Poppi's figure types in the 1570s. Poppi handles the black chalk with great subtlety and variety of effect. On the near side of the woman's head the chalk becomes a soft modeling veil, whereas in details such as the eyes and mouth it acquires a sharp precision. The result is an image of considerable plasticity and vitality, despite its small size.

In her features and in the arrangement of her hair the present figure is remarkably similar to Campaspe and to one of her companions in Poppi's *Alexander Giving Campaspe to Apelles,* painted for the Studiolo of Francesco I in 1571 (Bucci 1965, fig. 6). She is also similar in type to two women on the left of the *Foundry,* Poppi's other contribution to the Studiolo (Voss 1920, 2: fig. 109). The relationships are so striking that it seems reasonable to suppose that this drawing was done in connection with the panels in the Studiolo.

G.S.

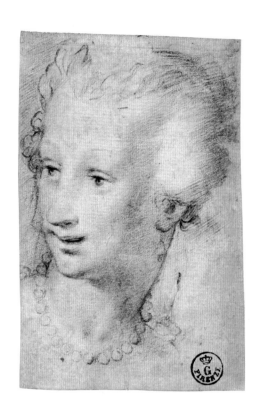

139

Jacopo (or Giacomo) Ligozzi

Verona ca. 1547—Florence 1627

61. *A Battle Scene*

Pen and brown ink and brown wash, heightened with gold, over traces of black chalk, on gray-brown paper, the left and bottom edges marked off preparatory to squaring for transfer; 348 × 332 mm

INSCRIPTION: on recto at bottom right in ink, 2

ANNOTATIONS: on verso in pencil (twice), *Ligozzi*

1911F

EXHIBITIONS: None.

REFERENCES: None.

Born and trained in Verona, where his family practiced painting and designed embroideries and tapestries, Jacopo Ligozzi arrived in Florence in 1577 at the invitation of Grand Duke Francesco I. He was admitted to the Accademia del Disegno during the following year and for the next fifty years, until his death in 1627, was employed as court painter to the Medici. Ligozzi's responsibilities were extraordinarily wide ranging, however. In addition to painting, Ligozzi supervised the Granducal Collections, prepared designs for glass, tapestries, and furniture, and executed a vast number of miniatures of animals, fish, and plants in connection with the scientific studies of Francesco I (for further information on Ligozzi's career see Bacci 1974, 269–276; for the scientific studies, see Florence 1961).

Ligozzi inscribed the preparatory drawing for his first painting in Florence *Jacopo Ligozzi miniator* (Bacci 1974, 272). This inscription not only gives us an insight into Ligozzi's perception of himself as an illuminator, but also accurately characterizes his style, both in painting and drawing. Highly finished and often heightened with gold, Ligozzi's drawings have the preciousness and fastidious detail of manuscript illuminations. Consequently, Ligozzi must have been rather isolated in the context of Florentine artistic production. Certainly, his background (including a period in residence at the Court of Innsbruck [Bacci 1974, 269]), his artistic training, and his drawing style set him apart from his Florentine contemporaries.

Voss (1920, 2:421) underlined the northern character of Ligozzi's draftsmanship, relating it to miniatures and to German chiaroscuro woodcuts by Hans Baldung Grien and Albrecht Altdorfer. In one instance, an *Allegory of Death* in the Pierpont Morgan Library, Ligozzi

depended directly on a chiaroscuro woodcut by Hans Burgkmair the Elder for the three principal figures in his composition (Voss 1920, 2:442 n. 1; Byam Shaw 1956, 282–284, figs. 1, 2; Bean and Stampfle 1965, 80, no. 146, pl. 146). The compatibility of Ligozzi's graphic style with chiaroscuro woodcuts is further indicated by the fact that Ligozzi himself made designs for chiaroscuro woodcuts. A four-block print by Andrea Andreani, representing *Virtue Defeated*, bears an inscription identifying Ligozzi as the inventor of the design (Stechow 1967, 193–196, pl. XXVII, fig. 2; Andreani also executed a *Holy Family with Saint Catherine* from a design by Ligozzi [Florence, Palazzo Strozzi 1980, 284, no. 792]).

This dramatic battle piece is a splendid example of Ligozzi's draftsmanship. The scene is rendered with great attention to detail, and the overall effect of the dark ground, brown ink and wash, and gold heightening is both dramatic and sumptuous. In technique and in detail the *Battle Scene* is closely related to two groups of drawings by Ligozzi at Christ Church, Oxford (Byam Shaw 1976, 1:86–88, nos. 215–220 and 2: pls. 140–145). The drawings in the first group, a series of three illustrations to Dante's *Divine Comedy*, are inscribed and dated 1587 and 1588 (on these drawings, and a fourth in the Albertina, see McGrath 1967, 31–35); the second group, four *modelli* for a series of frescoes illustrating episodes from the life of Saint Francis executed in the cloister of Ognissanti in Florence, can be dated to 1600. The meticulous treatment of the trees, rocks, and foliage in one of the Dante drawings and two of the Saint Francis *modelli* is extremely close to the handling of the tree and the foreground in this *Battle Scene*. In addition, two of the Dante drawings

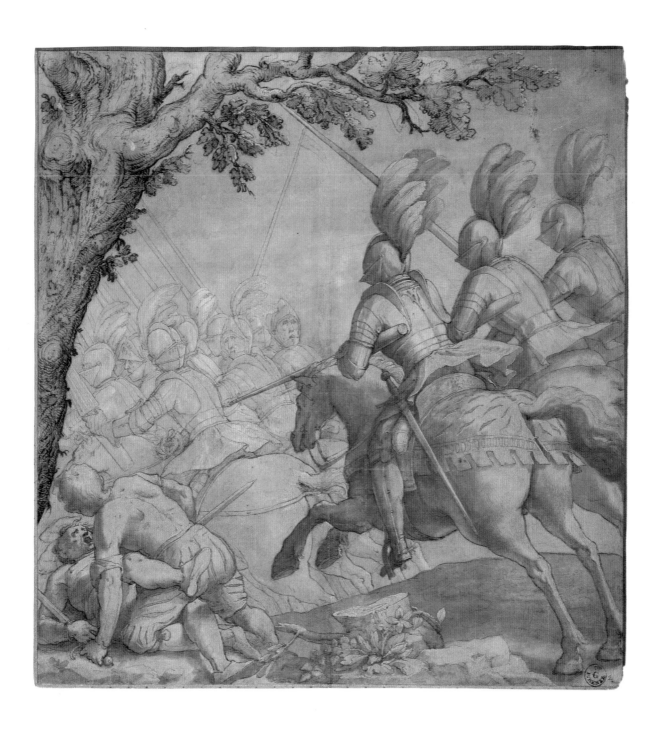

are framed by Ligozzi exactly as he has done in this drawing.

The purpose of this drawing has not been established. Many of Ligozzi's drawings appear to have been made as independent works of art, which may be the case here. On the other hand, the fact that the drawing is marked off for squaring, along the left and bottom margins, suggests that it may have been executed as a model, perhaps for a tapestry or possibly for a painting. The number 2, inscribed at the lower right, may indicate that this drawing was one of a series of battle pieces.

Among Ligozzi's paintings, this drawing compares most closely with his *Return from Lepanto* and *Capture of Nicopoli*, executed in 1604 and 1606 for the Church of Santo Stefano dei Cavalieri in Pisa (Bacci 1963, 69–70, 82 n. 48, figs. 26, 27). Two combatants, very similar to the struggling soldiers at the lower left corner in the present drawing (perhaps inspired by the figures fighting under the hooves of the horses in Leonardo's *Battle of*

the Standard for the Great Hall of the Palazzo Vecchio), appear in the same section of the composition in the *Capture of Nicopoli*. A very similar pair of struggling figures appears in Ligozzi's *Allegory of Death*, inscribed and dated 1597, in the Pierpont Morgan Library (Bean and Stampfle 1965, 80, no. 146, pl. 146). It is also worth mentioning that the victorious leader at the right side of the *Return from Lepanto* wears a plumed helmet similar to those worn by the three knights at the right of this drawing. Perhaps this device identifies them as knights of the Order of Santo Stefano, founded by Cosimo I in 1560 (Richelson 1978, 147–162), in which case the drawing may also be related to the decorations for Santo Stefano in Pisa. Whether or not this is the case, because of the relationships to the *Allegory of Death*, the Saint Francis series, and the paintings in Santo Stefano dei Cavalieri, it would seem reasonable to date this drawing about 1600.

G.S.

Antonio Tempesta
Florence ca. 1555—Rome 1630

62. *The Conversion of Saint Paul*

Pen and brown ink and pale brown wash over traces of black chalk, squared for enlargement in red chalk; 312 × 409 mm

ANNOTATIONS: at lower left in pencil, *23;* at lower right in pencil, *10052*

10052S

EXHIBITIONS: None.

REFERENCE: Santarelli 1870, 685, no. 23.

A pupil of Stradanus, Antonio Tempesta assisted Giorgio Vasari in the Palazzo Vecchio and may have participated in the decoration of the first corridor of the Uffizi between 1579 and 1580. Tempesta was established in Rome by June 1580. He remained there, with only brief interruptions, until his death in 1630. In Rome Tempesta had a successful career as a painter, working in the Vatican and in a variety of churches and palaces. He also received several commissions to decorate villas in the environs of Rome, among them being the Villa d'Este at Tivoli, the Palazzo Farnese at Caprarola, and the Villa Lante at Bagnaia. Despite his activity as a painter, Tempesta's fame today rests primarily on his extraordinarily prolific production as a draftsman and printmaker. Although he produced etchings with mythological and religious subjects, Tempesta specialized in battle pieces and hunting scenes, which provided him with unlimited opportunities to display his ability to portray horses (for Tempesta's career, see Cecchi 1986, 48–52).

This violent *Conversion of Saint Paul* is typical of Tempesta in its composition, graphic style, and lighting. The composition is theatrical in nature, with the narrow outcrop of rock on the left establishing a near foreground. Tempesta employed this device frequently in his drawings and prints (see, for example, Florence, Palazzo Vecchio 1980, no. 526). The nervous, linear character of the draftsmanship is also characteristic of Tempesta, as is the manner in which the violence of the subject is emphasized. Tempesta transforms the conversion of Saint Paul into a battle piece, with horses running amok and lances and standards waving dan-

gerously. The running fence of lances is also a motif that occurs frequently in Tempesta's battle prints.

The fact that this drawing is squared suggests that Tempesta considered the composition to be close to definitive. The drawing has not been connected with a painting or print by Tempesta, however. In fact, it is strikingly similar to a large etching representing the *Conversion of Saint Paul* published by Tempesta with a dedication to Luca Cavalcanti (Bartsch 1984, no. 496). Although the scenes are composed quite differently, there are several correspondences in the details, particularly in the manner in which Christ and his glory of angels appear in a dazzling break in the clouds above Saint Paul.

Neither the print nor the drawing can be dated precisely. On the other hand, both have clear affinities with Tempesta's *Horses of Different Lands,* published in 1590 with a dedication to Virginio Orsini (Bartsch 1983, nos. 941–968). In fact, Tempesta appears to have used the latter publication as a pattern book for the horses in this drawing. Saint Paul's horse, represented in the right foreground, is identical to the one portrayed by plate 18 in the series (Bartsch 1983, no. 958); the horse shown racing to the left, at the near left of the composition, derives from plate 12 in the series (Bartsch 1983, no. 952); the animal immediately above and behind is drawn from plate 17 in the series (Bartsch 1983, no. 957); finally, the rearing horse viewed frontally, directly behind Saint Paul, is modeled directly on plate 11 in the series (Bartsch 1983, no. 951).

G.S.

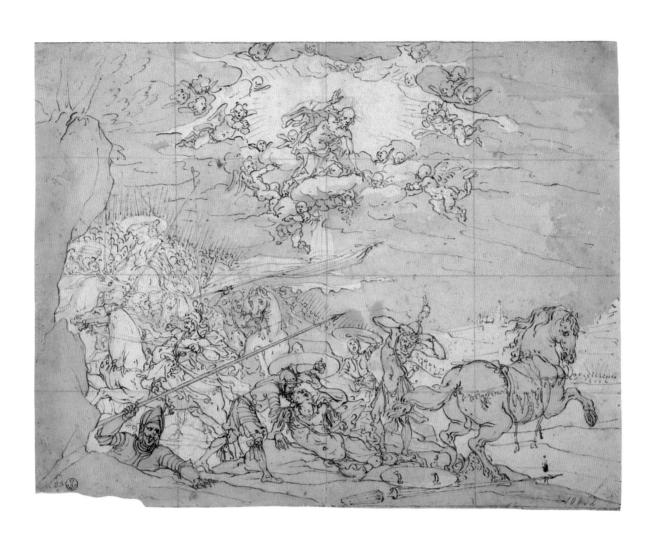

Giovanni Balducci, called Cosci

Florence 1560—Naples after 1631

63. *The Calling of Saint Matthew*

Black chalk, pen, dark brown ink, brown wash, and heightened with white, on blue paper; 342 × 229 mm

15639F

EXHIBITIONS: None.

REFERENCE: Petrioli Tofani 1982, 67.

Despite the fact that he was a contemporary of Cigoli, Commodi, and Pagani, Giovanni Balducci occupies a very different position in the history of Florentine painting. Unlike his colleagues, whose orientation was toward the future, throughout his long career he maintained a special connection with the masters of preceding generations, reining in his delicate and elegant narrative style to work within the bounds of a cultured and pleasing traditionalism.

Called Cosci after the surname of a paternal uncle who reared him, Balducci received his artistic training in the shop of Naldini. His early, extremely intense activity in Florence is reported in detail by Baldinucci (3:91–94), who mentions that the artist worked on the fresco cycle in the Chiostro Grande of Santa Maria Novella and the decoration of the underground chapel of Sant' Antonino in the church of San Marco, as well as making contributions to the stage sets for the wedding entertainment of Grand Duke Ferdinando in 1589, the decoration of the Oratorio dei Pretoni in Via San Gallo, and various other projects.

In 1594, together with Agostino Ciampelli, he moved to Rome at the invitation of Cardinal Alessandro de' Medici, who wanted him to work on the decoration of Santa Prassede, the cardinal's titular church; during this brief stay in Rome he was able to work in other important churches such as San Giovanni Decollato, San Giovanni in Laterano, San Giovanni dei Fiorentini, and San Gregorio al Celio.

After beginning to frequent the circle of a leading member of the papal court, Cardinal Alfonso Gesualdo, Balducci followed him to Naples, probably on the occasion of the prelate's official entrance for his investiture in that diocese on April 2, 1596. Here Balducci's work was widely successful, judging from the number of commissions he received up to 1631 (see Previtali 1978, 148–150). His paintings exhibit the transformation of Florentine Mannerism into simpler compositions of less dramatic balance in the spirit of the Counter Reformation.

This fine drawing is a good example of Balducci's substantial expressive traditionalism. Catalogued until a few years ago in the Uffizi as by an anonymous artist of the seventeenth century, it can be securely attributed to Cosci. Very characteristic is the quick light play of pen, as well as his very choice of media, and its stylistic dependence on Vasarian precedents of the type shown in cat. no. 37, clearly reworked according to the example of Naldini.

Developed in a composition suitable for an altarpiece, the subject seems to be a Calling of Saint Matthew, with Christ in the right foreground calling the apostle to him while Matthew is intent on his activity as a tax collector. The drawing unfortunately does not have a counterpart among the paintings attributed to the artist, neither those extant nor those which are documented and now lost. Dating the drawing is therefore not easy, and in the complete absence of external points of reference, it is impossible to go beyond noting that the graphic style seems to be the same as that of many drawings securely placed in Balducci's Florentine period.

A.M.P.T.

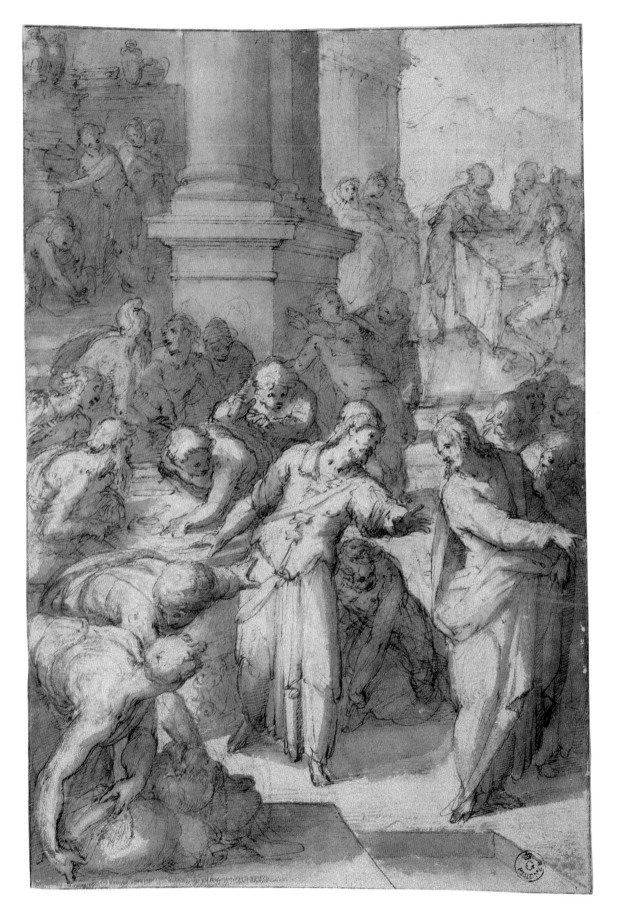

Andrea Boscoli

1560 Florence 1607

64. *Front View of Baccio Bandinelli's* Hercules and Cacus

Black chalk, pen and brown ink and pale brown wash, heightened with white, on beige paper; 396 × 236 mm

ANNOTATION: at top right in pen, *3*

8245F

EXHIBITION: Florence 1959, no. 28.

REFERENCES: Jacobsen 1904, 404, no. 537; Forlani 1963, 148, no. 126.

This drawing and four others, also in the Uffizi (8243F, 8244F, 8246F, 8270F), are studies from Baccio Bandinelli's monumental *Hercules and Cacus,* which was installed at the southwest corner of the Palazzo Vecchio in May 1534 (Pope-Hennessy 1970, 363–364, pl. 64). The five drawings, which are done on identical paper, examine the sculptural group from different points of view and clearly were executed as a series (Florence 1959, no. 28; for the related drawings see Forlani 1963, nos. 124, 125, 127, and 151, no. 152).

To execute this drawing, Boscoli must have taken up a vantage point near the northeast corner of the Loggia de' Lanzi, close to Benvenuto Cellini's *Perseus.* While Boscoli represents the *Hercules and Cacus* accurately, he also subtly changes both the form and character of the sculptural group. The point of view is such that the drawing eliminates the voids that exist between Hercules and Cacus and in the individual figures. As a result, in Boscoli's representation the *Hercules and Cacus* acquires a monolithic quality. In addition, Boscoli softens Bandinelli's figures and makes them appear more human. Their musculature is less exaggerated; their hair is treated in a much more naturalistic fashion, disre-

garding the profusion of tight, decorative curls of the sculpted figures; and Hercules's fierce scowl is suppressed. The result is an image that is at once curiously pathetic and surprisingly far removed from the bombast of the sculptural group. The shading to the left of the group serves to establish the figures on the page, while also suggesting the actual setting provided by the facade of the Palazzo Vecchio.

In addition to drawing from life, Boscoli drew extensively from contemporary and ancient works of painting, sculpture, and architecture in Florence, Rome, and elsewhere. This drawing and its companions fit into this category of study pieces, and so it seems sensible to date them relatively early in Boscoli's career. In fact, in style and medium the studies from Bandinelli's *Hercules and Cacus* are similar to a series of drawings, in pen and wash, after antique reliefs and sculpture, executed by Boscoli in Rome about 1580–85. Especially close is a study of a Hadrianic relief, representing an emperor received by a personification of Rome, in the Gabinetto Nazionale delle Stampe in Rome (Florence 1959, no. 17, fig. 7; Forlani 1963, fig. 12).

G.S.

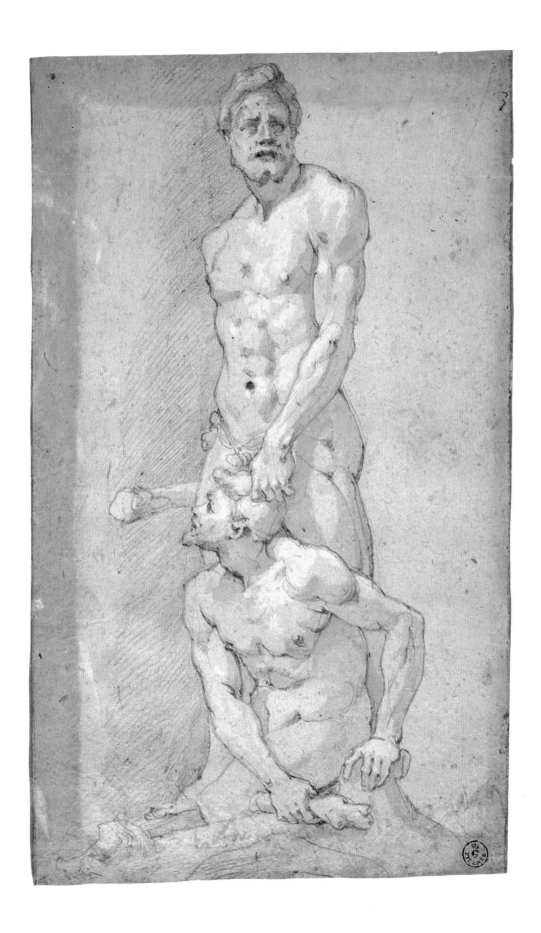

149

Andrea Boscoli

65. *The Punishment of Cupid*

Pen and brown ink and brown wash, heightened with white, over black chalk, on blue paper; 375 × 260 mm

806F

EXHIBITION: Florence 1959, no. 65.

REFERENCE: Forlani 1963, 142, no. 40.

In *The Golden Ass* Apuleius described Cupid as "that very wicked boy, with neither manners nor respect for the decencies, who spends his time running from building to building all night long with his torch and arrows, breaking up respectable homes" (115–116). This elaborate *modello*, which depicts the punishment of Cupid, a popular subject in ancient and Renaissance art and literature, represents woman's revenge on naughty Cupid (on the subject of the punishment of Cupid, see Tervarent 1958, 17, II and Panofsky 1962, 126–127 n. 79).

Bound to a column in an imposing piazza surrounded by porticos, Cupid is held captive by an army of young women; he is being beaten by three of the women, and two of them appear to be plucking feathers from his wings; Cupid's bow, quiver, and arrows lie broken and useless at center foreground. With the difference that Cupid is bound to a column rather than a tree, the scene compares in essentials with representations of *Amor cruciatus* that appear in fifteenth-century Italian prints and paintings (Schubring 1923, pl. CXIV, no. 482; Warburg 1969, 1:182–183, pl. XXVII, fig. 48). Various musical instruments are also scattered on the ground in the foreground. Presumably these refer to the frivolous pleasures associated with love. The entire scene is supervised by Juno, goddess of marriage, who watches from her chariot (identified by the two peacocks), which is parked on a bank of clouds directly above Cupid's column.

The subject is treated in a mock-serious fashion that suggests a theatrical entertainment. Certainly, one is not convinced of the gravity of Cupid's predicament. Boscoli's light-hearted treatment of antiquity has a great deal in common with the whimsical and often erotic representations of ancient myths that one associates with the Studiolo of Francesco I in the Palazzo Vecchio and with artists such as Hendrik Goltzius, Bartholomaeus Spranger, and Jacopo Zucchi.

The element of parody extends further in *The Pun-*

ishment of Cupid, however, in that we are surely intended to recognize that Boscoli's composition is a profane and erotic translation of the Flagellation of Christ. The principal elements are the same, and the woman kneeling before Cupid even brings to mind similar figures in a related Passion episode, the Mocking of Christ. In particular details, Boscoli's composition also recalls Raphael's *Ecstasy of Saint Cecilia,* painted for San Giovanni in Monte in Bologna about 1515–16 (Dussler 1971, 39–41, pl. 88; Mossakowski 1983, 52–53). The musical instruments scattered in the foreground of *The Punishment of Cupid* bring to mind those discarded by Saint Cecilia in Raphael's altarpiece. Moreover, Boscoli's composition, with tightly packed figures massed near the foreground and the heavenly apparition above, seems to owe a good deal to Raphael. Presumably Boscoli saw Raphael's altarpiece in Bologna in the course of one of the excursions that he is believed to have made to Parma, Genoa, and Venice (Florence, Palazzo Strozzi 1980, 80).

According to Filippo Baldinucci, Boscoli's first biographer, Boscoli made architectural drawings while in Rome, as well as studying the ancient statuary and modern painting in the city (3:73; Florence 1959, 7–8). A combination of architectural motifs from his native Florence with recollections of modern Rome, the architectural background of *The Punishment of Cupid* provides clear evidence of Boscoli's interest in architecture. The porticos immediately bring to mind those of the Ospedale degli Innocenti and the Confraternity of the Servi di Maria in the Piazza della Santissima Annunziata, while the general organization of the long piazza, closed by an imposing palace, recalls the Belvedere Court and Vatican Palace in Rome.

Among the drawings by Boscoli in the Uffizi, the one most closely related in medium, style, and subject matter to this drawing is an elaborate *Triumph of Bacchus,* a study for a large painting, now lost, executed on canvas (790F; Florence 1959, 38, no. 64, fig. 13; Forlani 1963,

150

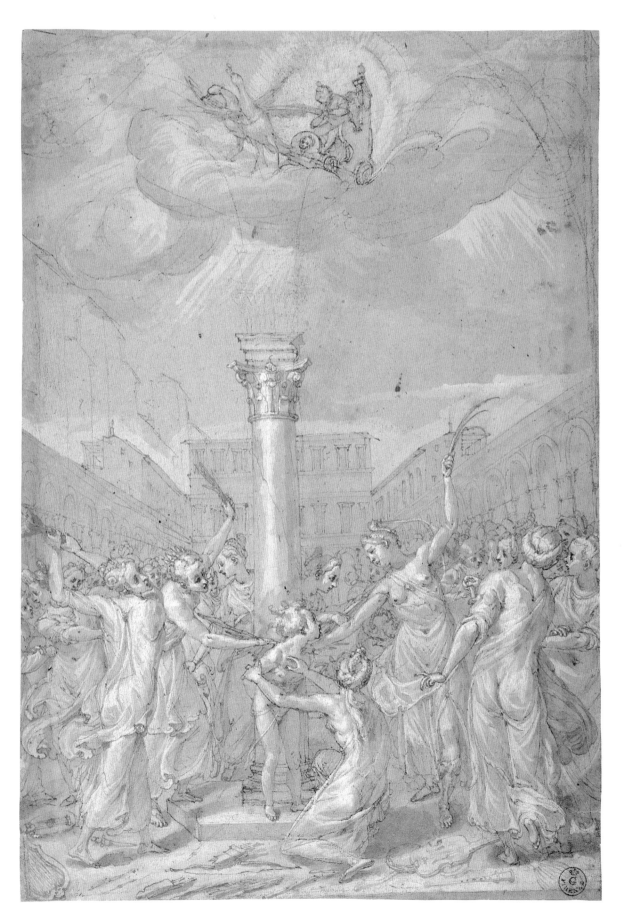

141, no. 25, figs. 27, 28). Like this drawing, the *modello* for the *Triumph of Bacchus* is executed in pen and wash, heightened with white, on blue paper; it is also a lively composition, packed with animated figures. In both drawings, the mannered poses and fluttering draperies make clear Boscoli's familiarity with Romano-Florentine Mannerists such as Perino del Vaga and Francesco Salviati. One figure in *The Punishment of Cupid,* the woman with her back to us at the right of the composition, is repeated almost exactly in the *Triumph of Bacchus,* which provides an additional reason for believing the drawings to be close in date. An entry dated May 17, 1599, in Boscoli's account book refers to a painting of the *Triumph of Bacchus,* and Forlani is certainly correct in connecting that entry with Uffizi 790F (1963, 136, no. 14, 199). Because of its close links with the *Triumph of Bacchus,* it also seems reasonable to date the present drawing at the end of the century.

The purpose of this drawing has not been established. It is possible that Boscoli intended it as an independent work of art. Alternatively, it may have been the *modello* for a private commission, similar to the lost *Triumph of Bacchus.* Also among the lost works by Boscoli, mentioned by Baldinucci, was a series of colored cartoons on canvas depicting love stories (Baldinucci 3:78; Forlani 1963, 138, no. 32). These were executed as wall hangings for Boscoli's own bedroom, which also contained a sumptuous bed (designed by Boscoli himself), with curtains painted with still more scenes of love. It is conceivable that the drawing is connected in some way with that cycle.

G.S.

66. *The Virgin and Child*

Red chalk, with stumping; 430 × 318 mm

ANNOTATIONS: at top right corner in pen, *464;* at bottom left corner in pen, *136* and *48;* on verso in pencil, *Boscoli*

464F

EXHIBITION: Florence 1959, no. 12, fig. 1.

REFERENCES: Clapp 1914, 53, 106, 107 n. 464; Forlani 1963, 140, no. 15.

This beautiful study is one of the most elegant, as well as one of the most mannered, of Andrea Boscoli's drawings. Although Forlani identifies the principal child as the Infant Christ (Florence 1959, 19–20, no. 12; Forlani 1963, 150, no. 15), one cannot be certain of his identity. In fact, the dramatic pose suggests an angel or putto, buffeted by air currents in an Assumption, or some similar subject, rather than the Christ Child (similar putti appear in Rosso Fiorentino's *Assumption of the Virgin* in the Santissima Annunziata, for example [Carroll 1976, 1:112, P.9, 2: fig. 14]). On the other hand, the manner in which the child rests his left arm in Mary's lap, a gesture reminiscent of the Christ Child in Michelangelo's *Bruges Madonna*, establishes an intimate link between the two and may imply that the child is indeed the Infant Christ.

This drawing effectively confirms Boscoli's wide-ranging eclecticism, an aspect of his work discussed extensively by Forlani (Florence 1959, 3–13; Forlani 1963, 85–118; Florence, Palazzo Strozzi, 1980, 80). The current attribution of this drawing, traditionally given to Pontormo, was first proposed by Clapp (1914, 53, 106, 107 n. 464). Although the previous attribution is incorrect, it is informative in drawing attention to the close relationships between Boscoli's and Pontormo's figure types and drawing styles. The soft handling of the red chalk and sharp contrasts in the draperies also bring to mind certain drawings by Rosso Fiorentino, however, as Forlani observed (Florence 1959, 20, no. 12). A closely related drawing in the Uffizi, identified tentatively by Forlani as a study for a *Raising of Lazarus*, shows the marked influence of Rosso Fiorentino (Florence 1959, no 13, fig. 4), as does a study for an *Annunciation*, in the Fogg Art Museum in Cambridge, Massachusetts (Forlani 1963, 139, no. 1; Olszewski 1981, 33, no. 8, fig. 8). Other artists mentioned by Forlani in connection with this drawing are Jacques Bellange, Federico Barocci, Lodovico Cigoli, Correggio,

and Santi di Tito (Florence 1959, 19–20, no. 12). To this list might be added Parmigianino, whose *Madonna of the Long Neck* seems an obvious prototype for the elegant distortions of the present figure.

It is difficult to establish a convincing chronology for Boscoli as a draftsman, since relatively few of his drawings can be connected with dated paintings. Forlani placed this drawing early in Boscoli's career, seeing it and the related *Raising of Lazarus* as youthful works (1963, 140, no. 14). She also compared this drawing with a study by Boscoli, in a private collection in Edinburgh, done after Michelangelo's *Medici Madonna* (1963, 140, no. 11). While the elongated proportions and complex pose of the Virgin in the Uffizi drawing certainly recall Michelangelo's sculpture, stylistically it is considerably more sophisticated than the study after the *Medici Madonna* or drawings associated with Boscoli's Roman trip, and reasonably datable circa 1580–85. Much closer in style is a study in the Uffizi for a *Temperance*, which appears to be connected with Boscoli's first documented commission, *The Martyrdom of Saint Bartholomew*, painted in the cloister of San Pier Maggiore in Florence in 1587 (Florence 1959, 26–27, no. 33, fig. 11).

A case can also be made for dating this drawing still later in Boscoli's career, during his period of activity in the Marches, between 1599 and 1605. In fact, it bears some relation to three paintings executed by Boscoli in the Marches—a fresco depicting the *Virgin Dispensing Gifts*, in the Chiesa del Brefotrofio at Fabriano, a *Madonna della Cintola*, in the Pinacoteca Comunale at Macerata, and an *Assumption of the Virgin*, in San Francesco at San Ginesio (Venturi 1934, fig. 412; Forlani 1963, figs. 67, 81, 82). In all three paintings the Virgin is depicted seated on a bank of clouds, attended by angels or putti; and, in the *Assumption of the Virgin* and the *Madonna della Cintola*, there are putti hovering below the Virgin in poses that recall the child here. A

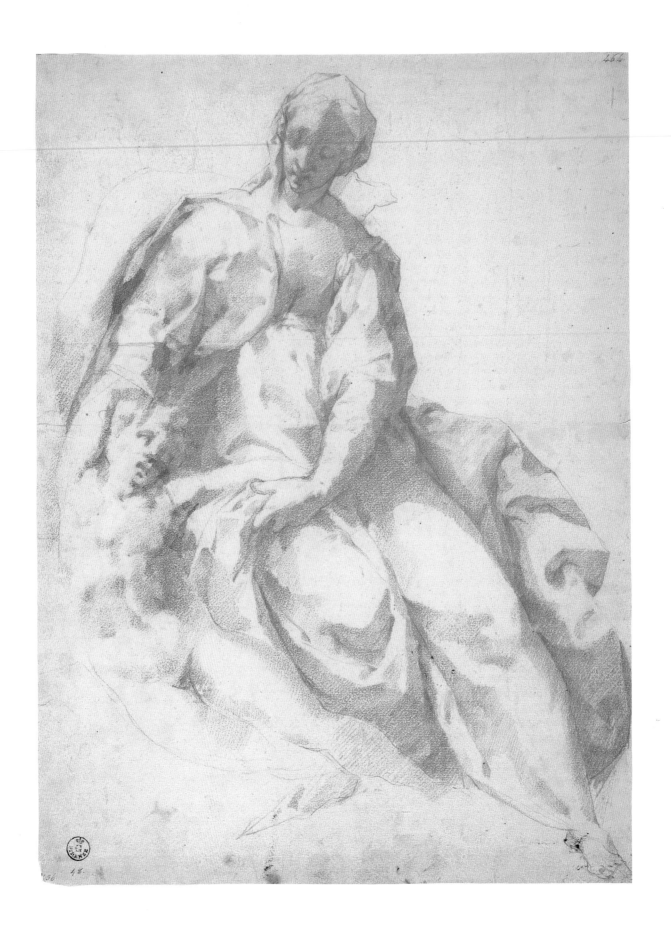

154

similar figure also appears in one of the two *modelli* for the Macerata *Assumption,* in the British Museum in London (Turner 1986, nos. 183, 184). In addition, the faceted appearance of the Virgin's draperies in this drawing recalls the treatment of draperies in several paintings and drawings executed by Boscoli in the Marches (Venturi 1934, figs. 405, 416, 417; Olszewski 1981, 33, no. 8).

Elements in the drawing can also be compared with two compositional studies by Boscoli, both dated by Forlani to the end of the century. The first, a study for a *Saint Luke Painting the Virgin,* is in the Gabinetto Nazionale delle Stampe in Rome, and the second, a study for an *Immaculate Conception,* is in the Uffizi (Florence 1959, 47–48, no. 86, no. 30, and 50, no. 91, figs. 32 and 33; Forlani 1963, 162, no. 296, 149, no. 132). One of the airborne putti in the former is similar to the child here, and the pose of the Virgin has a good deal in common with this drawing. In the latter the elongated proportions and elegant, slanting pose of the Virgin once more recall the Virgin seen here.

Two further points argue for placing this drawing during Boscoli's activity in the Marches. First is the fact that the features of the Virgin suggest a direct knowledge of Federico Barocci's types, in particular the Virgin in *The Annunciation,* now in the Pinacoteca Vaticana, commissioned for the Basilica of Loreto in 1582 (Bologna 1975, no. 150, fig. 150; reproduced in an etching by Barocci himself, probably between 1584 and 1588 [no. 151, fig. 151; also discussed and illustrated in Pillsbury and Richards 1978, fig. 75]). Also similar is the Virgin in Barocci's *Madonna of the Rosary* in the Palazzo Vescovile in Senigallia, painted between 1588 and 1592 (Bologna 1975, no. 198, fig. 198). Finally, the pose if not the proportions of the Virgin in this drawing appears to be derived from Raphael's *Madonna di Foligno,* painted for the high altar of Santa Maria in Aracoeli in Rome but removed to Santa Anna at Foligno in 1565 (Pope-Hennessy 1970, 288 n. 62, fig. 195). Presumably Boscoli saw Raphael's altarpiece while en route to Rimini in 1599 or during his sojourn in the Marches.

G.S.

Alessandro Casolani

1552 Siena 1606(?)

67. *Sheet of Studies*

Pen and brown ink and brown and gray-brown wash; 196 × 273 mm

4908S

EXHIBITIONS: None.

REFERENCE: Santarelli 1870, 349, no. 57.

Like Francesco Vanni and Ventura Salimbeni, Alessandro Casolani was a prominent figure in Sienese painting at the end of the sixteenth century (Venturi 1934, 1132–1141). Casolani's early training took place in Siena with Arcangelo Salimbeni and Cristofano Roncalli. In 1578, however, he traveled to Rome with Roncalli and the Brescian sculptor Prospero Antichi. There he devoted himself to studying the most important works by ancient and modern masters (Baldinucci, 3:85). Casolani returned to Tuscany in 1583, working primarily in Siena and its environs but also painting as far afield as Pavia.

The animated sketches in pen and wash on this sheet appear to be studies for two distinct subjects. On the left is a composition study, partially framed in brown ink, depicting two men in an interior. The figure on the left appears to be supporting his companion while directing him to the left. To the right of this vignette are four rapid sketches that appear to be connected with one another. The study to the left represents a woman in a complex twisting pose, drawing a child to her for protection. In the sketch immediately to the right Casolani drew the woman on her own, making more evident the source of her pose in Leonardo's lost *Leda* (Ettlinger and Ottino della Chiesa 1967, 107, no. 34). The study at the far right appears to be developed from the preceding two sketches but alters the head of the figure so that it looks to the right rather than turning to the left. The detail study at the top of the sheet elaborates the head of the figure in the new position.

The sketches have not been connected with known paintings by Casolani.

This sheet is characteristic of Casolani's drawings in pen and wash, a medium that enabled him rapidly to explore variant poses and effects of light and dark. Casolani's dramatic treatment of light in his drawings has been attributed in part to the influence of Lodovico Cigoli (Forlani 1962, 270) and in part to the example of artists such as Girolamo Muziano and Cesare Nebbia (Bagnoli 1980, 82). The Venetian elements in the paintings of Muziano and Nebbia certainly appear to have influenced Casolani during his period of residence in Rome (Kirwin 1978, 21). At the same time, it is important to recognize that Francesco Vanni and Ventura Salimbeni, Casolani's Sienese contemporaries, employed wash in a similarly pictorial manner. However, the artist closest to Casolani in these respects was Pietro Sorri, with whom Casolani collaborated on the decoration of the Certosa di Pavia between 1599 and 1600 (Bagnoli 1980, 82).

The freedom of the pen and wash in this drawing is not typical of Casolani's style at the end of the century, however. Rather, the elegant, twisting poses of the figures, the soft modeling of their faces, and the dramatic contrasts in light and dark appear to associate the drawing with a painting such as Casolani's *Birth of the Virgin* in San Domenico in Siena, painted between 1584 and 1585 (Bagnoli 1980, 76–77).

G.S.

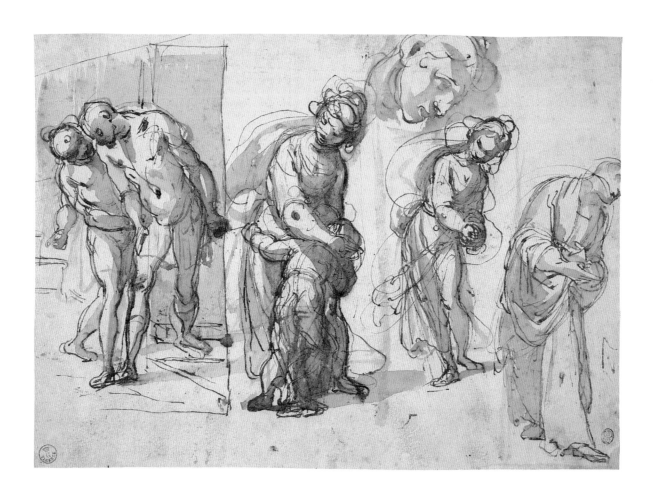

157

68. *David with the Head of Goliath, a Separate Study of the Head of David, a Study of Two Men, and a Sketch of a Seated Figure*

Black chalk, the seated figure in red chalk; 270 × 192 mm

INSCRIPTION: at upper left in black chalk, *Fabrano Pli[illegible] francio la 113a*

ANNOTATIONS: at upper right corner in ink, *60;* along lower right in ink, *4882*

4882S

EXHIBITIONS: None.

REFERENCE: Santarelli 1870, 347, no. 31.

The principal study on this sheet represents a full-length nude David standing over a diminutive head of Goliath. Drawn in black chalk, David is realized with forceful contour lines and modeled with strong contrasts of light and dark. At the top center of the sheet is a detail study for the head of David. The full-length study has something of the character of a drawing after sculpture and might be connected with the sketches done by Casolani during his Roman period. On the other hand, the vitality of the figure and the sense of alertness conveyed by the detail drawing of the head indicate that these are in fact studies from life. The drawings have not been connected with a known painting by Casolani.

However, Ugurgieri Azzolini referred to a painting by Casolani in which David was shown in the act of decapitating Goliath (1649, 379).

The rapidly sketched figures at the right of the sheet appear more contemporaneous and anecdotal in character, although it is not possible to establish precisely what is taking place. Bagnoli suggested some relationship between studies of this kind and drawings by Raffaellino da Reggio and Giovanni de' Vecchi (1980, 68).

The red chalk studies on the verso can be connected with another sheet by Casolani in the Uffizi (4879S).

G.S.

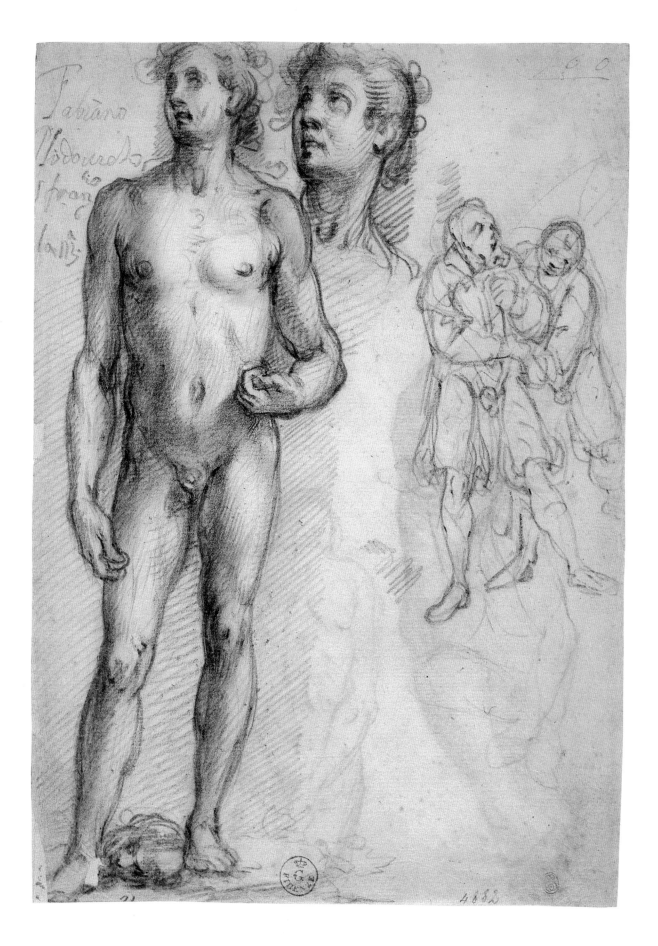

159

4682

159

Early Baroque

contradicted by Collareta (Florence 1985a, 76, no. 67), who argues, correctly I believe, that this drawing is related to similar studies of children done by Santi around 1600.

Santi's *Ecce Homo* is a self-conscious fusion of the historical and the contemporary. Consistent with their identity as the forces of the governor, the soldiers on the right of the composition wear Roman dress, while the crowd is represented in long, flowing costumes that presumably are intended to represent ancient Hebrew dress. The entrance portal and balcony of Pilate's palace have a distinctly Florentine flavor, however, and compare quite closely with similar details on buildings de-signed by Santi himself (see Chiarelli 1939, 126–155; Venturi 1939, 594–605). Since Santi was a practicing architect, we can take it that his provision of a contemporary and local setting for the *Ecce Homo* was considered and purposeful. In this respect his practice recalls that of Domenico Ghirlandaio at the end of the fifteenth century and Andrea del Sarto early in the sixteenth. Clearly, Santi looked back to the Florentine quattrocento and early cinquecento to arrive at a pictorial style and an approach to narrative that would communicate directly with his Florentine contemporaries.

G.S.

70. *The Miraculous Feeding of Saint Dominic and His Companions*

Pen and brown ink and brown wash, heightened with white, over traces of black chalk underdrawing, squared for enlargement in black chalk, the composition enclosed in an arched frame executed in pen and brown ink and brown wash; 238 × 248 mm

ANNOTATIONS: inside the frame near the lower left corner in ink, *59;* outside the frame at lower left corner in pencil, *861*

772F

EXHIBITIONS: Florence, Palazzo Strozzi 1980, no. 501; Florence 1985a, no. 21, fig. 23.

REFERENCES: Ferri 1890, 130; Arnolds 1934, 51, pl. XXXIX; Rome 1977, 23; Lecchini Giovannoni 1977, 50; Ward-Jackson 1979, no. 347; Spalding 1982, 111–113.

Between 1570 and 1582 a number of artists collaborated on the decoration of the large cloister of Santa Maria Novella. Santi di Tito contributed five scenes from the life of Saint Dominic, including one representing the miraculous feeding of Saint Dominic and his companions by two youths (Spalding 1982, 352–353, no. 31, fig. 57). The miracle is described as follows in *The Golden Legend* by Jacobus de Voragine:

> One day the brethren. . . , to the number of about forty, found that they had but a very small quantity of bread. But Saint Dominic ordered this to be divided on the table; and at the moment when each brother was breaking his bite of bread with joy, two youths of like form and vesture entered the refectory, with the pockets of their cloaks full of loaves. These they silently placed at the head of Dominic's table, and at once disappeared, so that none knew whence they had come nor whither gone. And Dominic stretched forth his hand to his brethren on all sides, and said: "Now, my beloved brothers, take and eat!" (1969, 421)

Ferri (1890, 130) was the first to recognize that this drawing is the finished *modello* for that scene. Apart from a reduction in the floor space in the foreground of the composition, the only significant difference between the drawing and the fresco is in the monk in the extreme right foreground. In the fresco he is represented pouring water from a large kettlelike utensil into a pitcher. This figure and his action are more easily legible in a drawing in the Victoria and Albert Museum (Ward-Jackson 1979, no. 347, fig. 347), possibly by Andrea Boscoli, copied from the fresco or from a subsequent composition study. A black chalk drawing from life for

this figure, preserved in the Uffizi (Florence 1986, no. 22, fig. 24), provides evidence of a further stage in Santi's preparatory process between the completion of the drawing here and the execution of the fresco. According to Baldinucci (2:537), Santi did a large number of life drawings of the monks at Santa Maria Novella for *The Miraculous Feeding of Saint Dominic and His Companions.* One can see that the monks are more individualized in the fresco, even in its present damaged state, than in this study.

The drawing and the resulting fresco are remarkable for their formal, spatial, and narrative clarity. Santi must have read *The Golden Legend,* since he was clearly intent on making visible the detail and mood of Voragine's narrative. The miraculous providers are "of like form and vesture," and distribute the loaves from the folds of their cloaks; in keeping with their characterization simply as "youths," they are wingless. Consistent with the silence of their entrance and the swiftness of their departure, they appear to be unnoticed by Saint Dominic's companions, who continue to converse quietly at table. Similarly, the monk in the pulpit remains absorbed in his task, as does his companion attending to the water in the right foreground. It is as if we alone witness the miracle with Saint Dominic.

Santi's narrative clarity is matched by an equally lucid pictorial and spatial organization, reminiscent of frescoes by Andrea del Sarto in the atrium of the Santissima Annunziata, especially those illustrating the life of Saint Philip Benizzi (Shearman 1965, 1: pls. 8, 10b, 13, 14). The distant landscape, viewed through the Serlian window behind Saint Dominic, also has a Sartesque quality (see Shearman 1965, 1: pl. 10b). Santi's treatment of

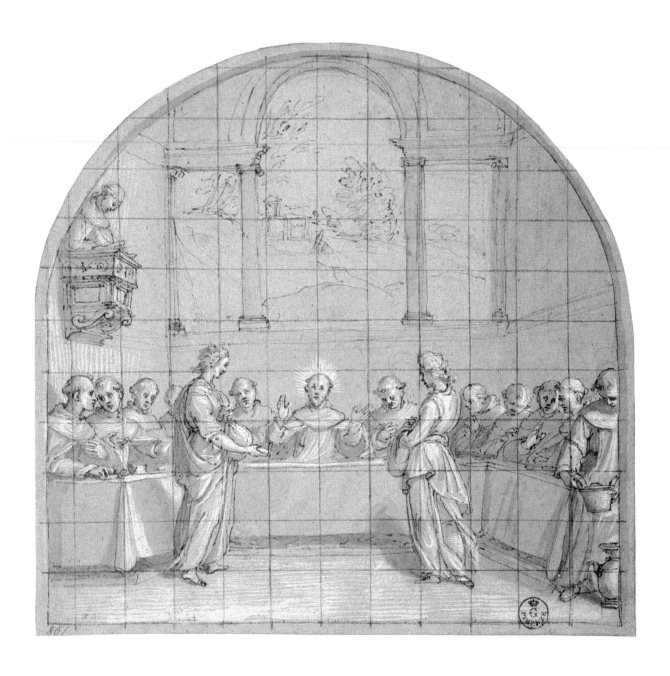

space, the scale of his figures, and the overall sense of repose also bring to mind late fifteenth-century narrative frescoes by Domenico Ghirlandaio, such as the *Last Supper* in the refectory of the Ognissanti in Florence (Borsook 1980, figs. 140, 142, 143).

Santi's interest in the fifteenth-century narrative tradition and in the classical style of the early sixteenth century anticipated the retrospective tendencies of a number of Florentine artists of the early Baroque (Thiem 1977, 12–14). In Santi's case his rediscovery of the earlier traditions of Florentine painting provided the basis for his own reform of Florentine Mannerism, exemplified by *The Miraculous Feeding of Saint Dominic and His Companions*. This emphasis on artistic tradition also served to draw attention to the continuity and longevity of the religious orders, as Lecchini Giovannoni observed (Florence 1985a, 42–43).

The immediate prototype for *The Miraculous Feeding of Saint Dominic and His Companions* is Santi's own *Feast in the House of Simon,* painted between 1572 and 1573 in the refectory of the Santissima Annunziata, as Spalding recognized (1982, no. 13, fig. 33, the *modello* reproduced as fig. 130). At the same time, the differences between the two compositions are as striking as the similarities. The *Feast in the House of Simon* is a bustling composition, crowded with incident and much less legible than *The Miraculous Feeding of Saint Dominic and His Companions*. In view of the contrast between the two compositions, it seems reasonable to date this drawing and the resulting fresco later in the decade. They are in fact similar in composition and mood to a *Last Supper* from the predella of an altarpiece painted by Santi between 1578 and 1580 for the Arciconfraternità della Misericordia in Florence (Spalding 1982, no. 30, fig. 53).

G.S.

71. *The Nativity with Saint Jerome and Saint Anthony Abbot*

Pen and brown ink and brown wash, heightened with white, over black chalk, squared for enlargement in black chalk, the composition enclosed in an arched frame executed in pen and brown ink and brown wash, on blue paper; 416 × 258 mm

ANNOTATION: at lower right corner in ink, *59*

753F

EXHIBITION: Florence 1985a, no. 24, fig. 26.

REFERENCES: Scacciati 1766, no. 48; Ferri 1890, 129; Spalding 1976, 278–280, pl. 36; Collareta 1977, 359–365, pl. XIII; Thiem 1977a, 174, no. 340; Spalding 1982, 113–115, fig. 64.

Spalding (1976, 278–280) and Collareta (1977, 359–365) identified this elaborate composition study as the *modello* for a *Nativity* painted by Santi di Tito in 1583 for an altar in Santa Maria del Carmine. The painting was destroyed in a fire in 1771, but its appearance can be partially reconstructed from references to it in two publications of the late sixteenth century.

Within a year of its completion, the Carmine *Nativity* was discussed in Raffaello Borghini's *Il Riposo* (1:131–132). He says that the altarpiece was commissioned by a certain Antonio di Girolamo Michelozzi, that Saint Jerome and Saint Anthony Abbot appeared in the painting, that the patron was portrayed as Saint Anthony, and that his son was introduced into the composition as one of the shepherds. Since Antonio Michelozzi's son was the source of this information, it can be taken to be accurate. Santi's Carmine *Nativity* was also mentioned in *Le bellezze della città di Fiorenza,* a guide to Florence published in 1591 by Francesco Bocchi (79–80). Bocchi's attention was caught by a young boy among the shepherds who gazed in wonder at a choir of angels in the sky.

As Spalding recognized, Saints Jerome and Anthony and the boy are important elements in this drawing and connect it unequivocally with Santi's altarpiece for the Carmine. Since the drawing is framed and squared for enlargement, with the only significant alteration being to the position of the left arm of the angel in the upper right foreground, it is likely that the finished painting corresponded closely to this drawing. This is supported by an earlier composition study in the Staatsgalerie at Stuttgart, connected by Thiem with the Carmine *Nativity* (1977a, no. 340), in which the shepherd in the right foreground is posed differently and the child is missing. A rare life study for the shepherd, in a private collection in Milan (Florence 1985, 46, fig. 27), represents the

figure in the pose that he assumes in the Uffizi *modello,* further confirming that it represents the definitive solution.

It appears that the lost altarpiece was similar in many respects to an earlier *Nativity* painted by Santi around 1565 for the Florentine church of San Guiseppe (Spalding 1976, 278, fig. 1). The *Nativity* in San Giuseppe is also a two-tiered composition, and individual figures are carried over from the earlier composition. The Christ Child in this drawing is almost identical to that in the San Giuseppe altarpiece, although he seems smaller and more vulnerable. Finally, in both compositions much later historical personalities attend Christ's Nativity. Saints Jerome and Anthony join the Holy Family in the Carmine *Nativity,* while Saint Francis kneels beside the Virgin in the altarpiece in San Giuseppe.

At the same time, it appears that there were significant differences between the altarpieces. That in San Giuseppe is a night-piece, whereas the treatment of light in this drawing suggests that the Carmine altarpiece was more evenly and brightly lit, making it possible to see beyond the foreground to the cavalcade of the Magi approaching. More important, with the Carmine *Nativity* the impression that we may participate in the holy event, as the Michelozzi did, is stronger. The down-to-earth character of the Carmine altarpiece, as we know it from the Uffizi drawing, and particular details give the composition a Netherlandish flavor that brings to mind Hugo van der Goes's Portinari altarpiece, now in the Uffizi, which was installed in Santa Maria Nuova in Florence in May 1483 (Panofsky 1953, figs. 462, 463; regarding the transportation of the triptych see Hatfield Strens 1968). Certainly the human sentiment, unaffected piety, and broad naturalism of Santi's mature works have a great deal in common with the *ars nova* of fifteenth-century Flanders.

G.S.

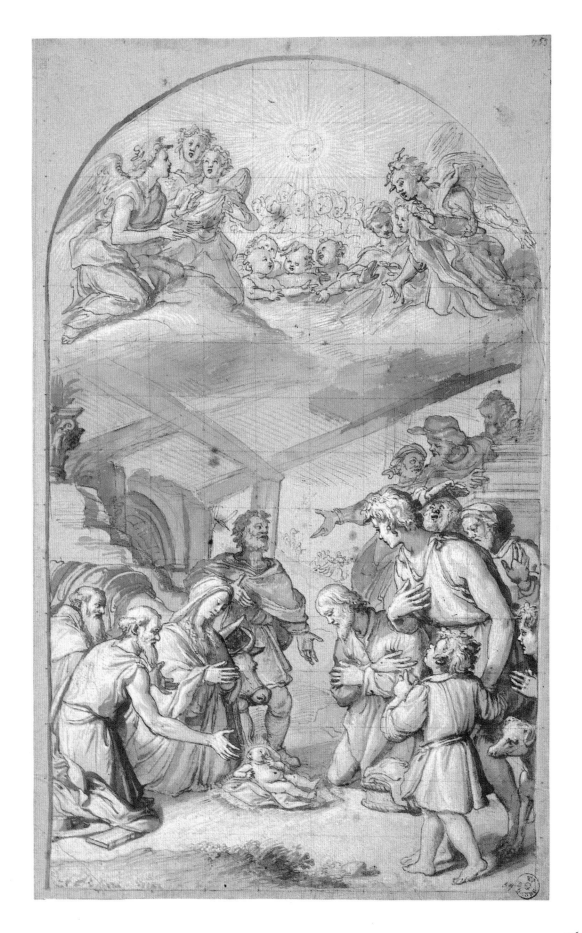

72. *An Elderly Man Attended by Four Young Women and Two Children in a Pastoral Setting*

Pen and brown ink and brown wash over traces of black chalk underdrawing, heightened with white, on yellowed blue paper; 154 × 228 mm

ANNOTATIONS: along lower edge at left of center in ink, *Santi di Tito;* at lower left corner in ink, *863*

767F

EXHIBITION: Florence 1985a, no. 19, fig. 20.

REFERENCE: Ferri 1890, 130.

In its present condition, with the original blue of the paper turned almost yellow, this bucolic composition has the appearance of a chiaroscuro woodcut, as the paper color, wash, and white heightening establish three graduated tones. The impression that the drawing is an independent, finished work is strengthened by the fact that the composition is framed and by the manner in which the figures fill the available space.

The subject of the drawing has not been established, although Collareta (Florence 1985a, 40, no. 19) associated it in a general way with the sixth Eclogue of Virgil. The drawing depicts a bearded old man half-seated and half-reclining on the ground. He has a purse slung over his shoulder, and a drinking vessel and garland lie on the ground beside him. He is attended by four lightly clad, smiling young women, and two cheerful infants bind his feet with a leafy cord. Although the old man seems bewildered by the attention that he is receiving and unable to defend himself against his beautiful captors, the mood of the scene seems jolly and good-natured rather than malicious.

While the precise subject of the drawing has not been identified, it is clear that it is related to a group of subjects in which defenseless old men are seduced, embarrassed, and abandoned by lovely young women. Apart from the fact that it shows four young women rather than two, the drawing has a good deal in common with depictions of Lot and his daughters. More generally, the drawing elaborates on the theme of the ill-assorted couple, of which Albrecht Dürer's engraving of around 1495 (Bartsch 1981, 207, no. 93) is a well-known example. The connection with this subject is strengthened by the fact that Santi di Tito shows the light fingers of the young woman on the left stealing toward the old man's purse. The wanton character of the subject is also expressed by the attention given to binding the old man's feet (Ronchetti 1922, 27, discusses feet under the heading "Affetti libidinosi").

With the exception of the two mythologies that he contributed to the Studiolo of Francesco I, Santi's paintings are almost exclusively religious in subject matter. Similarly, drawings with mythological or profane subjects by the artist are exceptionally rare. One other example is in the British Museum (Turner 1986, no. 187). In this case too the subject matter has not been precisely established.

In his representations of religious subjects Santi was much concerned with textual accuracy and narrative clarity. It appears that he felt freer with pagan or secular subjects, however. Perhaps he approached the profane subjects simply as fable and considered them susceptible to whimsical elaboration.

Collareta (Florence 1985a, 40, no. 19) proposes a date in the 1580s for this drawing, linking it with the subject matter of Santi's panels for the Studiolo of Francesco I while also discerning in it a more naturalistic style.

G.S.

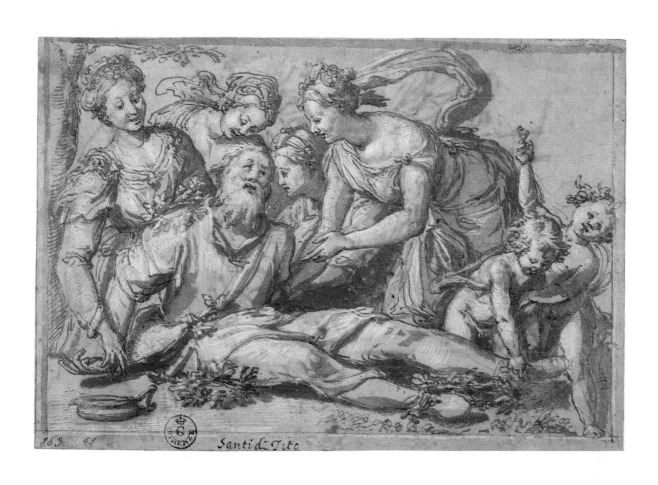

Bernardino Poccetti

San Mariano di Valdelsa 1548—Florence 1612

73. *A Standing Saint with His Right Hand Raised, a Second Standing Figure, and Two Small Composition Sketches*

Black chalk with touches of white chalk on blue paper; 411 × 245 mm

ANNOTATIONS: at lower left corner in pencil, *501;* at upper right corner in pencil, *859*

859F

EXHIBITIONS: Florence 1980, no. 18, fig. 17; Florence 1986b, no. 2.24, color pl. V.

REFERENCES: Forlani 1962, 262; Vitzthum 1972, 88.

During his early career in Florence, Bernardino Poccetti specialized in painting house facades. Following a relatively brief period of study in Rome between 1579 and 1580, he returned to Florence and transformed himself into a painter of large-scale fresco narrative cycles. During the next three decades Poccetti worked in the large cloister of Santa Maria Novella, in the cloister, vestibule, and chapel of San Pierino, in the Certosa di Val d'Elsa, and in the large cloister of the Santissima Annunziata, to mention only some of his most important Florentine commissions. Poccetti was much influenced by the paintings of Alessandro Allori and Santi di Tito. The work of Andrea del Sarto was also important in the formation of Poccetti's approach to narrative painting.

This imposing drawing is characteristic of finished figure studies done by Poccetti following his return from Rome. Vitzthum (1972, 88) was the first to recognize that it is a study for Saint Thomas in Poccetti's *Martyrdom of Saint Thomas,* executed for the cloister of San Pierino (Florence 1980, no. 18; a general view of the cloister is reproduced in Voss 1920, 2: fig. 136). Saint Thomas is identified by the builders' squares that he holds in his left hand. These allude to his appointment as architect to Gundoferns, King of India (Voragine 1969, 40–42; Kaftal 1952, 970). Apart from the elimination of these squares, in the fresco Saint Philip differs only in minor details from the principal figure in the present drawing. The saint's companion is almost completely eliminated from the painting, however. The rapid composition sketches in black chalk at the lower right are early studies for *The Agony in the Garden,* painted by Poccetti in the vestibule of San Pierino.

Poccetti's involvement in San Pierino began around 1585 when he contributed several scenes to the Passion cycle in the chapel (see Florence 1980, no. 16). Probably between 1585 and 1590, he executed seven of the fourteen lunettes in the cloister dedicated to the theme of the martyrdom of the apostles (see Florence 1986a, no. 1.9). *The Martyrdom of Saint Thomas* appears to have been one of the last to be executed and should be dated around 1590. Hamilton (Florence 1980, 11–12) has drawn attention to the fact that the theme of the martyrdom of the apostles is northern in origin and that there are no precedents for it in monumental Florentine painting before Poccetti's cycle. Studies connected with *The Agony in the Garden* appear on sheets with drawings for *The Martyrdom of Saint Matthew* and *The Martyrdom of Saint Thomas.* Consequently, it is reasonable also to date *The Agony in the Garden* to 1590 or soon after.

Poccetti's attention to the draperies and his evident awareness of their capability of idealizing and monumentalizing the human figure associate him with the pictorial traditions of the High Renaissance in Florence and Rome. Saint Thomas's dramatic, dignified gesture is also redolent of the rhetoric of the classical style. Hamilton emphasized the importance of figure studies by Andrea del Sarto as precedents for the present drawing but also suggested that the sharp folds of Poccetti's draperies have a northern quality that brings to mind the prints of Albrecht Dürer (Florence 1980, 14). While the subject of the fresco may be northern in character, the figure type and draperies are essentially Italian. They recall Raphael's figures and draperies in the Sistine tapestry cartoons and Andrea del Sarto's in the atrium of the Santissima Annunziata, in the Chiostro dello Scalzo, and in the *salone* at Poggio a Caiano (the tapestry cartoons reproduced in Shearman 1972; Sarto's frescoes reproduced in Shearman 1965). The rather jagged draperies and the artfully crumpled folds of the saint's rolled-up sleeves especially recall Sarto's drapery style in the *Tribute to Caesar* at Poggio a Caiano (Shearman 1965, 1: pls. 74, 76). There may also be some influence from the more contemporaneous classicism of Taddeo Zuccaro's frescoes in the Frangipani Chapel, in San Marcello al Corso in Rome (Gere 1969, pls. 89, 91).

The figure in this drawing reappears, as Christ, in Poccetti's later *Christ Healing the Leper* at the Certosa di Val d'Elsa (Venturi 1934, fig. 328).

G.S.

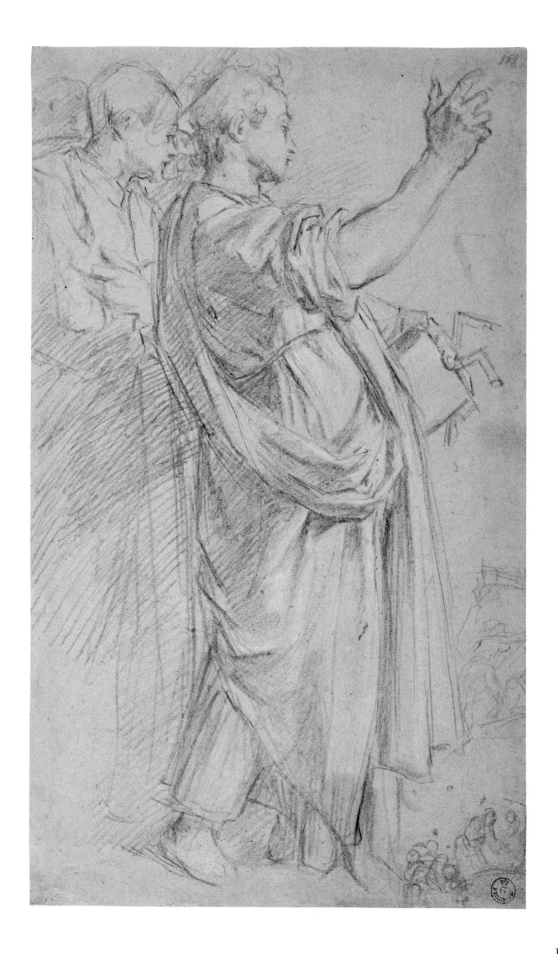

74. *The Visitation*

Pen and brown ink and brown and gray wash, heightened with gray, over traces of black chalk on gray paper; 262 × 171 mm

ANNOTATIONS: along lower margin to right of center illegible annotation or inscription in ink (canceled); on verso in brown ink, *Muziano;* in brown ink, 4

12831F

EXHIBITIONS: None.

REFERENCES: Byam Shaw 1976, 370, no. 51546; Florence 1980, 48, no. 31.

Traditionally attributed to Girolamo Muziano, a Brescian artist active in Rome during the second half of the sixteenth century, this composition study was recognized as Poccetti's by Philip Pouncey (note in curatorial files). Pouncey also associated it with a larger, squared drawing of the same subject by Poccetti (Uffizi 3920S; Florence 1980, no. 31, fig. 33). The studies have not been connected with an executed commission.

The drawings both employ rather dry, scratchy pen strokes over chalk, and represent successive stages in the preparatory process for the same work, with the squared study representing the definitive solution. They differ from each other in several significant respects, however. A cityscape is visible beyond the architecture in this drawing, whereas the two sides of the setting are joined by a tunnel vault in the definitive study, severely limiting the view. Space is more restricted in the larger study and the figures are much enlarged in relation to the overall height of the composition.

There are also significant differences in mood and iconography. In this drawing Mary wears an elegant long cape with raised collar, rather similar to that worn by the bride in a drawing by Poccetti representing the wedding of a princess (Uffizi 17475F; Florence 1980, no. 21, fig. 24). By contrast, in the later study she wears a dress with a collar cut low at the back, which emphasizes her long, slender neck and gives her a fragile, courtly appearance, reminiscent of a saint by Parmigianino or a princess by Paolo Uccello. Also, in this drawing Elizabeth's age is more apparent, and Poccetti's intention seems to be to make more of a contrast between the women. Perhaps more important, in this drawing the women's heads are almost at the same height, and Mary seems to take the initiative. In the later drawing Elizabeth is placed higher than the Virgin and clearly is the more forceful personality, with Mary appearing almost submissive by comparison.

Details such as the children in the right foreground of Poccetti's drawing bring to mind compositions by Santi di Tito (Spalding 1982, figs. 64, 128–129, 133).

There also seem to be relationships in motif and composition to works by Taddeo Zuccaro and Federico Barocci. Joseph's mule is remarkably like the one in studies by Taddeo for his *Flight into Egypt* in Santa Maria dell' Orto in Rome (Gere 1969, pls. 112, 113). The woman and children in the right foreground of this drawing bring to mind Barocci's *Madonna del Popolo* in the Uffizi (Bologna 1975, fig. 106), and the basket in the left foreground recalls domestic details that appear in several paintings by Barocci. In composition and iconography Poccetti's definitive scheme resembles Barocci's *Visitation* in the Chiesa Nuova in Rome (Bologna 1975, fig. 162), completed in 1586, though Barocci's composition is more austere than Poccetti's. The Chiesa Nuova *Visitation* postdates Poccetti's period of study in Rome and may be later than this drawing, so it is likely that any resemblances between the two are coincidental.

On the basis of relationships in style to a drawing for the *Founding of Santa Maria Maggiore* in Santa Felicita in Florence, Hamilton (Florence 1980, 48, no. 31) dated the larger *Visitation* study circa 1585–88. In its treatment of space and emphasis on architecture, however, this drawing closely resembles a study for the *Baptism of Saints Nereus and Achilleus,* executed for Santa Maria Maddalena de' Pazzi in Florence a decade later (Rome 1977, no. 21, fig. 21). The scenographic treatment of architecture and similarities in the handling of media also link this study to a *modello* for *Saint Andrew Corsini Healing a Blind Man at Avignon,* painted by Poccetti for Santa Maria del Carmine about 1599 (Rome 1977, no. 22, fig. 22).

A Florentine engraver, Stefano Mulinari (Thieme/ Becker 1931, 260), reproduced this drawing actual size between 1766 and 1774. The print bears the information *Girolamo Muziano inv: e del: Mulinari incis:* (Uffizi, *Stampe in Volume,* no. 607), so the drawing was attributed to Muziano prior to the Uffizi inventory of 1793.

G.S.

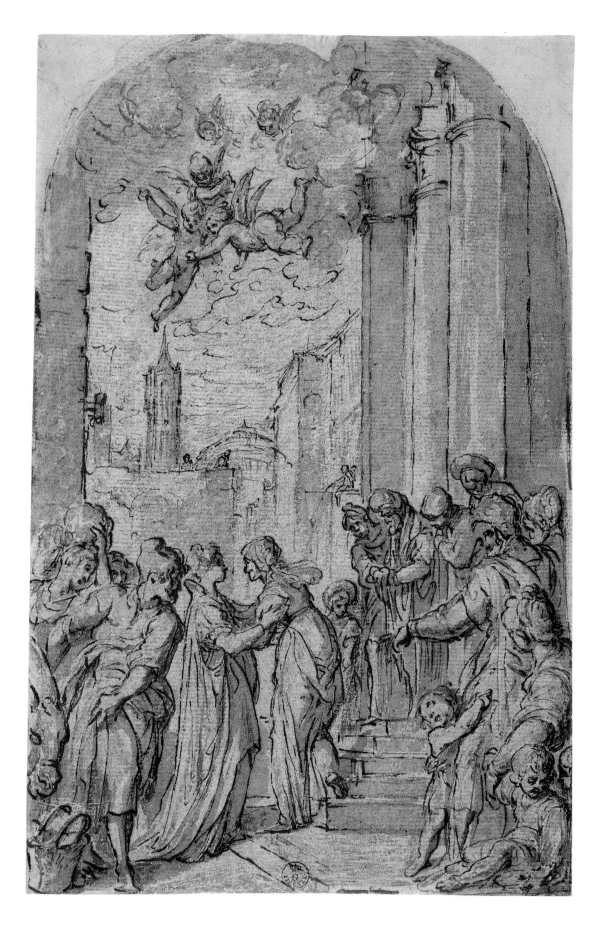

75. *Study for the Decoration of a Chapel with an Altarpiece and the Adoration of the Magi*

Pen and brown ink and brown wash over traces of black chalk; 270 x 363 mm

ANNOTATIONS: at lower left corner in pencil, *208;* at upper right corner in pencil, *840*

840F

EXHIBITION: Florence 1980, no. 105, fig. 129.

REFERENCES: None.

At the right of this sheet is a design for the frame of an altarpiece, drawn with the help of a straightedge. The elevation of the side wall of the chapel is drawn to the left, with the altar and altarpiece being shown in section at the right side of this study. A horizontal composition depicting the Magi and their attendants occupies most of the upper section of the wall. The scene is framed by paired pilasters which echo those on the frame of the altarpiece; between the pilasters are vertical oval and rectangular frames. Poccetti also used a straightedge in this section of the drawing, but the handling in general is considerably freer. Poccetti establishes the composition and setting in the large field but is not concerned with characterizing individual figures. He is concerned with describing the effects of light in the scene, however, and does so by employing a range of pale brown washes. The nature of the drawing suggests that it was intended to be submitted to a patron for his approval of a scheme for the decoration of a chapel.

It is reasonable to suppose that the altarpiece would have represented the Nativity, as Hamilton suggested (Florence 1980, 108, no. 105). In that case, the structure at the right of the scene on the side wall would probably have continued into the background of the altarpiece. Only two Magi are certainly identifiable in the sketch (although it may be that the figure in the middle distance at the left looking out of the composition is intended to be the third Magus), and so it is possible that the third Magus and his retinue were to be represented in a companion panel on the right wall of the chapel. The idea of having the Magi converge on the Madonna and Child from different directions was established in fifteenth-century Florence in an Epiphany pageant, the *Festa de' Magi,* and in paintings by Botticelli and Leo-

nardo (Hatfield 1970, 108–119; Hatfield 1976, figs. 1, 60, 63).

The Compagnia de' Magi, a confraternity devoted to the veneration of the three kings, took responsibility for the Epiphany pageant. It became an important element in the social and religious life of Florence during the fifteenth century, with important Florentine families, such as the Medici, identifying themselves with the Magi (Hatfield 1970, 107–161). From the mid-fifteenth century until 1494, when the confraternity was suppressed, the Compagnia de' Magi appears to have been established at San Marco. In December 1494 property belonging to the confraternity was transferred to San Marco, however, and in January 1498 Savonarola and the friars of San Marco themselves enacted the celebration of Epiphany. It is possible that Poccetti's study for a chapel in honor of the Magi, a modern version of the "tabernacle of the divine Three" in the Palazzo Medici (Hatfield 1970a, 232–249), was connected in some way with San Marco. An *Adoration of the Magi* and a *Marriage at Cana* were in fact executed in the presbytery at San Marco in the early eighteenth century.

Hamilton (Florence 1980, no. 105) convincingly dates Poccetti's drawing to the first decade of the seventeenth century on the basis of relationships in style, composition, and figure types to two drawings securely datable between 1604 and 1608. The first, in the British Museum (Turner 1986, no. 189), is for a *Marriage at Cana,* while the other, in the Metropolitan Museum of Art (Bean 1982, no. 182), is a study for the *Death of Saint Alexis Falconieri at Monte Senario,* one of the lunettes in the Chiostro dei Morti at the Santissima Annunziata.

G.S.

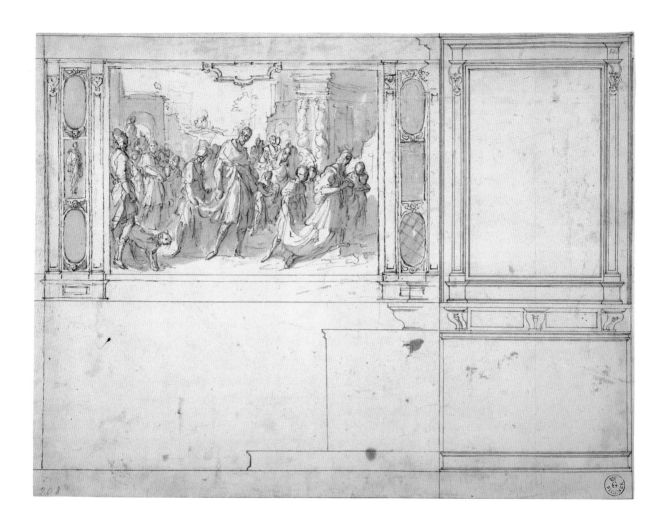

76. *Study for a Ceiling Decoration*

Pen and brown ink with light wash and white heightening, over traces of black chalk underdrawing, on brown paper; 235 x 315 mm

ANNOTATIONS: along right margin in brown ink, *Bernardino Poccetti;* at upper right corner in pencil, *19* (twice); on mount in pencil, *Bernardino Poccetti* and *39* (canceled)

930E

EXHIBITION: Florence 1980, no. 104, fig. 111.

REFERENCES: Ferri 1881, 52; Ferri 1890, 105.

The lively, small figures and delicate vegetation in this exhilarating drawing recall Poccetti's beginnings as a specialist in facade decorations and explain his sobriquet, "Bernardino delle grottesche." Superimposed on the airy field of the vault is a central octagon supported by putti seated on oval cartouches. An alternative scheme is considered in a third cartouche where the putti stand on either side of the frame rather than sitting on top of it. One of the cartouches contains a rapid sketch for a Nativity, while another has a seated, winged figure reminiscent of Raphael's personification of Poetry in the vault of the Stanza della Segnatura in the Vatican Palace (Pope-Hennessy 1970, fig. 136). In the central frame there appear to be two seated figures separated by a glory and surrounded by lightly indicated clouds.

Much the same decorative vocabulary can be found in other drawings by Poccetti in the Uffizi and in the Biblioteca Marucelliana in Florence (Florence 1980, nos. 25, 26; Florence, Palazzo Strozzi 1980, no. 382). Similar motifs can also be made out on the facade of the palace of Bianca Capello in Florence decorated by Poccetti between 1574 and 1579 (Thiem 1964, no. 52, figs. 136–140).

Hamilton (Florence 1980, no. 104) considered the scheme of this drawing to be a reelaboration of Poccetti's decorations for San Martino at the Certosa di Siena, executed between 1596 and 1599; he also related the drawing to Poccetti's project for the central vault of the loggia of the Ospedale degli Innocenti painted in 1611. On the basis of these relationships he proposed a date between 1605 and 1610 for the drawing.

The faintly suggested scene in the central octagon might almost be a first thought for a composition, representing the Trinity with the Virgin, saints, patriarchs, and angels, in the British Museum (Turner 1986, no. 195). Moreover, the putti in this drawing have many of the same features as the angels in the latter drawing. Hamilton (Florence 1980, 100, no. 91) connected the British Museum drawing with the decoration of the choir of Sant' Apollonia in Florence, executed by Poccetti circa 1611. This relationship lends support to Hamilton's late dating for the drawing here.

G.S.

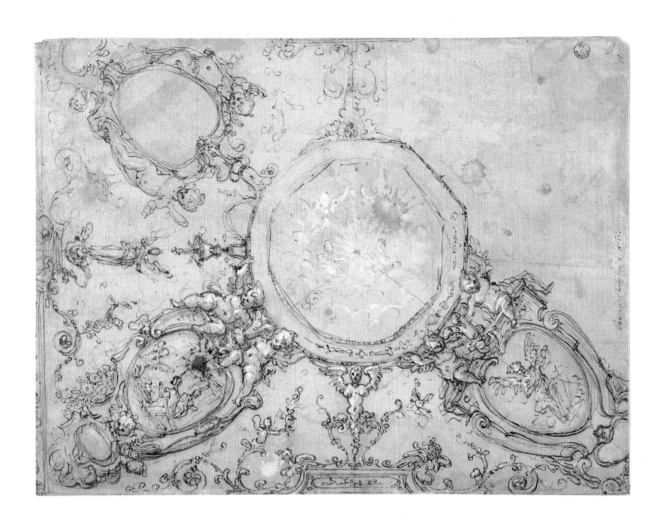

Jacopo Chimenti, called Empoli

1551 Florence 1640

77. *The Immaculate Conception*

Pen, brown ink, brown wash, and traces of black chalk, the page squared in red chalk; 434 x 284 mm. Mounted

ANNOTATIONS: at upper right in pen in different antique hands, *38.*, *36.*

3412F

EXHIBITION: Florence 1962, no. 12.

REFERENCES: Ferri 1890, 56; De Vries 1933, 348, 385; Florence 1962, 20, no. 12; Bianchini 1980, 116 n. 81; Neuburger 1981, 383–386.

The life of Jacopo Chimenti, called Empoli for his family's place of origin, is remarkable in that its events, as well as those of his artistic career, are so mundane. It seems that he never left Florence, the city of his birth; there he received an education typical of artists bound by the dictates of the Counter Reformation. This religious and intellectual movement advised artists, among other things, that "the purpose of painting is likeness to the thing represented, which some call the soul of painting, because all the other things like beauty, variety of color, and other ornaments, are accessories to it" (Paleotti 1582, 3).

It is logical to expect, therefore, that Empoli was profoundly influenced by those masters who could guide him in the elaboration of sober, well-balanced compositions in which he could fully express those sentiments of simple realism. His innumerable altarpieces tend to transform sacred subjects, even those with the loftiest theological content, into episodes of daily domestic life. Thus after his early artistic training following the lessons of Vasari and Maso da San Friano—the latter, according to Baldinucci (4:6), was his first real teacher—Empoli turned to search for examples better suited to those purposes, examples less compromised by the refined abstractions of Mannerism, finding them in Santi di Tito, Alessandro Allori and, going back a generation, Andrea del Sarto.

With these experiences as his background, he developed a figurative language of great decorum and consummate skill, whose results, while never reaching heights of real genius, do not plunge into mediocrity or worse.

Among his most characteristic achievements is the altarpiece representing *The Immaculate Conception* in the Florentine church of San Remigio, one of the best products of the artist's early maturity. For the execution of this altarpiece Niccolò Gaddi left the considerable sum of 100 florins in his will, which was drawn up by the notary Ser Andrea Andreini in 1591. The compositional genesis of this work must have been long and tortured if the sheet shown here documents an initial or very early stage in the process, as was first indicated by O. H. Giglioli in a handwritten note on the inventory card and later accepted by common consent. This drawing is an early idea destined to undergo major changes in the distribution of the figures, while maintaining a pronounced upward-looking viewpoint, the effects of light and shadow produced by the host of angels at the top, and the rather unusual arrangement of the figures shown from the back in the foreground. In the painting, the figure of the protagonist will become the Virgin rather than John the Baptist as seen in the drawing.

Unfortunately, most of the numerous studies that the artist must have done to develop the subject to its final version now seem to be lost. Of the various sheets that have most recently been connected with this work— Uffizi 3419F, 3452F, 3454F, 1820S, 1825S, 1826S, and 1834S—only the last, identified by Giglioli in a handwritten note on the mount, is actually preparatory for one of the figures of the San Remigio altarpiece, that of the angel in the upper left foreground. While different in technique (it is done in red and white chalk) and typology (it is the study of a detail rather than a compositional sketch), stylistically it is identical to the sheet shown here and also represents a moment of unique concurrence of Empoli's practice with the contemporary methods of Cigoli in the rapid course of its tangled lines and almost pictorial effect of the play of chiaroscuro.

A.M.P.T.

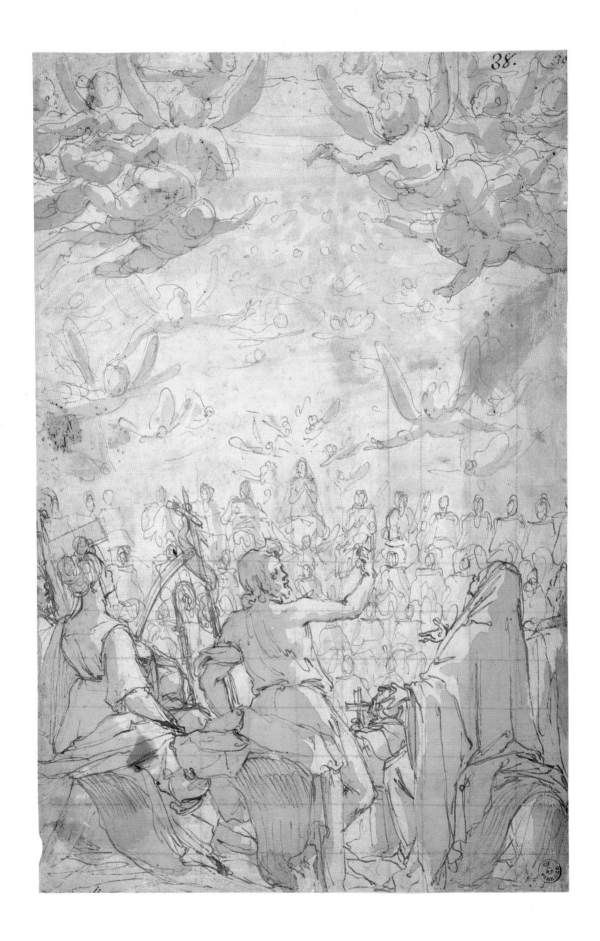

78. *Head of a Veiled Woman*

Black chalk, gray wash, and white lead, on gray-tinted paper; 393 x 266 mm. Mounted

9382F

EXHIBITIONS: Florence 1962, no. 64; Florence 1986, no. 2.85.

REFERENCE: De Vries 1933, 384; Florence 1962, 45, no. 64; Spear 1973, 68; Bianchini 1980, 132; Florence 1986c, 138, no. 2.85.

In the large group of drawings by Jacopo da Empoli, the majority of which are in the Uffizi, a beautiful series of studies of heads is of particular interest for understanding the artist's figurative language. They clearly show his considerable gifts as a portraitist, which we find fully documented in his paintings, where the characters, even when they are taken from the Scriptures, often suggest that they have been elaborated from real-life models. An example of Empoli's ability can be seen in this splendid drawing, which, while recalling in the simple purity of its line much earlier examples from Sarto, suggests contemporaneous works of Bolognese artists and especially Guido Reni in the harmonious rhythm of its serenely monumental forms.

As De Vries has pointed out, this is a preparatory study for the head of the female figure in the middle ground at the right in the altarpiece *Saint Ives Protector of Widows and Orphans* from 1616, now in the Palazzo Pitti.

If the word of Filippo Baldinucci is to be trusted, it is probable that the facial features of the young painter Giovan Battista Vanni are preserved here. The historian writes (4:547) that "we see here the portrait of this artificer, at the time when he was a youth of seventeen years of age, done by Jacopo da Empoli his teacher at the time, in the beautiful picture of Saint Ives" and then goes on to say "Empoli did this portrait so as to represent the faces of the widowed women." (The plural "widowed women" is justified by the fact that the features of this face are also found in another veiled woman at the extreme left of this painting.)

Connected with the Saint Ives altarpiece are two other sheets in the Uffizi: 1800S, containing various sketches for the cherubs at the top, and 9385F, preparatory for the young man standing hat in hand in the foreground of the composition, both identified by De Vries (1933, 384). There is a drawing in the Allen Memorial Art Museum, in Oberlin, Ohio, that seems almost certainly to be a copy from the painting (Spear 1973, 68).

A.M.P.T.

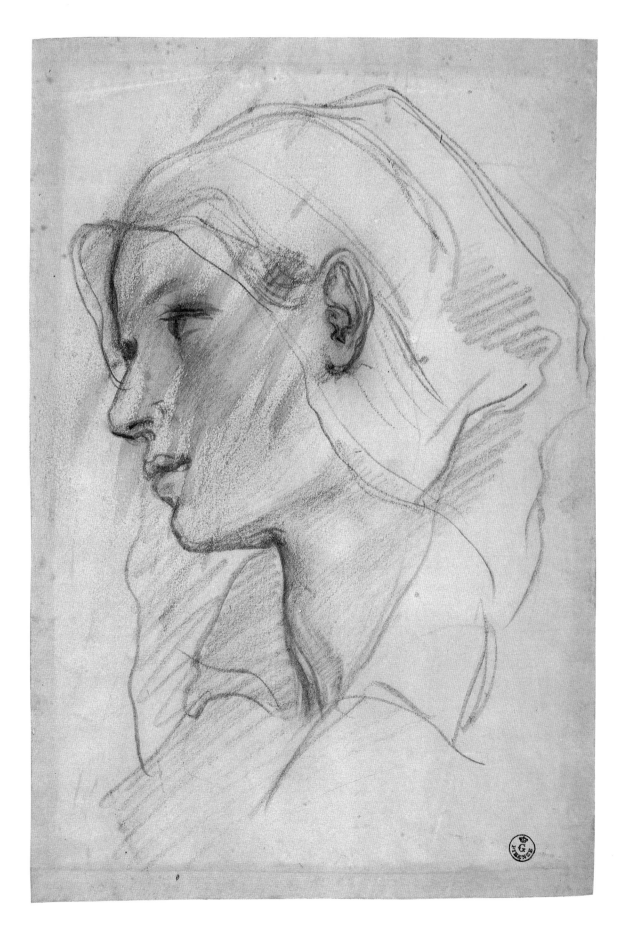

183

79. *Male Nude with His Arms behind His Back*

Charcoal and white chalk, on blue paper; 438 x 245 mm. Mounted

ANNOTATIONS: at lower right in pen, in a seventeenth-century hand, *In S. Lorenzo.*

9380F

EXHIBITIONS: None

REFERENCES: De Vries 1933, 355, 383; Florence, Palazzo Strozzi 1980, 114; Paris 1981, 22.

The major point of interest in a sheet of this kind lies not only in the extremely high quality of its graphic execution, which is free of error or uncertainty, but also in its value as a demonstration of the substantial continuity of intellectual approach to the concept of drawing found in the works of Florentine artists throughout the sixteenth and seventeenth centuries.

This is an academic study from life, in which the artist copies a real model standing in the pose that a certain character will take in a painting, but without the clothes and attributes that will identify him in the painted version. In this way the artist can study all those elements—from the relationship between volume and space to the dynamic tension of the gesture—that work together toward the perfect balance of the final formulation of the figure, both individually and in the context of the composition. In both the nature of this drawing and its graphic style, Empoli fits into a tradition that begins with Andrea del Sarto and Pontormo and includes Bronzino, Vasari, and Naldini. At the same time it furnishes a connection with sheets by artists of the younger generation, such as Cristofano Allori, Matteo Rosselli, and Francesco Furini.

This study, as suggested by the old inscription at the lower right, was identified by De Vries as preparatory for the figure of the protagonist in the altarpiece of the *Martyrdom of Saint Sebastian* in San Lorenzo. The painting is a work of uncertain dating which is now most often placed in the second decade of the seventeenth century (Bianchini 1980, 137–138). According to Baldinucci (3:12), Jacopo tried very hard, "making and remaking" the altarpiece, to find a satisfactory solution for many of the characters. This contention on the historian's part is confirmed by the existence of a group of drawings in the Uffizi. While none of the numerous figures found in the painting are absolutely identical to those in the drawings, these seem to be early ideas for some of them which were subsequently discarded or modified. Uffizi 9351F is a second study analogous to this one but giving a mirror image for Saint Sebastian; Uffizi 2243S and 9348F show the figure of a jailer studied in two alternatives; and Uffizi 9397F is a study from a nude model for the character kneeling in the left foreground.

A.M.P.T.

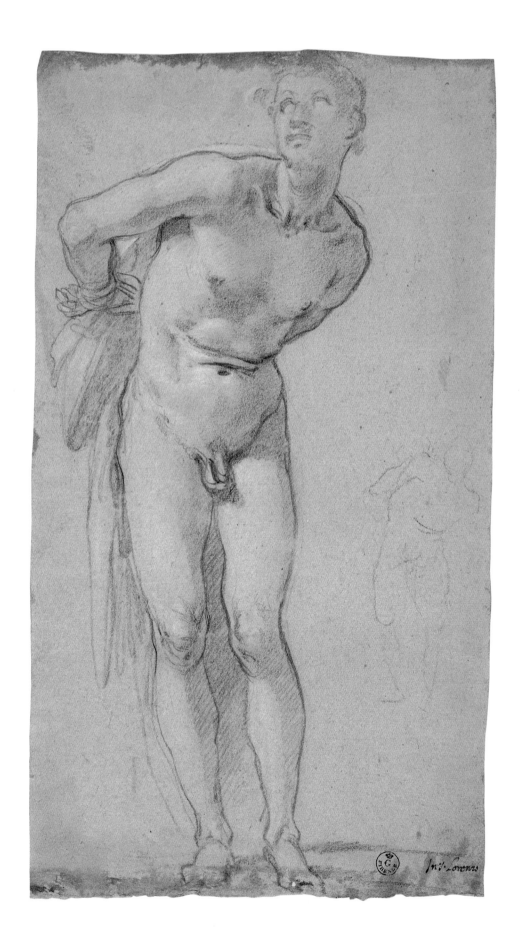

Cristofano Roncalli, called Il Pomarancio

Pomarance, Volterra 1551/52—Rome 1626

80. *The Departure of Pompey for the War against the Pirates in the Mediterranean*

Black chalk with traces of pen and brown ink, squared with a stylus and in black chalk; 210 x 300 mm

ANNOTATIONS: at lower right in ink, *C. Pomarancio;* on verso near the top left of the sheet in ink, *Pomarancio;* in lower section of the sheet in ink, *Incerto*

10156F

EXHIBITION: Florence 1979, no. 11, fig. 9.

REFERENCE: Kirwin 1978, 36–39, fig. 38a.

Cristofano Roncalli, known as Il Pomarancio, began his career in Siena but moved to Rome while still in his twenties, probably in 1578. With the exception of a decade in Loreto, between 1605 and 1615, Roncalli spent the remainder of his life in Rome, where he served Popes Gregory XIII, Clement VIII, and other patrons (for Roncalli's career, see Kirwin 1978, 18–26, and Florence 1979, 19–20).

In the ten years following his arrival in Rome, Roncalli succeeded in establishing himself on the Roman scene, acquiring a variety of important commissions, in large part through his involvement in the Oratory of San Filippo Neri in Santa Maria in Vallicella. An exception to this pattern was his collaboration in 1591 with Giovanni and Cherubino Alberti on the decoration of the *salone* of the Palazzo Ruggieri with scenes from the life of Pompey. This drawing, which represents the departure of Pompey for war against the pirates, is the *modello* for one of the two principal scenes in the *salone,* as Kirwin recognized (1978, 39, figs. 38a and 38b; Florence 1979, 31–32, no. 11; on the Palazzo Ruggieri and its decorations, see Brugnoli 1960, 223–246 [the *Departure of Pompey,* as by Giovanni and Cherubino Alberti, fig. 7], and Brugnoli 1961, passim). This drawing compares precisely with the painting except for one or two details. In the fresco, the soldier in the lower right corner is turned toward the spectator, and the bearded figure, immediately to the right of Pompey, is provided with a shield. The final composi-

tion is strongly reminiscent of a fresco by Niccolò Circignani, Roncalli's older colleague from Pomarance, in the Belvedere apartments in the Vatican (Smith 1977, fig. 85).

The authorship of the decoration of the Palazzo Ruggieri is not documented, but the traditional attribution of this drawing to Roncalli is certainly correct, as is evident if one compares it with the artist's *modello* in the British Museum for his *Visitation* in the church of San Giovanni Decollato in Rome, executed circa 1590 (Kirwin 1978, fig. 36). In addition to similarities in the handling of the black chalk, the general organization of the compositions and the particular deployment of the architectural settings are very similar. Moreover, in pose and features the young soldier with arm upraised, at the extreme left of this drawing, closely resembles a woman carrying a basket on her head on the right side of the *Visitation.*

In keeping with the antique subject matter, Roncalli modeled the principal group in the drawing on Roman *adlocutio* reliefs, such as that in the attic story of the Arch of Constantine in Rome. At the same time, the animated draperies and loose-hipped poses of Pompey and his officers show evidence of Roncalli's Sienese origins, bringing to mind Domenico Beccafumi's elegant classicism in his frescoes in the Palazzo Pubblico (Sanminiatelli 1967, pls. 47–47u; Briganti and Baccheschi 1977, pls. XXXV A-XXXIX B).

G.S.

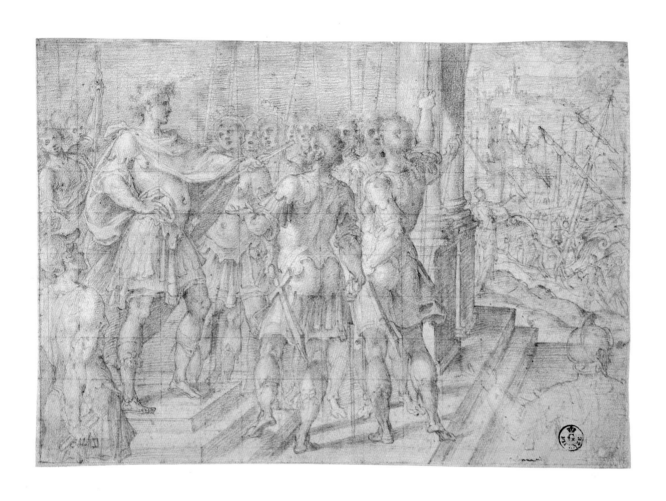

187

81. *Two Studies of a Nude Youth Seated on a Parapet and Separate Studies of a Head and a Right Leg*

Red and black chalk, with traces of white chalk, on blue paper; 255 x 420 mm

10159F

EXHIBITION: Florence 1979, no. 23, fig. 25.

REFERENCES: Chappell and Kirwin 1974, 134, n. 123; Kirwin 1978, 42.

Roncalli's career reached its culmination between 1599 and 1604, during the pontificate of Clement VIII. In that five-year period, Roncalli participated in one of the most important commissions of Clement's papacy, the decoration of the transept of San Giovanni in Laterano, and took charge of another, the decoration of the Cappella Clementina in Saint Peter's (Chappell and Kirwin 1974, 131–136, and passim; Florence 1979, 42). In connection with the latter project, Roncalli himself was commissioned to paint a monumental altarpiece for one of the side altars in the Cappella Clementina. Executed between the spring of 1603 and June 1604, this painting, which represents the death of Sapphira, is Roncalli's most dramatic and imposing achievement (reproduced in Chappell and Kirwin 1974, fig. 6).

As Chappell and Kirwin recognized (1974, 134 n. 123; Florence 1979, no. 23), the drawings gathered on this sheet are preparatory studies for one of the excited spectators who witness the death of Sapphira from vantage points on a raised structure behind Peter and his companions. The four finished studies and the sketch of a foot are all related to a figure seated on the parapet at the right of the group, immediately to the right of a centrally placed nude youth. The figure also appears in a composition drawing for the altarpiece preserved in the Uffizi (Chappell and Kirwin 1974, fig. 4; Florence 1979, no. 20, fig. 22), and in an oil *bozzetto,* formerly on the London art market (Pouncey 1977, fig. 108; the attribution to Roncalli doubted by Kirwin 1978, 59 n. 126). He also appears in a red chalk study, in a private collection, for the four principal figures in this group (Pouncey 1977, fig. 109).

In the present drawing, Roncalli clearly is intent on refining and finalizing the figure's pose and lighting through detailed studies from life. Roncalli made many studies of this kind, for this figure and for his companion (Chappell and Kirwin 1974, 134 n. 123, figs. 11–16; Florence 1979, figs. 25, 27–30). These studies are highly finished and achieve a remarkable sense of relief, suggestive of statuary. Not all the studies are drawn from life, however. In fact, the detail study for the head of the figure on this sheet is adapted from an antique bust of Apollo, owned at the end of the sixteenth century by Vincenzo Giustiniani (Kirwin 1978, 42; Florence 1979, 47). Curiously, the study from the sculpture appears more lifelike than those from the model. Roncalli appears to have given the antique model something of the softly seductive and erotic nature of Leonardo's types. In addition, the head is strikingly similar to that of Michelangelo's *Giuliano de' Medici* in the New Sacristy of San Lorenzo.

G.S.

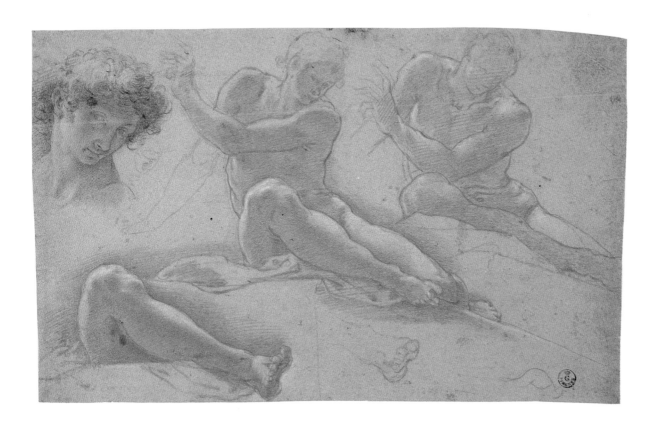

Gregorio Pagani

1558 Florence 1605

82. *The Virgin and Child in a Garden with Saint Dominic, Saint Sebastian, and Two Angels*

Pen and brown ink and brown wash, heightened with white, over traces of black chalk underdrawing, partially gone over with a stylus, on blue paper; 384 x 267 mm

ANNOTATIONS: on verso near upper right edge to right of center in brown ink, *Gregorio Pagani;* at upper left corner in brown ink, *Greg? Pagan[i]*

15160F

EXHIBITION: Florence, Palazzo Strozzi 1980, no. 337.

REFERENCES: None.

Like Lodovico Cigoli, his contemporary and friend, Gregorio Pagani was a pupil of Santi di Tito. With Cigoli and Santi he participated in the reform of Florentine Mannerism in the last quarter of the sixteenth century, developing a new, more naturalistic style. Federico Barocci was an important influence on Pagani, as was Correggio, whose paintings he studied on a visit to Lombardy in 1591. Pagani's drawing style shows the continuing influence of Santi, however.

Formerly classified among the anonymous seventeenth-century drawings, this study was attributed to Pagani by Annamaria Petrioli Tofani in a note written on the mount in 1976 and was published as such in 1980 (Florence, Palazzo Strozzi 1980, no. 337). Petrioli Tofani associated the drawing with a closely related sheet in the Victoria and Albert Museum, first attributed to Pagani by Pouncey (Ward-Jackson 1979, 107, no. 214, fig. 214; Florence, Palazzo Strozzi 1980, no. 336). In the latter drawing the upper part of the composition is completed to represent an arbor with fifteen circular medallions incorporated into the foliage. In addition, the angel to the right of the Virgin is brought to the same level of finish as his companion on the left.

Thiem (1970, 30, 58, G 44, 79, Z 23) associated the Victoria and Albert Museum drawing with Filippo Baldinucci's description of a painting, now lost, commissioned from Pagani by Giovansimone Tornabuoni about 1595. According to Baldinucci, the *concetto* was devised by Tornabuoni himself. The painting depicted the Virgin in a rose garden containing a palm, a thorn tree, and a rose tree. In medallions on the palm, shown to the left of the Virgin in the Victoria and Albert Museum drawing, Pagani represented the five Joyful Mysteries of the Incarnation—the Annunciation, the Visitation, the Nativity, the Circumcision, and Christ among the

Doctors. In the thorn tree, to the right of the Virgin, he painted the five Sorrowful Mysteries of the Passion—the Agony in the Garden, the Flagellation, the Crowning with Thorns, the Bearing of the Cross, and the Crucifixion. Finally, directly behind the Virgin, in the rose tree, he depicted the five Glorious Mysteries—the Resurrection, the Ascension, the Descent of the Holy Spirit, the Assumption, and the Coronation of the Virgin. Baldinucci also commented on the exceptional beauty of Saint Sebastian.

The *modello* for another lost painting on the theme of the Madonna of the Rosary, commissioned from Pagani by Giovanni Marenozzi, is preserved in the Louvre (Thiem 1970, 78–79, Z 20, fig. 37). It is closely related to this drawing in style as well as subject matter.

Several of the types in this drawing can be found in other works by Pagani from the 1590s. An almost identical Christ Child appears in a *Madonna and Child with Saint Michael and Saint Benedict* in San Michele Arcangelo in Le Ville near Terranuova Bracciolini, painted by Pagani circa 1594 (Thiem 1970, 49, G 5, fig. 5). A chalk study in the Uffizi for the head of a child, associated by Thiem (1970, 79, Z 24, fig. 42) with the Infant Christ in an altarpiece dated 1598, might equally well have served as a detail study for the Christ Child in the present drawing. Similarly, the moon-faced Virgin is characteristic of Pagani's depictions of the Madonna during the 1590s (Thiem 1970, figs. 2, 5, 6). Finally, the pose of Saint Sebastian and particularly the hyperactive fingers of his left hand recall a study by Pagani for the Saint John the Baptist in his Correggiesque *Madonna and Child with Saints* of 1592, now in the Hermitage in Leningrad (Thiem 1970, 76, Z 9, fig. 29, 48, G 3, fig. 2).

This drawing and Giovansimone Tornabuoni's paint-

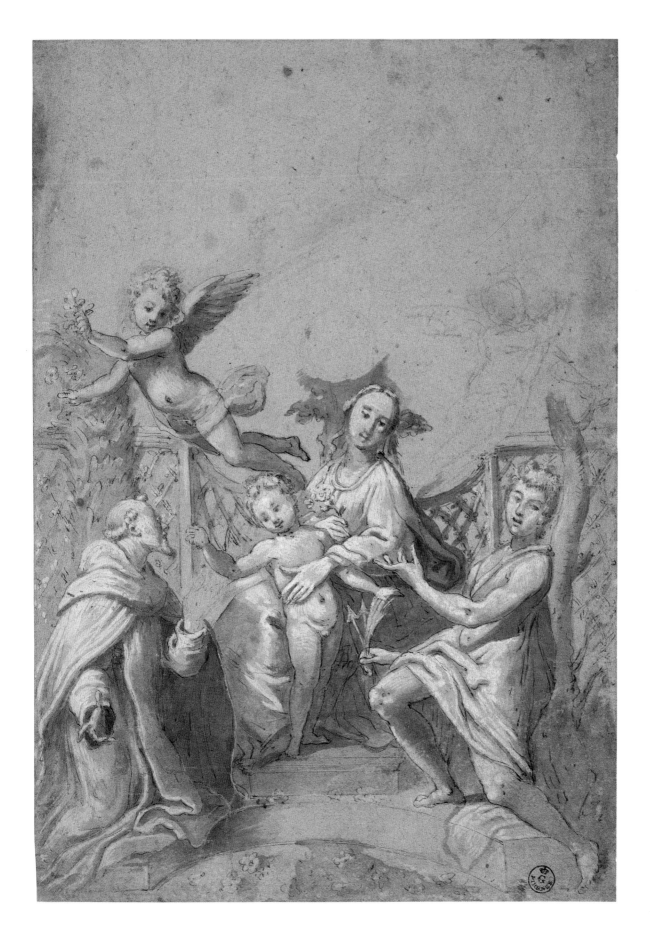

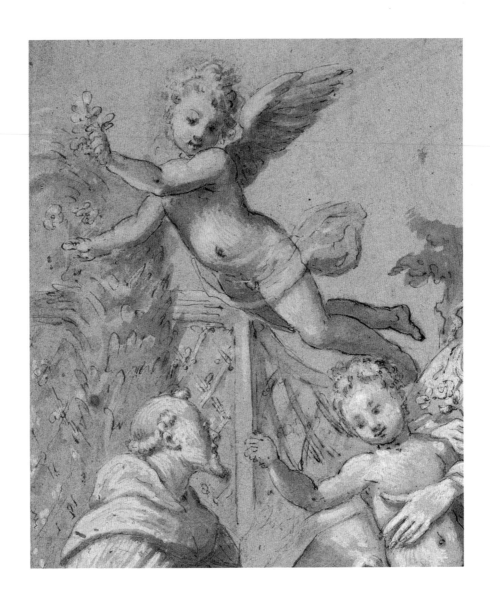

ing can be related in a general way to the iconographic theme of the *Rosenkranzbild,* made popular by the spread of the cult of the rosary and the founding in 1474 of the Confraternity of the Rosary (see Panofsky 1955, 110–112). The prominence given to Saint Dominic is intrinsic to the subject, as is Dominic's direct communion with the Christ Child. A novel feature is Saint Sebastian's presence as intermediary between us and the Virgin, however. This may have been carried over by Pagani from his Saint John the Baptist in the Leningrad *Madonna and Child with Saints.*

Giorgio Vasari's monumental *Madonna of the Rosary,* executed by Jacopo Zucchi in 1569 for the Capponi Chapel in Santa Maria Novella (Hall 1979, fig. 33), may have had some impact on the iconography of Pagani's painting. In general, however, Pagani's composition is quite different from that by Vasari. The simplicity of Pagani's composition, with a cast limited to the Virgin and Child, Saint Dominic, and Saint Sebastian, forms a striking contrast to the tightly packed multitude of posturing figures in Vasari's painting and suggests a new, accessible, and more personal form of piety, consistent with Counter-Reformation style.

According to Hall (1979, 115) the subject of the Madonna of the Rosary acquired a special currency following the defeat of the Turks at Lepanto in October 1571. The popularity of the theme was also enhanced by the institution of a feast of the rosary by Pope Gregory XIII in 1573 (Panofsky 1955, 111). The personal nature of Giovansimone Tornabuoni's and Francesco Marenozzi's commissions and their relation to traditional *Rosenkranzbilder* made it unlikely that they were connected in any way with the events surrounding the Battle of Lepanto, however.

G.S.

83. *The Flagellation of Christ*

Pen and brown ink and gray-brown wash, heightened with white (partially oxidized), over traces of black chalk, framed in pen and ink, the left and lower edges marked off for squaring for enlargement, on ocher paper; 438 × 290 mm (sheet); 254 × 252 mm (image)

ANNOTATION: on mount in pencil, *T (127) bottega Gregorio Pagani*

10498F

EXHIBITIONS: None.

REFERENCES: Voss 1920, 2:396 n. 1; Thiem 1970, 95, Z 127.

Between 1599 and 1601 Pagani received a series of payments for the preparation of three reliefs for the great bronze doors of the west facade of the cathedral of Pisa. These were commissioned in 1597 to replace the old doors, which had been destroyed by fire in 1596. Documents establish that Pagani was responsible for the *Agony in the Garden,* the *Flagellation,* and the *Crowning with Thorns* on the right side portal (Thiem 1970, 68, P 1–3, figs. 16–18; for a general view of the right side door, see von Erffa 1965, fig. 3).

This drawing is a finished model for the *Flagellation,* as Voss recognized (1920, 2:396 n. 1). The composition is reversed in the relief, however, and the relief differs from the drawing in several details. In the drawing the flagellation takes place in a grand but rather austere barrel-vaulted chamber, through which there is a view of the city. In the relief the architecture is more complicated, but the cityscape is less developed. As a result of the reversal of the composition it evidently was thought necessary to make certain changes to the soldier shown with his back to us. In order to maintain a right-handed action the scourge was transferred from his outflung hand to that crossed over his chest in front of him. As a result, in the relief he uses a backhanded and rather restricted gesture to scourge Christ. Also, without the scourge the outflung arm has less meaning and is less effective in the overall composition of the relief. In addition, the soldier's tight, slashed hose are replaced by a short, kiltlike tunic in the relief.

The reason for the reversal of the composition is not known. Thiem has suggested (1970, 95, Z 127) that the *Flagellation* may have been intended originally for the left rather than the right valve of the right side door, so that the reversal would have been necessary for compositional reasons. In any case, the decision to reverse the composition must have been made relatively late in the preparatory process since the drawing is marked off for enlargement along the left and lower edges of the sheet. Oddly, however, the two known detail studies for the *Flagellation* (one for Christ and one of the soldiers and the other for the arms of the soldier in the right foreground of the relief) both relate to the organization of the relief rather than to the present composition study (Thiem 1970, Z 29v and Z 30).

Thiem (1970, 95, Z 127) considered the *modello* for the *Flagellation* to be a workshop production. The differences between the drawing and the relief and the superior quality of the composition and conception of the former make this unlikely, however. In addition, the *modello* for the *Flagellation* compares closely with Pagani's finished composition drawings for the *Madonna of the Rosary,* in the Louvre, and the *Death of Pyramus and Thisbe,* in the Villa Farnesina in Rome (Thiem 1970, Z 20, fig. 37 and Z 26, fig. 41).

G.S.

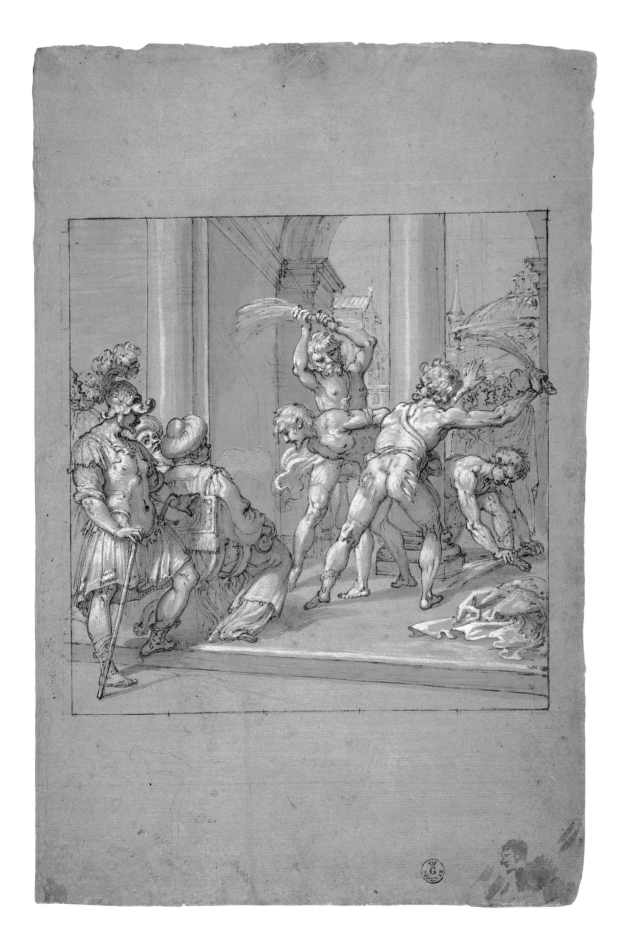

195

Lodovico Cardi, called Cigoli

Castelvecchio di Cigoli 1559—Rome 1613

84. *Seated Young Woman*

Red chalk; 418 × 276 mm

ANNOTATIONS: on verso in black chalk, in an antique hand, *50* (erased) and *57*, and in pen *di Lodovico da Cigoli Pittore;* in black chalk, in the handwriting of P. N. Ferri: *Per il Martirio di S.° Stefano*

9003F

EXHIBITIONS: Florence 1913, 10; Florence 1922, 3; Florence 1940, 208.

REFERENCES: Florence 1913, 1P; Ferri 1912–21, ser. 2, fasc. 1: no. 1; Florence 1922, 3; Florence 1967, 61.

Born in Cigoli, a town in the Tuscan countryside whose name he later assumed, Lodovico Cardi moved to Florence with his family when only thirteen years old. As he had decided at an early age to pursue an artistic career, this new atmosphere must have been particularly stimulating for him, since it offered a wide variety of experiences and opportunities, which he used to advantage. We know from sources that he was educated in the school of Alessandro Allori, copying works of the early cinquecento (principally those of Michelangelo and Pontormo, but also Andrea del Sarto, as seen in this drawing). He practiced life drawing with Santi di Tito and architectural drawing and stage design with Buontalenti. The fundamental influence on his figurative language came, however, with his discovery of Federico Barocci in the early 1580s (trips to Arezzo with his friend Gregorio Pagani and to Perugia with Passignano to study two of Barocci's masterpieces, the *Madonna del Popolo* and the *Deposition,* are well documented) and his later discovery of the Venetians and Correggio, which he shared with Pagani. On this network of influences is based all of his artistic production, in which we find a perfect harmony between the balance of a Neo-Renaissance type and a chromatic intensity and emotional emphasis that anticipate the Baroque.

This beautiful drawing is typical of Cigoli's working methods in his early years; inspired by Sarto in his energetic yet extremely well-defined use of red chalk, the artist has copied from life a figure in everyday clothing, which will be used in a composition after making the changes necessary for its narrative context.

Attributed correctly in the last century as "Cigoli influenced by Andrea Del Sarto" by P. N. Ferri—who identified this drawing as preliminary to the figure of a young man seated in the lower left of the *Martyrdom of Saint Stephen* in the Palazzo Pitti, to which it is completely unrelated—it was ascribed to Naldini by Giulia Sinibaldi (archival note) in 1959. She was evidently struck by certain stylistic characteristics of an older tradition, to the point of attributing it to a master

of the previous generation. It was returned to Cigoli in 1967 by Forlani Tempesti, who realized its connection with the figure seated at the lower left in his compositional study for a *Nativity of the Virgin* in the Uffizi (359S).

In this study Cigoli seems inspired by a painting of the same subject by Perino del Vaga which was once in the church of Trinità dei Monti in Rome and is now lost (Brugnoli 1962: 350). The drawing has been interpreted as an early idea, subsequently modified, for a very late work, the *Nativity of the Virgin* in the Santissima Annunziata in Pistoia of 1608. A certain perplexity in this regard was expressed by Forlani (1967), who wondered if, given the large number of iconographical divergences and the presence of squaring on the sheet, it could not have been destined for an unknown reworking of the same subject.

This hypothesis is a viable one, with the qualification that the painting in question must have preceded the version in Pistoia by a number of years. It should not be excluded that this work could be the lost *Nativity of the Virgin* that Baldinucci cites "in the church of the congregation of the Conception," listing it among the artist's early works (2:241). The style of the drawings linked with this composition, all held by the Uffizi, suggests an early epoch in Cigoli's career. The overall plan described by Uffizi 359S shows a taste for the decorative in its light, elegant use of pen and wash that is easier to find in the earlier works of Cigoli; to this can be added three beautiful studies in red chalk which are preparatory for single figures. These include, along with the sheet shown here, Uffizi 658S, in which this same figure is reproduced with a baby in her arms, in the form in which it will later be used in the composition, and finally a very lively and realistic sketch (Uffizi 969F) of a little girl drying clothes in front of the fire (a detail that appears in the lost *Nativity* and which Cigoli then repeats in the Pistoia altarpiece).

A.M.P.T.

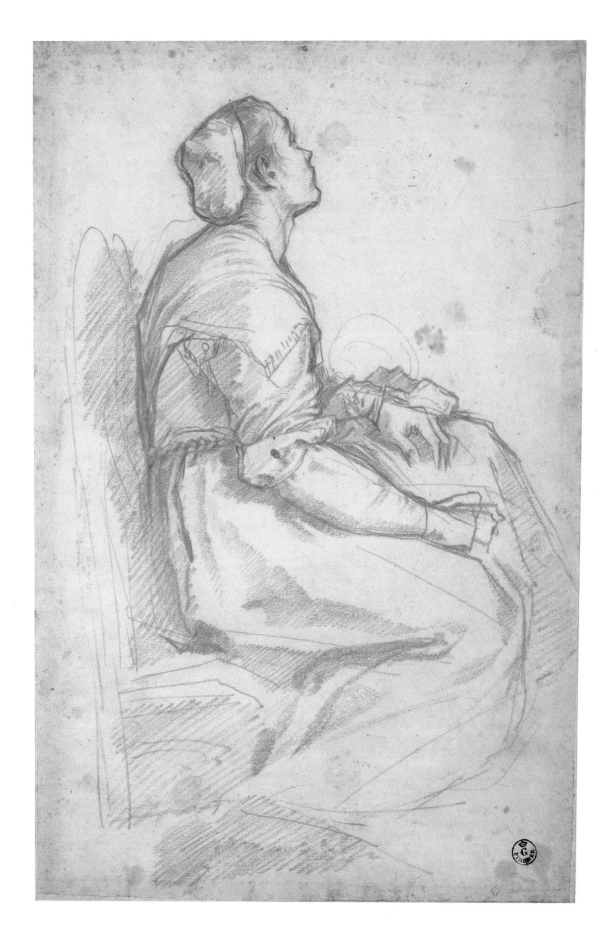

85. *Martyrdom of Saint Lawrence*

Red and black chalk, pen, brown ink, brown wash, and heightened with white, with traces of the stylus, the paper partially ruled in red chalk; 414 × 276 mm

ANNOTATION: at upper left in black chalk in a nineteenth-century hand, *214 Cigoli.*

2002S

EXHIBITIONS: None.

REFERENCES: Santarelli 1870, 149 n. 74; San Miniato 1959, 44; San Miniato 1969, 76; Florence 1986b, 110.

All of Cigoli's early artistic experience converges in the large altarpiece of the *Martyrdom of Saint Lawrence,* signed and dated 1590 and painted for the confraternity named for this saint in Figline Valdarno (now in the storerooms of the Florentine museums). It is the first work in which the artist's poetics find full maturity of expression and a definitive style.

On the sheet shown here Cigoli has fixed an early idea for this complex and monumental composition, in which he evidently was inspired by Titian's famous precedent in the church of the Gesuiti in Venice. He could have known this famous work by having seen it on a hypothetical trip to that city or from the print by Cornelis Cort that had quickly become celebrated in major Italian artistic circles. This study is characterized by a quick, nervous line that is apparently disorderly but shows great strength in the elaboration of forms and movements, a line that shows in its provisional nature evidence of being a particular phase in an ongoing creative process.

In a comparison with the painting it can be seen that Cigoli had already defined certain basic elements, such as the arched form of the altarpiece, the diagonal position of the martyr in the foreground and that of his executioner set slightly back to the left, the presence of the two angels holding the martyr's crown and palm

on the upper left, and in a very approximate form, the stage set of classical architecture at the bottom right. In the painted version there is a complete reversal of the group of figures that takes up a good part of the composition on the right, along with other minor variations.

Cigoli took another step toward a solution of this difficult compositional problem, especially in defining the architectural background in Uffizi 2001S: a preparatory study of high quality if perhaps of a less steady grasp than the drawing shown here.

The closest approach to the painting is found finally in Uffizi 8930F. This drawing presents more problems than the preceding ones; it is often considered a copy and is currently catalogued as such by the Uffizi, but it seems to be of a quality that would justify returning it to the hand of Cigoli, who was in this case trying out a rectangular composition without the upper arch (which would already seem to exclude its being a copy).

Uffizi 974F and 2049S should be considered early copies of the painting, as Bucci (San Miniato 1959, 44) has already pointed out; the other sheets (9036F, 1986S, and 2000S) that have sometimes been cited in this context have nothing at all to do with this composition.

A.M.P.T.

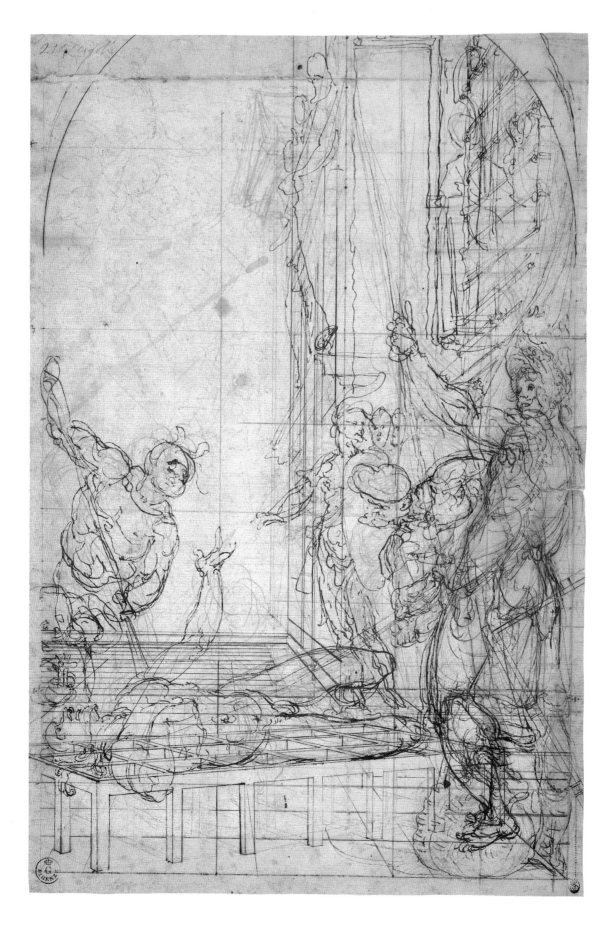

Lodovico Cardi, called Cigoli

86. *Study for a Scenic Background*

Black chalk, pen, dark brown ink, and light brown wash; 340 × 275 mm

ANNOTATIONS: at upper left in blue chalk in a nineteenth-century hand, *59*, and in lower right, *7.*; in black chalk, *707*; on verso in different antique hands, at upper center in black chalk, *49*; at lower left in pencil, *Cigoli Bello.*

59P

EXHIBITIONS: San Miniato 1959, no. 72; Florence 1973, no. 5; Florence, Palazzo Strozzi 1980, no. 178.

REFERENCES: Ferri 1890, 47; San Miniato 1959, no. 72, 135–136; Matteoli 1970, 349 n. 31; Chiarini 1972, no. 17; Florence 1973, no. 5; Florence, Palazzo Strozzi 1980, 106.

This drawing has perplexed scholars, despite the fact that its attribution to Cigoli is secure and its dating toward the end of the sixteenth century easy to surmise on the basis of its stylistic elements. What is less easy to understand are its purpose and subject, which scholars have tried unconvincingly to justify either as the preparatory study for a painting (San Miniato 1959, 135–136, Matteoli 1970, 349 n. 31) or as a pure landscape: a fantasy view of a lake or a river being traversed by a boat (Chiarini 1973, 16; Florence, Palazzo Strozzi 1980, 106). Both these interpretations are made unconvincing by peculiarities in the structure of the composition and, in the second case, by the complete absence of any naturalistic implications, both in the definition of the scene, which is too rigid, and in the abstract calligraphic elegance of the line, totally unsuited to any notation of any atmospheric or luministic character. Such peculiarities find their raison d'être when this drawing is placed in the realm of theatrical scenery.

Recalling that Cigoli's biographers (Cardi, 1913; Baldinucci 3:255–256) mention his contribution as stage designer for the presentation of a "comedy" in Florence for the marriage of Maria, niece of Grand Duke Ferdinando de Medici, to Henry IV of France, Molinari presented (1961, 62–63) the theory that this performance could have been *Euridice* by Ottavio Rinuccini, set to music by Jacopo Peri, presented under the direction of Jacopo Corsi on October 5, 1600, in the Salone dei Forestieri on the first floor of the Palazzo Pitti.

The correctness of Molinari's intuition can now be demonstrated thanks to a drawing which recently appeared on the market (Sotheby's sale in Florence, February 2, 1987, lot no. 1): a sheet from an anonymous hand of modest quality but significant documentary interest as it is the first eyewitness report of this extremely important performance. Various elements, both iconographic and scenographic/technical (for instance, certain lighting devices made of mirrors that were used

in this show), identify it as an illustration, meant in all probability to be engraved, of the stage setting of *Euridice* as it is described both in the script notes (*l'Euridice d'Ottavio Rinuccini, rappresentata nello sponsalitio Della Christianiss. Regina di Francia, e di Navarra. In Fiorenza, 1600. Nella Stamperia de Cosimo Giunti*) and in the account of the performance by Michelangelo Buonarroti il Giovane (*Descrizione delle felicissime Nozze Della Christianissima Maesta di Madama Maria Medici Regina di Francia e di Navarra dï Michelangnolo Buonarroti. In Firenze. Appresso Giorgio Marescotti. MDC*).

It should be stated at this point that, just as in the biographical notes on Cigoli there are no references to the title of the "comedy," in the documentation of the *Euridice* there is no reference to the name of the scene painter. The connection is now supplied unequivocally by this drawing and Uffizi 60P of the same subject. These two drawings present a number of iconographic links with the anonymous illustration discussed above. In it can be recognized the view of the "City of Dite" which according to Buonarroti's account could be seen on the stage of *Euridice* through "a break in a large cliff." In light of this connection certain aspects of the drawing shown here become intelligible, such as the rocky "stage flaps" which frame the "view," while the nudity of what was earlier defined generically as a "boatman" is more convincingly explained when he is identified as the mythological Charon.

Based principally on the identity of the graphic characteristics with the drawings discussed above, it is possible also to link a beautiful drawing in the Biblioteca Nazionale Centrale in Florence to the stage setting for *Euridice*. This drawing appears in Volume C.B.3.53 as pages 99v and 100r and is attributed to Buontalenti. It is certainly from the hand of Cigoli and could be a study for Pluto's chariot.

A.M.P.T.

Lodovico Cardi, called Cigoli

87. *The Pentecost*

Pen, dark brown ink, blue wash, white lead, and traces of black and red chalk, the paper blackened on verso with *spolvero;* 361 × 246 mm

991F

EXHIBITION: Florence 1913, 15.

REFERENCE: Forlani 1913, 15.

Even though there is no evidence to suggest that Cigoli ever treated the subject of the Pentecost, this is a drawing from his hand, as it has been traditionally attributed since at least the eighteenth century. A drawing done in pen and wash representing *The Descent of the Holy Spirit,* certainly identifiable with this one, is cited under Cigoli's name in the manuscript inventory of the Gabinetto Disegni e Stampe of the Uffizi prepared by G. Pelli Bencivenni at the end of the eighteenth century (Vol. xxi Grande, n. 118).

The intent of this drawing could be the illustration of some liturgical text; it furnishes a typical example of Cigoli's drawing preferences. By juxtaposing different instruments and materials—the pen, black and red chalk, white lead, and blue washes that he so often used—the artist pushes the dynamic play of chiaroscuro to the point where volumes and forms dissolve in a dramatic swirling contrast of light and shade that fully renders the sense of a miraculous event.

The best possibilities for stylistic comparison can be found in Cigoli's late drawings, in which the line, charged with an intense expressionism, can reach the point of assuming deforming and almost grotesque accents. This is an aspect which the artist will push to its furthest consequences in the drawings of his last years, of which we have a magnificent example in the next drawing.

A.M.P.T.

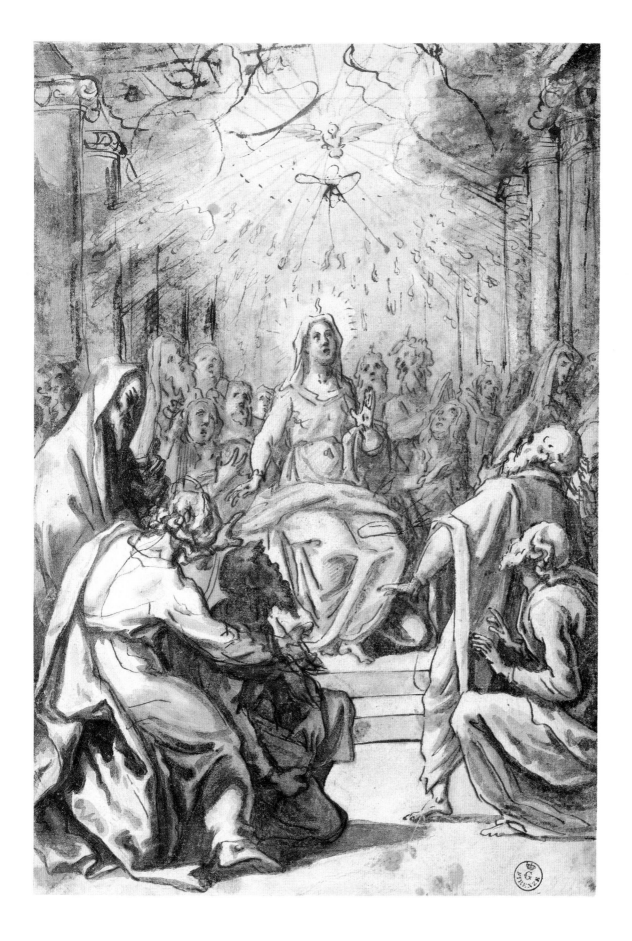

88. *Standing Man Wearing a Cloak*

Charcoal, with stumping, red chalk and white lead on gray-green paper; 431 × 308 mm

ANNOTATIONS: at lower right in pen in an antique hand, *Cigoli;* on verso in pen in different antique hands, *Del Cigoli, Cigoli.*

8972F

EXHIBITION: Florence 1979, no. 111.

REFERENCES: Florence 1979, no. 111, 165; Matteoli 1980, 247.

Between September 1610 and October 1612 Cigoli executed what can perhaps be considered the most important and certainly the most challenging of the works he did in Rome, the fresco of the *Triumph of the Virgin* decorating the dome of the Chapel of Paul V in Santa Maria Maggiore.

If the stylistic results of the fresco, despite certain strong innovations which seem to anticipate Lanfranco and Baroque painting, might arouse some perplexity because of an unresolved harshness in the composition (which is clearly a final homage to the still-admired Correggio), many of the preparatory drawings that preceded the painted version can instead be considered among Cigoli's greatest achievements in the graphic field. Such is the drawing shown here.

The intense degree of the artist's involvement in the *Triumph of the Virgin* is seen in the large number of drawings related to it in which he meticulously studied every aspect and minute detail. These drawings were listed by Chappell in 1979 (Florence 168–171). The sequence proposed by Chappell remains without doubt the most reliable as far as attributions are concerned, and the most recent scholars frequently refer to it (see Faranda 1986, 169–171). On the other hand, in a

number of cases the conclusions reached by Matteoli (1980) are not acceptable; without convincing arguments she attributes this drawing to the hand of Cigoli's student Sigismondo Coccapani.

In the sheet exhibited here Cigoli uses a nude model to study the pose for Saint Paul, who appears in the lower part of the dome at the Virgin's right hand. In the fresco the figure will have a different face and will wear a robe over which is thrown a cloak in a manner similar to that considered in this drawing; a long sword will be placed in his right hand, identifying him as the apostle Paul, while the base on which the model rests his left foot will be replaced by a cloud. Even more variations can be found on the recto of Uffizi 8841F, a copy of a study now lost, executed by the artist himself, probably to try out the effect of a figure in a reversed position. The sketch on the verso of this same sheet seems to be later, perhaps also later than the study shown here (the most probable order seems to be 8841F recto, 8972F, 8841F verso). The definitive study for Saint Paul is in the British Museum (1946.7.13.230), as Chappell indicates; it is squared for enlargement.

A.M.P.T.

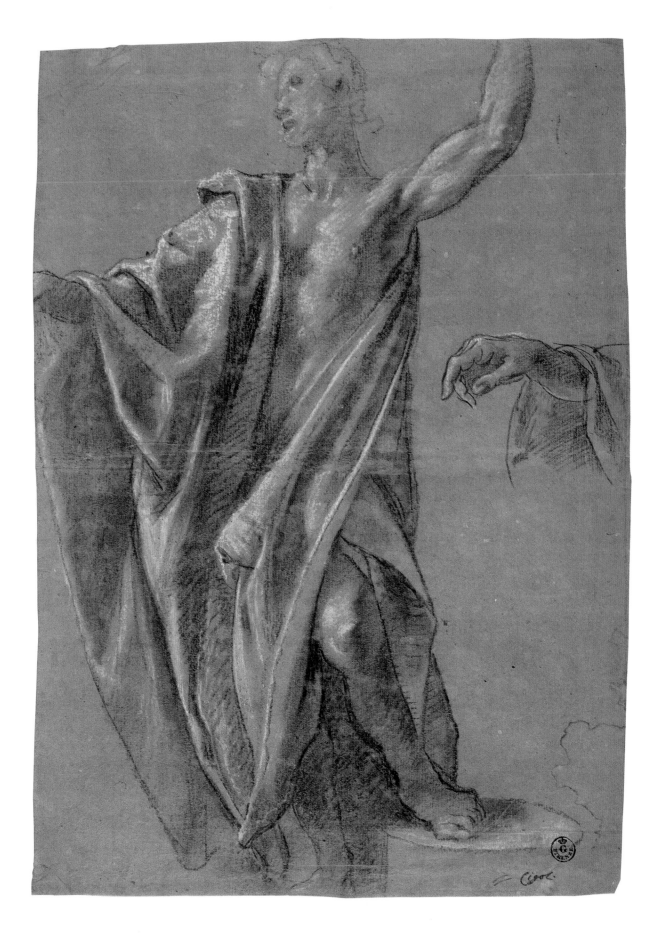

Domenico Cresti, called Passignano

1559 Passignano—Florence 1638

89. *A Princely Wedding*

Pen and dark brown ink; 217 × 288 mm. Mounted

ANNOTATIONS: at lower right in pen in an antique hand, *Passigniano;* at lower center in black chalk in a nineteenth-century hand, *78*

874F

EXHIBITIONS: None

REFERENCES: None.

One of the most typical and fervent exponents of the artistic theories of the Counter Reformation, Domenico Cresti was born in Passignano, a town in the Tuscan countryside, the name of which he later took. According to Baldinucci (3:430–431) he was educated in Florence, first by working with Girolamo Macchietti and later in the workshop of Giovan Battista Naldini.

However, the influence that would later be seen to be the most important and formative for his future as an artist was that of Federico Zuccaro. Zuccaro lived in Florence between 1575 and 1579 and was given the prestigious task of finishing the fresco decorations for the dome of the cathedral, which had been interrupted by the death of Vasari in 1574. Evidently during the years Zuccaro was in Florence, Passignano was able to establish a particularly solid professional partnership with him, to the point of following Zuccaro on his return to Rome.

In the company of Zuccaro, who following a trial in 1581 was expelled from the Vatican, Passignano went to Venice for a stay which stretched over several years. We can deduce from sources that this was a period of intense artistic activity for him, but given the current state of knowledge, we can only hypothesize about his production (Petrioli Tofani 1982, 84, fig. 44). The only thing that can be maintained with conviction is that prolonged contact with Venetian painting made a profound impression on Passignano, leading him toward stylistic choices that were strongly conditioned by the chromatic and luministc preferences of Venetian art. In turn, once he was back in his homeland, Passignano would influence the handling of color and light in contemporaneous Florentine painting.

As is indicated by the antique handwriting at the lower right, this drawing has long been attributed to Passignano. Nothing is known about its intention or its date, although the characters in the composition and the subject itself—a princely wedding celebrated by a bishop in lavish architectural surroundings—might suggest that it is a plan for a monochrome painting, such as those destined for the temporary stage sets that were frequently mounted in Florence on the occasion of important Medici ceremonies.

We know from Baldinucci (3:433–435) that Passignano played an important role in the execution of the sumptuous set of triumphal arches with which Florence greeted the arrival of Christine of Lorraine as the bride of Grand Duke Ferdinando I on April 30, 1589. And, although the documentation (see Florence 1969, 68) does not show that this composition was actually part of this set, it can be theorized that this study was subsequently rejected. On the other hand, it is possible that its origin lies in some other episode of Florentine history, such as the funeral of Philip II of Spain celebrated in San Lorenzo in 1598 (Florence 1969, 86–89), in which Passignano certainly took part. However, the characteristics of his handling of line, which in the steady and brilliant use of the pen recall contemporaneous examples from Cigoli or Palma il Giovane, are very similar to those of another pen and ink drawing in the Uffizi (1125S) that is certinaly related to the sets for the wedding of Ferdinando I (Petrioli Tofani 1979, 76, fig. 1). If this connection is correct, the date for the sheet shown here would be one not much later than the artist's return from Venice. A further possibility is that this might be a study for a tapestry, given the characteristics and proportions of the compositional structure of this scene.

In any case, despite the impossibility of reaching an exact definition of the subject, this drawing is of particular interest as a document of a very important aspect of sixteenth-century Florence: festivities and court ceremonies.

A.M.P.T.

Domenico Cresti, called Passignano

90. *Christ and the Virgin in Glory with Saint Sebastian and Angels*

Red chalk, gray and yellow wash; 500 × 434 mm. Mounted

7098F

EXHIBITION: Florence 1972, no. 59.

REFERENCES: Ferri 1890, 50; Florence 1972, 90 no. 59.

An able as well as a prolific draftsman, Passignano left numerous drawings of the most varied types: from anatomical studies of a strictly scientific nature to those in which the human figure is analyzed in different positions to capture every possible formal implication; from rapid sketches of specific groupings or dynamic arrangements of a few figures to complete compositional elaborations to carefully completed *bozzetti* for approval by a patron. His drawings utilize all the instruments or materials available at that time: pen, chalk, wash, pastel and oil colors, and the blue paper favored by the Venetians as well as the white paper typical of the Florentine tradition.

Because of his willingness to tackle graphic expression in all the range of its possibilities (as well as his various stylistic preferences in the course of his career), Passignano's creativity achieved its best results in drawing. The principal components of his figurative language can be seen in this drawing of high quality. It is based on the clear and competent line typical of Florence onto which are grafted chromatic and luministic subtleties typical of Venice, as well as concessions to a Late Mannerist elegance reminiscent of the Zuccari.

This sheet represents the middle point of a journey of compositional formulation which, begun in a more summary sketch of the same scene (Uffizi 9170F), seems to end in a third, more complex study (Uffizi 7099F) that moves the trio of protagonists—Christ, the Virgin,

and Saint Sebastian—to the center of the composition in order to leave space at the bottom for other figures of saints.

The present drawing is evidently a plan for the decoration of a ceiling (or dome) which has not yet been identified. The project must have come fairly late in the artist's activity, at least to judge from a comparison with a study for a similar decoration held in the Louvre (12599; see Paris 1981, no. 27), which shows a more precocious style than this one and can be linked to the 1599 frescoes of the vault of the choir in the cathedral of Pistoia. A theory that could be cautiously advanced is that the three Uffizi drawings were done by Passignano in preparation for the fresco decoration of the chapel dedicated to Saint Sebastian in the Villa Aldobrandini at Frascati, a project on which he worked along with other artists in the years 1614–16. Unfortunately, after progressive deterioration due to atmospheric humidity, these frescoes are practically destroyed (D'Onofrio 1963, 137 n. 2).

It is worth emphasizing the fact that Passignano was able to attract the attention of younger artists such as Francesco Furini and especially Ottavio Vannini with drawings of this type, which work out figurative problems not too different from those solved by Baroque style.

A.M.P.T.

Andrea Commodi

1560 Florence 1638

91. *The Annunciation*

Charcoal; 281 × 210 mm

10441F

EXHIBITIONS: None.

REFERENCES: None.

An original and eccentric artist, Commodi thwarts every attempt to force him into the principal currents of Italian art in the years between the end of the cinquecento and the beginning of the seicento. His work remains within the bounds of late Mannerism nourished by the examples of contemporary Florentine and Roman painting, but also betrays an interest in Caravaggesque luminism and an unexpected attraction to the caustic reality expressed in Flemish art.

Florentine by birth, according to Baldinucci (3:655–656), Commodi seems to have received his artistic education under the guidance of Cigoli—who, given the closeness of their ages, must have been more friend than master—and by studying and copying the works of Correggio. From a note in his handwriting on a drawing in the Uffizi (18446F), we know also that he worked at Lorenzo dello Sciorina's side and that he made a first trip to Rome in 1583 and a second in 1592. A number of his paintings remain in Rome, where he stayed for a long time on various occasions; among these should be mentioned the large fresco in the apse of San Vitale. From 1609 to 1612 Commodi resided in Cortona, where he worked on a number of projects for the churches and had as a student the young Pietro Berrettini, who would become a leading exponent of Baroque painting in Italy. Having returned to Rome in 1612, he obtained from Pope Paul V the commission for an enormous fresco that would, imitating Michelangelo's *Last Judgment* in the Sistine Chapel, decorate the internal facade of the chapel of the papal palace at the Quirinale. This was a project that he never managed to complete, even though he expended enormous effort; it is documented only in a partial *bozzetto* (Briganti 1960, 33–37) and in a beautiful series of preparatory drawings (Florence 1986c, 151–152, with bibliography).

The position of Commodi's abundant graphic corpus runs parallel in a certain sense to that of his pictorial production because the possibilities for making precise connections between the two fields are limited. This is fairly unusual for his generation. His work consists of a series of studies based on a few readily identified types: copies from Michelangelo and other Renaissance masters, exercises from life (which are the ones of greater interest, including cat. no. 92), pages filled with obsessive repetitions of small leaping or possessed figures, experimentation with pastels probably suggested to him by the example of Barocci, as well as some landscapes in a necromantic vein and scattered compositional studies.

It does not appear that the artist in the course of his long career ever painted an Annunciation, a theme that he instead treated extensively in drawings, as demonstrated by a very interesting group of works in the Uffizi (10339F, 17431F, 10396F, 10397F, 10398F, 10399F, and 10442F), all traditionally attributed to Commodi. These are so homogeneous stylistically that they must have been done one after the other in a short period of time during which Commodi entertained himself with a series of "variations on a theme."

In terms of graphic style, this *Annunciation* clearly shows signs of the artist's experiences in his formative years in Florence. His dependence on the methods of Lorenzo dello Sciorina emerges, for example, from a comparison with the only drawing certainly attributable to the latter's hand (Uffizi 10261F; see Petrioli Tofani 1982, 86), preparatory for one of the large frescoed lunettes in the Chiostro Grande of Santa Maria Novella, while a more substantial influence from Cigoli can be seen in the jumpy, nervous dynamism of the charcoal lines and in the richness of the chiaroscuro, showing a pictorialism that anticipates certain of Giovanni Bilivert's results.

A.M.P.T.

Andrea Commodi

92. *Portrait of a Turbaned Woman*

Charcoal with stumping; 294 × 215 mm

18517F

EXHIBITIONS: None.

REFERENCES: None.

From the facts of Commodi's life and the characteristics of his work as a painter, the daring and corrosive expressiveness of an important portion of his graphic production is unexpected. These surprising drawings are portraits for the most part, or in any case studies from life, which bear witness to the artist's extremely personal approach to reality. Sometimes he selects the rawest aspects of reality and recreates them in the polished abstract patterns of an extravagant hand that reaches the most daring heights of later Mannerist Florentine drawing. This is an approach that was probably inspired by the great lesson of Caravaggio. Because of the components of strain and eccentricity which predominate in these works, they can be seen more as expressions of fantasy than as instances of a strict realism.

We find many studies of this type in the large group of drawings in the Uffizi traditionally attributed to Commodi (Florence 1986c nos. 2.92–2.95); to this nucleus can be added others that are included, as in the splendid example shown here which calls to mind certain heads by Zurbaran, in the collection of drawings by anonymous artists from the sixteenth and seventeenth centuries (15720F, 18370F, 18390F, 18391F, 18392F, 18404F, 18409F, 18413Fv, 18420F, 18518F, 18520F, 18525F, 18526F, 18527F, 18533F, 18534F, 18536F, 18537F, and 18539F). It is because this group is so numerous that we can attempt an evaluation of their style and level of quality, which is exceptional in many ways. However, in the absence of any documentation, establishing a chronological order is at present an impossible undertaking.

A.M.P.T.

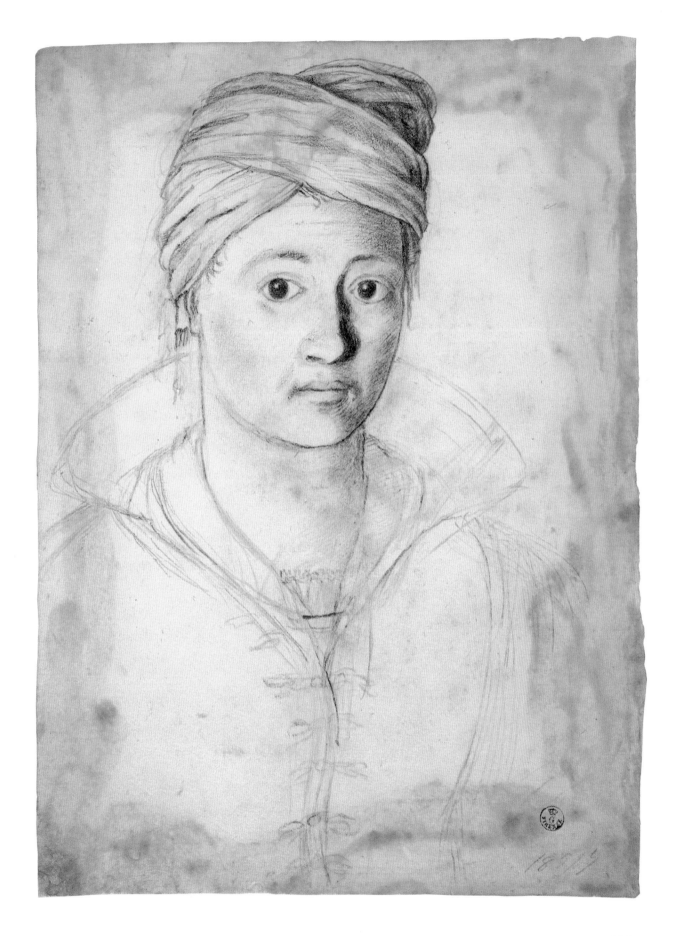

Agostino Ciampelli

Florence 1565—Rome 1630

93. *Half-Length Study of a Boy*

Black chalk with touches of white chalk on blue paper; 236 × 193 mm

ANNOTATION: on verso on reinforced lower left corner in pencil, *7176/Ciampelli*

7176F

EXHIBITION: Florence 1979, no. 34, fig. 39.

REFERENCE: Thiem 1971, 361–362, 364 n. 13, pl. 76.

Agostino Ciampelli began his career in Florence in the studio of Santi di Tito but moved to Rome in 1594 to join his patron, Cardinal Alessandro de' Medici. In his biography of the artist, published in 1642, Baglione mentions that Ciampelli took with him to Rome a large oil painting, the *Marriage at Cana*, which was displayed prominently in Cardinal Alessandro's palace (1642, 319; quoted in Thiem 1971, 361). The painting no longer exists, but its appearance is recorded by an elaborate composition study in the Louvre (Thiem 1971, pl. 4). This drawing is a study for one of the servants in a group in the right foreground of the Louvre *modello*, as Thiem recognized (1971, 361–362).

Ciampelli executed a large number of studies from life, in black and white chalk on blue paper, for the *Marriage at Cana* (Thiem 1971, pls. 5a–7b; Florence 1979, figs. 36–44, 47). This concern for natural appearances certainly derives from Ciampelli's early training with Santi di Tito, as does his reliance on life studies.

In addition, certain elements in Ciampelli's composition (in particular, the groups of servants in the foreground) presuppose a knowledge of Santi di Tito's own *Marriage at Cana*, painted in 1593 for the chapel of the Villa I Collazzi, near Florence (Spalding 1982, fig. 88). Ciampelli may also have known Santi's preparatory drawings for his *Marriage at Cana* (two composition studies, in the Uffizi, are reproduced in Florence 1985a, figs. 42 and 43). Certainly, some of the figures in the Louvre *modello* have closer parallels in Santi's studies than in the finished painting.

This drawing is consistent in style with the others in the group, combining energetic and forceful contour lines with soft and exceptionally delicate interior modeling. At the same time, the drawing is particularly fresh and attractive in appearance, possessing as it does the character of a portrait study.

G.S.

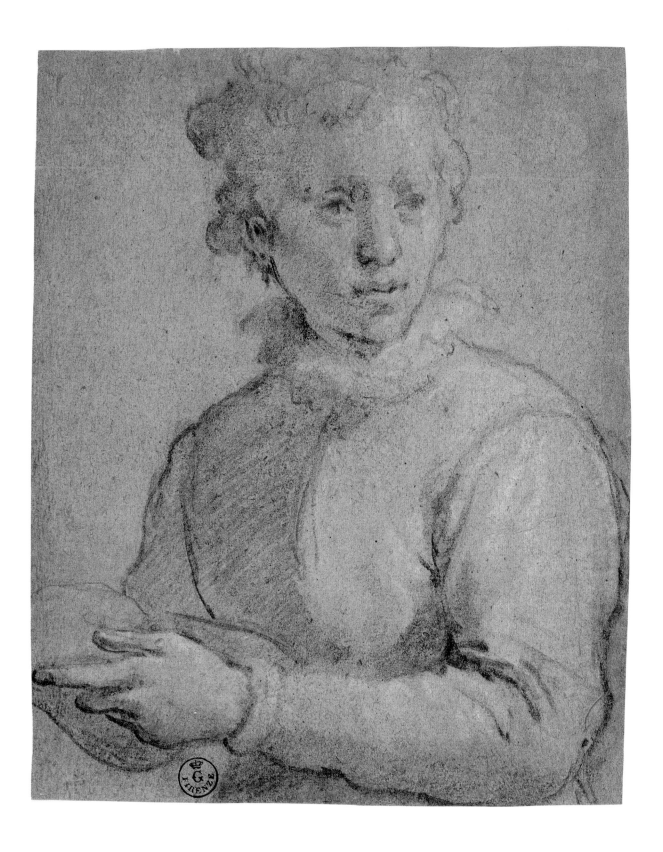

94. *Crucifixion of Saint Peter*

Pen and brown ink and brown wash over traces of black chalk (a section of the sheet cut out to the left of the cross and replaced); 535 × 392 mm

ANNOTATIONS: at lower left in ink, *870;* at lower right in ink, partly obscured by Uffizi stamp, *65*

1054F

EXHIBITIONS: None.

REFERENCES: None.

In 1596 Ciampelli participated in the program of decoration and renovation undertaken by Pope Clement VIII at San Giovanni in Laterano, painting two scenes in the sacristy. These frescoes, which illustrate episodes from the life of Pope Clement I, are characterized by a fresh approach to narrative, in which the subject is clearly legible, and contain lively groups of figures set in landscapes of a generally northern type (for the frescoes see Prosperi Valenti 1972, figs. 56, 57; a composition study for one of the scenes, the *Martyrdom of Saint Clement,* is in the Metropolitan Museum of Art [Bean 1982, no. 49]). Ciampelli's paintings in San Giovanni in Laterano link him to his Florentine teacher, Santi di Tito, who developed a similar approach to narrative and possessed a similar touch with landscape.

This large and elaborate composition study for a *Crucifixion of Saint Peter* is related to Ciampelli's scenes from the life of Clement I in its narrative clarity, wealth of incident, and landscape setting, and, like them, also recalls works painted in Florence by Santi immediately prior to Ciampelli's departure for Rome in 1594. The composition of the drawing is very similar to that of Santi di Tito's *Multiplication of Loaves and Fishes* in Santi Gervasio e Protasio in Florence (the painting and preparatory studies reproduced in Spalding 1982, figs. 86, 140, 141), in which secondary figures are massed in the foreground while the principal subject is set back in space at the center of the sheet. Moreover, the figure turning to the left and pointing toward Saint Peter in the lower left corner of the *Crucifixion of Saint Peter* closely resembles a young servant occupying the same position in Santi's *Marriage at Cana* of 1593 in Villa I Collazzi near Florence (Spalding 1982, fig. 88).

This drawing has not been connected with a known commission undertaken by Ciampelli, but it is possible to speculate on its intended purpose. As a participant in the decoration of San Giovanni in Laterano, Ciampelli could reasonably have expected to take part in Clement VIII's other great undertaking, the production of a series of monumental altarpieces representing scenes from the life of Peter for the *navi piccole* of the new Saint Peter's (on this program, see Chappell and Kirwin 1974, passim). Between 1602 and 1605, Domenico Passignano in fact painted a *Crucifixion of Saint Peter* for one of the side altars of the Cappella Clementina (fragments of the altarpiece, preparatory studies, and a print after the painting by Jacques Callot reproduced in Chappell and Kirwin 1974, figs. 19–25; the history of the commission discussed in detail in Florence 1979, no. 56). Given Ciampelli's association with Clement VIII and the likely dating of this drawing circa 1600, it is possible that it was a presentation study, prepared with the commission for the Cappella Clementina altarpiece in mind.

If that were the case, the reasons for Ciampelli's failure to win the commission are not difficult to deduce. In part because of the landscape setting and in part because of its lively, processional nature, Ciampelli's *Crucifixion of Saint Peter* has a festive quality that is quite different from the rhetoric of other altarpieces in this series. For example, in Cristofano Roncalli's *Death of Sapphira,* commissioned in 1599 for another altar in the Cappella Clementina (Chappell and Kirwin 1974, fig. 6), the monumental figures are complemented and amplified by grand, classical architectural settings. This formula was followed in the altarpieces executed subsequently by Passignano, Francesco Vanni, Lodovico Cigoli, and Giovanni Baglione (Chappell and Kirwin, figs. 26, 32, 33, 46). Clearly, Ciampelli's composition, which has something of the character and charm of a pastorale, does not possess the monumentality and high seriousness expected of the altarpieces for this cycle.

Late in his life, in 1629, Ciampelli did execute an altarpiece for Saint Peter's, however. Representing *Saint Simon and Saint Jude in Persia,* it follows the pattern of huge figures set before a monumental architectural backdrop established by the altarpieces in the Petrine cycle (Prosperi Valenti 1972, fig. 69).

G.S.

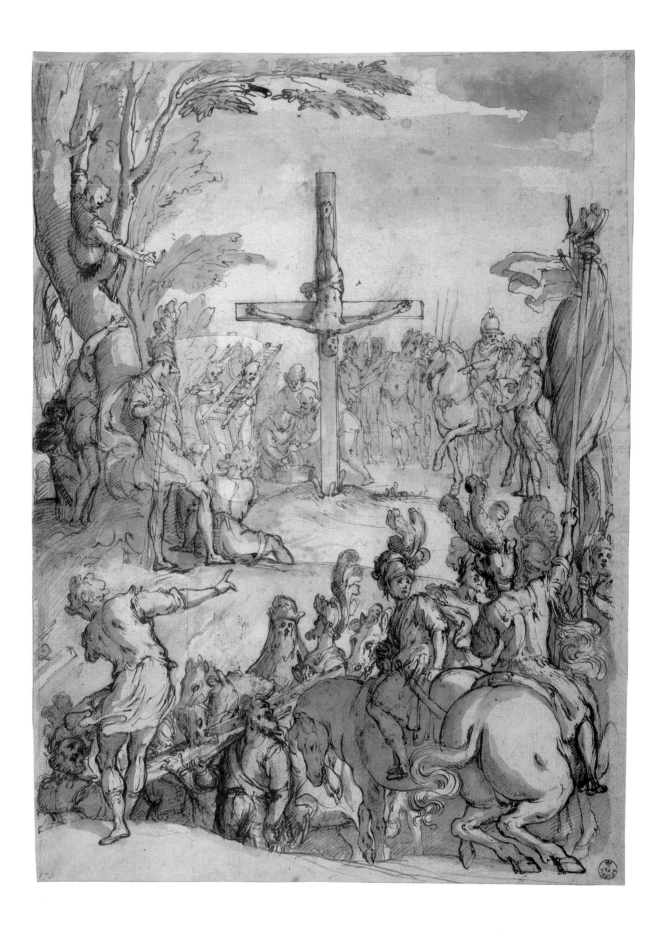

Aurelio Lomi

1556 Pisa 1622

95. *The Adoration of the Magi*

Black chalk and pen and dark brown ink; 406 × 281 mm. The sheet is made up of numerous fragments

ANNOTATION: at upper right in pen in an antique hand, *85*

7273F

EXHIBITIONS: None.

REFERENCE: Voss 1920, 2:412, no. 1.

Although he was much less prolific as a draftsman, Lomi's artistic career is remarkably similar to that of Pietro Sorri, as are the dates of their birth and death and the fact that each spent long periods away from their homelands. In the last years of the century, both lived in Genoa at the same time for a long period, working intensely and in a certain sense almost in competition with each other. They played similar roles as interpreters and disseminators of Florentine Counter-Reformation paintings, although Lomi in Pisa functioned in an artistic environment that was undoubtedly more amorphous than that of Siena.

Lomi's education took place in Florence, where he was a student of Lodovico Cigoli according to Baldinucci (3:708). Important paintings by Lomi remain in Florence, such as *Saint Sebastian before the Tyrant* formerly in the Pucci Chapel in the Santissima Annunziata and now in Palazzo Pucci, the *Visitation* in Santa Maria del Carmine, and the *Adoration of the Magi* in Santo Spirito. However, it can be deduced by examining his work that an even greater influence than Cigoli's was that of the masters of the preceding generation, and especially those who, under Vasari's leadership, were decorators of the rooms of the Palazzo Vecchio and in the Studiolo of Francesco I. In this drawing there are references in the handling of the pen and chalk to drawings by Alessandro Allori, and also in the elegant and elongated figures a reminder of Macchietti or Cava-lori. A northern influence brought by Giovanni Stradanus and Jacopo Ligozzi is visible in the taste for detailed description of costumes and objects and in the crowded composition surrounded by ruins.

As Voss recognized, the drawing is preparatory with few modifications for the large altarpiece of the Ridolfi Chapel in Santo Spirito (1920, 2:412 n. 1). It is possible to connect two other drawings with this altarpiece as early possibilities for individual figures which were later varied, one in the British Museum (1966.3.3 1 v) and Uffizi 7480S, the latter attributed to Jacopo Tintoretto but certainly from Lomi's hand.

At a very early time, the sheet was torn into nineteen pieces and later summarily recomposed of fragments glued on a backing of antique paper. It was probably in the course of this operation that a fragment of a different paper was added in the lower right-hand corner, where the drawing was reworked by a later hand. Since a reading of the drawing was made difficult by the imprecise joining of the pieces, in 1981–82 the Restoration Laboratory of the Gabinetto Disegni e Stampe of the Uffizi completely dismounted and correctly recomposed the sheet. An autograph variant for the figure of the kneeling young man who is holding a pitcher was discovered below the fragment at the extreme lower right.

A.M.P.T.

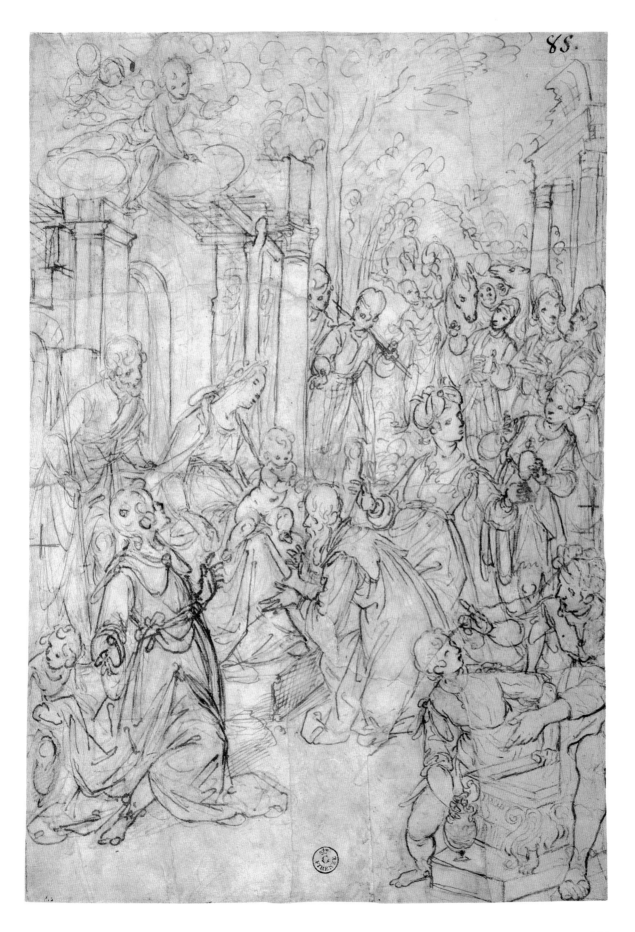

Pietro Sorri

San Gusmè (Castelnuovo Berardenga) 1556—Siena 1622

96. *The Marriage of the Virgin*

Red chalk, red wash, and pen and dark brown ink; 286 × 244 mm

ANNOTATION: at lower right in red chalk in an eighteenth-century hand, *Sorri*

1295F

EXHIBITIONS: None.

REFERENCE: Martini 1984, 95–96.

This drawing is part of a group of sheets in the Uffizi traditionally attributed to Sorri. Although not very numerous, these serve as an important point of reference for his graphic production, on which scholars' attention has only recently been focused (Martini 1981, 107–117). Its highly finished character makes it unusual in the graphic corpus of this artist, which consists principally of sketches that are rapid and summary in nature. It is a significant example not only of its author's stylistic preferences but also of the general direction of Sienese drawing as it moved from the sixteenth to the seventeenth century.

Typically Sienese is the particular chromatic sensibility with which he uses the media, constructing his chiaroscuro through a play of red chalk and washes, with later additions in pen serving only to heighten the effects of light. This working method almost certainly reflects some Venetian influence and is in complete contrast with the method of Florentine artists, who for the most part first executed the figures in line with pen or chalk and then suggested the volume with washes.

After an education in Siena in the shop of Arcangelo Salimbeni, where a fellow student was Alessandro Casolani, Sorri met Domenico Passignano. Even though some years older, he married Passignano's daughter Arcangela and was strongly influenced by Passignano's style. Baldinucci wrote that Sorri "acquired his [Passignano's] manner to the point where quite often the paintings of one could not be distinguished from those of the other" (3:459). During the 1580s Sorri went with Passignano to Venice, where he studied local painting, particularly the work of Veronese, probably remaining there for a fairly long time. At the end of this sojourn he had become such a master of the various media that he enjoyed wide success in Counter-Reformation reli-gious circles and had to travel frequently in order to keep up with his numerous commissions, with prolonged stays in Siena, Florence, Genoa, Pavia, Pistoia, and Rome.

This drawing could have been executed in Rome; it is preparatory for a painting signed and dated 1611 in the Pinacoteca of the Palazzo Pubblico in Siena. Baldinucci informs us—and the circumstance is confirmed also in a series of documents cited by Martini (1980, 100–101)—that Sorri was in Rome between 1610 and 1612; it is thus possible that he could have done the painting there, sending it to its destination in the Sienese convent of Santuccio, from which it was later moved to its current location. A second drawing in the Uffizi, representing the *Education of the Virgin*, analogous to this in measurement, technique, and compositional structure, could lead us to suppose that at least originally this *Marriage* was meant to have a pendant.

Very similar stylistic characteristics and graphic peculiarities can be found in other sheets, for example, Uffizi 4905S, attributed to Casolani and tentatively moved to Sorri by Peter Anselm Riedl in a handwritten note on the mount, preparatory for the *Naming of Saint John the Baptist* in the Lucca Pinacoteca; Uffizi 721S, a compositional study for a *Christ in the Garden* erroneously attributed to Naldini; Uffizi 9316S, held under the name of Barocci; Uffizi 9125F, earlier given to Passignano and recognized as by Sorri's hand in an anonymous annotation; and Uffizi 5090S and 5091S, two very fine studies for a composition having as protagonist the risen Christ, held with the works of Giuseppe Nasini. All these drawings are so similar that they can be dated in more or less the same period.

A.M.P.T.

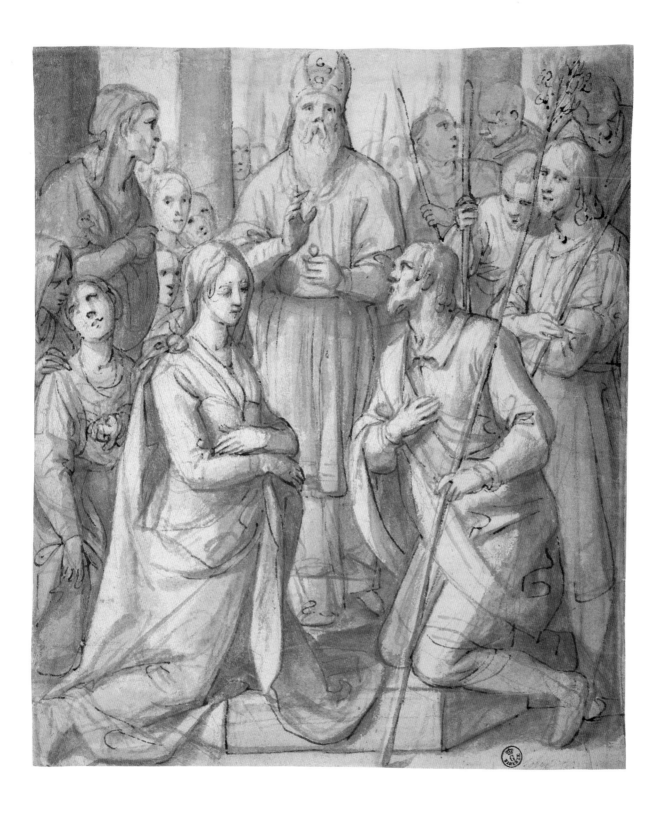

Francesco Vanni

1563 Siena 1610

97. *Virgin and Child*

Red chalk with red wash; 250 × 182 mm

ANNOTATIONS: at lower right in brown ink in a seventeenth-century hand, *di Cav.* *Vanni;* on verso at top left in pencil, *Salimbeni Ventura*

1292F

EXHIBITION: Florence 1976, no. 21, fig. 21.

REFERENCES: Ferri 1890, 178; Brandi 1931, 75; Venturi 1934, 1070, fig. 601.

Soon after the canonization in 1594 of Saint Hyacinth, a thirteenth-century Polish Dominican missionary, Francesco Vanni was commissioned to paint two major altarpieces representing miracles of the saint for Dominican churches in Siena. The earlier of the two, *Saint Hyacinth Resuscitating a Drowned Boy,* was in place in the Baragli Chapel in Santo Spirito by 1596 (Bagnoli 1977, 84; the painting is reproduced in Venturi 1934, fig. 592).

This powerful and luminous drawing is a study for the Virgin and Child, who are represented in the painting as heavenly witnesses to the miraculous resuscitation of the drowned child. The painting differs from the drawing in many respects, and in fact appears rather conventional and timid when compared with the drawing. In the painting the Christ Child is shown clothed and seated on his mother's lap; the Virgin is represented in profile, with her left arm hanging inactive at her side, and the forceful gesture of her right hand is abandoned. In fact, the drawing is much closer but not identical to the group as it appears in a *bozzetto* in oil paint on paper, from the collection of Pierre-Jean Mariette, now in the Louvre (reproduced in color in Bacou 1982, no. 44). In the oil sketch Christ is depicted blessing with his right hand; also his head is more comfortably on the axis of his body, rather than twisted to the left and

up as in the drawing. The definitive study, between the *bozzetto* and the finished painting, is also preserved in the Louvre (1993). Several other drawings for *Saint Hyacinth Resuscitating a Drowned Boy* have survived, among them one in the same red chalk and red wash for Saint Hyacinth himself, in the Uffizi, and another for the female spectator standing in the right foreground of the composition in the Metropolitan Museum of Art (Florence 1976, no 20, fig. 21; Bean 1982, no. 258).

Vanni handles the chalk and wash in a very dramatic fashion, with strong contrasts between the lit and shadowed areas. Whereas the Virgin appears very natural and seems to have been studied from life, the Christ Child has the appearance of being derived from a piece of sculpture, perhaps an antique Cupid. His muscular legs, robust torso, and plump features are forcefully realized with strong outlines and emphatic interior modeling, giving him the appearance of a Rubensian Silenus in miniature.

There is a curious (and presumably quite coincidental) echo of the energetic pose and faceted appearance of Vanni's infant in the "rich contours and powerful contrasted movements" of the Cupid (by Puget or Duquesnoy) in Cézanne's late *Still Life with Plaster Cupid* in the Courtauld Institute (Schapiro 1965, 98–99).

G.S.

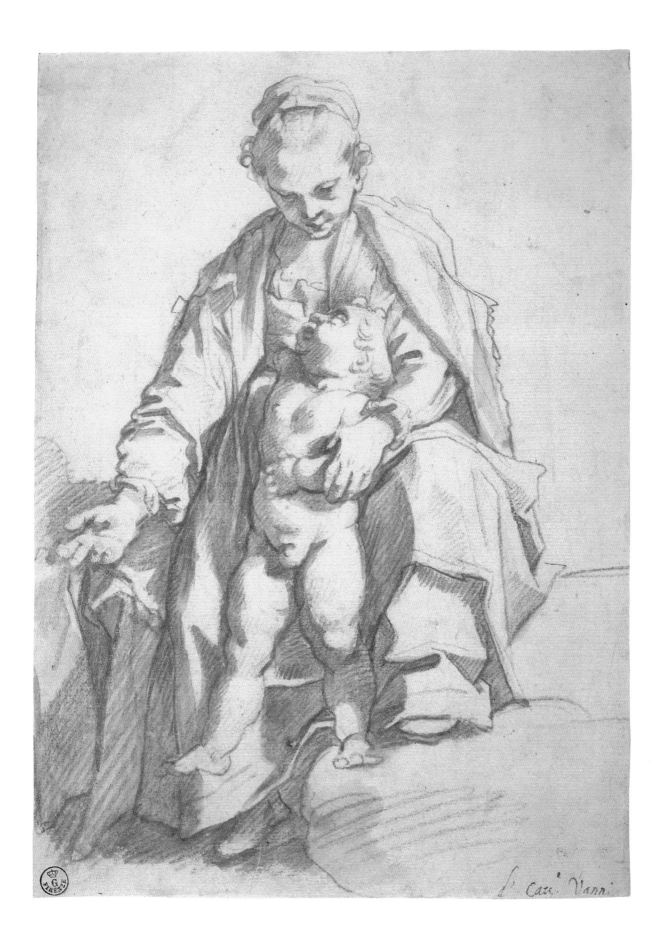

Cavⁱ Vanni

223

98. *The Mystic Marriage of Saint Catherine of Siena*

Black chalk, pen and brown ink with brown and gray washes, heightened with white, squared in red chalk; 377×250 mm

1693E

EXHIBITION: Florence 1976, no. 28, fig. 24.

REFERENCE: Ferri 1890, 178.

This elaborate drawing is the *modello* for one of Francesco Vanni's principal works, *The Mystic Marriage of Saint Catherine* in the Chiesa del Rifugio in Siena (Venturi 1934, fig. 593). The altarpiece can be dated 1601 on the basis of documentary evidence (Florence 1976, no. 28). Vanni's concern in the *modello* is with space and light. By using chalk and wash separately or in combination, he achieves a great range in tone, from the somber sleeping figure in the left foreground to the light-struck heavenly choir at the top center. Similarly, he succeeds in suggesting and defining many layers of space, from the solid figures in the foreground and near foreground to the vaguely suggested figures in the farthest distance.

A number of drawings precede this one in Vanni's preparations for the commission, the earliest being a sheet in the Pierpont Morgan Library (Fairfax Murray 1912, no. 191). Several other studies exist that seem to reflect nearly the same conception of the scene as the Uffizi *modello*. Also in the Uffizi is a partial *modello* for the altarpiece treating the figure of Christ, the attendant angels, and the shrouded figure in the left foreground (Florence 1976, no. 29, fig. 29). In addition, there are numerous studies for the figure of King David (Florence 1976, nos. 30, 32, with references to other drawings).

Despite the finished appearance of this drawing, the altarpiece differs from the *modello* in many respects, both compositional and iconographic. In the heavenly sphere, Saint Dominic is moved to the left side of the composition, replacing Saint John, and Dominic's place is taken by a female figure holding a chalice and book. Also, the crowd of angels at the top of the composition is much reduced in number in the painting.

Since Vanni was a native of Siena, it is not surprising that a significant part of Vanni's activity was devoted to celebrating the life and deeds of Saint Catherine. A scene very similar to this one, involving Christ, the Virgin, Saint Catherine, King David, and Saints John, Paul, and Dominic, was included in the *Life and Miracles of Saint Catherine of Siena*, published in 1597 with engravings by Pieter de Jode I from designs by Vanni (Hollstein, 9:204, nos. 71–82). Vanni's designs for this scene and five others in the same publication are preserved in the Albertina, and two other studies are in the collection of the Duke of Devonshire at Chatsworth (the Albertina drawings are reproduced in Stix and Fröhlich-Bum 1932, nos. 418–423; on this series and a second, published by Philip Galle, see Florence 1976, no. 11).

Vanni's *Mystic Marriage of Saint Catherine* (the Uffizi *modello* more so than the painting) gives evidence of the artist's diverse training and experience in Siena, Rome, and Bologna. The upper tier of the composition, with saints seated on an arc of clouds and the host of angels, reflect his period of study in Rome, ultimately recalling Raphael's *Disputa* in the Stanza della Segnatura in the Vatican Palace. At the same time, Vanni's drapery and figure types (especially the sweet, pointed-oval face of the Virgin and the mild features of the Christ) bring to mind Federico Barocci. The composition also recalls in a general way works by Barocci such as *Il Perdono* in San Francesco in Urbino (Bologna 1975, nos. 74–76).

G.S.

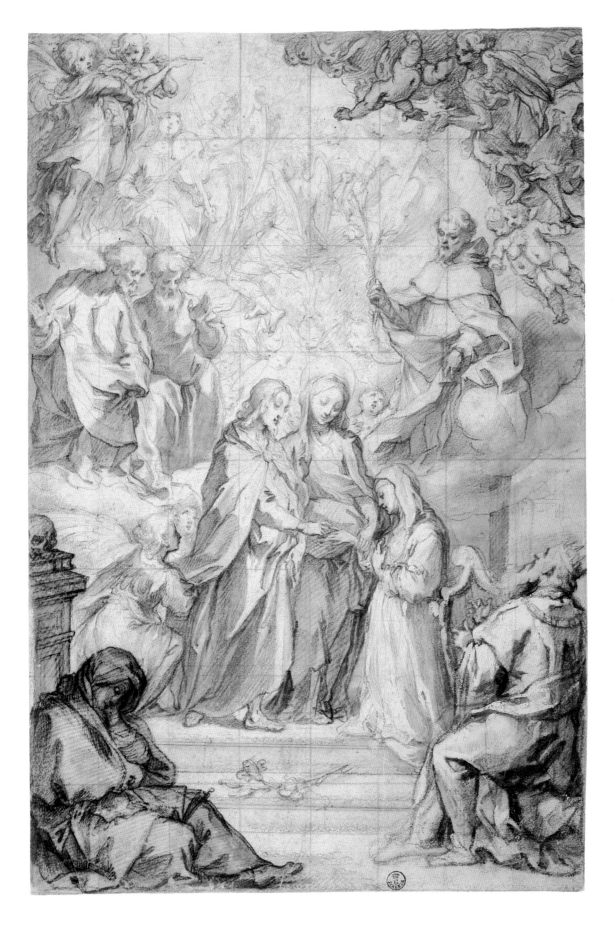

Francesco Vanni

99. *Studies for a Flagellation with Saint Peter*

Pen and brown ink, the framed composition at top left in black-brown ink, the remaining studies in brown ink; 202 × 273 mm

4778S

EXHIBITION: Florence 1976, no. 46, fig. 47.

REFERENCES: Santarelli 1870, 341, no. 81; Riedl 1978, 318.

This sheet of lively studies and two closely related sheets, one also in the Uffizi and the other in the Biblioteca Comunale in Siena, can be connected with a *Flagellation of Christ* executed by Francesco Vanni between 1601 and 1602 for the church of Santa Cecilia in Trastevere in Rome (for the Uffizi drawings see Florence 1976, nos. 45 and 46, figs. 45 and 47; for the drawing in Siena see Riedl 1978, 319, fig. 8). The painting was described as being in a ruinous state early in the nineteenth century, but something of its appearance is recorded by a variant in the Chigi-Saraceni Collection in Siena (Riedl 1978, 319, fig. 7; Riedl also refers to a version of the composition in Rome).

Vanni sketched the figure of Christ no fewer than eleven times on the three sheets. Christ's tormentors appear with him in all but three of the studies, and they are the subject of separate studies on the sheet in Siena, but it is evident that Vanni's principal concern was to establish the pose of the beleaguered Christ. In the other Uffizi drawing Christ has fallen to the ground but supports himself on his left arm in such a way that the spectator is given a full frontal view of his outstretched body. In the drawing exhibited here it is as if Christ had toppled over toward the spectator, so that he now lies almost face down. As Riedl observed, Christ's pose in this version is very similar to that of Saint Cecilia in Vanni's *Death of Saint Cecilia*, painted for Santa Cecilia in Trastevere at the same time as the *Flagellation of Christ* (Florence 1976, 52, no. 45, and Riedl 1978, 318; the *Death of Saint Cecilia* is reproduced in Venturi 1934, fig. 594; the composition engraved by Hieronymus Wierix [Salmina-Haskell 1982–83, fig. 4]). The composition sketch closest to the painting in the Chigi-Saraceni Collection is that on the lower right in this drawing, as Riedl recognized (1978, 318), but in the painting Vanni settled on the forward position of Christ's right arm, rather than showing it drawn in toward his body. In addition, the viewpoint is significantly altered.

In the drawing we witness the scene almost from Christ's position, whereas in the painting we look down on him from the vantage point of his tormentors.

The most important departure from the drawings is in the elimination of Saint Peter as a witness to Christ's Flagellation. That the figure on the left of the composition study (at the top left of this sheet) and the three separate figure sketches represent Saint Peter is confirmed by the principal study on the other Uffizi drawing. In that a similar figure stands in a doorway looking at the beaten Christ; perched in a window behind this figure is a hastily drawn cock, referring to Peter's Denial of Christ. Saint Catherine is inserted in the lower right corner, as a substitute for Saint Peter, in the painting in the Chigi-Saraceni Collection.

It is interesting that Vanni adopted the new, post-Tridentine iconography for the Flagellation of Christ, showing him prostrate and bound by his hands to an iron ring set into a low column, rather than standing and supported by a tall column. The latter type was standard in Italy during most of the sixteenth century, with famous examples being executed by Michelangelo, Sebastiano del Piombo, and Taddeo Zuccaro, among others. The new iconography, introduced near the end of the sixteenth century, is at once more archaeological and more emotional. The low column is based on one that was believed to be the actual column of the Flagellation. Brought from Jerusalem in 1223, it was placed in the Chapel of San Zeno in Santa Prassede in Rome (Mâle 1949, 186–187; Réau 1957, 452–456). A consequence of the introduction of this more literal iconography is that the Flagellation of Christ becomes a pathetic rather than heroic subject. Without the support provided by the tall column, Christ often falls to the ground, where he is beaten, kicked, and humiliated by his tormentors. Vanni's composition is an early manifestation of the new type.

G.S.

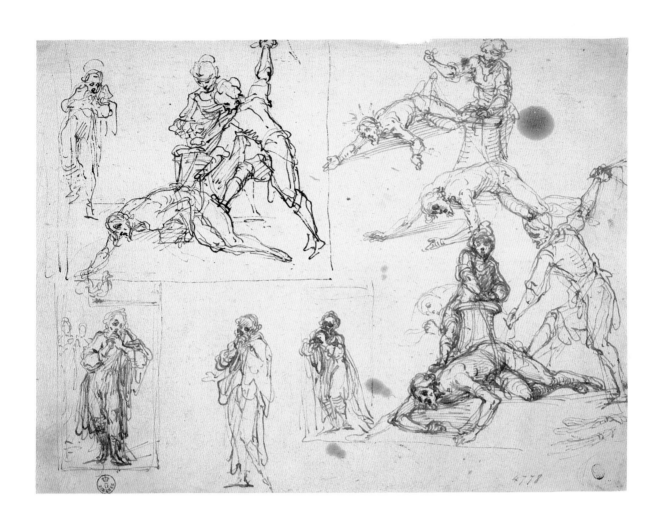

Ventura Salimbeni

1568 Siena 1613

100. *The Martyrdom of Saint Quiricus and Saint Julitta*

Pen and brown ink and brown wash over traces of black chalk, squared for enlargement in black chalk; 189 × 321 mm

15065F

EXHIBITION: Florence 1976, no. 99, fig. 104.

REFERENCE: Riedl 1959, 66, fig. 12.

Ventura Salimbeni began his career in Rome during the pontificates of Gregory XIII and Sixtus V. By 1595 he was working in Siena, however, where he was much influenced by his half-brother, Francesco Vanni. Together, Vanni and Salimbeni dominated Sienese painting in the last years of the sixteenth century and the first decade of the seventeenth.

As Riedl recognized (1959, 66), this beautiful drawing is the definitive study for *The Martyrdom of Saint Quiricus and Saint Julitta*, painted by Salimbeni in the apse of Santi Quirico e Giulitta in Siena in 1603. The drawing and fresco represent two violent episodes of martyrdom separated by a serene architectural view. The infant Quiricus is depicted in the upper left corner of the composition, moments before being hurled to the pavement by the judge Alexander, while in the right foreground Julitta, Quiricus's mother, is beaten by two tormentors (Kaftal 1952, no. 260, cols. 865–869). Despite the vitality and apparent freedom of Salimbeni's study, there are very few changes between it and the finished fresco (Riedl 1959, fig. 13), the only significant alteration being to the figures in the left foreground. In

the fresco both have their backs to the spectator and look into the painted scene.

The separation of the narrative incidents by a deep architectural view responds in part to the work's physical situation in the choir, where the fresco is partially interrupted by the altar (indicated at the lower center of the drawing). Salimbeni succeeds in turning this awkward compositional problem to good effect, however, creating a dramatic contrast between the dark, violent figure groups at left and right and the calm, light vista in the center of the composition.

Like Francesco Vanni, Salimbeni was much influenced by Federico Barocci, and the treatment of light and dark and certain details in pose and expression in this drawing recall works by Barocci. At the same time, the drama and violence of *The Martyrdom of Saint Quiricus and Saint Julitta* may indicate some relationship to Lodovico Cigoli's *Martryrdom of Saint Stephen* of 1597 in the Palazzo Pitti, as Riedl suggested (1959, 66).

G.S.

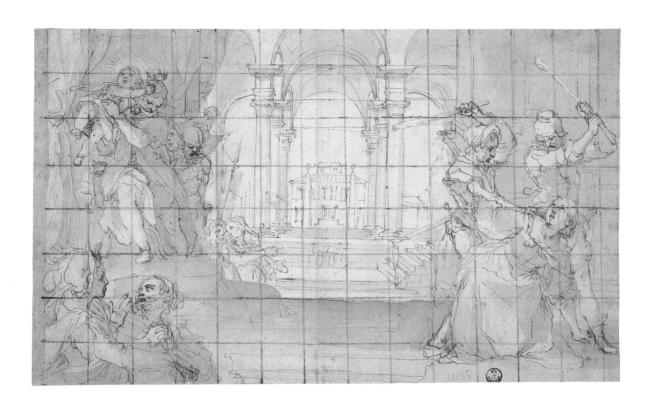

Bibliography

Album Michelangiolesco 1875
Album Michelangiolesco dei disegni originali di Michelangiolo Buonarroti riprodotti in Fotolitografie. Florence: Stabilimento Fotolitografico e Calcografico P. Smorti & C., 1875.

Allegri and Cecchi 1980
Allegri, Ettore and Cecchi, Alessandro. *Palazzo Vecchio e i Medici.* Florence: Studio per Edizioni Scelte, 1980.

Amerson 1977
Amerson, L. P. *The Problem of the Ecorché: A Catalogue Raisonné of Models and Statuettes from the Sixteenth Century and Later Periods.* Ann Arbor: UMI Press, 1977.

Ames-Lewis 1981
Ames-Lewis, Francis. *Drawing in Early Renaissance Italy.* New Haven and London: Yale University Press, 1981.

Amsterdam 1954
Het eerste Manierisme in Italie. 1500–1540. Catalogus van de Tentoonstelling van Tekeningen uit het Bezit der Musea te Florence, Rome en Venetie. Catalogue by various authors. Amsterdam, Rijksprentenkabinet, 1954.

Andrews 1964
Andrews, Keith. "A Note on Bronzino as a Draughtsman." *Master Drawings* 2 (1964): 157–160.

Andrews 1966
Andrews, Keith. Review of *The Drawings of Pontormo* by Janet Cox-Rearick. *Burlington Magazine* 108 (1966): 577–582.

Andrews 1968
Andrews, Keith. *National Gallery of Scotland: Catalogue of Italian Drawings.* 2 vols. Cambridge: Syndics of the Cambridge University Press, 1968.

Apuleius
Apuleius, Lucius. *The Golden Ass.* Translated by Robert Graves. Harmondsworth: Penguin Books, 1950.

Arezzo 1950
Mostra d'arte sacra della diocesi e della provincia dal sec. XI al XVIII. Anonymous catalogue. Arezzo, Palazzo Pretorio: Del Turco Editore, 1950.

Arezzo 1981
La Toscana nel Cinquecento. Giorgio Vasari: Principi, letterati, e artisti nelle carte di Giorgio Vasari. Catalogue by various authors. Arezzo, Casa di G. Vasari e Sottochiesa di S. Francesco and Florence: Edam, 1981.

Arnolds 1934
Arnolds, G. *Santi di Tito pittore di Sansepolcro.* Arezzo: R. Accademia Petrarca, 1934.

Baccheschi 1973
Baccheschi, Edi. *L'opera completa del Bronzino.* Milan: Rizzoli Editore, 1973.

Bacci 1963
Bacci, Mina. "Jacopo Ligozzi e la sua posizione nella pittura fiorentina." *Proporzioni* 4 (1963): 46–84.

Bacci 1974
Bacci, Mina. "Jacopo Ligozzi." In *Maestri della pittura veronese,* edited by Pierpaolo Brugnoli. Verona: Banca Mutua Popolare di Verona, 1974: 269–276.

Bacou 1963
Bacou, Roseline. "A Group of Drawings by Sogliani." *Master Drawings* 1 (1963): 41–43.

Bacou 1982
Bacou, Roseline. *I grandi disegni italiani della Collezione Mariette al Louvre di Parigi.* Milan: Silvana editoriale, 1982.

Baglione 1642
Baglione, Giovanni. *Le Vite de' pittori, scultori et architetti dal Pontificato di Gregorio XIII del 1572. In fino a' tempi di Papa Urbano Ottauo nel 1642.* Reprinted with an introduction by Valerio Mariani. Rome: Arti Grafiche E. Calzone, 1935.

Bagnoli 1977
Bagnoli, Alessandro. Review of *Disegni dei barocceschi senesi (Francesco Vanni e Ventura Salimbeni)* by Peter Anselm Riedl. *Prospettiva* 9 (April 1977): 82–85.

Bagnoli 1980
Bagnoli, A. "Alessandro Casolani." In *L'arte a Siena sotto i Medici.* Rome, 1980: 67–86.

Baldini 1950–52
Baldini, U. *Catalogo della mostra vasariana.* In *Studi Vasariani. Atti del Convegno Internazionale per il IV Centenario della prima edizione delle 'Vite' del Vasari.* Florence: G. C. Sansoni, 1950–52: 257–287.

Baldinucci
Baldinucci, Filippo. *Notizie dei professori del disegno.* Edited by F. Ranalli. 5 vols. Florence: Batelli e Compagni, 1846.

Bardazzi and Castellani 1981
Bardazzi, S. and Castellani, E. *La Villa Medicea di Poggio a Caiano.* 2 vols. Prato: Cassa di risparmi e depositi di Prato, 1981.

Barocchi 1950
Barocchi, Paola. *Il Rosso Fiorentino*. Rome: Gismondi, 1950.

Barocchi 1962
Barocchi, Paola. *Michelangelo e la sua scuola. Disegni di Casa Buonarroti e degli Uffizi*. Florence: Leo S. Olschki, 1962.

Barocchi 1964
Barocchi, Paola. "Appunti su Francesco Morandini da Poppi." *Mitteilungen des Kunsthistorischen Institutes in Florenz* 11 (1964): 117–148.

Barocchi 1964a
Barocchi, Paola. "Complementi al Vasari pittore." In *Atti dell'Accademia Toscana delle Scienze e Lettere "La Colombaria,"* Vol. 28. Florence: Leo S. Olschki, 1964: 253–309.

Barocchi 1964b
Barocchi, Paola. *Vasari Pittore*. Milan: Edizioni per il Club del Libro, 1964.

Barocchi 1965
Barocchi, Paola. "Itinerario di Giovan Battista Naldini." *Arte Antica e Moderna* 31 (1965): 244–288.

Barocchi 1968
Barocchi, Paola. "Proposte per Carlo Portelli." In *Festschrift Ulrich Middeldorf*, edited by Anteje Kosegarten and Peter Tigler. Berlin: Walter de Gruyter, 1968: 283–289.

Barsanti and Lecchini Giovannoni 1977
Barsanti, Anna, and Lecchini Giovannoni, Simona. "I Santi Martiri dell'Allori: Osservazioni su documenti e disegni inediti." In *Scritti di storia dell'arte in onore di Ugo Procacci*, edited by Maria Grazia Ciardi, Dupré Dal Poggetto and Paolo Dal Poggetto. Milan: Electa Editrice, 1977: 2:448–458.

Bartsch 1803–21
Bartsch, Adam von. *Le Peintre-Graveur*, Vol. 14. Vienna: P. Mechetti, 1803–21.

Bartsch 1981
Bartsch, Adam von. *The Illustrated Bartsch*, Vol. 10, *Albrecht Dürer*, edited by Walter L. Strauss. New York: Abaris Books, 1981.

Bartsch 1983
Bartsch, Adam von. *The Illustrated Bartsch*, Vol. 36, *Antonio Tempesta*, edited by Sebastian Buffa. New York: Abaris Books, 1983.

Bartsch 1983a
Bartsch, Adam von. *The Illustrated Bartsch*, Vol. 48, *Italian Chiaroscuro Woodcuts*, edited by Caroline Karpinski. New York: Abaris Books, 1983.

Bartsch 1984
Bartsch, Adam von. *The Illustrated Bartsch*, Vol. 35, *Antonio Tempesta*, edited by Antonio Buffa. New York: Abaris Books, 1984.

Bayersdorfer 1893
Bayersdorfer, Adolf. *Zeichnungen alter Italiener in den Uffizien zu Florenz*. Munich, 1893.

Bean 1960
Bean, Jacob. *Bayonne-Musée Bonnat. Les dessins italiens de la collection Bonnat*. Paris: Editions des Musées nationaux, 1960.

Bean 1982
Bean, Jacob, with the assistance of Lawrence Turčić. *15th and 16th Century Italian Drawings in the Metropolitan Museum of Art*. New York: Metropolitan Museum of Art, 1982.

Bean and Stampfle 1965
Bean, Jacob and Stampfle, Felice. *Drawings from New York Collections*, Vol. 1, *The Italian Renaissance*. New York: Metropolitan Museum of Art, Pierpont Morgan Library, distributed by New York Graphic Society, 1965.

Becherucci 1943
Becherucci, Luisa. *Disegni del Pontormo*. Bergamo: Istituto italiano d'arti grafiche, 1943.

Becherucci 1955
Becherucci, Luisa. *I grandi maestri del disegno: Andrea del Sarto*. Milan: A. Martello, 1955.

Beck 1973
Beck, James. "Precisions concerning Bandinelli pittore." *Antichità Viva* 12, no. 5 (1973): 7–11.

Berenson 1903
Berenson, Bernard. *The Drawings of the Florentine Painters*. 2 vols. London: E. P. Dutton, 1903.

Berenson 1935
Berenson, Bernard. "Andrea di Michelangelo e Antonio Mini." *L'Arte* 38 (1935): 243–283.

Berenson 1938
Berenson, Bernard. *The Drawings of the Florentine Painters*. 3 vols. Chicago: University of Chicago Press, 1938.

Berenson 1954
Berenson, Bernard. *Disegni di maestri fiorentini del Rinascimento in Firenze*. Turin: Edizioni Radio Italiana, 1954.

Berenson 1961
Berenson, Bernard. *I disegni dei pittori fiorentini*. 3 vols. Milan: Electa Editrice, 1961.

Berge 1935
Berge, Inge. "Un dipinto sconosciuto del Bachiacca et il suo modello." *Rivista d'Arte* 17 (1935): 85–90.

Bernari and De Vecchi 1970
Bernari, Carlo and De Vecchi, Pierluigi. *L'opera completa del Tintoretto*. Milan: Rizzoli Editore, 1970.

Berti 1956
Berti, Luciano. "Nota ai *Pittori toscani* in relazione con *Pietro da Cortona*." *Commentari* 7 (1956): 278–282.

Berti 1956a
Berti, Luciano. "Sembianze del Pontormo." *Quaderni Pontormeschi* 5 (1956).

Berti 1964
Berti, Luciano. *Pontormo*. Florence: Edizioni d'arte Il Fiorino, 1964.

Berti 1965
Berti, Luciano. "I Disegni." In *Michelangelo: artista, pensatore, scrittore*, edited by M. Salmi. Novara: Istituto geografico de Agostini, 1965.

Berti 1965a
Berti, Luciano. *Pontormo: Disegni*. Florence: La Nuova Italia, 1965.

Berti 1966
Berti, Luciano. "Precisazioni sul Pontormo." *Bolletino d'Arte* 51, ser. 5 (1966): 50–57.

Berti 1967
Berti, Luciano. *Il principe dello studiolo. Francesco I dei Medici e la fine del Rinascimento fiorentino*. Florence: Edam, 1967.

Berti 1973
Berti, Luciano. *L'opera completa del Pontormo*. Milan: Rizzoli Editore, 1973.

Bertolotti 1882
Bertolotti, Antonio. *Don Giulio Clovio, principe dei miniatori, notizie e documenti inediti*. Vol. 3, no. 13. Modena, 1882.

Bianchini 1980
Bianchini, Adelaide. "Jacopo da Empoli." *Paradigma* 3 (1980): 91–146.

Bocchi 1591
Bocchi, Francesco. *Le bellezze della città di Fiorenza*. Florence, 1591.

Bologna 1975
Mostra di Federico Barocci. Catalogue by Andrea Emiliani with Giovanna Gaeta Bertelà. Bologna, Museo Civico: Edizioni Alfa, 1975.

Borghini 1807
Borghini, Raffaello. *Il Riposo*. Florence, 1584; rpt. 3 vols. Milan: La Società Tipografia de' Classici Italiani, 1807.

Borgo 1971
Borgo, Ludovico. "The Problem of the Ferry Carondelet Altar-piece." *Burlington Magazine* 113 (1971): 362–371.

Borgo 1976
Borgo, Lodovico. *The Works of Mariotto Albertinelli*. New York and London: Garland, 1976.

Borsi 1974
Borsi, Franco. *Firenze del Cinquecento*. Rome: Editalia, 1974.

Borsook 1965
Borsook, Eve. "Art and Politics at the Medici Court. I: The Funeral of Cosimo I de' Medici." *Mitteilungen des Kunsthistorischen Institutes in Florenz* 12 (1965): 31–54.

Borsook 1980
Borsook, Eve. *The Mural Painters of Tuscany from Cimabue to Andrea del Sarto*. Second edition, revised and enlarged. Oxford: Clarendon Press, 1980.

Brandi 1931
Brandi, C. "Francesco Vanni." *Art in America* 19 (1931): 63–85.

Brandi 1933–34
Brandi, Cesare. "Disegni inediti di Domenico Beccafumi." *Bollettino d'Arte* 27, ser. 3 (1933–34): 350–369.

Briganti 1960
Briganti, Giuliano. "L'occasione mancata di Andrea Commodi." *Paragone* 11, no. 123 (March 1960): 33–37.

Briganti and Baccheschi 1977
Briganti, Giuliano and Baccheschi, Edi. *L'opera completa del Beccafumi*. Milano: Rizzoli Editore, 1977.

Brigstocke 1978
Brigstocke, Hugh. *Italian and Spanish Paintings in the National Gallery of Scotland*. Edinburgh: National Gallery of Scotland, 1978.

Brinckmann 1925
Brinckmann, A. Erich. *Michelangelo Zeichnungen*. Munich: R. Piper, 1925.

Briquet 1907
Briquet, L. M. *Les Filigranes: Dictionnaire historique des marques du papier des leur apparition vers 1282*. 4 vols. Paris: A Picard & Fils, 1907.

Brugnoli 1960
Brugnoli, Maria Vittoria. "Un palazzo romano del tardo '500 e l'opera di Giovanni e Cherubino Alberti a Roma." *Bollettino d'Arte* 45, ser. 4 (1960): 223–246.

Brugnoli 1961
Brugnoli, Maria Vittoria. *Palazzo Ruggieri*. Rome: Istituto di studi romani, 1961.

Brugnoli 1962
Brugnoli, Maria Vittoria. "Gli affreschi di Perin del Vaga nella Cappella Pucci." *Bollettino d'Arte* 47 (1962): 327–350.

Bucci 1965
Bucci, Mario. *Lo studiolo di Francesco I*. Florence: Sadea Editori, 1965.

Byam Shaw 1956
Byam Shaw, James. "The Prototype of a Subject by Giacomo Ligozzi." *Art Quarterly* 19 (1956): 283–284.

Byam Shaw 1976
Byam Shaw, James. *Drawings by Old Masters at Christ Church Oxford*. 2 vols. Oxford: Clarendon Press, 1976.

Cannon Brookes 1965
Cannon Brookes, Peter. "Three Notes on Maso da San Friano." *Burlington Magazine* 107 (1965): 192–197.

Cardi 1913
Cardi, Giovan Battista. *Vita di Ludovico Cardi Cigoli 1559–1613*. Edited by G. Battelli and K. H. Busse. Florence: San Miniato al Tedesco, 1913.

Carroll 1961
Carroll, Eugene A. "Some Drawings by Rosso Fiorentino." *Burlington Magazine* 103 (1961): 446–454.

Carroll 1966
Carroll, Eugene A. "Drawings by Rosso Fiorentino in the British Museum." *Burlington Magazine* 108 (1966): 168–180.

Carroll 1971
Carroll, Eugene A. "Some Drawings by Salviati Formerly Attributed to Rosso Fiorentino." *Master Drawings* 9 (1971): 15–37.

Carroll 1976
Carroll, Eugene A. *The Drawings of Rosso Fiorentino*. 2 vols. New York and London: Garland, 1976.

Carroll 1978
Carroll, Eugene A. "A Drawing by Rosso Fiorentino of Judith and Holofernes." *Los Angeles County Museum of Art Bulletin* 24 (1978): 24–49.

Cecchi 1956
Cecchi, E., ed. *Jacopo da Pontormo: Diario*. Florence: Felice le Monnier, 1956.

Cecchi 1986
Cecchi, Allesandro. *"La pêche des perles aux Indes: Une peinture d'Antonio Tempesta."* *Revue du Louvre* 36 (1986): 45–57.

Chappell and Kirwin 1974
Chappell, Miles L. and Kirwin, Chandler W. "A Petrine Triumph: The Decoration of the Navi Piccole in San Pietro under Clement VIII." *Storia dell'arte* 21 (1974): 119–148.

Cheney 1963
Cheney, Iris H. "Francesco Salviati's North Italian Journey." *Art Bulletin* 45 (1963): 337–349.

Cheney 1973
Cheney, Iris. Review of *Bronzino as Draughtsman: An Introduction* by Craig Hugh Smyth. *Master Drawings* 11 (1973): 165–171.

Chiarelli 1939
Chiarelli, Renzo. "Contributi a Santi di Tito architetto." *Rivista d'Arte* 2 (1939): 126–155.

Chiarini 1972
Chiarini, Marco. *I disegni italiani di paesaggio dal 1600 al 1750*. Treviso: Libreria Editrice Canova, 1972.

Ciletti 1979
Ciletti, Elena. "On the Destruction of Pontormo's Frescoes at S. Lorenzo and the Possibility That Parts Remain." *Burlington Magazine* 121 (1979): 765–770.

Clapp 1914
Clapp, Frederick Mortimer. *Les dessins de Pontormo*. Paris: E. Champion, 1914.

Clapp 1916
Clapp, Frederick Mortimer. *Jacopo Carucci da Pontormo: His Life and Work*. New Haven: Yale University Press, 1916.

Clifford 1975
Clifford, Timothy. "Old Master Drawings in Albemarle Street." *Burlington Magazine* 117 (1975): 319.

Collareta 1977
Collareta, M. "Tre note su Santi di Tito." *Annali della Scuola Normale Superiore di Pisa* 8 (1977): 351–369.

Comandé 1952
Comandé, Giovanni Battista. *L'opera di Andrea del Sarto*. Palermo: Palumbo, 1952.

Cox-Rearick 1964
Cox-Rearick, Janet. *The Drawings of Pontormo*. 2 vols. Cambridge: Harvard University Press, 1964.

Cox-Rearick 1964a
Cox-Rearick, Janet. "Some Early Drawings by Bronzino." *Master Drawings* 2 (1964): 363–382.

Cox-Rearick 1970
Cox-Rearick, Janet. "The Drawings of Pontormo: Addenda." *Master Drawings* 8 (1970): 363–378.

Cox-Rearick 1971
Cox-Rearick, Janet. "Les dessins de Bronzino pour la chapelle d'Eleonora au Palazzo Vecchio." *Revue de l'Art* 14 (1971): 7–22.

Cox-Rearick 1981
Cox-Rearick, Janet. *The Drawings of Pontormo*. 2 vols. Revised and augmented edition. New York: Hacker Art Books, 1981.

Cox-Rearick 1981a
Cox-Rearick, Janet. "Two Studies for Bronzino's Lost *Noli me tangere*." *Master Drawings* 19 (1981): 289–293.

Cox-Rearick 1984
Cox-Rearick, Janet. *Dynasty and Destiny in Medici Art: Pontormo, Leo X, and the Two Cosimos*. Princeton: Princeton University Press, 1984.

Cox-Rearick 1987
Cox-Rearick, Janet. "A 'St. Sebastian' by Bronzino." *Burlington Magazine* 129 (1987): 155–162.

Cust 1904
Cust, Robert H. Hobart. "On Some Overlooked Masterpieces." *Burlington Magazine* 4 (1904): 256–266.

Cust 1906
Cust, Robert H. Hobart. *Giovanni Antonio Bazzi*. New York: E. P. Dutton, 1906.

Dami 1919
Dami, Luigi. "Domenico Beccafumi." *Bollettino d'Arte* 13, ser. 1 (1919): 9–26.

Darragon 1983
Darragon, Eric. *Manierisme en crise: Le* Christ en gloire de Rosso Fiorentino à Città di Castello (1528–1530). Academie de France à Rome, VI. Rome: Edizioni dell'Elefante, 1983.

Davidson 1954
Davidson, Bernice. "Vasari's *Deposition* in Arezzo." *Art Bulletin* 36 (1954): 228–231.

Davidson 1985
Davidson, Bernice. *Raphael's Bible: A Study of the Vatican Logge.* University Park and London: Published for The College Art Association of America by The Pennsylvania State University Press, 1985.

Delacre 1938
Delacre, Maurice. *Le dessin de Michel-Ange.* Brussels: Palais des académies, 1938.

Demus 1935
Demus, Otto. *Die Mosaiken von San Marco in Venedig.* Baden bei Wien: Verlag Rudolf M. Rohrer, 1935.

De Rinaldis 1923
De Rinaldis, Aldo. "Il cofanetto farnesiano del Museo di Napoli." *Bolletino d'Arte* 3, ser. 2 (1923): 145–165.

Desjardins 1883
Desjardins, Abel. *La vie et l'oeuvre de Jean Bologne.* Paris: A. Quantin, 1883.

De Vries 1933
De Vries, Simonetta. "Jacopo Chimenti da Empoli." *Rivista d'Arte* 15 (1933): 329–398.

Dhanens 1956
Dhanens, E. *Jean Boulogne, Giovanni Bologna Fiammingo.* Brussels: K. Vlaamse Academie voor Wetenschappen, Letteren en Schone Kunsten van België, 1956.

Di Pietro 1910
Di Pietro, Filippo. "I disegni d'Andrea del Sarto negli Uffizi." *Vita d'Arte* 6 (1910): 127–171.

Di Pietro 1910a
Di Pietro, Filippo. *I disegni di Andrea del Sarto negli Uffizi.* Siena: L. Lazzeri, 1910.

Di Pietro 1921
Di Pietro, Filippo. "Disegni ornamentali italiani dei secoli XV, XVI, XVII." In *I disegni della R. Galleria degli Uffizi,* vol. 20, ser. 5, fasc. 4. Florence: Leo S. Olschki, 1921.

D'Onofrio 1963
D'Onofrio, Cesare. *La Villa Aldobrandini di Frascati.* Rome: Staderini, 1963.

Dussler 1959
Dussler, Luitpold. *Die Zeichnungen des Michelangelo.* Berlin: Gebr. Mann, 1959.

Dussler 1971
Dussler, Luitpold. *Raphael.* London: Phaidon Press, 1971.

Edinburgh 1978
Giambologna: Sculptor to the Medici. Catalogue by Charles Avery and Anthony Radcliffe. Edinburgh: Arts Council of Great Britain, 1978.

Edinburgh 1980
National Gallery of Scotland Illustrations. Edinburgh: Trustees of the National Galleries of Scotland, 1980.

Ettlinger and Ottino della Chiesa 1967
Ettlinger, L. D. and Ottino della Chiesa, Angela. *L'opera completa di Leonardo da Vinci.* Milan: Rizzoli Editore, 1967.

Faccio 1902
Faccio, Cesare. *Giovan Antonio Bazzi (Il Sodoma), pittore vercellese del secolo XVI.* Vercelli: Gallardi and Ugo, 1902.

Fairfax Murray 1912
Fairfax Murray, C. *Drawings by the Old Masters, Collection of J. Pierpont Morgan,* Vol. 4. London: privately printed, 1912.

Faranda 1986
Faranda, Franco. *Ludovico Cardi, detto il Cigoli.* Rome: De Luca, 1986.

Ferri 1881
Ferri, Pasquale Nerino. *Catalogo delle stampe esposte al pubblico nella R. Galleria degli Uffizi.* Florence: Arte della Stampa, 1881.

Ferri 1885
Ferri, Pasquale Nerino. *Indice geografico-analitico dei disegni di architettura civile e militare esistenti nella R. Galleria degli Uffizi in Firenze.* Rome: Presso i Principali Librai, 1885.

Ferri 1890
Ferri, Pasquale Nerino. *Catalogo riassuntivo della raccolta di disegni antichi e moderni posseduta dalla R. Galleria degli Uffizi di Firenze.* Roma: Presso i Principali Librai, 1890.

Ferri 1912–21
Ferri, Pasquale Nerino. "Disegni del Cigoli, dell'Empoli, di Cristofano Allori e del Furini." In *I Disegni della R. Galleria degli Uffizi,* ser. 2. Florence: Leo S. Olschki, 1912–21.

Ferri 1912–21a
Ferri, Pasquale Nerino. "Disegni di Andrea del Sarto." In *I Disegni della R. Galleria degli Uffizi,* ser. 4, fasc. 3. Florence: Leo S. Olschki, 1912–21.

Ferri 1912–21b
Ferri, Pasquale Nerino. "Disegni di Scuola Fiorentina (secoli XV e XVI). In *I Disegni della R. Galleria degli Uffizi,* IV/IV. Florence: Leo S. Olschki, 1912–21.

Florence 1870
Catalogo della Raccolta di disegni autografi antichi e moderni donata dal Prof. Emilio Santarelli alla Reale Galleria di Firenze. Catalogue by E. Santarelli, E. Burci, and F. Rondoni. Florence: M. Celli, 1870.

Florence 1910
Catalogo della mostra dei disegni di Andrea del Sarto e del Pontormo. Anonymous catalogue. Florence, Gabinetto Disegni e Stampe degli Uffizi: Tipografia Giuntina, 1910.

Florence 1911
Catalogo dei ritratti eseguiti in disegno ed in incisione da artisti italiani fioriti dal sec. XV alla prima metà del sec. XIX, esposti nella R. Galleria degli Uffizi. Anonymous catalogue. Florence, Galleria degli Uffizi: Tipografia Giuntina, 1911.

Florence 1913
Mostra dei disegni di Ludovico Cardi detto il Cigoli nel Gabinetto dei disegni della R. Galleria degli Uffizi. Catalogue by P. N. Ferri and F. Di Pietro. Bergamo, 1913.

Florence 1922
Catalogo della mostra di disegni italiani del Sei e Settecento. Catalogue by O. H. Giglioli. Florence, Gabinetto Disegni e Stampe degli Uffizi: Leo S. Olschki, 1922.

Florence 1939
Catalogo della mostra di disegni fiorentini del Cinquecento. Anonymous catalogue. Florence, Gabinetto Disegni e Stampe degli Uffizi: Arte Tipografia Fiorentina, 1939.

Florence 1940
Mostra del Cinquecento toscano. Catalogue by various authors. Florence, Palazzo Strozzi: Casa Editrice Marzocco, 1940.

Florence 1947
Mostra d'arte fiamminga e olandese dei secoli XV e XVI. Catalogue by various authors. Florence, Palazzo Strozzi: G. C. Sansoni, 1948.

Florence 1950
Catalogo della mostra vasariana. Catalogue by G. Brunetti and U. Baldini. Florence, Palazzo Vecchio: G. C. Sansoni, 1950.

Florence 1954
Mostra di disegni dei primi Manieristi italiani. Catalogue by G. Sinibaldi, with L. Marcucci, M. Fossi, B. M. Mori, and P. Barocchi. Florence, Gabinetto Disegni e Stampe degli Uffizi: Leo S. Olschki, 1954.

Florence 1956
Mostra del Pontormo e del primo Manierismo fiorentino. Catalogue by Luisa Marcucci. Florence, Palazzo Strozzi: Tipografia Giuntina, 1956.

Florence 1957
Mostra documentaria e iconografica di Palazzo Vecchio. Catalogue by G. Camerani Marri. Florence, Archivio di Stato, 1957.

Florence 1959
Mostra di disegni di Andrea Boscoli. Catalogue by A. Forlani. Florence, Gabinetto Disegni e Stampe degli Uffizi: Leo S. Olschki, 1959.

Florence 1960
La caccia e le arti. Catalogue by various authors. Florence, Palazzo Strozzi: Tipografia Il Cenacolo, 1960.

Florence 1960a
Mostra di disegni dei grandi maestri. Catalogue by G. Sinibaldi. Florence, Gabinetto Disegni e Stampe degli Uffizi, Tipografia Giuntina 1960.

Florence 1961
Mostra di disegni di Jacopo Ligozzi. Catalogue by M. Bacci and A. Forlani. Florence, Gabinetto Disegni e Stampe degli Uffizi: Leo S. Olschki, 1961.

Florence 1962
Disegni di Jacopo da Empoli. Catalogue by A. Bianchini and A. Forlani. Florence, Gabinetto Disegni e Stampe degli Uffizi: Leo S. Olschki, 1962.

Florence 1963
Mostra di disegni dei fondatori dell'Accademia delle Arti del Disegno nel IV centenario della Fondazione. Catalogue by P. Barocchi, A. Bianchini, A. Forlani, and M. Fossi. Florence, Gabinetto Disegni e Stampe degli Uffizi: Leo S. Olschki, 1963.

Florence 1964
Mostra di disegni del Vasari e della sua cerchia. Catalogue by P. Barocchi. Florence, Gabinetto Disegni e Stampe degli Uffizi: Leo S. Olschki, 1964.

Florence 1967
Disegni italiani della collezione Santarelli. Secoli XV–XVIII. Florence, Gabinetto Disegni e Stampe degli Uffizi: Leo S. Olschki, 1967.

Florence 1968
Mostra di disegni di Bernardo Buontalenti. Catalogue by I. M. Botto. Florence, Gabinetto Disegni e Stampe degli Uffizi: Leo S. Olschki, 1968.

Florence 1969
Feste e apparati medicei da Cosimo I a Cosimo II. Catalogue by A. Petrioli Tofani and G. Gaeta Bertelà. Florence, Gabinetto Disegni e Stampe degli Uffizi: Leo S. Olschki, 1969.

Florence 1970
Mostra di disegni di Alessandro Allori (Firenze 1535–1607). Catalogue by S. Lecchini Giovannoni. Florence, Gabinetto Disegni e Stampe degli Uffizi: Leo S. Olschki, 1970.

Florence 1972
Disegni di Francesco Furini e del suo ambiente. Cata-

logue by Giuseppe Cantelli. Florence, Gabinetto Disegni e Stampe degli Uffizi: Leo S. Olschki, 1972.

Florence 1972a
Mostra di opere restaurate dalla Soprintendenza alle Gallerie: Firenze restaura, il laboratorio nel suo quarantennio. Guide to the exhibition by Umberto Baldini and Paolo Dal Poggetto. Florence, Fortezza da Basso: G. C. Sansoni Editore, 1972.

Florence 1973
Mostra di disegni italiani di paesaggio del Seicento e del Settecento. Catalogue by Marco Chiarini. Florence, Gabinetto Disegni e Stampe degli Uffizi: Leo S. Olschki, 1973.

Florence 1975
I disegni di Michelangelo nelle collezioni italiane. Catalogue by Charles de Tolnay. Florence: Centro Di, 1975.

Florence 1976
Disegni dei barocceschi senesi (Francesco Vanni e Ventura Salimbeni). Catalogue by P. A. Riedl. Florence, Gabinetto Disegni e Stampe degli Uffizi: Leo S. Olschki, 1976.

Florence 1976a
Omaggio a Leopoldo de Medici. Parte 1: Disegni. Catalogue by A. Forlani Tempesti and A. Petrioli Tofani. Florence, Gabinetto Disegni e Stampe degli Uffizi: Leo S. Olschki, 1976.

Florence 1979
Disegni dei Toscani a Roma (1580–1620). Catalogue by M. L. Chappell, with W. C. Kirwin, G. L. Nissman, and S. Prosperi Valenti Rodinò. Florence, Gabinetto Disegni e Stampe degli Uffizi: Leo S. Olschki, 1979.

Florence 1980
Disegni di Bernardino Poccetti. Catalogue by P. C. Hamilton. Florence, Gabinetto Disegni e Stampe degli Uffizi: Leo S. Olschki, 1980.

Florence, Forte di Belvedere 1980
Il potere e lo spazio (Firenze e la Toscana dei Medici nell'Europa del Cinquecento). Catalogue by various authors. Florence, Forte di Belvedere: Electa Editrice, 1980.

Florence, Palazzo Medici Riccardi 1980
La scena del Principe (Firenze e la Toscana dei Medici nell'Europa del Cinquecento). Catalogue by various authors. Florence, Palazzo Medici Riccardi: Electa Editrice, 1980.

Florence, Palazzo Strozzi 1980
Il primato del disegno (Firenze e la Toscana dei Medici nell'Europa del Cinquecento). Catalogue by various authors. Florence, Palazzo Strozzi: Electa Editrice, 1980.

Florence, Palazzo Vecchio 1980
Palazzo Vecchio: Committenza e collezionismo medicei (Firenze e la Toscana dei Medici nell'Europa del Cin-quecento). Catalogue by various authors. Florence, Palazzo Vecchio: Electa Editrice, 1980.

Florence 1981
Restauro e conservazione delle opere d'arte su carta. Catalogue by various authors. Florence, Gabinetto Disegni e Stampe degli Uffizi: Leo S. Olschki, 1981.

Florence 1984
Immagini anatomiche e naturalistiche nei disegni degli Uffizi Secc. XVI e XVII. Catalogue by R. P. Ciardi and L. Tongiorgi Tomasi. Florence, Gabinetto Disegni e Stampe degli Uffizi: Leo S. Olschki, 1984.

Florence 1985
Disegni di architetti fiorentini 1540–1640. Catalogue by A. Morrogh. Florence, Gabinetto Disegni e Stampe degli Uffizi: Leo S. Olschki, 1985.

Florence 1985a
Disegni di Santi di Tito (1536–1603). Catalogue by S. Lecchini Giovannoni and M. Collareta. Florence, Gabinetto Disegni e Stampe degli Uffizi: Leo S. Olschki, 1985.

Florence 1986
Andrea del Sarto 1486–1530. Dipinti e disegni a Firenze. Catalogue by various authors. Florence, Palazzo Pitti: D'Angeli-Haeusler editore, 1986

Florence 1986a
Disegni di Fra Bartolommeo e della sua scuola. Catalogue by C. Fischer. Florence, Gabinetto Disegni e Stampe degli Uffizi: Leo S. Olschki, 1986.

Florence 1986b
Il Seicento Fiorentino. Arte a Firenze da Ferdinando I a Cosimo III. Pittura. Catalogue by various authors. Florence, Palazzo Strozzi: Cantini Edizioni d'Arte SpA, 1986.

Florence 1986c
Il Seicento Fiorentino. Arte a Firenze da Ferdinando I a Cosimo III. Disegno/Incisione/Scultura/Arti minori. Catalogue by various authors. Florence, Palazzo Strozzi: Cantini Edizioni d'Arte SpA, 1986.

Forlani 1962
Forlani, Anna. *I disegni italiani del Cinquecento.* Venice: Sodalizio del libro, 1962.

Forlani 1963
Forlani, Anna. "Andrea Boscoli." *Proporzioni* 4 (1963): 85–208.

Forlani 1963a
Forlani, Anna in *Mostra di disegni dei fondatori dell'Accademia delle Arti del Disegno nel IV centenario della Fondazione.* Florence, Gabinetto Disegni e Stampe degli Uffizi: Leo S. Olschki, 1963.

Forlani Tempesti 1967
Forlani Tempesti, A. "Nota al Pontormo disegnatore," review of *The Drawings of Pontormo* by Janet Cox-Rearick. *Paragone* 18, no. 207 (1967): 70–86.

Forlani Tempesti 1968
Forlani Tempesti, Anna. "Alcuni disegni di Giambattista Naldini." In *Festschrift Ulrich Middeldorf,* edited by Antje Kosegarten and Peter Tigler. Berlin: Walter de Gruyter, 1968: 294–300.

Forster 1964
Forster, Kurt W. "Probleme um Pontormos Porträtmalerei (I)." *Pantheon* 22 (1964): 376–385.

Forster 1966
Forster, Kurt W. *Pontormo.* Munich: F. Bruckmann KG, 1966.

Fraenckel 1935
Fraenckel, J. *Andrea del Sarto, Gemälde und Zeichnungen.* Strassburg: J. H. E. Heitz, 1935.

Franklin 1987
Franklin, David. "Rosso, Leonardo Buonafé and the Francesca de Ripoi Altar-piece." *Burlington Magazine* 129 (1987): 652–662.

Frantz 1879
Frantz, E. *Fra Bartolommeo della Porta. Studie über di Renaissance.* Regensburg, 1879.

Freedberg 1963
Freedberg, S. J. *Andrea del Sarto.* 2 vols. Cambridge: Harvard University Press, 1963.

Freedberg 1971
Freedberg, S. J. *Painting in Italy 1500 to 1600.* Harmondsworth: Penguin Books, 1971.

Freedberg 1979
Freedberg, S. J. *Painting in Italy 1500 to 1600.* 2nd revised, integrated edition. Harmondsworth: Penguin Books, 1979.

Frey 1930
Frey, Karl. *Der literarische Nachlass Giorgio Vasaris.* 3 vols. Munich: G. Muller, 1930.

Gabelentz 1922
Gabelentz, Hans von der. *Fra Bartolommeo und die florentiner Renaissance.* 2 vols. Leipzig: Karl W. Hiersemann, 1922.

Gamba 1914
Gamba, C. "Disegni di Baccio della Porta detto Fra Bartolommeo." In *I Disegni della R. Galleria degli Uffizi,* vol. 6, ser. 2, fasc. 2. Florence: Leo S. Olschki, 1914.

Gaye 1840
Gaye, Johann Wilhelm. *Carteggio inedito d'artisti dei secoli XIV. XV. XVI. pubblicato ed illustrato con documenti pure inediti.* 3 vols. Florence: Giuseppe Molini, 1840.

Gere 1969
Gere, J. A. *Taddeo Zuccaro: His Development Studied in His Drawings.* London: Faber and Faber, 1969.

Gere and Pouncey 1983
Gere, J. A., and Pouncey, Philip, with the assistance of Rosalind Wood. *Italian Drawings in the Department of Prints and Drawings in the British Museum: Artists Working in Rome c. 1550 to c. 1640.* London: British Museum Publications, 1983.

Gibellino-Krasceninnicowa 1933
Gibellino-Krasceninnicowa, M. *Il Beccafumi.* Florence: Leo S. Olschki, 1933.

Giglioli 1923
Giglioli, Odoardo H. "Disegni inediti di Alessandro Allori, di Andrea Boscoli, di Annibale Carracci, di Giovanni Bilivert, di Cristofano Allori, di Giovanni di San Giovanni, di Francesco Furini, di Pietro da Cortona, di Vincenzo Mannozzi, nella R. Galleria degli Uffizi." *Bollettino d'Arte* 2, ser. 2 (1923): 498–525.

Giovannozzi 1933
Giovannozzi, Vera. "Ricerche su Bernardo Buontalenti." *Rivista d'Arte* 15 (1933): 299–327.

Gli Uffizi 1979
Gli Uffizi Catalogo Generale. Catalogue by various authors. Florence: Centro Di, 1979.

Goldner 1983
Goldner, George R. *Master Drawings from the Woodner Collection.* Malibu: J. Paul Getty Museum, 1983.

Goldner 1985
Goldner, George R. "A New Drawing by Sodoma." *Burlington Magazine* 127 (1985): 775–776.

Goldscheider 1951
Goldscheider, Ludwig. *Michelangelo Drawings.* London: Phaidon Press, 1951.

Gotti 1875
Gotti, Aurelio. *Vita di Michelangelo Buonarroti.* 2 vols. Florence: Gazzetta d'Italia, 1875.

Gruyer 1886
Gruyer, G. *Fra Bartolommeo della Porta et Mariotto Albertinelli.* Paris: Librairie de l'art, 1886.

Guinness 1899
Guinness, H. *Andrea del Sarto.* London: G. Bell and Sons, 1899.

Hadeln 1906
Hadeln, Detlev, Freiherr von. *Die wichtigsten Darstellungsformen des H. Sebastian in der italienischen Malerei bis zum Ausgang des Quattrocento.* Strassburg: J. H. E. Heitz, 1906.

Hall 1979
Hall, Marcia B. *Renovation and Counter-Reformation: Vasari and Duke Cosimo in Sta. Maria Novella and Sta. Croce 1565–1577.* Oxford: Clarendon Press, 1979.

Hartt 1971
Hartt, Frederick. *The Drawings of Michelangelo.* New York: Harry N. Abrams, 1971.

238

Hatfield 1970
Hatfield, Rab. "The Compagnia de' Magi." *Journal of the Warburg and Courtauld Institutes* 33 (1970): 107–161.

Hatfield 1970a
Hatfield, Rab. "Some Unknown Descriptions of the Medici Palace in 1459." *Art Bulletin* 52 (1970): 232–249.

Hatfield 1976
Hatfield, Rab. *Botticelli's Uffizi "Adoration": A Study in Pictorial Content.* Princeton: Princeton University Press, 1976.

Hatfield Strens 1968
Hatfield Strens, Bianca. "L'arrivo del trittico Portinari a Firenze." *Commentari* 19 (1968): 315–319.

Hayum 1976
Hayum, Andrée. *Giovanni Antonio Bazzi—"Il Sodoma."* New York and London: Garland, 1976.

Hayward 1976
Hayward, J. F. *Virtuoso Goldsmiths and the Triumph of Mannerism 1540–1620.* London: Sotheby–Parke Bernet, 1976.

Heikamp 1964
Heikamp, Detlef. "Baccio Bandinelli nel Duomo di Firenze." *Paragone* 15, no. 175 (July 1964): 32–42.

Heikamp 1967
Heikamp, Detlef. "Federico Zuccari a Firenze (1575–1579)." *Paragone* 18, no. 205 (March 1967): 44–68.

Heikamp 1969
Heikamp, Detlef. "Die Arazzeria Medicea im 16 Jahrhundert Neue Studien." *Münchner Jahrbuch der Bildenden Kunst* 20 (1969): 33–74.

Hendel Sarsini 1960
Hendel Sarsini, L. "Un'opera di Carlo Portelli nello Studiolo di Francesco I." *Rivista d'Arte* 35 (1960): 99–102.

Hirst 1963
Hirst, Michael. "Three Ceiling Decorations by Francesco Salviati." *Zeitschrift für Kunstgeschichte* 26 (1963): 146–165.

Hollstein
Hollstein, F. W. H. *Dutch and Flemish Etchings, Engravings, and Woodcuts, ca. 1450–1700.* 15 vols. Amsterdam: Menno Hertzberger, n.d.

Jacobsen 1898
Jacobsen, Emil. "Die Handzeichnungen der Uffizien in ihren Beziehungen zu Gemälden, Sculpturen und Gebäuden in Florenz." *Repertorium für Kunstwissenschaft* 21 (1898): 263–283.

Jacobsen 1904
Jacobsen, Emil. "Die Handzeichnungen der Uffizien in ihren Beziehungen zu Gemälden, Skulpturen und Gebäuden in Florenz." *Repertorium für Kunstwissenschaft* 27 (1904): 113–132.

Jerusalem 1984
Disegni italiani della Galleria degli Uffizi. Catalogue by the Gabinetto Disegni e Stampe degli Uffizi. Jerusalem: Israel Museum, 1984.

Judey 1932
Judey, J. *Domenico Beccafumi.* Inaugural Dissertation, Freiburg in Br., 1932.

Justi 1909
Justi, Carl. *Michelangelo. Neue Beiträge zur Erklärung seiner Werke.* Berlin: G. Grote'sche, 1909.

Kaftal 1952
Kaftal, George. *Iconography of the Saints in Tuscan Painting.* Florence: Sansoni, 1952.

Kirwin 1978
Kirwin, W. C. "The Life and Drawing Style of Cristofano Roncalli." *Paragone* 29, no. 335 (1978): 18–62.

Kloek 1975
Kloek, W. T. *Beknopte catalogus van de Nederlandse tekeningen in het Prentenkabinet van de Uffizi te Florenz.* Utrecht: Haentjens Dekker & Gumbert, 1975.

Knapp 1903
Knapp, Fritz. *Fra Bartolommeo della Porta und die Schule von San Marco.* Halle: Wilhelm Knapp, 1903.

Knapp 1907
Knapp, Fritz. *Andrea del Sarto.* Leipzig: Velhagen & Klasing, 1907.

Knapp 1928
Knapp, Fritz. *Andrea del Sarto.* Second edition. Leipzig: Velhagen & Klasing, 1928.

Kris 1929
Kris, Ernst. *Meister und Meisterwerke der Steinschneidekunst in der italienischen Renaissance.* 2 vols. Vienna: Anton Schroll & Co., 1929.

Kultzen 1970
Kultzen, R. *Jagddarstellungen des Jan Van der Straet auf Teppichen und Stichen des 16. Jahrhunderts.* Hamburg and Berlin: Parey, 1970.

Kusenberg 1931
Kusenberg, Kurt. *Le Rosso.* Paris: A. Michel, 1931.

Ladner 1961
Ladner, Gerhart B. "Vegetation Symbolism and the Concept of the Renaissance." In *De artibus opuscula XL: Essays in Honor of Erwin Panofsky,* edited by M. Meiss. 2 vols. New York: New York University Press, 1961: 1:303–322.

Lagrange 1862
Lagrange, Léon. "Catalogue des Dessins des Maîtres exposés dans la Galerie des Uffizi, a Florence." *Gazette des Beaux-Arts,* 12, 13, (1862): 535–554, 276–284.

Lasareff 1966
Lasareff, Victor. "Appunti sul manierismo e tre nuovi quadri di Battista Naldini." In *Arte in Europa: Scritti di Storia dell'Arte in Onore di Edoardo Arslan*. Milan: Tipografia Artipo, 1966: I: 581–590.

Lecchini Giovannoni 1977
Lecchini Giovannoni, S. "Disegni fiorentini 1560–1640." *Antichita Viva* 16 (1977): 48–51.

Lecchini Giovannoni 1980
Lecchini Giovannoni, Simona. "Di uno 'scartafaccio' ed altri disegni di Alessandro Allori." *Paragone* 31, no. 365 (July 1980): 64–83.

Leningrad 1982
Disegni italiani del XV–XVII secoli nella collezione del Gabinetto Disegni e Stampe degli Uffizi. Catalogue by C. Caneva. Leningrad, The Hermitage, 1982.

Leporini 1925
Leporini, H. *Handzeichnungen grosser Meister: Andrea del Sarto*. Vienna: Manz, 1925.

London 1930
A Commemorative Catalogue of the Exhibition of Italian Art Held in the Galleries of the Royal Academy, Burlington House London, January–March 1930. Catalogue by Lord Balniel, Kenneth Clark, and Ettore Modigliani. London: Oxford University Press, 1931.

Mâle 1949
Mâle, Emile. *Religious Art from the Twelfth to the Eighteenth Century*. New York: Pantheon, 1949.

Mantz 1876
Mantz, Paul. "Le génie de Michel-Ange dans les dessins." *Gazette des Beaux-Arts* 18 (1876): 5–33.

Mantz 1876a
Mantz, Paul. "Michel-Ange Peintre." *Gazette des Beaux-Arts* 18 (1876): 119–186.

Marcucci 1955
Marcucci, Luisa. "Girolamo Macchietti disegnatore." *Mitteilungen des Kunsthistorischen Institutes in Florenz* 7 (1955): 121–132.

Marcucci 1958
Marcucci, Luisa. "Contributo al Bachiacca." *Bollettino d'Arte* 43 (1958): 26–39.

Martini 1981
Martini, Laura. "Note su Pietro Sorri disegnatore." In *Per A. E. Popham*. Parma: Consigli arte, 1981.

Martini 1984
Martini, Laura. "Aggiunte a Pietro Sorri." *Fondazione di Studi di Storia dell'Arte Roberto Longhi* 1 (1984).

Matteoli 1970
Matteoli, Anna. "Una biografia inedita di Giovanni Bilivert." *Commentari* 21 (1970): 326–364.

Matteoli 1980
Matteoli, Anna. *Lodovico Cardi-Cigoli, pittore e architetto*. Pisa: Giardini editori e stampatori, 1980.

Mayer 1982
Mayer, Rosemary. *Pontormo's Diary*. New York: Out of London Press, 1982.

McComb 1928
McComb, Arthur. *Agnolo Bronzino: His Life and Works*. Cambridge: Harvard University Press, 1928.

McCorquodale 1981
McCorquodale, Charles. *Bronzino*. New York: Harper and Row, 1981.

McGrath 1967
McGrath, Robert L. "Some Drawings by Jacopo Ligozzi Illustrating 'The Divine Comedy.'" *Master Drawings* 5 (1967): 31–35.

Middeldorf 1929
Middeldorf, Ulrich. "An Erroneous Donatello Attribution." *Burlington Magazine* 54 (1929): 184–188.

Milan 1970
Disegni del Pontormo di Gabinetto Disegni e Stampe degli Uffizi. Catalogue by Anna Forlani Tempesti. Milan, Pinacoteca di Brera: Centro Di, 1970.

Molinari 1961
Molinari, Cesare. "L'attività teatrale di Ludovico Cigoli." *Critica d'Arte* 47, 48 (1961): 62–67, 62–69.

Monbeig-Goguel 1971
Monbeig-Goguel, Catherine. *Il manierismo fiorentino*. Milan: Fratelli Fabbri Editori, 1971.

Monbeig-Goguel 1972
Monbeig-Goguel, Catherine. *Vasari et son temps. Inventaire général des dessins italiens*. Paris, Musée du Louvre: Editions des Musées Nationaux, 1972.

Monbeig-Goguel 1976
Monbeig-Goguel, Catherine. "Salviati, Bronzino, et 'La Vengeance de l'Innocence.'" *Revue de l'Art* 31 (1976): 33–37.

Monbeig-Goguel 1978
Monbeig-Goguel, Catherine. "Francesco Salviati e il tema della resurrezione di Cristo." *Prospettiva* 13 (April 1978): 7–23.

Monti 1965
Monti, Raffaele. *Andrea del Sarto*. Milan: Edizioni di Comunità, 1965.

Morelli and Habich 1893
Morelli, G. and Habich, E. "Handzeichnungen italienischer Meister in photographischen Aufnahmen von Braun u. co. in Dornach, kritisch gesichtet von Giovanni Morelli (Lermolieff) mitgeteilt von E. Habich." *Kunstchronik* 11 (1893): 84–86.

Mossakowski 1983
Mossakowski, Stanislaw, "Il significato della Santa Cecilia di Raffaello." In *La Santa Cecilia di Raffaello*. Edited by A. Emilani. Bologna: Edizioni Alfa, 1983: 51–79.

Naples 1952
Fontainebleau e la Maniera Italiana. Catalogue by F. Bologna and R. Causa. Naples, Mostra d'Oltremare e del lavoro italiano nel mondo, 1952.

Neuburger 1981
Neuburger, Susanne. "Paggi, Passignano oder Empoli: Ein Konkurrenzentwurf zum 'Paradies' in San Remigio in Florenz." *Mitteilungen des Kunsthistorisches Institutes in Florenz* 25 (1981): 383–390.

Nicco Fasola 1947
Nicco Fasola, G. *Pontormo o del Cinquecento.* Florence: Arnaud, 1947.

Olszewski 1981
Olszewski, Edward J., with the assistance of Jane Glaubinger. *The Draftsman's Eye: Late Renaissance Schools and Styles.* Cleveland: Cleveland Museum of Art, and Bloomington: Indiana University Press, 1981.

Orbaan 1903
Orbaan, J. A. F. *Stradanus te Florence.* Rotterdam: Nijgh & Van Ditmar, 1903.

Ovid
The "Metamorphoses" of Ovid. Translated and with an introduction by Mary M. Innes. Harmondsworth: Penguin Books, 1968.

Paatz 1931
Paatz, Walter and Paatz, Elisabeth. *Die Kirchen von Florenz.* Frankfort: Vittorio Klosterman, 1931.

Paatz 1953
Paatz, Walter and Paatz, Elisabeth. *Die Kirchen von Florenz.* Frankfort: Vittorio Klosterman, 1953.

Paatz 1955
Paatz, Walter and Paatz, Elisabeth. *Die Kirchen von Florenz.* Frankfort: Vittorio Klosterman, 1955.

Pace 1973
Pace, Valentino. "Carlo Portelli." *Bollettino d'Arte* 58, ser. 5 (1973): 27–33.

Pace 1973a
Pace, Valentino. "Contributo al catalogo di alcuni pittori dello studiolo di Francesco I." *Paragone* 24, no. 285 (November 1973): 69–84.

Paleotti 1582
Paleotti, G. *Discorso intorno alle immagini sacre e profane.* Bologna, 1582.

Panofsky 1927–28
Panofsky, Erwin. "Kopie oder Fälschung?" *Zeitschrift für bildende Kunst* 61 (1927–28): 221–244.

Panofsky 1953
Panofsky, Erwin. *Early Netherlandish Painting, Its Origins and Character.* 2 vols. Cambridge: Harvard University Press, 1953.

Panofsky 1955
Panofsky, Erwin. *The Life and Art of Albrecht Dürer.* Princeton: Princeton University Press, 1955.

Panofsky 1962
Panofsky, Erwin. *Studies in Iconology: Humanistic Themes in the Art of the Renaissance.* New York: Oxford University Press, 1939; Torchbook ed., New York: Harper & Row, 1962.

Paris 1950
Trésors des Bibliothèques d'Italie. Catalogue by G. Sinibaldi and A. Petrucci. Paris, Bibliothèque Nationale, 1950.

Paris 1981
Dessins baroques florentins du Musée du Louvre. LXXIV^e exposition du Cabinet des Dessins. Catalogue by F. Viatte and C. Monbeig-Goguel. Paris, Cabinet des Dessins, Musée du Louvre: Editions de la Réunion des Musées Nationaux, 1981.

Paris 1986
Hommage à Andrea del Sarto. Catalogue by Dominique Cordellier. Paris, Cabinet des Dessins, Musée du Louvre: Editions de la Réunion des Musées Nationaux, 1986.

Parker 1956
Parker, K. T. *Catalogue of the Collection of Drawings in the Ashmolean Museum,* Vol. 2, *Italian Schools.* Oxford: Clarendon Press, 1956.

Passavant 1969
Passavant, Gunther. *Verrocchio.* London and New York: Phaidon Press, 1969.

Petrioli Tofani 1972
Petrioli Tofani, Annamaria. *I grandi disegni italiani degli Uffizi.* Milan: Silvana Editoriale d'Arte, 1972.

Petrioli Tofani 1979
Petrioli Tofani, Annamaria. Review of *Florentiner Zeichner des Frühbarock* by Christel Thiem. *Prospettiva* 19 (1979): 74–88.

Petrioli Tofani 1982
Petrioli Tofani, Annamaria. "Postille al 'Primato del Disegno.'" *Bollettino d'Arte* 67, ser. 6 (1982): 63–88.

Petrioli Tofani 1985
Petrioli Tofani, Annamaria. *Andrea del Sarto: Disegni.* Florence: La Nuova Italia, 1985.

Petrioli Tofani 1985a
Petrioli Tofani, Annamaria. "Due nuovi disegni del Vasari agli Uffizi." In *Giorgio Vasari tra decorazione ambientale e storiografia artistica: Convegno di Studi.* Edited by Gian Carlo Garfagnini. Florence: Leo S. Olschki, 1985.

Petrioli Tofani 1986
Petrioli Tofani, Annamaria. *Gabinetto disegni e stampe degli Uffizi: Inventario 1. Disegni esposti.* Florence: Leo S. Olschki, 1986.

Petrioli Tofani 1987
Petrioli Tofani, Annamaria. *Gabinetto disegni e stampe degli Uffizi: Inventario 2. Disegni esposti.* Florence: Leo S. Olschki, 1987.

Pillsbury 1970
Pillsbury, Edmund. "The Temporary Facade on the Palazzo Ricasoli: Borghini, Vasari, and Bronzino." *National Gallery of Art Report and Studies in the History of Art 1969*. Washington: Trustees of the National Gallery of Art, 1970.

Pillsbury 1973
Pillsbury, Edmund. "Vasari and His Time." *Master Drawings* 11 (1973): 171–175.

Pillsbury 1974
Pillsbury, Edmund. "Drawings by Jacopo Zucchi." *Master Drawings* 12 (1974): 3–33.

Pillsbury 1974a
Pillsbury, Edmund. "Jacopo Zucchi in S. Spirito in Sassia." *Burlington Magazine* 116 (1974): 434–444.

Pillsbury 1976
Pillsbury, Edmund. "The Sala Grande Drawings by Vasari and His Workshop: Some Documents and New Attributions." *Master Drawings* 14 (1976): 127–146.

Pillsbury 1977
Pillsbury, Edmund. Review of *The Drawings of Pontormo* by Janet Cox-Rearick. *Master Drawings* 15 (1977): 177–180.

Pillsbury and Richards 1978
Pillsbury, Edmund and Richards, Louise. *The Graphic Art of Federico Barocci*. New Haven: Yale University Art Gallery, 1978.

Pope-Hennessy 1954
Pope-Hennessy, John. Samson and a Philistine *by Giovanni Bologna*. London, Victoria and Albert Museum: Her Majesty's Stationery Office, 1954.

Pope-Hennessy 1964
Pope-Hennessy, John. *Catalogue of Italian Sculpture in the Victoria and Albert Museum*. Vol. 2. London: Her Majesty's Stationery Office, 1964.

Pope-Hennessy 1968
Pope-Hennessy, John. *Essays on Italian Sculpture*. London and New York: Phaidon Press, 1968.

Pope-Hennessy 1970
Pope-Hennessy, John. *Italian High Renaissance and Baroque Sculpture*. Second edition. London and New York: Phaidon Press, 1970.

Popham 1931
Popham, Arthur Ewart. *Italian Drawings Exhibited at the Royal Academy, Burlington House London, 1930*. London: Oxford University Press, 1931.

Popham and Wilde 1949
Popham, Arthur Ewart and Wilde, Johannes. *The Italian Drawings of the XV and XVI Centuries in the Collection of His Majesty the King at Windsor Castle*. London: Phaidon Press, 1949.

Popham and Pouncey 1950
Popham, Arthur Ewart and Pouncey, Philip. *Italian Drawings in the Department of Prints and Drawings in the British Museum. The Fourteenth and Fifteenth Centuries*. 2 vols. London: Trustees of the British Museum and Oxford University Press, 1950.

Popp 1925
Popp, Anny E. Review of *Michelangelo Zeichnungen* by A. E. Brinkmann. *Belvedere* 8 (1925): 72–75.

Posner 1974
Posner, Kathleen Weil Garris. *Leonardo and Central Italian Art 1515–1550*. New York: New York University Press, 1974.

Pouncey 1952
Pouncey, Philip. "Two Drawings by Cristofano Roncalli." *Burlington Magazine* 94 (1952): 356–359.

Pouncey 1962
Pouncey, Philip. "Contributo a Girolamo Macchietti." *Bollettino d'Arte* 47, ser. 4 (1962): 237–240.

Pouncey 1977
Pouncey, Philip. "A 'Bozzetto' by Roncalli for his Altarpiece in St. Peter's." *Burlington Magazine* 119 (1977): 225.

Pouncey 1977a
Pouncey, Philip. "Drawings by Alessandro Allori for the Montauto Chapel in the SS. Annunziata." In *Scritti di storia dell'arte in onore di Ugo Procacci*, edited by Maria Grazia Ciardi, Dupré Dal Poggetto, and Paolo Dal Poggetto. 2 vols. Milan: Electa Editrice, 1977: 2:442–447.

Previtali 1978
Previtali, Giovanni. *La pittura del Cinquecento a Napoli e nel Vicereame*. Turin: G. Einaudi, 1978.

Print Quarterly 1987
"Stradanus *Venationes*." *Print Quarterly* 4 (1987): 57–58.

Priuli-Bon 1900
Priuli-Bon, Lilian. *Sodoma*. London: George Bell and Sons, 1900.

Prosperi Valenti 1972
Prosperi Valenti, Simonetta. "Un pittore fiorentino a Roma e i suoi committenti." *Paragone* 23, no. 265 (1972): 80–99.

Ragghianti 1972
Ragghianti, Carlo L. "Pertinenze francesi nel Cinquecento." *Critica d'Arte* 19 (March–April 1972): 3–92.

Ragghianti Collobi 1974
Ragghianti Collobi, Licia. *Il libro de' Disegni del Vasari*. 2 vols. Florence: Vallecchi, 1974.

Réau 1957
Réau, Louis. *Iconographie de l'Art Chrétien*, Vol. 2. Paris: Presses Universitaires de France, 1957.

Réau 1959
Réau, Louis. *Iconographie de l'Art Chrétien*, Vol. 3. Paris: Presses Universitaires de France, 1959.

Reff 1977
Reff, Theodore. *Cézanne: The Late Work*. New York: Museum of Modern Art, 1977.

Ricci 1902
Ricci, Corrado. *Michel-Ange*. Florence: Alinari, 1902.

Richelson, 1978
Richelson, Paul. *Studies in the Personal Imagery of Cosimo I De' Medici, Duke of Florence*. New York and London: Garland, 1978.

Riedl 1959
Riedl, Peter Anselm. "Zu Francesco Vanni und Ventura Salimbeni." *Mitteilungen des Kunsthistorischen Institutes in Florenz* 9 (1959): 60–70.

Riedl 1960
Riedl, Peter Anselm. "Zum Oeuvre des Ventura Salimbeni." *Mitteilungen des Kunsthistorischen Institutes in Florenz* 9 (1960): 221–248.

Riedl 1978
Riedl, Peter Anselm. "Zu Francesco Vannis Tätigkeit für romische Auftraggeber." *Mitteilungen des Kunsthistorischen Institutes in Florenz* 22 (1978): 313–354.

Rinehart 1964
Rinehart, Michael. "A Drawing by Vasari for the Studiolo of Francesco I." *Burlington Magazine* 106 (1964): 74–76.

Rome 1977
Disegni fiorentini 1560–1640 dalle collezioni del Gabinetto Nazionale delle Stampe. Catalogue by S. Prosperi Valenti Rodinò. Rome, Villa della Farnesina alla Lungara: De Luca Editore, 1977.

Rome 1980
Disegni dei Toscani a Roma (1580–1620). Catalogue by M. L. Chappell, with W. C. Kirwin, J. L. Nissman, and S. Prosperi Valenti Rodinò. Rome, Gabinetto Nazionale delle Stampe, 1980.

Ronchetti 1922
Ronchetti, C. *Dizionario illustrato dei simboli*. Milan: Ulrico Hoepli, 1922.

Saint-Cyr de Rayssac 1875
Saint-Cyr de Rayssac. "Quinze sonnets de Michel-Ange." *Gazette des Beaux-Arts* 17 (1875): 5–18.

Salmina-Haskell 1982–83
Salmina-Haskell, Larissa. "A Sheet of Studies by Francesco Vanni." *Bulletin, Museums of Art and Archaeology, The University of Michigan* 5 (1982–83): 29–33.

Sanminiatelli 1956
Sanminiatelli, Donato. "Domenico Beccafumi's Predella Panels." *Connoisseur* 138 (December 1956): 155–159.

Sanminiatelli 1967
Sanminiatelli, Donato. *Domenico Beccafumi*. Milan: Bramante Editrice, 1967.

San Miniato 1959
Mostra del Cigoli e del suo ambiente. Catalogue by M. Bucci, A. Forlani, L. Berti, M. Gregori, and G. Sinibaldi. Florence: San Miniato, Accademia degli Euteleti: Cassa di Risparmio di S. Miniato, 1959.

San Miniato 1969
Mostra d'Arte Sacra della Diocesi di San Miniato. Catalogue by A. Matteoli, L. Bellosi, and D. Lotti. Florence: San Miniato, Accademia degli Euteleti: Cassa di Risparmio di S. Miniato, 1969.

Santarelli 1870
Santarelli, E., Burci, E., and Rondoni, F. *Catalogo della raccolta di disegni autografi antichi e moderni donato dal Prof. Emilio Santarelli alla Reale Galleria di Firenze*. Florence: La Galileiana, 1870.

Scacciati 1766
Scacciati, A. *Disegni originali d'eccellenti pittori esistenti nella R. Galleria di Firenze, incisi in rame con imitazione, grandezza e colore, ad acquerello, penna, e matita*. Florence, 1766.

Schapiro 1943
Schapiro, Meyer. "The Image of the Disappearing Christ, The Ascension in English Art around the Year 1000." *Gazette des Beaux-Arts* 85 (1943): 135–152.

Schapiro, 1965
Schapiro, Mayer. *Paul Cézanne*. New York: Harry N. Abrams, 1965.

Schonbrunner and Meder 1896–1908
Schonbrunner, J. and Meder J. *Handzeichnungen alter Meister aus der Albertina und anderen Sammlungen*. Vienna: Gerlach & Schenk, 1896–1908.

Schubring 1923
Schubring, Paul. *Cassoni, Truhen und Truhenbilder der italienischen Frührenaissance*. Leipzig: Karl W. Hiersemann, 1923.

Scorza 1984
Scorza, R. A. "A 'modello' by Stradanus for the 'Sala di Penelope' in the Palazzo Vecchio." *Burlington Magazine* 126 (1984): 433–437.

Shearman 1959
Shearman, John. "Andrea del Sarto's Two Paintings of the Assumption." *Burlington Magazine* 101 (1959): 124–134.

Shearman 1960
Shearman, John. "Rosso, Pontormo, Bandinelli, and Others at SS. Annunziata." *Burlington Magazine* 102 (1960): 152–156.

Shearman 1965
Shearman, John. *Andrea del Sarto*. 2 vols. Oxford: Clarendon Press, 1965.

Shearman 1967
Shearman, John. *Mannerism*. Harmondsworth: Penguin Books, 1967.

Shearman 1972
Shearman, John. *Raphael's Cartoons in the Collection*

of Her Majesty the Queen and the Tapestries for the Sistine Chapel. London and New York: Phaidon Press, 1972.

Shearman and Coffey 1976
Shearman, J. and Coffey, C. *Maestri Toscani del Cinquecento*. Biblioteca di Disegni, vol. 20. Florence: Istituto Alinari, 1976.

Sinibaldi 1963
Sinibaldi, Giulia. "Un disegno di Girolamo Macchietti." In *Scritti di storia dell'arte in onore di Mario Salmi*. Rome: De Luca Editore, 1963. Vol. 3, 89–93.

Smith 1976
Smith, Graham. "Rosso Fiorentino's *Sposalizio* in San Lorenzo." *Pantheon* 34 (1976): 24–30.

Smith 1977
Smith, Graham. *The Casino of Pius IV*. Princeton: Princeton University Press, 1977.

Smith 1982
Smith, Graham. "Cosimo I and the Joseph Tapestries for the Palazzo Vecchio." *Renaissance and Reformation*, N.S. 6 (1982): 183–196.

Smyth 1971
Smyth, Craig Hugh. *Bronzino as Draughtsman: An Introduction*. Locust Valley, New York: J. J. Augustin, 1971.

Sotheby's 1987
Dessins de Stradanus (Extraits du catalogue de la Bibliothèque Marcel Jeanson, Première partie: Chasse). Sotheby's Monaco, March 1, 1987. Uxbridge, Middlesex: Hillingdon Press, 1987.

Spalding 1976
Spalding, Jack. "A Drawing by Santi di Tito for His Lost Carmine *Nativity*." *Master Drawings* 14 (1976): 278–280.

Spalding 1982
Spalding, Jack. *Santi di Tito*. New York and London: Garland, 1982.

Spalding 1983
Spalding, Jack. "Santi di Tito and the Reform of Florentine Mannerism." *Storia dell'Arte* 47 (1983): 41–52.

Spear 1973
Spear, Richard E. "Jacopo da Empoli's St. Ivo with Widows and Orphans." *Allen Memorial Art Museum Bulletin* 30 (1973): 63–73.

Stechow 1967
Stechow, Wolfgang. "On Büsinck, Ligozzi and an Ambiguous Allegory." In *Essays in the History of Art presented to Rudolf Wittkower*, edited by Douglas Fraser, Howard Hibbard, and Milton J. Lewine. London: Phaidon, 1967: 193–196.

Stix and Fröhlich-Bum 1932
Stix, Alfred and Fröhlich-Bum, L. *Beschreibender Katalog der Handzeichnungen in der graphischen Sammlung Albertina*, Vol. 3, *Die Zeichnungen der toskanischen, umbrischen und romischen Schulen*. Vienna: Anton Schroll & Co., 1932.

Tervarent 1958
Tervarent, Guy de. *Attributs et Symboles dans l'Art Profane*. Geneva: Librairie E. Droz, 1958.

Thiem 1958
Thiem, Gunther. "Studien zu Jan van der Straet, genannt Stradanus." *Mitteilungen des Kunsthistorischen Institutes in Florenz* 8 (1958): 88–111.

Thiem 1959
Thiem, Gunther. "Studien zu Jan van der Straet, genannt Stradanus." *Mitteilungen des Kunsthistorischen Institutes in Florenz* 8 (1959): 155–166.

Thiem 1960
Thiem, Gunther. "Vasaris Entwürfe für die Gemälde in der Sala Grande des Palazzo Vecchio zu Florenz." *Zeitschrift für Kunstgeschichte* 23 (1960): 97–135.

Thiem 1964
Thiem, Gunther and Thiem, Christel. *Toskanische Fassaden-Dekoration in Sgraffito und Fresko*. Munich: F. Bruckmann KG, 1964.

Thiem 1970
Thiem, Christel. *Gregorio Pagani: Ein Wegbereiter der Florentiner Barockmalerei*. Stuttgart: Galerie Valentien, 1970.

Thiem 1971
Thiem, Christel. "The Florentine Agostino Ciampelli as a Draughtsman." *Master Drawings* 9 (1971): 359–364.

Thiem 1977
Thiem, Christel. *Florentiner Zeichner des Frühbarock* (Italienischen Forschungen herausgegeben vom Kunsthistorischen Institut in Florenz, 3rd. ser., vol. 10). Munich: F. Bruckmann KG, 1977.

Thiem 1977a
Thiem, Christel. *Italienische Zeichnungen 1500–1800*. Stuttgart: Staatsgalerie Stuttgart, 1977.

Thiem and Becker 1931
Thiem, Ulrich and Becker, Felix. *Allgemeines Lexikon der Bildenden Künstler von der Antike bis zur Gegenwart*, Vol. 25. Leipzig: E. A. Seeman, 1931.

Thode 1913
Thode, Henry. *Michelangelo. Kritische Untersuchungen über seine Werke*, Vol. 3, *Verzeichnis der Zeichnungen, Kartons und Modelle*. Berlin: G. Grote'sche, 1913.

Tietze 1953
Tietze, Hans. "A Self-Portrait by Pontormo." *Gazette des Beaux-Arts* 95 (1953): 365–366.

Tokyo 1982
Disegni italiani della Galleria degli Uffizi. Catalogue by the Gabinetto Disegni e Stampe degli Uffizi. Tokyo, Bridgestone Museum, 1982.

Tolnay 1950
Tolnay, Charles de. "Les fresques de Pontormo dans le choeur de San Lorenzo à Florence." *Critica d'Arte* 9 (1950): 38–52.

Tolnay 1960
Tolnay, Charles de. *Michelangelo*, Vol. 5, *The Final Period*. Princeton: Princeton University Press, 1960.

Tolnay 1976
Tolnay, Charles de. *Corpus dei disegni di Michelangelo*. 4 vols. Novara: Istituto Geografico de Agostini, 1976.

Turner 1986
Turner, Nicholas. *Florentine Drawings of the Sixteenth Century*. London: British Museum Publications, 1986.

Ugurgieri Azzolini 1649
Ugurgueri Azzolini, I. *Le pompe sanesi*, Vol. 2. Pistoia, 1649.

Utz 1971
Utz, Hildegard. "The Labours of Hercules and Other Works by Vincenzo de' Rossi." *Art Bulletin* 53 (1971): 344–366.

Vasari/Gaunt
Vasari, Giorgio. *The Lives of the Painters, Sculptors and Architects*. Edited by William Gaunt. 4 vols. London: J. M. Dent and Sons, Ltd., 1963.

Vasari/Milanesi
Vasari, Giorgio. *Le vite de' più eccellenti pittori scultori ed architettori scritte da Giorgio Vasari pittore aretino con nuove annotazioni e commenti di Gaetano Milanesi*. 9 vols. Florence: G. C. Sansoni Editore, 1906.

Venturi 1925
Venturi, A. *Storia dell'arte italiana*, Vol. 9, *La pittura del Cinquecento*, part 1. Milan: Ulrico Hoepli, 1925.

Venturi 1933
Venturi, A. *Storia dell'arte italiana*, Vol. 9, *La pittura del Cinquecento*, part 6. Milan: Ulrico Hoepli, 1933.

Venturi 1934
Venturi, A. *Storia dell'arte italiana*, Vol. 9, *La pittura del Cinquecento*, part 7. Milan: Ulrico Hoepli, 1934.

Venturi 1939
Venturi, A. *Storia dell'arte italiana*, Vol. 11, *Architettura del Cinquecento*, part 2. Milan: Ulrico Hoepli, 1939.

Vercelli and Siena 1950
Mostra delle opere di Gio. Antonio Bazzi detto "Il Sodoma." Catalogue by E. Carli. Vercelli: Museo Borgogna and Siena: Pinacoteca, 1950.

Viale Ferrero 1961
Viale Ferrero, M. *Arazzi italiani*. Milan: Electa Editrice, 1916.

Vitzthum 1963
Vitzthum, Walter. "The Accademia del Disegno at the Uffizi." *Master Drawings* 1 (1963): 57–58.

Vitzthum 1965
Vitzthum, Walter. Reviews of *Vasari Pittore, Complementi al Vasari Pittore, Mostra di disegni del Vasari e della sua cerchia* by Paola Barocchi. *Master Drawings* 3 (1965): 54–56.

Vitzthum 1966
Vitzthum, Walter. Review of *Pontormo: Disegni* by Luciano Berti. *Master Drawings* 4 (1966): 311.

Vitzthum 1972
Vitzthum, Walter. *Die Handzeichnungen des Bernardino Poccetti*. Berlin, 1972.

von Erffa 1965
von Erffa, Hans Martin. "Das Programm der Westportale des Pisaner Domes." *Mitteilungen des Kunsthistorischen Institutes in Florenz* 12 (1965): 55–106.

von Holst 1974
von Holst, Christian. *Francesco Granacci*. Munich: F. Bruckmann KG, 1974.

Voragine 1969
Voragine, Jacobus de. *The Golden Legend*. Translated by Granger Ryan and Helmut Ripperger. New York: Longmans, Green and Co., 1969.

Voss 1920
Voss, Hermann. *Die Malerei der Spätrenaissance in Rom und Florenz*. 2 vols. Berlin: G. Grote, 1920.

Voss 1928
Voss, H. *Teekeningen der late Italiaansche Renaissance*. Zutphen: W. J. Thieme, 1928.

Warburg 1969
Warburg, Aby. *Gesammelte Schriften*, Vol. 1. Nendeln/Lichtenstein: Kraus Reprint, 1969.

Ward 1981
Ward, Roger. "Some Late Drawings by Baccio Bandinelli." *Master Drawings* 19 (1981): 3–14.

Ward-Jackson 1979
Ward-Jackson, Peter. *Italian Drawings*, Vol. 1, *14th–16th Century*. London, Victoria and Albert Museum: Her Majesty's Stationery Office, 1979.

Washington 1984–85
Old Master Drawings from the Albertina. Catalogue by Walter Koschatzky and others. Washington, D.C.: International Exhibitions Foundation, 1984.

Washington 1987
Rosso Fiorentino: Drawings, Prints, and Decorative Arts. Catalogue by Eugene A. Carroll. Washington, National Gallery of Art, 1987.

Wilde 1959
Wilde, Johannes. "*Cartonetti* by Michelangelo." *Burlington Magazine* 101 (1959): 370–381.

Wiles 1933
Wiles, Bertha Harris. *The Foundations of Florentine Sculptors and Their Followers from Donatello to Bernini*. Cambridge: Harvard University Press, 1933.

Wittkower 1964
The Divine Michelangelo, the Florentine Academy's Homage on His Death in 1564: A Facsimile Edition of "Esequie del divino Michelagnolo" Florence 1564. Introduced, translated, and annotated by Rudolf Wittkower and Margot Wittkower. London: Phaidon Press, 1964.

Wölfflin 1890
Wölfflin, Heinrich. "Die Sixtinische Decke Michelangelo's." *Repertorium für Kunstwissenschaft* 13 (1890): 264–272.

Wölfflin 1899
Wölfflin, Heinrich. *Die klassische Kunst: Eine Einführung in die Italienische Renaissance.* Munich: n.p., 1899.

Wolk 1984
Wolk, Linda. "Sodoma's *Holy Family with Saint John.*" *Bulletin of the Detroit Institute of Arts* 61 (1984): 22–33.

Index